Collective Vision

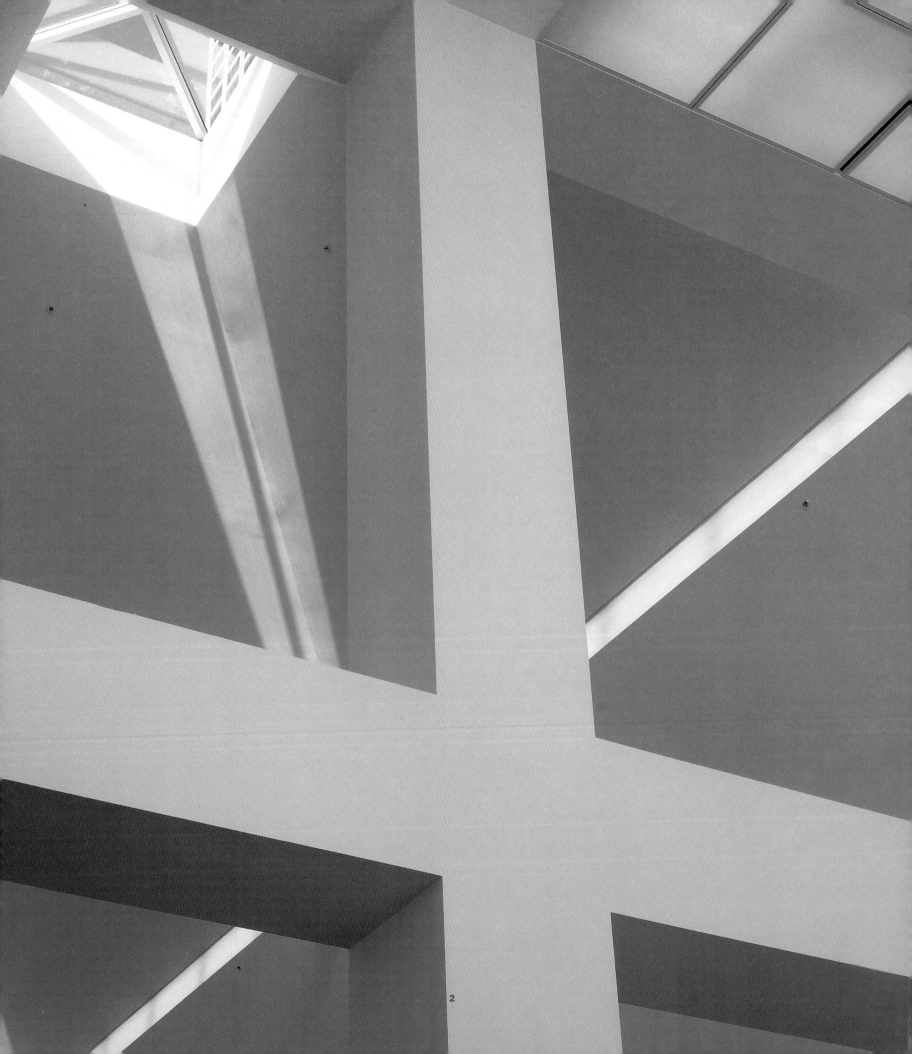

Collective Vision

Creating a Contemporary Art Museum

Museum of Contemporary Art
Chicago

Collective Vision was published in conjunction with the opening of the Museum of Contemporary Art on July 2, 1996, in Chicago.

The Museum of Contemporary Art (MCA) is a non-profit tax-exempt organization. The MCA's exhibitions, programming, and operations are member supported and privately funded through contributions from individuals, corporations, and foundations. Additional support is provided through the Illinois Arts Council, a state agency, and American Airlines, the official airline of the Museum of Contemporary Art.

Lead corporate sponsors for the Museum of Contemporary Art's grand opening and inaugural year are American Airlines, Bank of America, Hal Riney & Partners, Marshall Field's and Target stores, Philip Morris Companies Inc., and the Sara Lee Corporation.

ISBN 0-933856-42-3 (cloth)
0-933856-43-1 (paper)

Published by the Museum of Contemporary Art, 220 East Chicago Avenue, Chicago, Illinois, 60611.
Distributed by The University of Chicago Press.

Produced by the Publications Department of the Museum of Contemporary Art, Chicago, Donald Bergh, Director, and Amy Teschner, Associate Director.

Publication Coordinator and Editor: Terry Ann R. Neff, t.a. neff associates, inc., Tucson, Arizona

Architecture photography by Steve Hall, © Hedrich Blessing, Chicago.

Printed and bound by Friesens in Altona, Manitoba, Canada.

Photography Credits
Photographs on pages ii, viii, 1, 25, 26 (bottom), 28 (top), 37–45, and 47 by Steve Hall, © Hedrich Blessing; on page 2 by Shunk-Kender, New York; on page 7 (top) by David Van Riper; on page 7 (bottom) by Jean-Claude LeJeune; on pages 13 and 15 by Tom Van Eynde; on page 17 (bottom) by Artur Starewicz; on pages 21 and 30 (top) by James Prinz; on pages 26 (top) and 46 by Hélène Binet; on page 30 (bottom) by Sackmann fotographie; page 32 by Jörg P. Anders, Staatliche Museen zu Berlin—Preussischer Kulturbesitz Kupferstichkabinett; and on page 34 © Hedrich Blessing. All other photographs © Museum of Contemporary Art, Chicago.

Contents

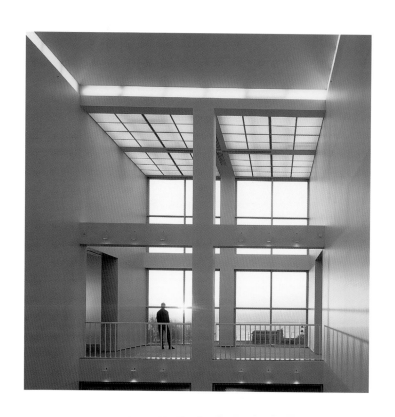

A Vision and a Legacy

In 1967 vision, courage, commitment, and hard work led to the founding of a new museum in Chicago, the Museum of Contemporary Art. In 1996 those same qualities have resulted in the museum's new building, an architectural landmark that allows the MCA to take its place among the great museums in the world.

These achievements have grown from the belief that the City of Chicago and the State of Illinois deserve a great contemporary art museum. We saw the need for a museum where people of all ages and backgrounds could experience and learn about contemporary art, a place with expansive facilities and innovative educational programs. We dreamed of a home for the masterpieces in Chicago's remarkable collections. We envisioned a forum where art by today's most thoughtful and gifted artists could illuminate the issues confronting our society.

That vision, coupled with a profound belief that art has the power to change lives for the better, formed the foundation for the MCA's plans for a new museum. Next came the courage to act on that vision. The museum we dreamed of would quintuple the present physical plant and triple its operating budget. Even after extensive economic analysis, a thorough assessment

of market conditions, and prudent strategic and financial planning, the decision to proceed with the project was a brave one—which could not succeed with timid steps forward, but required bold and forceful action.

The commitment of the Museum of Contemporary Art's Board of Trustees to launch the project was just such a bold act. Under the leadership of trustee Jerome H. Stone, the museum initiated the Chicago Contemporary Campaign with the unprecedented sum of $37 million committed by its fifty board members. It has been a monumental achievement by any standard, even in a city like Chicago that is rich with civic accomplishments. Now having surpassed its $55 million goal on its way to $65 million, the Chicago Contemporary Campaign has received support from corporations, foundations, and individuals throughout the community who endorse our vision and confirm the pressing need for the project.

Ultimately, the new museum has been made possible by the inspired efforts of countless devoted, gifted individuals. Fueled by their shared passion for contemporary art, the MCA family has worked together tirelessly to ensure the museum's

future. Especially deserving of recognition are the esteemed men and women who preceded me as chairs of the Museum of Contemporary Art and who served on the Armory Planning Committee, where the new museum project began, Joseph Randall Shapiro, Edwin A. Bergman, Lewis Manilow, Helyn D. Goldenberg, John D. Cartland, and Paul Oliver-Hoffman each made peerless contributions toward the museum's success.

Also deserving of praise is the distinguished trustee group I had the privilege of leading in the quest to find an architect for the new museum. After a world-wide search and hours in deliberation, we chose Josef P. Kleihues of Berlin, who has confirmed our initial judgment with a brilliant addition to Chicago's architectural legacy.

"On time and on budget" is a phrase rarely applied to major construction, but the MCA's project has earned that distinction thanks to the diligence and expertise of J. Paul Beitler and his fellow trustees on the building and design review committee. The MCA has been most fortunate of all in the leadership of its director and chief executive officer, Kevin E. Consey. He has made the dream of a new museum a reality. His insight, intellect, leadership, energy, and ability sustained the project from concept to completion. Without Kevin Consey and the support of an outstanding staff of professionals, the new museum project would not have been possible.

From the Women's Board, to the volunteer guides, to the museum's supporters on the Contemporary Art Circle, heartfelt thanks are due to all of the people who nurtured, sustained, and made real our vision for a new museum.

As exciting as is this moment in the MCA's history, with a striking new building, innovative programs, and fresh ideas, I am most excited by the museum's future. As we look ahead to a new century, the MCA is poised to take a lead in the effort to make art more central to the life of our community.

Allen M. Turner
Chairman, Board of Trustees

Building for
the Future

In any complex project, but perhaps especially building projects, one runs the risk of losing the forest for the trees. Whether you are building a summer cottage or a museum, tending to thousands of essential details—doorknobs, air ducts, materials, codes—can cause you to lose track of the real reason you are building in the first place. The hows can overwhelm the whys.

Thanks to a remarkable group of trustees, a dedicated staff, a generous and supportive community, and exceptionally talented consultants, how we built this new museum never became more important than why we were doing it. The solutions to the challenges we faced during the years of this project always supported our overarching goal: to create a new type of museum that would effectively and vividly present and preserve contemporary art. For a relatively young museum—the MCA was founded in 1967—this was a heady challenge and one that demanded considerable hard work and not a little nerve.

In 1984 the museum took stock of its history and accomplishments and began to chart a course toward the next millennium. The results of this analysis were sobering, indicating that the museum could not expect to continue to fulfill its mission in its facility at 237 East Ontario Street. The demands of the changing world of contemporary art, combined with the museum's rapidly expanding audience, were rendering the current building obsolete. Contemporary art exhibitions and even individual works of art were becoming too large to fit inside the museum's galleries. Only a fraction of the works in the MCA's extraordinary collection could be on public view at any time, restricting the interest of both the public and potential donors. The demand for educational programs was four to five times greater than the museum could provide. With options for expansion at its current address limited, the leadership of the museum began to look for a new home for the MCA.

The site of the Chicago Avenue Armory, where the Illinois National Guard had been quartered for approximately eighty years, is arguably one of the most magnificent building sites in the world. Overlooking Lake Michigan to the east and historic Water Tower to the west, bounded by two public parks in the heart of Chicago's most vital retail, business, and residential neighborhood, the site is ideally suited for a museum. Through an unprecedented private-public partnership, the MCA

was granted a ninety-nine-year-renewable lease on the property from the State of Illinois Department of Conservation (thereby becoming the first major Illinois state park in the City of Chicago). In exchange, the museum donated to the State Department of Military Affairs a significant parcel of land and building on Prairie Avenue that were readily converted into the new Chicago headquarters for the Illinois National Guard.

The Armory deal, structured in 1989, galvanized the planning efforts for the new museum with a daunting challenge. To live up to the extraordinary potential of the site, the new MCA had to become one of the foremost art museums in the world. Based on the MCA's rich and distinguished history, the staff and board set out to draft an artistic and educational blueprint for an expanded institution. The goal was to create a new international standard for what a contemporary art museum should and could be.

The time was right for a fresh examination of a contemporary art museum's role and potential. Museums throughout the nation and world were in a state of flux verging on crisis due to diminishing funding sources and rising expenses. Contemporary art itself was in a transitional state, rebounding from the economic boom and star system of the 1980s to a period with an unprecedented array of school's, styles, movements, and philosophies. Artists taking radical approaches to scale, mediums, and location were pressing the existing definitions and boundaries of contemporary art—and art museums—to the breaking point.

Coupled with these trends was the often uncomfortable dynamic of the shifting demographics of the city. It became harder to reach out to all segments of society, particularly those traditionally underserved by cultural resources. The elimination of art education from public school curriculums raised the likelihood that future generations would suffer from an absence of art in their lives.

In the light of these developments, it seemed clear that museums could no longer serve only as aesthetic and educational institutions, but had to become agents of social change as well. As a result, the Museum of Contemporary Art began to develop a new, expanded vision for the institution that addressed the questions these new challenges raised: What forms will con-

temporary art take in the future and how can a museum retain the flexibility necessary to accommodate them? How do people learn about art and what sorts of resources are needed to reach people of all ages and backgrounds? What role should a permanent collection play in a museum of contemporary art? How can the relationships between visual art and other art forms be successfully explored in a museum setting? How can the interplay between art created locally and elsewhere in the world best be portrayed?

As the artistic and educational vision for a new museum took shape, it was translated into an architectural program, a document that detailed the museum's space needs and technical requirements. The architectural program covered such topics as the use of natural and artificial light in gallery spaces, temperature and humidity needs for the protection and preservation of art, guidelines to ensure ease of public circulation, and specifications for a state-of-the-art educational theater. The program ensured that the MCA's new building would be designed from the inside out, with the activities and mission of the museum shaping the building rather than vice versa.

Simultaneously, a long-range strategic plan was developed to set the course for the fulfillment of the museum's mission, now revised and expanded. The plan set forth a financial structure intended to provide adequate funds not just for construction of the new facility, but also for a high standard of operations in perpetuity. An operating budget was developed to support a rich array of artistic and educational offerings, and an outreach program was put in place so that a broad and varied audience would benefit from the MCA's programs.

Central to the plan was a major fundraising effort called the Chicago Contemporary Campaign, launched in 1989. Fueled by the enthusiasm of corporations, foundations, and private individuals in Chicago and throughout the nation, the campaign in 1996 is on its way to exceeding its $55 million goal. With the Chicago Contemporary Campaign providing endowment and operating support for the MCA's programs, the future of the museum's financial structure was cemented with the issuance in 1994 of $50 million in tax-exempt bonds to fund the new building construction.

With a site secured, programmatic needs defined, and a

strategic operating plan in place, the MCA selected the architect who would give physical form to its ambitious plans. In 1990 the MCA sought nominations from throughout the world and reviewed the work of over 200 architects. This list was eventually narrowed to six masters in the field. The selection committee met with all the architects and traveled throughout the world to experience their work firsthand. Finally, in 1991 Josef Paul Kleihues was selected as the architect best suited to the project, best able to translate the museum's program into a building of distinction.

Kleihues's design for the museum is his first in the United States, following a number of outstanding projects in his native Germany. First unveiled in 1992, his design combines a sensitivity to the tradition of modern architecture in Chicago with a clarity of structure and spirit of innovation—notably in his decision to use cast-aluminum panels on the exterior of the museum. Kleihues's design for the MCA respects the function of the building and lives up to the potential of the site.

Having chosen an architect, the MCA now assembled a team that would oversee the efficient, high-quality construction of the new museum. Architect Kleihues opened an office in Chicago to maintain close involvement in the project. A. Epstein and Sons International, Inc., was brought on board to serve as associate architect. The museum selected Schal Bovis, Inc., as program manager, while Ove Arup & Partners acted as design engineers. This team, under the supervision of MCA staff project manager Richard Tellinghuisen, brought experience and expertise to this most important project in the museum's history. Following demolition of the Chicago Avenue National Guard Armory, groundbreaking for the new museum building occurred in 1993.

With the completion of its new building, the Museum of Contemporary Art stands ready to fulfill its mission and the promise of this extraordinary venture. The exhibition and program schedule will be carefully crafted through joint efforts of the curatorial and education departments. Programming during the first year in the new building will give audiences a taste of what the new MCA is intended to be. The inaugural exhibition, *Negotiating Rapture: The Power of Art to Transform Lives* explores the urge of contemporary artists to push beyond the limits of everyday experience toward a realm beyond human perception. Organized by Richard Francis, Chief Curator and James W. Alsdorf Curator, this challenging exhibition features such artists as Francis Bacon, Joseph Beuys, Anselm Kiefer, Bruce Nauman, and Ad Reinhardt.

The equally ambitious exhibition that immediately follows, curated by Special Projects Curator Lynne Warren, is *Art in Chicago: 1945-1995.* The first comprehensive historical survey of art created in Chicago, "Art in Chicago" explodes the myths surrounding Chicago art and explores the efforts to create and exhibit art in light of the city's politics, social activism, architecture, neighborhoods, and culture.

Perhaps more significant than any single exhibition is the fact that in the new building the MCA will have, for the first time, galleries dedicated to its exceptional permanent collection. Limited to occasional displays in its former building, the MCA's permanent collection is a treasure that has perhaps been overlooked by Chicagoans, despite the fact that it consists of some of the most exciting artworks created and collected in the past fifty years. In the new museum, works from the collection will be on display on a full-time basis, allowing visitors to gain an understanding of recent art history in a way never before possible. It is also expected that the new building will attract future gifts and loans from private collections, like the exceptional bequest of 105 works from the late Gerald S. Elliott—the largest gift to the MCA and one that would be a significant addition to any museum.

The new building will also feature a video gallery, allowing the museum to present an important development in recent art that is often neglected in more conventional museums and gallery spaces. Smaller spaces for temporary exhibitions will allow the MCA to continue to present the work of younger and more experimental artists as an ongoing part of its programming. Finally, the Robert B. and Beatrice C. Mayer Education Center, featuring a 300-seat auditorium, classrooms, conference room, and a 15,000 volume library, will help visitors of all ages gain an understanding of the challenging world of contemporary art. Together, these exhibitions and facilities will allow visitors to explore the exciting interactions that exist among recent art, art of previous generations, and the culture

that surrounds us. We believe that the experience of contemporary art will be enhanced and perhaps even transformed in a museum building designed specifically for that art.

Many museums are like history books, subject to occasional revision but essentially stable and even reassuring pictures of the distant past. Our conception of the Museum of Contemporary Art is that it is like a newspaper, covering breaking stories, providing analysis and perspective, capturing the moment in all of its contradictory, unstable glory. Our new building will be the ideal place to present the art of our day, the ideal way to keep this experience vivid and alive for generations to come.

Kevin E. Consey
Director and Chief Executive Officer

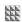

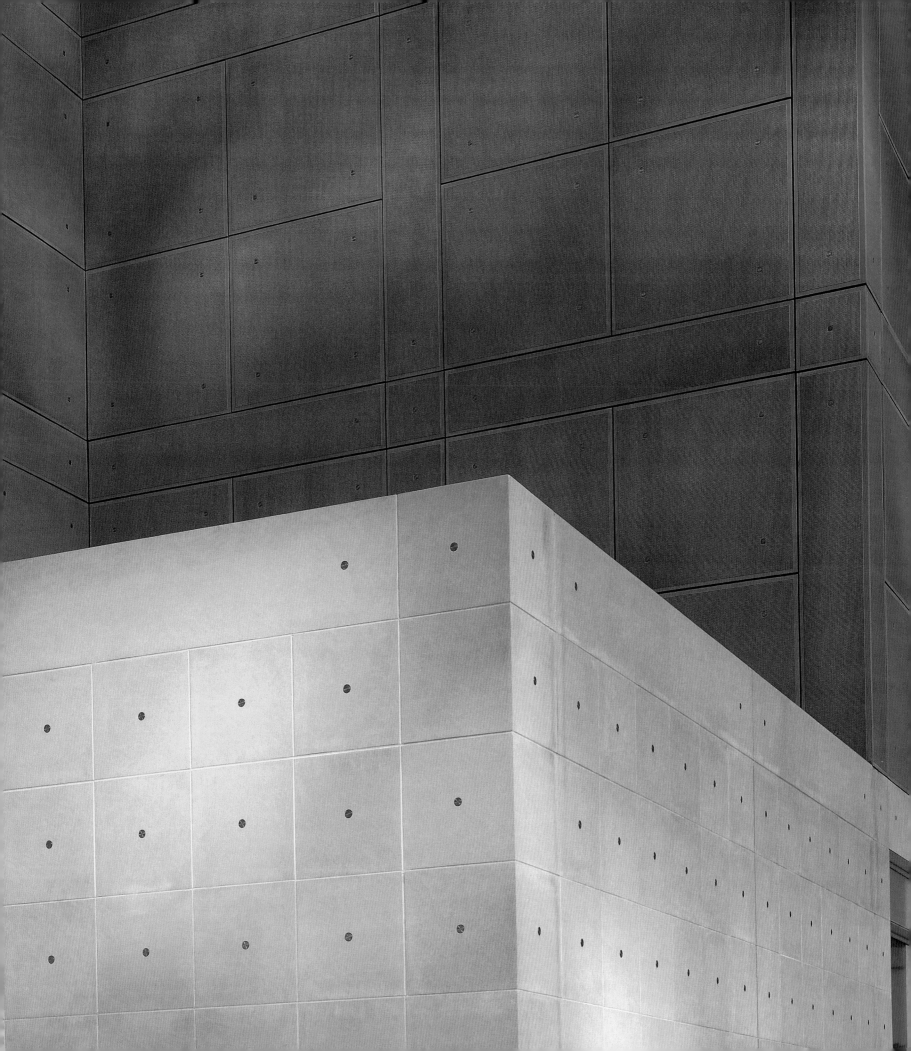

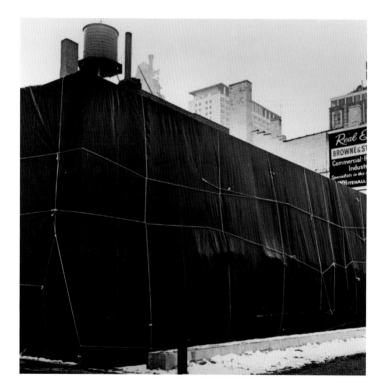

Christo wraps the MCA in
Christo Wrap In/Wrap Out,
1969.

Chronicle: Thirty Years of Change

EVA M. OLSON

Over the past three decades, the Museum of Contemporary Art has carved out a singular presence as a passionate and sometimes irreverent advocate for the art of the moment. Its establishment in the late 1960s created new opportunities for Chicago viewers to experience contemporary art at a time when standard offerings encompassed only the traditional and time-tested. The museum's tempestuous history has mirrored the vitality and turmoil of America's past thirty years. Throughout that time, the MCA has upheld its role as a laboratory for new ideas—experimenting, informing, and illuminating the nature of contemporary art.

The MCA's ongoing commitment to exhibiting art of the present makes consideration of its past particularly intriguing: What has this commitment entailed? What particular responsibilities and enthusiasms has it required? How much improvisation has been needed? How should the wisdom of experience influence a museum that so values the experimental?

Now an established cultural institution with thirty years of maturity, the MCA remains devoted to the innovative and current. Poised on the threshold of its new incarnation on Chicago Avenue, it can best go forward with an instructive sense of its own defining moments. The present soon becomes the recent past and, directly or indirectly, influences whatever ideas and efforts soon follow. So it is in art, and so it is in a growing, changing art museum.

·

THE FOUNDING YEARS The 1960s were a dynamic, turbulent era in America, and the art of the times, often shattering traditional media and content, reflected the political and social unrest many were experiencing. The MCA's arrival during this decade also broke new ground—the museum was a pioneer in presenting current and provocative art.

The Museum of Contemporary Art started as the dream of a small group of postwar collectors with similar tastes, passionate individuals who remained the museum's spiritual parents for many years. As early as 1960, Joseph Randall Shapiro, then chairman of the Program Committee for the Society for Contemporary American Art at The Art Institute of Chicago, was writing to Mrs. Walter (Elizabeth) Paepcke concerning the activities of the society. Their correspondence spawned the

notion of the Museum of Contemporary Art.[1]

Aware of the need for a venue in which contemporary art could be exhibited in Chicago, Doris Butler, Daniel Brenner, Mildred Fagen, Bernard Jacobs, Robert B. Mayer, and Franz Schulze first met on December 18, 1963, to discuss the formation of a new institution. The group was also discouraged by The Art Institute of Chicago's neglect of contemporary art.[2]

Along with Alberta Friedlander, Sigmund Kunstadter, Edwin A. Bergman, and Joseph Shapiro, these were "the people who had the vision and the stamina to pull it together, to organize the body of people that were interested in the same things, to hold them together and get them to coalesce."[3] Fortunately, Joseph Shapiro and each of his "small band of conspirators possessed the four essential ingredients necessary to bring it off: vision, energy, money, and the capacity to part with it."[4]

MCA life trustee and legal counsel Marshall M. Holleb remembers the debates at the early meetings "and the difficulties of thrashing out common purposes. What did it mean to be the museum of just contemporary art? What was the definition of contemporary art at that time? And who would decide? And was it a museum of local artists only? Or were we to be a museum for artists throughout the whole United States—or the whole world?… In 1963 there was hardly anybody who had a view that this would ultimately evolve into a museum of national or international importance."[5]

On January 9, 1964, twenty-five artists, collectors, architects, art dealers, and critics met to formulate plans for the museum. The next month this group, with architect Daniel Brenner as chairman, discussed the US Court of Appeals building located at 1212 Lake Shore Drive as a possible site for a contemporary art center. The Gallery of Contemporary Art was incorporated as a nonprofit organization for the purpose of filling a need in Chicago for a second museum to supplement the work of the Art Institute. The new organization's board of trustees[6] met in November with the museum's location still unresolved; Joseph Shapiro reminded them that the idea of a contemporary art center was more important than the site.

In 1965 mounting bureaucratic and financial tangles promised to preclude the possibility of transforming the Court

1968
●
MCA presents George Segal's first full-scale museum exhibition.

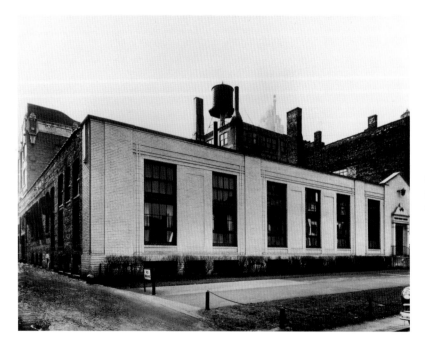

237 East Ontario Street, future site of the Museum of Contemporary Art, circa 1966.

4

of Appeals building into a viable museum. Alternate sites were suggested, including the Hancock Building and a structure originally built as a bakery in 1915, later serving as the corporate offices of Playboy Enterprises at 237 East Ontario Street. The Court of Appeals plan was ultimately abandoned in 1966,[7] and the board began actively to pursue the Ontario Street structure, logical and desirable because it was located on what was then informally known as "gallery row." Joseph Shapiro announced at a press conference at The Arts Club of Chicago that the museum trustees had signed a five-year lease on the Ontario Street building, which was subsequently redesigned and renovated by Daniel Brenner to become the new Museum of Contemporary Art.

The museum's founder, often described as its spiritual father as well, Joseph Shapiro functioned in the early days of the MCA not only as board president, but chief development officer, marketing director, and occasional custodian. According to Marshall Holleb, "What Joe opened up in our community was an appreciation of art that had not found a focusing point in Chicago. Joe had a strong feeling for art generally and got more intense about contemporary art because it was fresh and there was no other place in Chicago that was showing it at the time."[8] Joseph Shapiro was skillful in communicating his vision, and in guiding others toward establishing a visible and significant presence for contemporary art in Chicago. As he stated in 1967, "What we need in Chicago is a meeting place—an arena for an interchange of ideas about contemporary art, always with reference to the actual material at hand—not just an exhibition hall or a school, but education on an adult, sophisticated level through discourse and communion with original works of art."[9] And his passion and enthusiasm for the daunting tasks faced in the early days of the MCA has remained undimmed. He recently said, "We didn't think anything was difficult. I think it was all a joy. It was an adventure. It was full of our spirit, our enthusiasm, and we just loved every *minute* of it."[10]

Joseph Shapiro was not the only one taking the role of trustee to new levels of devotion. He and fellow pioneers Edwin A. Bergman and Robert B. Mayer took turns spending part of each day in the MCA office, handling day-to-day business operations until staff members were hired.

Fundraising for the first building began, under Joseph Shapiro's eloquent and tireless aegis, a mere six months before the October 1967 opening. Asking corporations to support the newly formed museum was difficult. "I would say 'I'm from the Museum of Contemporary Art,' and they would say, 'The what of what?' They never heard of you because you weren't in existence yet. And it was very difficult. We had no record of performance, but we managed."[11] Significant early contributors included The Chicago Community Trust, the Field Foundation, The Woods Charitable Trust (Art Institute President Frank Woods), and Hugh Hefner.

In the early days the board kept the doors open and the lights on, although the funds to do so often were scarce. As former board president John D. Cartland recalled, "It wasn't unusual in Joe's day to come down to the end of the year and sort of pass the hat and everybody chip in. We were hand-to-mouth during the year."[12] The trustees' dedication to building and sustaining the resources needed to provide quality experiences for MCA audiences has remained a bench mark at the museum.

The Women's Board, the earliest of the MCA's support groups, began with twenty-nine charter members in early 1967, predating the opening of the museum. The following year the Women's Board instituted a docent training program and held their first art auction for the benefit of the museum; they also opened and managed the Museum Store as a mobile unit. Through their multiple efforts, from education to fundraising activities, the Women's Board has been instrumental in shaping the vision of the institution, providing inexhaustible volunteer efforts until funds could be found for a professional staff and then, once the staff came together, continuing to provide invaluable support for the growing museum.

Each step the Museum of Contemporary Art has taken along the path of its development has been influenced by its internal culture as well as the larger cultural, social, and political forces of the moment. To announce the opening in 1967, a brochure stated the purpose and goals of the institution:

The Museum of Contemporary Art is dedicated to the art of today. As no other institution in our community, it will provide a forum for current creativity in the arts. The Museum of Contemporary Art will explore

the new. Its staff will be inquiring in outlook, liberal in viewpoint, and devoted to its task. Its programs will be not only educational, but also stimulating and exciting. This will not be a regional museum but, rather, a gathering place for the best in art today, regardless of where it is produced.

•

The first director, Jan van der Marck, came to the MCA from the Walker Art Center in Minneapolis and quickly developed a reputation for daring, controversial exhibitions.[13] Jan van der Marck saw the museum primarily as a laboratory, a place to exhibit the works of new and untested artists. Although his exhibition proposals occasionally caused stormy encounters with the trustees, they led to a series of groundbreaking MCA events.

The opening exhibition, *Pictures To Be Read/Poetry To Be Seen*, emphasized audience participation and featured sixty-eight works by twelve artists who fused abstract visual elements with text. The artists challenged the very existence of art museums and proclaimed the end of art. Intrinsic to this disconcerting message was the revelation that the MCA would support challenging ideas even, perhaps especially, at the cost of its own comfort. The museum would communicate its support of innovation by giving voice to a message that questioned the young MCA's very existence. What better way could there be to indicate the museum's unconventional intentions? And what better way could there be to communicate the museum's idea—and *ideal*—of the *kunsthalle*, an institution defined by the presentation of the best possible exhibitions and educational programming? In the early days the kunsthalle model vigorously set the MCA's priorities, and little thought was given to the development of a permanent collection.

Pictures To Be Read/Poetry To Be Seen, along with an exhibition of Claes Oldenburg's *Objects for Museums and Related Drawings*, attracted over 18,000 people in the first six weeks. Next on the schedule was *Two Happening Concepts: Allan Kaprow and Wolf Vostell*; the museum commissioned Kaprow to produce and direct a new Chicago happening.

Nicknamed "The Little Museum That Could" by a local newspaper, the MCA in its early days was, in the words of art critic Alan Artner, "a place where you could expect the

unexpected. And it generally didn't disappoint in that sense."[14] The museum continued to amaze—and occasionally confound— audiences with its audacious shows. *Dan Flavin: Pink & Gold*, an exhibition consisting of fifty-four eight-foot fluorescent light tubes, received a dramatic response from some viewers. As Joseph Shapiro later recalled: "People would come in, pay their admission fee, walk in, and they'd say, 'Where's the exhibition?' And we'd say, 'This is it.' And they'd say, 'I want my money back.'"[15]

The MCA's desire to educate audiences by encouraging visual literacy and familiarity with contemporary art has been present since its inception. Jan van der Marck believed in introducing challenging work that required effort by the viewer.[16] At a time when the museum staff was small, everyone joined in the attempt to educate the museum's public. "We knew we were doing it by the simplest means. Largely we had to make the *curatorial* effort one of education at the same time."[17] Early discussions of education by the museum's trustees focused on the need to offset popular shows with more experimental work— "balance the new with crowd-pleasers"—while teaching the viewer. Joseph Shapiro noted at the time that the MCA's market comprised a heterogeneous public—"the young, the Silent Majority, and the elitists who read *Art International*."[18]

Initial outreach endeavors included *Art and Soul*, a 1968 pilot project in the Lawndale area under the auspices of the Illinois Sesquicentennial Commission. Representatives of the Conservative Vice-Lords, a former street gang active in Lawndale, approached the museum for advice on bringing art to their community within the framework of a neighborhood rehabilitation program, with arts and crafts classes, exhibitions by black artists, and African artifacts.

The 237 East Ontario land and structure were purchased for $510,000 in 1968. Memorable exhibitions that year included *Made with Paper*, a survey of the creative use of the material, featuring examples from sixteen countries of paper as art form. Atop the roof of the museum appeared papier-mâché figures of a football team, complete with coach and cheerleaders, made by local high-school students. Also shown were *George Segal: Twelve Human Situations*, the artist's first full-scale museum exhibition; *Robert Whitman: Four Cinema Pieces* (which, in lieu

Allan Kaprow's *Words*, in the
inaugural exhibition
Pictures to Be Read/Poetry to Be Seen,
October 1967.

Dan Flavin: Pink & Gold,
1968.

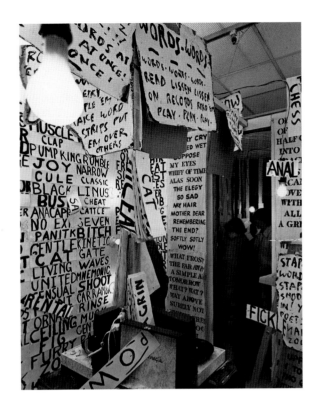

Bruce Nauman's *Jump* being
videotaped for the exhibition
Art by Telephone, 1969.

of a catalogue, featured a phonograph record on which Whitman sang songs related to the works); *The Original Baron and Baily Light Circus*, in which light, sound, and film converted the lower gallery into a seven-ring environmental circus; *Selections from the Collection of Mr. and Mrs. Robert B. Mayer*, featuring eighty works by seventy-four artists; *New British Painting and Sculpture*; and *Violence in Recent American Art*, a survey including thirty artists, ten of whom were based in Chicago. Chicago artist Ed Paschke, whose work was included in the exhibition, summarized the museum's role: "I think the nature of a museum that addresses the issues of contemporary art is always going to be upsetting to people at times, because that's what it's about. It's about breaking ground, breaking the rules."[19]

In 1969 the MCA continued to take artistic risks when Christo wrapped the building with 8,000 square feet of tarpaulin and rope, an installation that attracted considerable attention—and controversy. According to past board president Lewis Manilow, this exhibition more than any other may symbolize the continuing spirit of the MCA. "It was avant-garde in the best possible sense. That is to say, it expanded the vision of art. We had a grand vision. I remember dancing and cloth being everywhere, and looking at this new building, the whole idea, the scale of the imagination."[20] Visitors were able to enter the wrapped museum and view other wrapped objects. Despite the difficulties of resolving the objections of the fire marshal and the quizzical response of a few trustees, the exhibition was a great public and critical success, and again communicated the daring nature of the young museum.

Also in 1969, following a lengthy debate, the trustees applied their boldness to the cost of admission, doubling it from $0.50 to $1.00. The museum also took the unorthodox step of staying open three nights a week, with staff and trustees stating their belief that a new museum should not be bound by traditional hours of operation. Retrospectives of H. C. Westermann, Franz Kline, and László Moholy-Nagy appeared, as well as *Art by Telephone*, a conceptual exhibition in which thirty-four artists described over the telephone the specifications for works to be executed by the museum staff. *Don Baum Says:"Chicago*

Needs Famous Artists" featured twenty-eight local artists, including works by the Hairy Who, the Nonplused Some, and False Image groups. The final exhibition of the decade was *Selections from the Collection of Mr. and Mrs. Joseph Randall Shapiro*, the first large public showing of 172 works from the Shapiros' distinguished collection. With offerings such as these, the increase in admission price did not deter attendance.

Jan van der Marck believed that the museum could "best strengthen Chicago's artistic pulse by being truly international in scope."[21] He sought to integrate Chicago artists within the broader context of exhibitions.[22] In 1971 the focus shifted with the appointment of Steven S. Prokopoff as director. Emphasizing his wish to focus on Chicago artists, Prokopoff stated that "an institution ought to take care of the [artists] in its own community with the same seriousness that it took care of more celebrated international artists. We really had the field to ourselves."[23] Over the next five years, the MCA evolved in several areas: an increase in exhibitions of local artists, focus on a permanent collection, and more public programming were hallmarks of this period. As the museum matured, it began to develop an institutional self-confidence and expand the ways it fulfilled its mission of education and engagement.

•

The 1970s had arrived, and audiences continued to flock to see innovative shows at the MCA. Openings were drawing 600–900 people and public programs were standing room only. The Men's Council (originally the Young Men's Council) was founded in 1971, and sponsored annual events, including a popular street fair, to fund programs and exhibitions. In 1971 the Education Department was formally established and immediately began an active schedule of lectures, trips, and formal docent training. The MCA Library originated that same year.

Notable exhibitions in 1970 included The Architectural Vision of Paolo Soleri, as well Andy Warhol and Robert Rauschenberg retrospectives. *49th Parallels: New Canadian Art*; retrospectives of Cosmo Campoli and Enrico Baj; *Lucas Samaras: Boxes* (including fifty real boxes plus drawings of imaginary, impossible-to-construct boxes); and *Murals for the People* were presented in 1971. Highlights of the 1972 schedule included *Comix*, a bawdy and brash exhibition of underground comics;

Modern Masters from Chicago Collections, a fifty-year survey of paintings, drawings, and sculpture; works of James Rosenquist; *Deliberate Entanglements*, a fiber show of international scope; and the first major exhibition of the Chicago Imagists, with an opening event/street fair attended by 10,000 people.

In 1973 the MCA featured *Post-Mondrian Abstraction in America*; a posthumous Eva Hesse show; a popular exhibition of Diane Arbus photographs; one-person exhibitions of Richard Artschwager and Alan Shields; and *Joseph Cornell in Chicago*, which included forty boxes and eighteen collages drawn from local collections. Two vastly dissimilar visions of American life were coupled when, along with a Norman Rockwell retrospective, the museum exhibited *Executive Order 9066*, a photographic record of the relocation of 100,000 Japanese-Americans during World War II. Stephen Prokopoff later stated: "That was very deliberate, of course, and the idea was that Rockwell presented an aspect of America that everybody liked to believe—the benign, friendly place—and I wanted to suggest that there was perhaps a darker, meaner side to it."[24]

Initially, the MCA did not seek to establish a permanent collection, in part because the trustees did not wish to compete with the Art Institute.[25] Yet the kunsthalle concept so central to the museum's early days yielded over the succeeding years. No one doubted that the works of unknown and untested artists would always be presented, but it became clear that a permanent collection could support that activity. The trustees became convinced that truly to shine as an institution the MCA needed to pursue a strong permanent collection, especially as the need to present and preserve Chicago's many significant private collections became more apparent. The commitment to such a collection was voiced by Lewis Manilow at a board meeting in late 1973; the following year, the trustees voted to actively develop a permanent collection.

Joseph Shapiro remained president until April 17, 1974, when leadership passed to Edwin A. Bergman. Edwin Bergman's goals were to increase membership and formalize the permanent collection; as well, he was instrumental in the formation of trustee committees. Jim Nutt and Leon Golub retrospectives appeared at the MCA in 1974, along with an exhibition of twenty life-size figures by sculptors Duane Hanson and John De Andrea. A major retrospective of Alexander Calder opened concurrently with the unveiling of two Calder public sculptures in Chicago. A circus parade led from the MCA to the Loop sites of the other works. The Calder exhibition, the year before the artist's death, holds special meaning for Stephen Prokopoff: "Calder arrived the day before the exhibition opened. It was quite a moment because he could barely walk, he was really tottering." After requesting a hammer, Calder proceeded to fine-tune the works to the specifications he wanted, and "as he moved from piece to piece, slowly, adjusting the works, almost everybody had tears in their eyes."[26]

The museum presented a full complement of public programs at a time when such offerings were rare in Chicago. In addition to artist lectures and gallery talks, a weekly film series, jazz concerts, and an active schedule of performances (featuring such celebrated artists as Philip Glass, Anthony Braxton, and John Cage) showcased the MCA as a center for cultural activity. *Holiday Happenings* at the end of 1974 featured three weeks of activities for "children of all ages" and saw parents and children lined up all the way to Michigan Avenue. Such programs have remained an important means of introducing audiences to the museum and increasing access to its collections and exhibitions. The MCA has embarked on collaborative ventures with several Chicago organizations, including The Poetry Center, which was founded at the museum in October 1974. The first event was *Chicago Poets Look at Paintings*, a reading by over twenty poets of poems based on works of art that were shown as slides during the event. Major writers to appear at the MCA as part of The Poetry Center's reading series included Stanley Kunitz, Gwendolyn Brooks, Galway Kinnell, Allen Ginsberg, and William Burroughs.

Notable in 1975 were *Made in Chicago*, an expanded version of an exhibition that represented the United States in the 1973 São Paulo Bienal and featured twelve Chicago artists, and a Robert Irwin retrospective. The Collectors Group was formed, and MCA membership expanded from 3,000 to 4,500.

But perhaps most exciting that year was *Bodyworks*, an exhibition that remains clearly etched in the minds of those who witnessed it. A survey of over twenty artists, *Bodyworks*

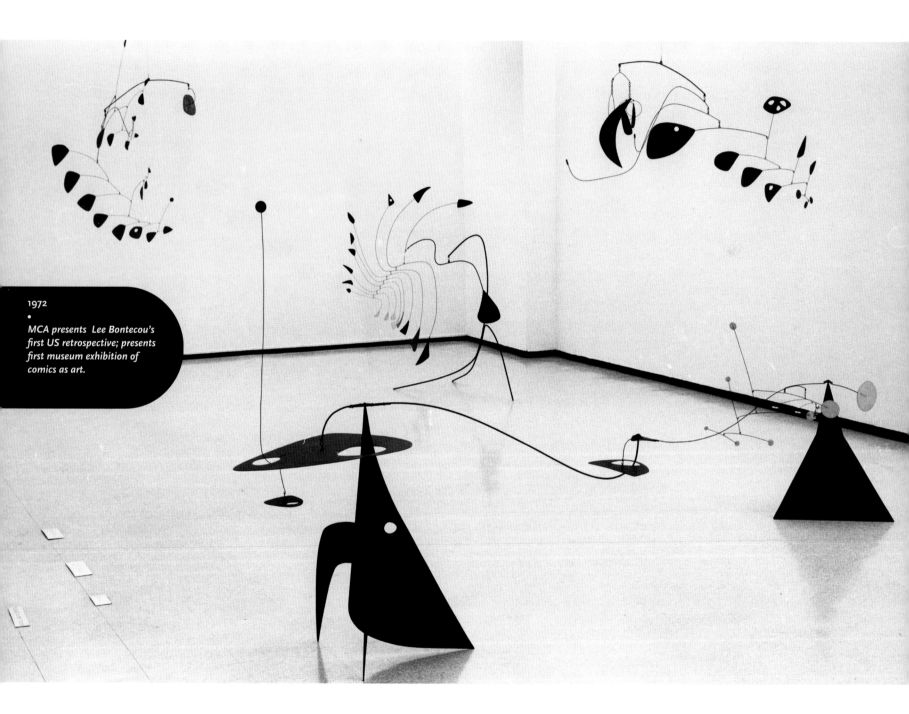

1972
•
MCA presents Lee Bontecou's
*first US retrospective; presents
first museum exhibition of
comics as art.*

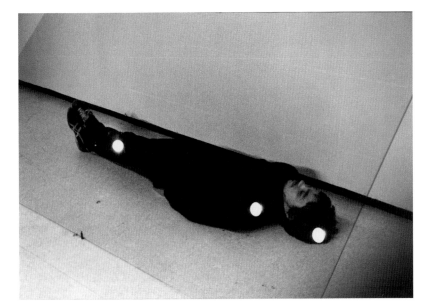

Chris Burden performing in
Bodyworks, 1975.

Left
*Alexander Calder: A Retrospective
Exhibition*, 1974.

was curated by Ira Licht and featured live performances by Vito Acconci, Dennis Oppenheim, Laurie Anderson, and Chris Burden. Burden asked for a sheet of glass, a clock on the wall, and a hammer behind the door, then proceeded to spend forty-five hours lying under the glass while the MCA received national media attention. The press was there in numbers, people came and went, and some even sang songs. Alene Valkanas (then director of public relations) and Licht made the decision to keep the museum open past its usual closing time so that the performance could go on uninterrupted. Eventually everyone went home, returning the next morning to find the artist still in place, and Valkanas remembers, "finally, [MCA technical specialist] Dennis O'Shea, the only one with a Buddhist sense of compassion, filled a pitcher of water, and put it next to Chris's head." As soon as he had done this, Burden got up, smashed the clock with the hammer, and came up to Valkanas with a "grisly" look on his face, really upset. For him, the terms of the piece meant it would be over as soon as someone interfered. "He did not expect to have to endure as long as he did; he thought we would be a museum—museums are formal and structured about

their hours, they have unions, they can't make adjustments—that we would come up to him and we would alter the piece by making him leave. He did not realize that he would have to go the long haul."[27]

As it approached its tenth anniversary, the MCA continued to be not only a forum for experimentation, but, increasingly, an institution with a secure presence in Chicago's cultural landscape. The question was no longer how brash could the MCA be, but rather how could adventure and security coexist?

•

A GROWING STATURE: 1976–1985 Lewis Manilow succeeded Edwin Bergman as president in 1976. At a time when both contemporary art and the MCA were gaining increased respectability and attracting a broader public, Lewis Manilow stated his desire to strike a balance between venturesome and popular exhibitions, retrospectives of international figures as well as shows involving local artists. He also reasserted the board's commitment to presenting bold work. "The hunger is for the more challenging. We can be [inspired] by daring, excitement,

and courage."[28] He pledged to move ahead on the permanent collection, and the museum began a formal policy of accepting gifts and bequests.

Surprising and stimulating the curious viewer were now more important than ever. The museum responded to its growing popularity and more secure position as a cultural institution by collecting and presenting the very art that had started it all. By featuring provocative works that celebrated the significance of contemporary art, the museum could provide fascinating juxtapositions with special exhibitions. Postwar artworks would come together under the roof of the MCA and inform a growing audience about the late twentieth century, right up to the present.

These twin goals, presenting both the newest art and a growing permanent collection, accentuated the need for more space. Negotiations were soon underway for an adjacent three-story brownstone at 235 East Ontario Street. Edwin Bergman set a fundraising goal of $1.5 million, to be met by the museum's tenth birthday in October 1977; significant contributors toward the expansion included Mrs. Joseph (Helen) Regenstein and the Kresge Foundation in Detroit. Borg-Warner Corporation provided initial funding for a gallery dedicated to the work of Chicago-based artists.

Chicago-themed exhibitions dominated the 1976 schedule: the MCA's 100th show, *Abstract Art in Chicago*, included fourteen local artists; *100 Years of Architecture in Chicago: Continuity of Structure and Form* featured plans, photographs, and models by 100 Chicago architects and traveled to several European cities. Works by Chicago artists Manierre Dawson and John Storrs were exhibited. Ira Licht was succeeded as curator by Judith Russi Kirshner.

Notable exhibitions in 1977 included retrospectives of Antoni Tapies, Richard Lindner, and Walker Evans; *A View of a Decade*, a survey celebrating the MCA's tenth anniversary; and Claes Oldenburg's humorous *The Mouse Museum/The Ray Gun Wing*.

John Hallmark Neff succeeded Stephen Prokopoff as director in March 1978. John Neff stated at the outset that his priorities were to complete the building addition, further pro-

fessionalize staff and procedures, place a stronger emphasis on exhibitions and publications featuring European artists, and initiate MCA-sponsored commissions. Prior to the closing of the museum for expansion in the summer of 1978, exhibitions included *Art in a Turbulent Era: German and Austrian Expressionism*; a June Leaf retrospective; and the first Frida Kahlo exhibition in the United States.

In the late 1970s the MCA further expanded its curatorial perspective by commissioning artists from outside Chicago, such as Gordon Matta-Clark, Michael Asher, Max Neuhaus, and Charles Simonds, to create site-specific works. *Circus*, or *The Caribbean Orange*, a piece that combined performance and exhibition, was the final project of Matta-Clark, who used circular cuts to carve out a work of "anarchitecture" in the annex prior to its remodeling into four new galleries. The Max Neuhaus installation was one of the first permanent sound sculptures in an American museum: thirty vertically stacked speakers invisibly placed in the museum's four-story stairwell were each programmed to collectively shape one's experience of the space with sound. Together with Michael Asher's exterior/interior installation, these commissions were the first Conceptual artworks to receive NEA funding as acquisitions for a permanent collection. Concurrent with his retrospective organized by John Neff, artist Charles Simonds created the wall installation *Dwellings* in 1981 for the museum's new Site Café.

Despite bad winter weather and consequent delays, construction on the expanded MCA was completed in March 1979. Converted by architect Lawrence O. Booth into a single structure with a dramatic, light-filled bridge spanning the second floor, the facility more than doubled its exhibition space to over 11,000 square feet. The MCA reopened to rave reviews the weekend of March 24, 1979. During Friday evening rededication ceremonies, *Spotlight on the Museum* featured an installation of 300 sealed beam lights by the artist John David Mooney on the sidewalk and street in front of the building. Inaugural exhibitions included *New Dimensions: Volume and Space* and *Wall Painting*, followed that year by the Michael Asher installation; a Sol LeWitt exhibition; contemporary Latino artists in *Ancient Roots/New Visions*; *Fotografia Polska*, a 140-year survey of Polish photography; *The Complete Drawings of Barnett*

1973
•
MCA presents Richard Artschwager's first one-person museum exhibition; presents Alan Shields's first one-person museum exhibition.

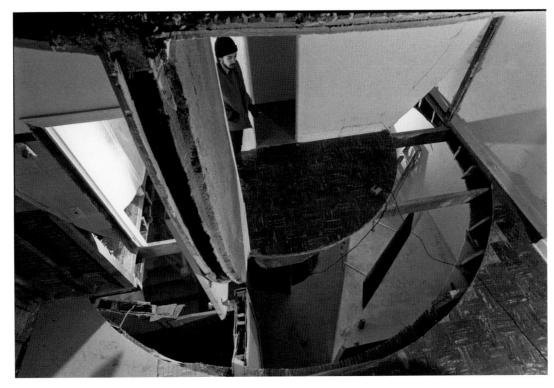

Gordon Matta-Clark's
Circus or
The Caribbean Orange
deconstructs
the future museum
annex in 1978.

The 1980 Vito
Acconci retrospective
featured
Trailer Camp,
an installation in the
Bergman Gallery.

Newman; and *Outsider Art in Chicago*, featuring Lee Godie and five other Chicago artists. "Options," an ongoing series designed to showcase the work of younger, emerging artists as well as new work by established artists, was launched in 1979 with an installation by Elyn Zimmerman. Contemporary video works were shown in the *5th Annual Ithaca Video Festival* and the *Everson Video Review*.

As had been planned, the expanded space offered more opportunities to exhibit the museum's permanent collection. Annual exhibitions of painting and sculpture in the permanent collection were featured, along with the MCA's collection of artist's books. The Contemporary Art Circle was established in 1979. According to current MCA Director Kevin E. Consey, "The Circle remains the premier individual annual contributor's vehicle for exhibitions and educational programs at the MCA even today, seventeen years later."[29]

Over two-thirds of the ninety exhibitions during John Neff's tenure were organized by the MCA. He noted in 1980 that the MCA "has come to serve a research and development role for other museums,"[30] and that the character of its exhibitions involved taking risks and questioning tradition. Memorable shows in 1980 included a Vito Acconci retrospective (including sculpture, video, poetry, and performance); *German Realism of the Twenties: The Artist as Social Critic*; *Hare Toddy Kong Tamari: Karl Wirsum*; *MA, The Japanese Concept of Time/Space*, an examination of eleven Japanese artists featuring architecture, photography, and landscape design; *Balthus in Chicago*; and the "Options" exhibitions of Martin Puryear, Lawrence Weiner, and Helen and Newton Harrison. It had become clear that a regard for the unconventional in art could be supported by taking steps to stabilize the institution. Hence the MCA began a two-year process of seeking accreditation from the American Association of Museums, recognition that was conferred in 1982.

When the museum expanded in 1978, its dedication to providing a variety of educational programs and activities benefited from the generosity of Beatrice Foods, which funded an orientation space to show educational videotapes related to

1974
•
MCA presents Leon Golub's first full-scale public museum exhibition.

exhibitions on view. The School Outreach Program, established in 1980, allowed the museum to reach significantly more students with expanded tours, free bus service, and teacher workshops.

Helyn D. Goldenberg became president in 1981. A founding member of the Women's Board, Helyn Goldenberg brought to her tenure the desire to expand the education program, balance the budget, and run the MCA like a business. She was also keenly aware of the need to broaden audiences, and amenities such as The Site Café (which opened in 1981) and the expanded Museum Store were redesigned to attract more visitors. Helyn Goldenberg recently summarized the MCA's history as a venture of extraordinary magnitude, noting that "the failures have been as interesting as the successes, and I think that's fine."[31]

In 1981 The Woods Charitable Fund sponsored a free day on Tuesday, and attendance rose thirty percent over the previous year. Exhibitions included Joan Miró; solo shows of Roger Brown, Chuck Close, and Robert Smithson; *California Performance Then and Now*, cosponsored by The Renaissance Society at the University of Chicago; and video by Chicago artist Skip Blumberg. The MCA originated traveling exhibitions of the work of Margaret Wharton and Charles Simonds. The "Options" series featured works of Jane Wenger, Ritzi and Peter Jacobi, Shigeko Kubota, and the female artist collaborative Disband at the Dustbowl. The critic and collector Dennis Adrian pledged nearly 500 works to the permanent collection—the first complete collection to be promised to the MCA.

By the 1980s the unselfconscious energy of 1970s art was being replaced with a marketing perspective that reflected the times. Visual art, and the artist as creator, were granted a great deal of attention, support, and opportunity—as well as demand. Museums sought to boost attendance with large-scale, blockbuster exhibitions. The burgeoning Chicago "art scene" of the 1980s gained much of its verve from the MCA; in turn, the MCA enjoyed record-breaking attendance.

Highlights of the MCA's 1982 schedule were an Yves Klein retrospective; *Selections from the Dennis Adrian Collection* (organized to commemorate his donation to the museum); more than sixty video works by Nam June Paik; Melvin Charney

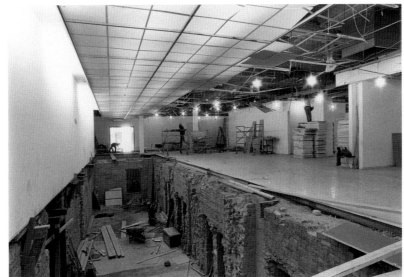

Under construction:
the museum expands its
quarters, 1978.

Rededication ceremonies in
March 1979 feature an
installation by John David
Mooney.

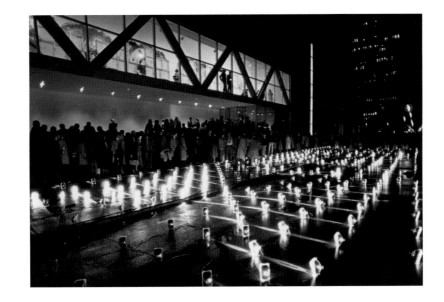

(the Canadian artist's *Chicago Construction* transformed the museum facade); and Laurie Anderson. *New Music America*, an ambitious festival of experimental music, was sponsored by the City of Chicago with the assistance of MCA staff. This half-million-dollar festival took place over eight days at Navy Pier, opened at Orchestra Hall, and was broadcast live. As part of the festival, John Cage's *A Dip in the Lake* was performed aboard the S.S. *Clipper* docked at Navy Pier. The MCA scheduled a benefit at the museum in conjunction with the Chicago International Art Expo in May—an event that moved to Navy Pier the following year and became an annual tradition. The Affiliates, under the aegis of the Women's Board, were also formed in 1982; its members and programs continue to serve as community liaisons for the museum. MCA education programs expanded to include docent visits to schools as well as extensive in-house activities that would become models for educational programming at other museums.

Looking beyond New York toward Europe, the MCA was reaffirming its global awareness by organizing international exhibitions, reflecting European leadership in the art field and the rise of *Documenta*, the international exhibition held in Kassel, Germany, as aesthetic arbiter. Mary Jane Jacob curated exhibitions of such acclaimed artists as Poland's Magdalena Abakanowicz. The artist's first major US retrospective and the museum's most ambitious exhibition to date, the 1982 show boasted outstanding attendance and media coverage. Indications that the MCA would soon outgrow its home on Ontario Street also began to surface, in part due to the massive scale of Abakanowicz's works.[32] The museum placed several of the larger pieces at the Chicago Cultural Center, and MCA leadership began to look toward the future and the possibility of expanding to a much larger facility. Soon after, Beatrice Cummings Mayer noted that "someday we must have another, larger home—we owe it to Chicago."[33]

The Abakanowicz exhibition also signaled the beginning of a greater presence for the MCA outside its own walls. In 1983 an exhibition of works from the permanent collection appeared at a retail space at 900 North Michigan Avenue, with 18,000 people viewing the works in a two-month run. In 1983 the museum began an outreach collaboration with N.A.M.E. Gallery called *Eleven Chicago Artists*, in which the artists' works, along with videotapes and teacher packets, were loaned to Chicago-area schools and senior citizen centers.

In 1983 the MCA exhibited works by Louise Bourgeois and Malcolm Morley; Earth Art selections from the permanent collection; and the famed George Costakis Collection, featured in *Art of the Avant-Garde in Russia*. "Options" included Alice Aycock, *Dogs!*, Peter Joseph, and film and video from the 1983 Whitney Biennial. The permanent collection was further enhanced when Joseph Shapiro and his wife, Jory, promised over thirty works of art, including works by Max Ernst, Marisol, and Enrico Baj. Works bequeathed by the estate of Mary and Earle Ludgin were also shown.

In 1984 the trustees commissioned an independent study of the museum's prospects for growth. The study confirmed the critical need for a new facility. One of the primary goals, voiced by many trustees, was to have sufficient space to keep and exhibit Chicago art treasures in Chicago. Lewis Manilow later recalled the early phases of fundraising: "My happiest moments were going around promoting this idea because I really thought we could do it!… The first and most important moment or phase of fundraising is convincing yourself. It *should* take months—we were lucky about delays because had it come too quickly, we would not have been financially or emotionally prepared."[34]

I. Michael Danoff succeeded John Neff as director in May 1984. Danoff's stated focus was to locate a larger museum facility. Since development of the permanent collection had spanned ten years and reached some 1,400 artworks, he planned to further determine its concept and direction. Highlights of the exhibition schedule that year included *Ten Years of Collecting*, featuring over 200 works celebrating the collection's diversity and excellence; opera set designs by David Hockney; and *The MCA Selects*, paintings and sculpture shown off-site at Marshall Field's. A larger and more diverse MCA audience was introduced to such artists as Anselm Kiefer and Georg Baselitz in *Expressions: New Art from Germany*. *Dada and Surrealism in Chicago Collections* reflected the astonishing local strength of these holdings. Rebecca Horn, Dieter Roth, and Giuseppe Penone were

Nam June Paik with
collaborator Charlotte Moorman,
wearing *TV Bra,*
at the 1982 opening of his
exhibition.

Laurie Anderson performing at the
museum in 1982.

Magdalena Abakanowicz's *Abakaus*
are installed at the Chicago Cultural
Center, as part of her retrospective at
the museum in 1982.

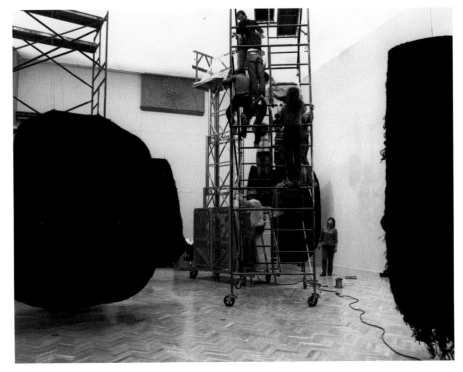

featured in the "Options" series. The New Group, a support group targeted at the growing number of young professionals expressing a strong interest in contemporary art, was initiated that year. With John Cartland as committee chair, the trustees embarked on a long-range planning process.

Exhibitions in 1985 included works by Leon Golub; *Selections from the William J. Hokin Collection*; *The Angels of Swedenborg*, an MCA-commissioned performance by Ping Chong; a Gordon Matta-Clark retrospective; Eric Fischl; and Robert Ashley's *Atalanta (Acts of God)*. The "Options" series featured emerging local artists Paul Rosin, Ken Warneke, Jin Soo Kim, Jo Ann Carson, and Robert C. Peters. Exhibitions of works from the permanent collection included *The Figure in Chicago Art*, a comprehensive survey of American painting and sculpture; *Nouveau Realism and Pop Art*; and artists' books and recordings. The Senior Outreach Program was introduced, sending MCA educators to senior centers and bringing senior citizens into the museum for exhibition tours, workshops, and follow-up activities. The program was acclaimed by the National Council on Aging and became a model for other institutions.

1983
•
MCA presents Kenneth Josephson's first full-scale museum exhibition.

The exhibitions and programs of the early 1980s were at once innovative and popular, and they indicated that expansion would mean far more than building a new, larger facility. The MCA could document healthy growth in virtually every area of the institution. But rather than bask in this success, the museum acted in character: Why stop taking risks? Why not give Chicago an even more energetic and ambitious Museum of Contemporary Art?

BUILDING THE FUTURE: 1986–95 Helyn Goldenberg was succeeded as board president in 1986 by John Cartland. John Cartland's term was distinguished by actions to further professionalize museum operations and consolidate plans for growth.

During 1986 the MCA presented eight thematic installations using works from the permanent collection, which then numbered some 1,647 objects and 1,386 artists' books. The legendary Jannis Kounellis exhibition, his first in the United States, included installations in off-site locations, as well as works using fire in the MCA galleries. Also shown that year were works by Robert Morris; the retrospective *Mies van der Rohe Centennial*; and *A New Generation from SAIC*, which highlighted the multimedia, high-tech works of sixteen recent graduates of the School of the Art Institute. More than 16,000 students visited the museum, and the *Eleven Chicago Artists* exhibition traveled to twenty-two schools.

As plans to occupy the Armory site advanced from dream to reality, a group of nine trustees gathered at the Hancock apartment of Beatrice Cummings Mayer in March 1986 and committed $5 million as seed money. Plans for the MCA expansion began to crystallize the following month when Governor James R. Thompson appointed a task force to determine the future of the Illinois National Guard Armory located on Chicago Avenue. "We took some difficult chances to bring it all together," Marshall Holleb later recalled. "The State of Illinois Department of Military Affairs announced they were going to get rid of the building on Chicago Avenue. I was particularly stimulated to go get it."[35] Streeterville residents were concerned about the possibility of a high-rise building on the site, and were pleased when the MCA presented a proposal that addressed the need for continued open space. The governor's task force recommended development of the site as a park with a museum and sculpture garden. Marshall Holleb and others began to meet with city and state officials (including the Illinois Department of Conservation, Department of Military Affairs, and Capital Development Board) to negotiate the use of the site, and MCA trustees approved funds for a feasibility study. Late in the year, R.R. Donnelley & Sons offered to donate to the MCA a 145,000-square-foot building at 1910 South Calumet Avenue, which could provide support and space for the MCA. A few years later, when discussions began in earnest with the State of Illinois for the MCA's use of the Chicago Avenue property, it became clear that the Donnelley building would be a suitable home for the Illinois National Guard. John Cartland later noted that "without the Donnelley building we would not have been able to do it. This was the only solution. It was just very fortuitous—the timing was amazing."[36]

In 1987 the MCA organized major exhibitions includ-

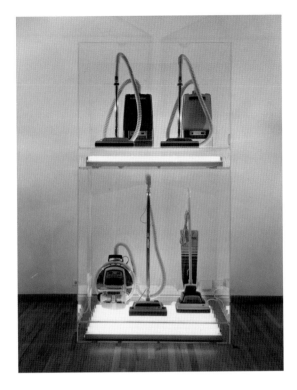

Jeff Koons's
New Hoover Quadraflex,
New Hoover Convertible,
New Hoover Dimension 900,
New Hoover Dimension 1000
was included in his
exhibition in 1988.

ing *British Sculpture Since 1965: Cragg, Deacon, Flanagan, Long, Nash, Woodrow.* Mary Jane Jacob was succeeded as curator by Bruce Guenther. Exhibitions during the year also included works by Donald Sultan and David Salle, and the MCA hosted the comprehensive exhibition *The Spiritual in Art.* Jenny Holzer was featured in the "Options" series. *The MCA at 333 West Wacker* included Minimalist works, Pop Art, and Earth Art from the permanent collection.

The 1988 exhibition schedule featured the work of Christian Boltanski, along with Edward Ruscha, Jeff Koons, and Gerhard Richter. Also included were a retrospective of Nancy Spero; *Three Decades: The Oliver-Hoffmann Collection;* the first public showing of the Marshall Frankel Collection; and the first group exhibition in the United States of Francesco Clemente's *14 Stations.* "Options" featured Odd Nerdrum and the photographers Doug and Mike Starn.

In 1989 the museum hosted *Robert Mapplethorpe: The Perfect Moment,* a traveling exhibition that brought 1,600 to the opening and boasted the highest attendance in the museum's history to date. The Mapplethorpe exhibition did not draw the controversy attendant at other venues, but carried a poignant and memorable note when the artist died of AIDS the day it opened at the MCA. Also that year were *Chicago Artists in the European Tradition;* the MCA-organized *Object, Site, Sensation: New German Sculpture;* three shows of works from the permanent collection; Arnulf Rainer; Peter Saul; the survey *Photography of Invention;* and, in "Options," Mark Innerst and Brazilian artist Tunga. The Keith Haring mural project, jointly sponsored by the MCA and the Chicago Board of Education, brought 500 high-school students to Grant Park to paint a 540-foot mural designed by Haring, who spent several days supervising the project as well as counseling students on the merits of staying in school.

In 1988 the Illinois legislature had passed a bill permitting the MCA to transfer the Donnelley building to the National Guard in exchange for a renewable ninety-nine-year lease on the Armory property, negotiated with the Illinois Department of Conservation. In 1989, as the State moved toward final approval of the title on the Donnelley property and authorization for the transfer, the trustees focused their efforts

on planning the conversion of the Armory site into the MCA's new home. An early endorsement of the MCA's ambitious plans came in the form of a $2 million grant from The John D. and Catherine T. MacArthur Foundation to establish an education endowment for the new facility.

Michael Danoff was succeeded by Kevin E. Consey in November 1989. In the interim between directors, John Cartland appointed Jerome H. Stone as chair of the Government Committee, which oversaw a restructuring process that clarified roles and responsibilities as well as changed titles of trustees and staff. John Cartland was succeeded by Paul Oliver-Hoffmann as the first chairman of the board.

As the museum's director and chief executive officer for the past seven years, Kevin Consey has been responsible for the operations of the Ontario Street museum, implementation of the new museum project, as well as long-term planning for the new building. He sees his role as a continuation of the museum's legacy. "I'm very much aware of the notion of collective work of over thirty years of my predecessors—on the staff, board members, contributors—[and how it] has given the MCA a tangible sense of presence. I feel as the CEO it is my responsibility to respect that presence."[37]

Also in 1989, under Paul Oliver-Hoffmann's chairmanship and led by Deputy Chairman Jerome Stone, the Chicago Contemporary Campaign was launched. This capital campaign would eventually see the MCA trustees, many of whom were involved in the museum's first incarnation a quarter-century earlier, contributing an astounding sum—more than $38 million toward the overall $55 million goal. As Jerome Stone recently recalled:

When I conferred with our fundraising counsel about the campaign, they talked to me about their evaluation of the feasibility study. They did receive a lot of comments from the leadership in Chicago that it seemed a risky undertaking for a museum that had $2.5 million operating budget to go after a $50 million campaign. It was only after I pointed out that the enthusiasm of the board should guarantee a solid foundation for such a campaign that they felt it was doable. Certainly the "I will" and "Can do" spirit of the board was convincing to me. This campaign has been a leap of faith for all of us, and in all of my fundraising experience, I have never been so inspired and motivated because of the splendid reaching gifts from our board of trustees. I do believe that this inspired all members of Chicago's supporters to join in to make this a successful campaign. [38]

Marshall Holleb noted at a board meeting that the "Miracle on Chicago Avenue"[39] was moving forward: the State approved the title on the Donnelley property late in 1989, and in 1990 the museum officially signed the lease on its new home. The commitment to educating Chicagoans along with other museum visitors continued as Beatrice Cummings Mayer and her family contributed $7.5 million to name a wing of the new museum The Robert B. and Beatrice C. Mayer Education Center. Featuring a 300-seat auditorium, classrooms, and a 15,000-volume library, the center is designed to encourage access and engagement for the museum's growing audiences. Beatrice Mayer discussed the rationale behind the education center:

My children, Robert N. Mayer and Ruth M. Durschlag, and I had long discussed a memorial to my late husband and their father, Bob. With the reality of the new museum the idea of an education center seemed most appropriate. This facility would be a natural continuation of our family's commitment to the MCA from its birth. Bob Mayer educated us all with his passionate desire to communicate the many ways in which contemporary art enriches our lives. My commitment to community service is shared in the way this center will touch so many diverse populations.[40]

•

Expanding its global connections to include the Pacific rim, the MCA hosted an exhibition of monumental sculpture, *A Primal Spirit: Ten Contemporary Japanese Sculptors*, in 1990. Other highlights included a Robert Longo retrospective that drew record crowds; *Toward the Future: Contemporary Art in Context*; *Julian Schnabel: Works on Paper, 1975–1988*; *The Art of Betye and Alison Saar*; and, in "Options," Richard Rezac and Willi Kopf.

One byword for the 1990s is diversity; multicultural artists have begun to play a greater role in art-making, and women artists such as Jenny Holzer and Lorna Simpson have

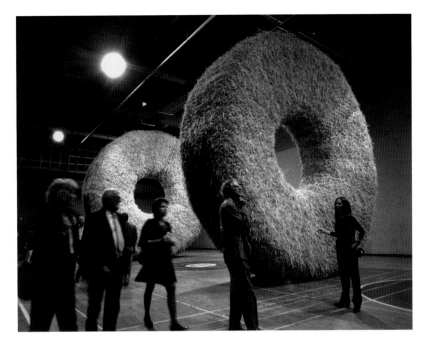

Michael Shaughnessy's
Two Rings/Gathered Rising
was included in
**Art at the Armory: Occupied
Territory,** 1992.

become "art stars" in their own right. Overall, there now is greater prominence for artists outside the dominant (white male) culture. The market concerns of the 1980s have been replaced with a profusion of political and social concerns, to which artists are responding with a multiplicity of new voices and forms. There also has been a progression from 1980s blockbuster to 1990s community, as institutions have begun to approach audiences outside museum walls and in their own neighborhoods.

The MCA's exhibition schedule maintained its diverse character as plans for the new building began to solidify. In 1991 the museum exhibited CUBA-USA: *The First Generation*; the work of Jean-Pierre Raynaud; Sigmar Polke; Rosemarie Trockel; Alan Rath; and *Memory and Metaphor: The Art of Romare Bearden, 1940–1987.* "Options" showcased emerging artists Cheri Samba, Julia Wachtel, and Lorie Novak.

Allen M. Turner became chairman of the board in 1991. He has guided the MCA through the challenging process of architect selection, planning, and fundraising for the new Chicago Avenue structure. After an extensive search, Berlin-based Josef Paul Kleihues, who had designed museums in Germany,

was named the architect for the building in May 1991. Allen Turner's description of the selection process evokes the original priority of Joseph Shapiro and his "small band of conspirators" in the 1960s: a desire to advance dramatically the presentation of contemporary art in Chicago, for Chicago:

When we set out on the journey to build our museum, it was important that the building be architecturally significant, a piece of art in itself, one that contains surprise, but one that does not compete with the art shown inside. We wanted a building sympathetic to its surroundings and context. To do this we decided that the appropriate process was to pick an architect and not a design. Picking a design would not allow flexibility as we developed our program.

In terms of design, we were very concerned about Post-modernism, Deconstructivism, and other current trends. The committee thought such styles would clash with the neighborhood and our art.

We chose Josef Kleihues not only because he had built museums, but because he was a collector of contemporary art and understood what was important about a contemporary art museum. He had been an academic as well as a practicing architect and had a strong

philosophical and intellectual approach that we liked. Also, he had sympathy for and knowledge of Chicago architecture. He was dealing with updated Modernism, similar to the style that Mies van der Rohe brought to Chicago, but a step beyond. The final result—the nature of the materials and their strong gritty presence, the power of the building, its shape, its floor plans—is very Chicago. This building will wear well. I think Chicago will look with great pride on this museum one hundred years from today.[41]

The board approved Kleihues's conceptual design for the building and sculpture garden late in the year. The museum unveiled plans for the new building on March 19, 1992, at a gala celebrating its twenty-fifth anniversary.

In 1992 *Robert Rauschenberg: The Early 1950s*, coupled with John Cage scores from the era, opened to record-breaking attendance. Installations by Donald Lipski and Alfredo Jaar were shown, along with *Lorna Simpson: For the Sake of the Viewer*.

1987
•
MCA presents Donald Sultan's first full-scale museum exhibition.

The Lorna Simpson exhibition, curated by Beryl Wright, won the 1993 College Art Association Award for Distinguished Body of Work, Exhibition, Presentation, or Performance. Yasumasa Morimura's trompe l'oeil works were featured in "Options." *Art at the Armory: Occupied Territory* featured eighteen installations in the soon-to-be-razed Armory building.

The museum received a National Endowment for the Arts Permanent Collection grant and initiated a "Permanent Collection Focus" series to allow audiences an opportunity to see selections in anticipation of installation at the new museum facility. By the mid-1990s the collection totaled more than 6,800 works, including 4,384 artist's books and 2,443 works in various media. In addition to the major bequest of Gerald S. Elliott of 105 Minimal, Conceptual, and Neo-Expressionist works, those who have given or promised works to the collection to date include Mr. and Mrs. Edwin A. Bergman, Frances and Thomas Dittmer, Stefan Edlis and Gael Neeson, Ralph and Helyn Goldenberg, Paul and Camille Oliver-Hoffmann, William Hokin, Ruth Horwich, Lewis and Susan Manilow, Mr. and Mrs. Robert B. Mayer, Albert and Muriel Newman, Joseph Shapiro, Howard

and Donna Stone, Lynn and Allen Turner, and other generous individuals and families.

Hand-Painted Pop: American Art in Transition, 1955-1962; Ilya Kabakov; Susan Rothenberg; and *In the Spirit of Fluxus* were featured in 1993. *Conceptual Photography from the Gerald S. Elliott Collection* highlighted Gerald Elliott's significant bequest. The "Options" series featured Libby Wadsworth and Rachel Whiteread.

Richard Francis joined the staff in 1993 as chief curator. *Radical Scavenger(s): The Conceptual Vernacular in Recent American Art* in 1994 was his initial curatorial effort; other exhibitions that year were *Op/Ed*, Fred Wilson's critique of the museum; a Gary Hill video installation; and a series featuring local artists Kay Rosen, Vincent Shine, Hollis Sigler, Jeanne Dunning, and Jim Lutes. Gabriel Orozco and Dan Peterman were the featured "Options" artists.

In its final year at the Ontario Street facility, the museum featured *Franz Kline: Black and White 1950-1961*; *Bruce Nauman: Elliott's Stones*; *Visions of Hope and Despair: Contemporary Photography from Chicago Collections*; *Beyond Belief: Recent Art from East Central Europe*; exhibitions of Wesley Kimler, Jeff Wall, Jack Pierson, Beverly Semmes, Robert Smithson, and Andres Serrano, whose mid-career retrospective concluded the schedule at the Ontario Street site. The MCA expanded its range of education programs with an innovative student docent program, while continuing to offer teacher education and free bus service for Chicago-area students. It also received reaccreditation from the American Association of Museums for another ten-year period.

Groundbreaking at the Chicago Avenue site took place on November 30, 1993, with Jane Alexander, chairman of the National Endowment for the Arts, as keynote speaker. The Kresge Foundation awarded a $750,000 challenge grant to the MCA, which was announced when the building was "topped out" on December 10, 1994. By June 1995 the Chicago Contemporary Campaign had reached ninety-five percent of its goal with $52,317,506 raised. Six- and seven-figure commitments to the Chicago Contemporary Campaign were being made by Chicago's leading corporations and foundations, a ringing endorsement of the museum's expansion plans. Counted among the MCA's key

supporters were Polk Bros. Foundation, The Chicago Community Trust, Robert R. McCormick Tribune Foundation, The Joyce Foundation, as well as corporations such as ComEd, Bank of America, Sara Lee Corporation, First Chicago NBD, AON Corporation, and Johnson Publishing Company, Inc. The staff took occupancy in February 1996, followed by architectural previews, and in June, public preview events and a weeklong celebration for MCA members, donors, and friends.

•

For three decades pioneering exhibitions have paralleled the development of the MCA's own identity. There have been wild "happenings" as well as calm, sophisticated institutional planning. Now the museum takes its vitality and daring to a new venue where it can better reflect and affect the art of our time and its role in our time. As Allen Turner has expressed it: "The building part, as big a challenge as it was, may not be as big a challenge as executing, because when you execute the plan, you step into the world of programming, of scholarship, of service, and those things are more difficult. It's easier to build a building than to fulfill its promise."[42]

Out of this endeavor to realize its potential comes the MCA's paramount obligation: to foster dialogue, solitude, even cacophony—to engage Chicago's residents and visitors in the most stimulating contemporary art.

Notes

1 The Feigen Gallery newsletter (July 1960) described the Society for Contemporary American Art's then-current exhibition as "shockingly bad," and said the members had chosen amateur and insignificant works. Melvin Brorby, then president of the society, wrote a response to Richard Feigen, emphasizing the educational aspects of the society: to teach its members to "better understand and enjoy contemporary art" and not to simply give more works to the Art Institute or produce the best shows. Mrs. Paepcke wrote to Mr. Brorby on August 22, 1960, thanking him for the letter to Mr. Feigen, and expressing her dismay with the article. She added: "Out of the [Feigen article] and because of our own disappointment with the Art Institute's attitude toward modern art in general," a meeting was held in the apartment of Richard Feigen with Doris Lane [Butler], Alberta Friedlander and others, in order to discuss forming a museum of contemporary art, in about 1962-63. (Art in America, May 1972, notes that until the involvement of Joseph Shapiro, the idea of forming the museum did not gain the motivation and direction it needed to become a reality.)

2 "The Art Institute of Chicago, long the grande dame of the local art scene, was seen as unsympathetic to contemporary art, and its doors were soundly closed to a new group of collectors whose energies and income were committed to contemporary art." James Yood, New Art Examiner, February 1986.

3 Marshall Holleb, interview with the author, September 29, 1995.

4 Wendy Hamas interview with Joseph Randall Shapiro, April 14, 1992.

5 Wendy Hamas interview with Marshall Holleb, April 22, 1992.

6 Edwin A. Bergman, Daniel Brenner, Doris Lane Butler, George Cohen, Alberta Friedlander, Byron Harvey, Mrs. Edwin Hokin, Marshall Holleb, Patrick Hoy, Robert B. Johnson, Albert Keating, Sigmund Kunstadter, Richard Latham, Robert B. Mayer, Charles Murphy, Jr., Leo Schoenhofen, Joseph Randall Shapiro, Aaron Siskind, Dr. Joshua Taylor, John Walley, and Edward H. Weiss sat on the first board of trustees.

7 As quoted in The Chicago Sun-Times, October 22, 1967: "The bid for the Court of Appeals Building, as board president Joseph Randall Shapiro relates it, was a dreary, soul-destroying struggle, 'like trying to get to Kafka's Castle.'"

8 Marshall Holleb (note 3).

9 The Art League News 14, 8 (April 1967).

10 Joseph Shapiro (note 4).

11 Ibid.

12 John D. Cartland, interview with the author, October 4, 1995.

13 Jan van der Marck was quoted in the October 22, 1967, issue of The Chicago Sun-Times: "We want people who have something new to say; artists who are not yet accepted; whose ideas are tougher to take."

14 Wendy Hamas interview with Alan Artner, May 6, 1992.

15 Joseph Shapiro (note 4).

16 Jan van der Marck stated: "We will choose the most valid of the traditional ideas, the ones that are always vital and challenging enough to illuminate the contemporary art which is our main purpose... this museum deals in difficult ideas which must never be oversimplified. Contemporary art is not and cannot be simple. It is complex and demands an effort from the viewer. With more and more adult education, more sophistication in every realm of life, the museum has the right to expect a serious effort" (note 13).

17 Jan van der Marck, telephone interview with the author, October 17, 1995.

18 Minutes of Museum of Contemporary Art Board of Trustees, January 20, 1970.

19 Wendy Hamas interview with Ed Paschke, April 22, 1992.

20 Wendy Hamas interview with Lewis Manilow, May 12, 1992.

21 Jan van der Marck (note 13).

22 Quoted in The Art League News, April 1967, on the question of whether this is a Chicago museum, Jan van der Marck replied: "It is a far more ambitious undertaking, and I think, in terms of what Chicago needs...it is a national museum...once you set aside certain works of art as being Chicago art or art of Illinois...you in effect are segregating. You are not doing a Chicago artist a service by putting him in a separate room.... And I certainly don't plan anything of this sort. For instance, if we do an exhibition of certain types of painting...you put in such a show artists in Chicago who are working in that medium, along with artists who are working in Paris, Los Angeles, Tokyo, and where have you. And then I think the individual artist will be present with more dignity and more justice."

23 Stephen S. Prokopoff, telephone interview with the author, October 19, 1995.

24 Ibid.

25 "We have had to fend off offers of art works from all round, and could have easily emptied all kinds of attics around the city. Perhaps in a couple of years, we might start putting stuff in warehouses for a permanent collection." Joseph R. Shapiro, quoted in The Chicago Sun-Times, October 22, 1967.

26 Stephen Prokopoff (note 23).

27 Alene Valkanas, interview with the author, October 18, 1995.

28 Lewis Manilow, interview with the author, September 22, 1995.

29 Kevin E. Consey, interview with the author, February 12, 1996.

30 Minutes (note 18), June 24, 1980.

31 Helyn D. Goldenberg, interview with the author, September 22, 1995.

32 Helyn Goldenberg recalled that she and Lawrence Booth were walking down Michigan Avenue after a meeting; as she muttered about the Abakanowicz works being too big to fit in the museum space, he asked, "Well, why don't you take the Armory?" They agreed that the best idea was for the MCA to move to the Armory; the rumor spread fast, and Irving Kupcinet picked it up in his "Kup's Column" about three weeks later (note 31).

33 Minutes (note 18), January 24, 1983.

34 Lewis Manilow (note 28).

35 Marshall Holleb (note 3).

36 John Cartland (note 12).

37 Kevin E. Consey, interview with the author, October 24, 1995.

38 Jerome H. Stone, interview with the author, October 20, 1995.

39 Minutes (note 18), April 17, 1989.

40 Beatrice Cummings Mayer, interview with the author, September 29, 1995. Mrs. Mayer was quoted in the 1991 Chicago Contemporary Campaign brochure: "This is a museum for all the people of the city of Chicago and we want to give them every opportunity to visit the museum and we want to make them feel welcome. We also want this new museum to be a meaningful learning and aesthetic experience for families. If we can educate the children of our community, maybe they'll bring their parents in. That's the role our family envisions for the Mayer Education Center."

41 Allen M. Turner, interview with the author, October 10, 1995.

42 Ibid.

1988

•

MCA presents Jeff Koons's first full-scale museum exhibition; coorganizes Gerhard Richter's first American retrospective.

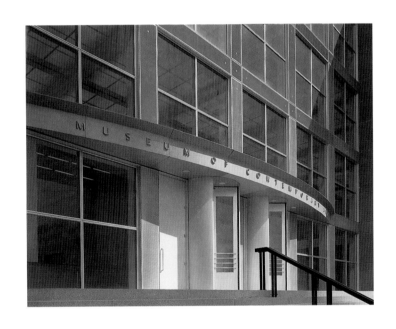

Josef Paul Kleihues: Chicago and Berlin

FRANZ SCHULZE

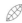

In the course of the last generation the art museum, especially the type devoted to twentieth-century art, has become the genre of creative choice among the major architects of the world. Public and private institutions have grown as adventurous in their tastes as the artists whose work they exhibit and the architects they hire to provide a frame for that work. It is customary in the 1990s to think of the art museum as a vehicle for the freest expression of its designer's talents and theoretical ambitions.

In a similar spirit of latitude, boundaries of nationality have broken down in architecture almost as completely as they did long ago in painting and sculpture. Distinguished museums have been built in Stuttgart by an Englishman, James Stirling; in Los Angeles by a Japanese, Arato Isozaki; in Frankfurt by an Austrian, Hans Hollein; in London by an American, Robert Venturi—and the list runs on, far beyond these few names and places.

At the same time, it includes architects who, having designed more than one museum, within their home countries or without, have been obliged to tame personal expressive impulses by studying contexts unfamiliar to them and ensuring that the physical character and historical spirit of a specific locale are appropriately articulated in the finished building or, surely, not violated by it. A further constraint often follows from the more than occasional assignment to bond a newly conceived structure to an already existing one.

The art museum, then, challenges resourcefulness as often as it invites license. And among the contemporary architects whose careers have been defined largely by their work in museum design, none is more conscious of the interplay of discipline and freedom, or more responsive to it, than Josef Paul Kleihues of Berlin.

Two of Kleihues's most important recent projects are designs for the Museum of Contemporary Art in Chicago and the Hamburger Bahnhof Museum in Berlin. While the names reflect their commonality of purpose, in an architectural sense they represent for the most part contrasting approaches to that end. The Chicago project has been erected on a choice parcel of land on the city's elegant Near North Side, where it dominates a wide strip extending eastward from one of Chicago's most famous landmarks, the Old Water Tower, to the edge

The site of the Museum of Contemporary Art is between the Old Water Tower to the west and Lake Michigan to the east.

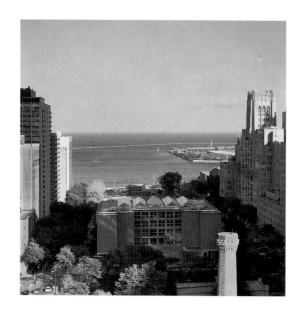

The Hamburger Bahnhof Museum occupies a building constructed in 1846–47 as a railroad station linking Berlin and Hamburg.

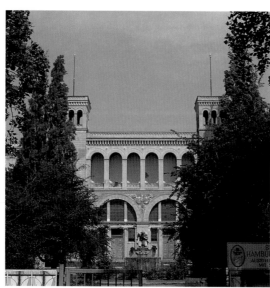

of its equally celebrated Lake Shore Drive and the shoreline of Lake Michigan. The building is altogether of Kleihues's making, an almost unrestricted embodiment of his expressive and theoretical ideas. Its gallery spaces are allocated roughly equally to temporary exhibitions and to the museum's permanent collection, with a sculpture garden effecting a passage between the building and the lake. Auxiliary functions include an education center, a bookstore, an auditorium, and a restaurant, all standard components of today's art museums.

The site of the Hamburger Bahnhof Museum is no less impressive in its own dissimilar way. It lies just immediately east of the line that divided East and West Berlin during the Cold War. The wall that marked that grievous split is now gone, demolished in 1989. The new museum occupies a standing building already rich in a history both inspiriting and depressing. Constructed in 1846–47 as a railroad station linking Berlin and Hamburg, it stood for the high hopes of the Industrial Revolution that galvanized central Europe in the mid–nineteenth century. As other rail facilities were added to Berlin, it was eventually transformed into a transportation and building museum

and still later into a hapless ruin, one of thousands left in the German capital as monuments to the horror of World War II. Restored in the 1980s as an exposition hall, it recently underwent yet another change of identity, this one attached to the art museum that will open in the fall of 1996 following the completion of Kleihues's reconstitutive plans.

In outer form, the Bahnhof museum will incorporate enough of the original structure that its past associations with political conflict and violence will remain rooted in the minds of its Berlin constituency. The interior, while substantially larger in area than the Chicago MCA, will include essentially the same functions. Appropriately, then, each museum in its very materiality communicates a measure of the cultural tradition of the city it represents. In Berlin, the older of the two metropolises, with the more convoluted history, a structure vast, sprawling, and complex in plan consists of parts built at various times in various styles over a century and a half. Younger Chicago, often called the most American of cities, physically untouched by war and famous for its commerce and a collectively pragmatic turn of mind, has gained a building that is clean, compact, confi-

dent, new throughout, and stylistically of a piece. The façade of the Bahnhof museum, the part most visible to the public, retains its typical mid-nineteenth-century Berlin *Rundbogenstil* ("round arch style"), while the Chicago MCA is a recapitulation of the renowned Chicago frame in its elevation, of the Chicago street grid in its plan.

At first glance, then, the two finished works seem strikingly different from each other, one, a Central European hybrid, the other, an American unity. Moreover, while the architect in charge of both is a Berliner, he has left no doubt about his special passion for Chicago architecture. "Even as a student," he has said, "the two cities that interested me more than all others were Rome and Chicago."[1]

Taking him at his word suggests that there may be more of a connection between the Bahnhof museum and the Chicago MCA than appears initially. For one thing both buildings owe more than a little to the classical tradition. The arches, columns, and pilasters of the Bahnhof museum's symmetrical middle tract, together with the embrace of a forecourt by two powerful wings,

attest to this. A similar bilaterality is apparent in Chicago, as well as a comparable winged embrace of a central area, where a monumental staircase rising between the wings brings to mind the ascent to the Propylaea, the great gate to the Acropolis in Athens. The stairs at Chicago lead to an entrance, thence to a formal lobby that crosses the longitudinal axis on the second level. A central hall traces that axis, running the length of the building to the restaurant and a panoramic view of the sculpture garden toward the lake. Parallel to the central hall are the main galleries. On the second level, which is effectively the *piano nobile*, these take the form of two generous, unimpeded spaces two stories high, intended for temporary exhibitions, while their equivalent areas one floor higher are split into two pairs of long rooms meant to house the permanent collection. These latter spaces are the most spectacular interiors of the museum, their glazed barrel vaults providing a capstone to the Classicism that informs the whole structure.

The Bahnhof museum, on the other hand, largely because it was built in fits and starts over decades, departs from

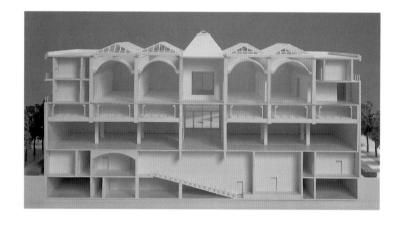

Section through the Museum of Contemporary Art Chicago

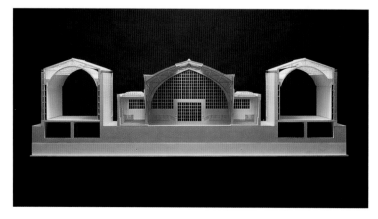

Section through the Hamburger Bahnhof Museum Berlin

the classical paradigm at several points. The great railroad shed, for instance, which will be kept as a space for the exhibition of very large objects, is a piece of unadorned industrial engineering before it is anything else. Moreover, while the interior of the east wing of the old building has retained some of its late romantic relief and stencil ornament, most of the space will be carried out in a contemporary decorative program of utmost simplicity.

The kinships and contrasts in the two museums recall a pair of architects whose careers developed in Berlin and whom Kleihues admires more than any other designers associated with that city. While their shared inclination toward classicism was strong enough to have given Kleihues ample reason to follow it in his two museums, they were also different enough to have left their individual stamps on his finished designs. Karl Friedrich Schinkel (1781–1841) was the more complex and versatile of the two, Ludwig Mies van der Rohe (1886–1969) the more concentrated. Schinkel lived his whole life in or near Berlin. Mies stayed there for roughly three decades before immigrating to Chicago, where his career covered a comparable span.

Schinkel was one of the towering figures of the period suggested by his dates, an era of upheaval in the Western arts when Neoclassicism and Romanticism coexisted, conflicted, and overlapped. The body of architecture that emerged from this collision of forces, like much of the contemporaneous literature, music, and painting, was often epic in scale and no less revolutionary in intent than the radical politics of the time. Schinkel's mastery of classical form is abundantly apparent in his Altes Museum, whose columned façade rises, via a great stair, from a plaza bordering Berlin's splendid boulevard Unter den Linden. Yet it is hardly a work of mere custom, standing instead for one of the earliest efforts to grant the general public access to great works of art earlier available only to the upper classes. The nobility of temper of the Altes Museum derives not from considerations of style alone, but from motives of social progress and public service that Schinkel learned in part from his readings of works by such philosophers as Fichte and Hegel.

Other works meanwhile, like the Werdersche Church and the Kreuzberg Monument, are reminders that he could be Gothic as well as Greek, revivalist as well as revolutionary, even

Romantic and Classicistic at once, as in the seamless blending of free and formal elements in the Gardener's Cottage and Roman Baths at Schloss Charlottenhof. Nor did these widely varying interests preclude a serious study of industrial structures, especially those encountered on a trip to England that prompted him to utilize brick, glass, and iron in the design of several buildings, including a *Kaufhaus*, or shopping center.

This much said, it is instructive to compare Kleihues's motives with those of Schinkel and his two museums with several of Schinkel's works. In the Bahnhof museum the mixture of functional elements with shifting historical styles is reminiscent of Schinkel's willingness to make the most of all constructive possibilities available to him. Fittingly, then, the two wings that Kleihues has added to the northwest and northeast of the middle tract are as Modernist in aspect as the shed between them is industrial. The middle tract itself is framed by a pair of towers that recall similar volumes in Schinkel's catalogue, especially those at Schloss Tegel. The latter work is reflected in Chicago too, the towers flanking its indented front mirrored in the two extending wings of the Chicago MCA. Schinkel's Altes Museum, moreover, addresses Unter den Linden rather as Kleihues's MCA façade faces Mies van der Rohe Way and, at a greater distance, Chicago's own great concourse, Michigan Avenue.

Today such deference to context is associated chiefly with the Postmodernist outlook, less so with the Modernism that movement sought to replace. Yet the Chicago MCA building is as unapologetically Modernist in design as it is indifferent to the historically allusive devices of Postmodernism. There is more reason to trace Kleihues's contextual concerns to Schinkel than to any other source. In the design process, "It is important," Kleihues has said, "to get to know the site first, become fully acquainted with the cultural tradition of a city, discover the 'genius loci,' and only then develop the architecture that is right for both the place and the particular brief."[2]

Even in the one element of Kleihues's Chicago design that seems personally, even willfully, inspired, the example of Schinkel springs to mind. It is the sculpture garden, where the rigorous symmetries and balanced axialities of the building itself give way to a plan dominated by diagonal ramps

Altes Museum
Karl Friedrich Schinkel
Berlin

and staircases, unexpected curves and informal plantings, even an asymmetrically placed pool. Thus organized, three terraces descend from the patio of the restaurant to ground level. The contrast of moods, between calculation in the building and caprice in the garden, recalls the characterization that most critics, following Kleihues's own formulation, have applied to his mature work: "poetic rationalism."[3] The term seems fitting enough, yet one cannot help recalling too that Kleihues is a painter as well as an architect. And so was Schinkel, whose remarkable landscapes of giant Gothic churches silhouetted against a setting sun are among the most arresting documents of nineteenth-century Romantic art.

It should be added that Kleihues's Modernism leaves ample room for elements that orthodox, International Style–type Modernism would have found dissonant and inappropriate. His acceptance of variations in styles and periods in the Bahnhof museum is evidence enough of that. In fact, the cultivation of disparities was central to his 1986–89 design program for the Museum of Pre- and Early History in Frankfurt, where he crossed the nave of a ruined late Gothic parish church with a rectangular Modernist block, effecting a unity of color between the two components but otherwise preserving their strong period differences—even accentuating them by roofing over the nave with a frankly industrial steel truss.

Indeed, among the dozen-odd museum projects Kleihues has designed since 1972, the Chicago MCA may be the least complex in form or varied in historical references. It is thus far the only American commission in his vita, and its attachment to Chicago and a sharply defined architectural culture may help to explain a straightforwardness of design customarily associated with the history of building in this city. While respect for the "genius loci" is one of his fundamental architectural principles, Kleihues has admitted that he is more interested in the Chicago School of Architecture than in the architectural character of the neighborhood surrounding the new museum.[4] Since his design, in fact, suggests considerable respect for that neighborhood, one must infer that his loyalties to the Chicago School are uncommonly strong, and indeed, the emphasis on expression of the structural grid obvious on the exterior would seem to bear this out.

Nevertheless, the overtones of Classicism already dis-cussed here point more to Mies and the Mies-influenced generation of the 1950s and 1960s than to Jenney, Root, Holabird/Roche, Sullivan, or any of the other Chicago pioneers of the late nineteenth century and the early twentieth. Mies, after all, more than any other Chicago architect, was a conscious Classicist, renowned in his own right as a staunch admirer of Schinkel. While clarity, coherence, and concision are hallmarks of his architecture both early and late, they are especially evident in the work of his Chicago period. When he resumed his practice here following flight from the Berlin of the National Socialist years, the uncompromising directness of his design approach proved consistent with a local tradition that he went on to raise to a level of unsurpassed precision and refinement. That his example revitalized Chicago architecture in the 1950s and 1960s is apparent in several of the finest buildings in the neighborhood Kleihues's MCA occupies: the John Hancock Center (Skidmore, Owings & Merrill, 1969), Lake Point Tower (Schipporeit & Heinrich, 1968), the Crate & Barrel Flagship Store (Solomon, Cordwell Buenz & Associates, 1990).

•

Notwithstanding the various influences cited here, it is important to affirm that the Chicago and Berlin museums are finally and foremost the works of a mature artist with his own firmly developed point of view. That Kleihues is no mere epigone of Schinkel is apparent in personal stylistic consistencies, most notably a reliance on the module as the device that both generates and guides the invention of forms. That he has learned from Mies without imitating him may be inferred from a major qualification he has imposed on his fundamental respect for Mies: "I believe that Mies turned away from crafts principles too soon."[5] Indeed, another feature identified with Kleihues's work is the frequent appearance of the humble screw, used partly to underscore its role in structure, partly to animate the surfaces of his walls. Wood, a material often of secondary importance in Mies's realized works, is employed generously, in the form of oak, in the interiors of the Chicago museum, while the rough texture of cast aluminum tempers the smoothly machined geometric frame of the exterior.

Finally, while Kleihues's interest in philosophy may be likened to similar proclivities in Schinkel, Mies, and German

860–880 North Lake Shore Drive
Mies van der Rohe
Chicago, 1948–51

architects as a national group, he has formed conclusions from his reading that are a further sign of independence of thought. Reflecting on the subject of the museum of contemporary art as a cultural institution, he has remarked:

The concept and practice of memory play a strong part in our understanding of museums as places of collecting and preserving, of classification and presentation....What you call our historically understood existence for me includes not only interest [in] but also an active support of development for the future....The German philosopher Adorno, who repeatedly dwells on the question of tradition, discusses the same thing when he comments, "A question doesn't exist that could be asked in which knowledge of the past is not kept, and which doesn't press on ahead to the future."[6]

Notes

1 Unpublished interview with Josef Paul Kleihues, (Chicago: Museum of Contemporary Art, March 10, 1991).
2 "Towards a Poetic Rationalism," interview with Vittorio Magnago Lampugnani, *Domus*, September 1991, p. 30.
3 Ibid.
4 Unpublished interview with Josef Paul Kleihues (note 1).
5 "Towards a Poetic Rationalism" (note 2).
6 Dr. Claus Baldus and Josef Paul Kleihues, Dialogue, *Josef Paul Kleihues: The Museum Projects* (New York: Rizzoli, 1989), p. 41.

Even as a student,
the cities that interested me more than all the others were Rome and Chicago....
As one who has long loved Chicago,
this commission fulfills one of my wildest dreams.

Transparency
and
Containment

Simplicity, openness, quiet,
as well as the interplay between transparency and containment—these will be the key elements.
You enter the building and look through the axis of the building,
which is transparent, to the lake;
entering from the sculpture garden, you look through the building
to Michigan Avenue.

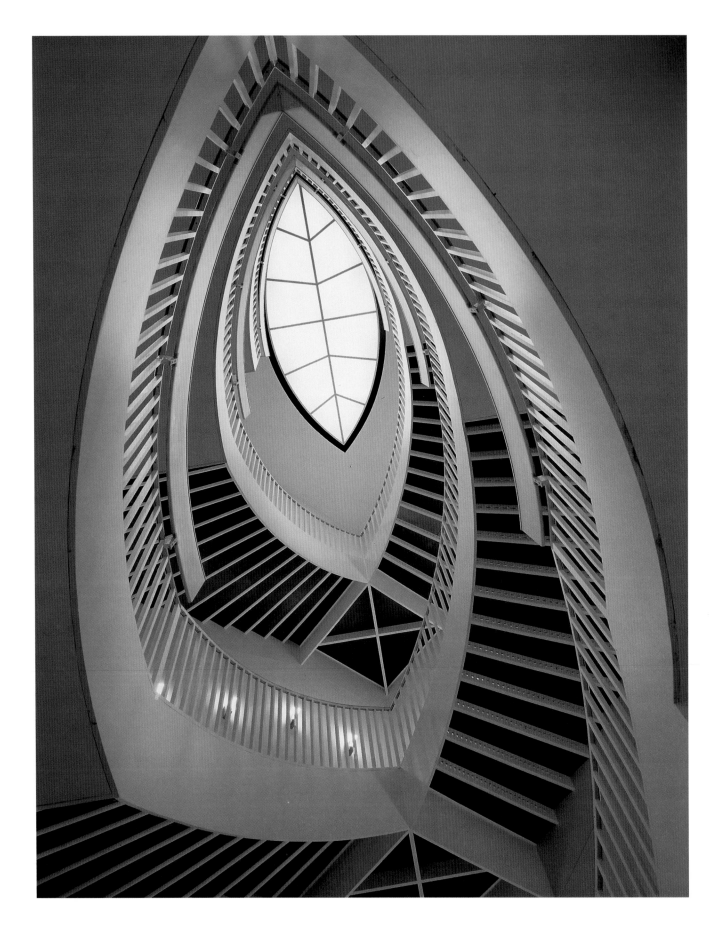

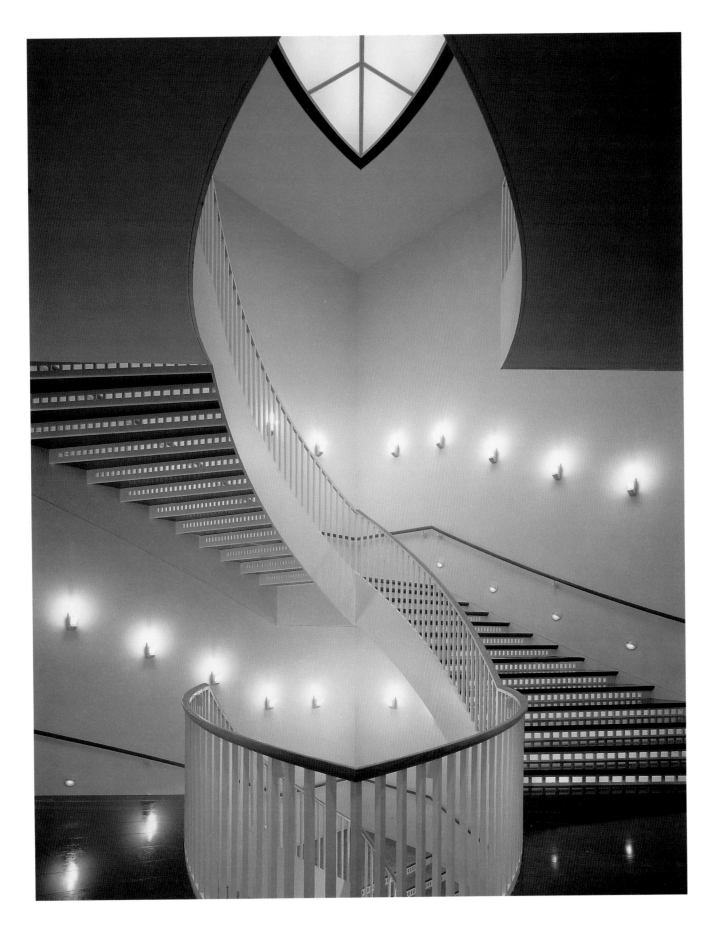

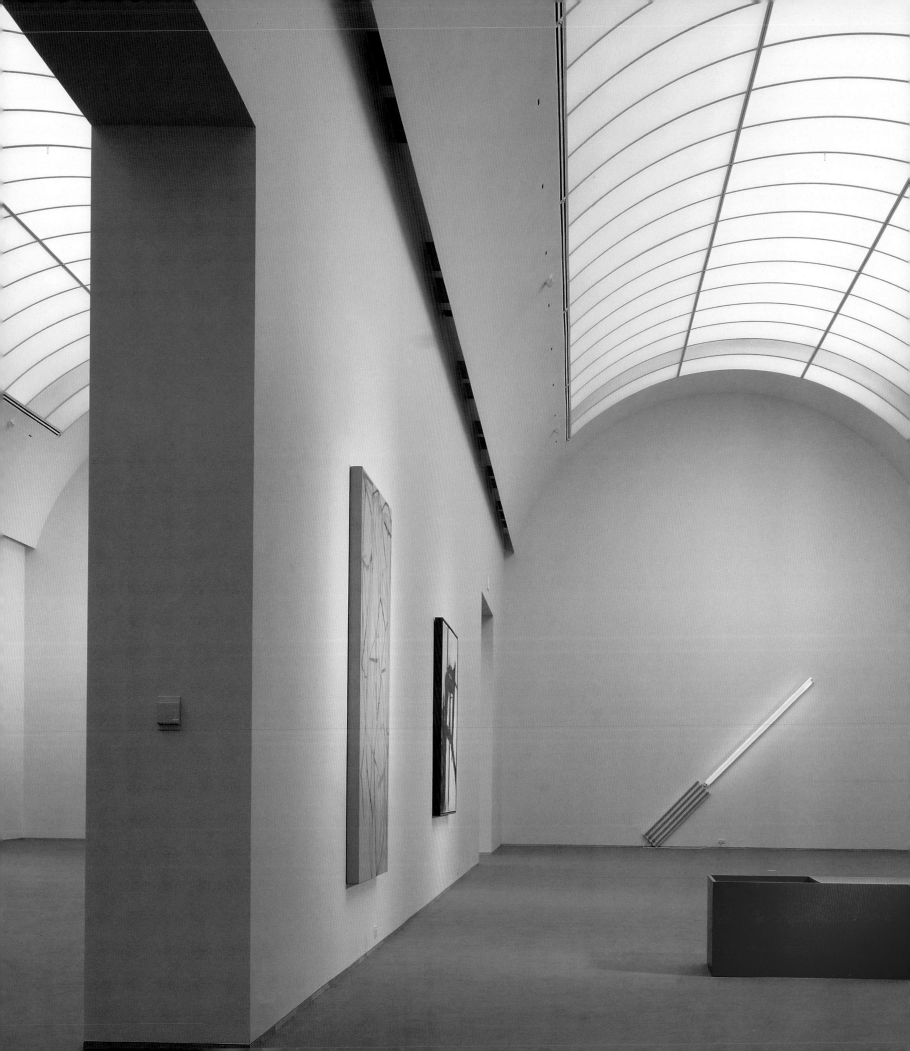

I want the MCA building to be animated,
while also allowing for the concentrated and undisturbed contemplation of works of art.

As soon as you enter the exhibition space, you are in some way isolated with the art.

This is an important concept:

not to create any kind of environment in that space of the museum where art is displayed.

There are very few museums where you have this control and separation of different purposes.

*I want the new building to manifest something of the pragmatism
that characterizes Chicago's best architecture and which I consider to be the real Chicago architecture.
I also want it to show something
of the serene reserve that has to do with my theory of "poetic rationalism."*

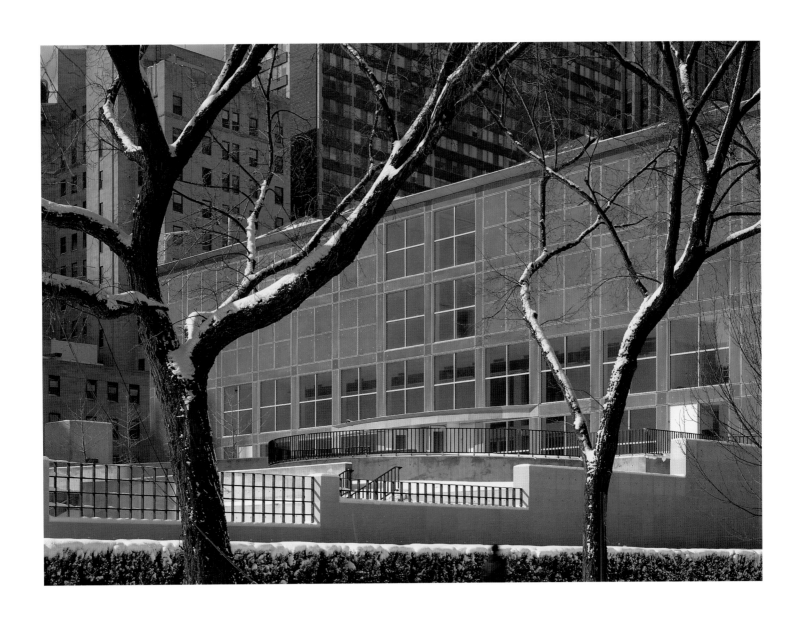

In the Shadow of Storms:

Art of the Postwar Era

RICHARD ARTSCHWAGER

•

American, born 1924

Since the mid-1960s, Richard Artschwager's work has elegantly and intelligently crossed the boundaries between Pop Art, Minimalism, and Photo Realism. Like the Pop artists, Artschwager derived the imagery of his two-dimensional work from magazine illustrations and popular culture; similarly, his three-dimensional sculpture has taken the form of banal, everyday objects—books, chairs, tables, and doors. Artschwager's commercial production background— he operated a furniture factory in New York from 1955 to 1965—undoubtedly played some part in stimulating his interest in the mass-produced or everyday object. It may also have introduced him to the nonart materials, such as Formica and Celotex (an industrial material that can be produced in large sheets), that he uses frequently.

Artschwager's work is simultaneously both furniture and sculpture or painting and object (the three-dimensionality of the painting/objects is created by their substantial scale and by the inclusion of the frame as part of the work). By enlarging or framing the object and denying its functionality, Artschwager sets out to defamiliarize his everyday objects and imagery. In this respect, Artschwager's work is perhaps closest to that of his contemporary Claes Oldenburg, whose irreverent and humorous soft-fabric sculptures depict oversize objects or food. Artschwager's work, however, has a Minimalist simplicity and elegance that sets it apart from that of the iconoclastic Pop artists.

Although the actual view of the apartment room in *Polish Rider I* was taken from a magazine illustration and reproduced, enlarged, with the aid of a grid, onto an enormous panel of celotex, the title refers to Rembrandt's *Polish Rider* (c.1655; Frick Collection, New York) in which the figure of the rider blocks the point at which the perspectival lines would intersect. In the MCA's *Polish Rider*, Artschwager has chosen an image in which the receding space comes to a similarly abrupt halt, blocked by the apartment's rear wall. In a letter to a curator at the MCA, Artschwager commented that, "In the Rembrandt painting the figure, or the 'wall' is both in repose and in stop-motion; this is also true of the 'wall' in your painting, with somewhat different devices at work." *Polish Rider I* is one of a series of four works that share the same title and represent similar interior scenes with the sharp perspectival recession blocked; none of them bears a direct resemblance to Rembrandt's painting.

Artschwager's practice of restricting his palette to black, white, and gray (or grisaille) for these interior scenes helps to re-create the photographic appearance of the image. The uneven, bumpy texture of the Celotex reinforces the documentary feeling, drawing a connection to the newspaper print from which the image was originally derived. Close up, the image is fuzzy and difficult to read—a quality that has also been likened to the French nineteenth-century paintings of Eduard Vuillard and Pierre Bonnard, whose interior scenes have a similar quietude and record the nineteenth-century bourgeois home.

JM

1970–71
Acrylic on Celotex
44 x 60 ³/₁₆ in. (111.8 x 152.9 cm)
Gift of Mrs. Robert B. Mayer
(84.2)

FRANCIS BACON

•

British, born Ireland, 1909–1992

Francis Bacon described the genesis of his paintings as coming from periods of daydreaming when the images would drop like slides into his mind. He used phrases from great literature and images culled from many sources to prompt the daydreams, including, in 1949, the year of *Study for a Portrait*, a medical textbook of diseases of the mouth, a still image of the nurse screaming in Sergei Eisenstein's film *The Battleship Potemkin* (1925), and photographs of war criminals. Bacon appears to have conflated all three sources here, with the most prominent being an image of the dock, a bullet-proof glass box.

Bacon painted early in the day, working quickly in a studio whose floor was often strewn with paper cuttings and photographs. He used the images to trigger memories and to make his recollections more powerful as he tried to express them in paint. Bacon's action in the studio combined the visual actuality of the image with an idiosyncratic understanding of the emotional, psychological, and political implications of what he was using.

In the immediate postwar years, Bacon made a number of pictures with a strange, amorphous shape that in later works becomes more clearly defined as a depiction of the avenging furies of Greek tragedy. The blue shadow in the foreground of this picture resembles the "birds alighting" in *Painting* (1946; The Museum of Modern Art, New York) and the shadows of creatures that appear in the works of subsequent years.

In 1949 Bacon made a group of four images of the head, less portraits than excuses for concentrating on the open mouth, and its glittering sexual potency. Bacon described his ambition to make a portrait of a scream that was equivalent to a Monet sunset: "I did hope one day to make the best painting of the human cry."

When Bacon talked about the box device he used here and in subsequent portraits of Pope Innocent X after the seventeenth-century Spanish master Velázquez, he described it only as a means to concentrate the image. The excitement that he manufactured for himself in part derives from the honesty with which he explored these potentially corrosive subjects and what seems to have been a perverse pleasure in their combination.

Bacon's work proposes a view of the world unencumbered by nicety, while always maintaining a delicate "politesse." The images distend and disturb our sensibility with a troubling exhilaration that is ultimately irresistible.
RF

1949
Oil on canvas
58 13/16 x 51 7/16 in. (149.3 x 130.6 cm)
Gift of Joseph and Jory Shapiro
(76.44)

JOHN BALDESSARI

•

American, born 1931

John Baldessari was born and educated in Southern California, where he continues to live, work, and—until recently—teach, primarily at the California Institute of the Arts. The importance of this place on his artistic development is both obvious (the frequent use of Hollywood film and television stills in his mixed-media works) and subtle (he remained relatively untouched by the grandiosity of the New York art world and continued to rely on teaching both as a source of income and inspiration). However, his California residency may also account for the fluctuations in the success of his career.

Having abandoned, and later symbolically cremated, his "traditional" paintings from the 1950s and early 1960s, Baldessari moved rapidly towards Conceptual Art, a movement that in 1970 was just beginning to develop in New York and Los Angeles. Conceptual Art values or emphasizes the *idea*—or concept—over execution. Some of Baldessari's earliest Conceptual pieces are texts on canvas which later developed into combinations of text and photographs, either taken by himself or culled from the media. As with other Conceptual artists who also used text or combinations of text and media, such as Joseph Kosuth and Lawrence Weiner, there was an underlying political dimension to Baldessari's work either in the language itself or in the radical questioning of the boundaries of art.

Among Baldessari's most infamous Conceptual Art gestures are his Commissioned Paintings (1969), for which he hired amateur artists to execute a series of canvases, thereby calling into question the originality of the art object. In 1971 Baldessari staged another notorious event: he assigned a group of his students to write continuously on a gallery wall, "I will not make any more boring art."

His own work developed alongside that of his students in the now famous "Post-Studio Art" course which he taught at CalArts. The no-requirements, no-grades course produced an impressive roster of successful students that includes David Salle, Barbara Bloom, and Eric Fischl.

Baldessari is best known for his photoworks, begun in the 1980s and continued to the present day, in which apparently unrelated film or photo stills are juxtaposed. Linking the images are colored lines that have symbolic or metaphorical associations; flat colored dots block out the faces of those represented, thereby denying the individuality of the subjects. *Fish and Ram* (1988), for example, consists of six color photographs joined together to form an irregular geometric shape. A red line—the red, according to Baldessari, symbolizes danger or abused power—courses through the images.

It begins in a photo of a woman wearing fur that Baldessari has categorized as a typical woman-as-sex-object image, continues through a group of stockbrokers, and becomes a whip in a picture of a man being assaulted. Directly beneath this photo is an image of conformity, soldiers in formation. In contrast to these images suggestive of a violent and constrictive society are two photographs of animals. Although hunted, the fish and the ram, according to Baldessari, are invested with an instinctual wisdom and oppose the image of a rational bureaucratic society run amok.

JM

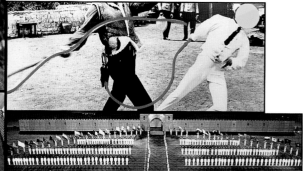

Fish and Ram

1988
Black-and-white and color
photographs with vinyl paint;
mounted on board
Overall: 109 ³/₄ x 144 ¹/₄ in. (278.8 x 366.4 cm)
Restricted gift of Gerald S. Elliott;
and National Endowment
for the Arts Purchase Grant
(89.2.a-e)

BALTHUS (COUNT BALTHAZAR KLOSSOWSKI DE ROLA)

•

Swiss, born France, 1908

Balthus was born in Paris to a cultured family of Polish ancestry—the son of a painter and an art historian. He began to make drawings as a child in Switzerland, where the family relocated during World War I. In 1924, at the age of sixteen, Balthus moved to Paris in order to immerse himself in art. The Louvre was his academy; he educated himself by copying from the Old Masters, figural and compositional references that would appear repeatedly in his mature works. In Paris, Balthus established influential and lasting friendships with avant-garde writers (particularly poets) and artists, including Diego Giacometti, André Derain, and Joan Miró. Balthus painted *André Derain* (seen with his daughter) in 1936 and *Joan Miró and His Daughter* the following year.

In the early 1940s Balthus began to paint the scenes for which he is renowned— enigmatic bourgeois interiors laden with sexual tension. Like many of his Parisian contemporaries who were involved with the Surrealist movement in the 1920s and 1930s, Balthus leaned heavily on the side of Freudian sexual suggestions in his imagery. The silent dramas are staged in closed interiors—a drawing room or parlor—in which two, sometimes three, self-absorbed adolescents are seen lost in their own abandoned reverie. In their poses and gestures, his youthful subjects bear strong kinship to the children who figured in his 1933 illustrations made for a new edition of Emily Brontë's *Wuthering Heights* (originally published in 1847). Throughout his career Balthus has imbued his figurative works (he is also highly recognized as a painter of pastoral land-scapes) with traces of art history, literature, and theater.

Two Young Girls is one of four closely related works from 1949 in which an adolescent child dozes on a chaise longue, stretching provocatively as if lost in a dreamy awakening of her own sexuality. Although his reclining figure recalls a long and respected artistic tradition of sensual nudes— from Titian's young Venus in *Bacchanal* (1523; Museo del Prado, Madrid) to Jean Auguste Dominique Ingres's *Grande Odalesque* (1814; Musee du Louvre, Paris), Balthus charges the scene with a mysterious tempera-ment of disquiet. Coyly suggestive, but never explicit, Balthus provokes an unclear stasis between what has already transpired and what is imminent.

LB

1949
Oil on board
27 1/2 x 29 1/2 in. (69.9 x 74.9 cm)
Promised gift of
Joseph Randall Shapiro

BERND AND HILLA BECHER

●

German, born 1931 and 1934

Since the late 1950s, the husband-and-wife team Bernd and Hilla Becher have been traveling throughout Germany, Holland, France, and North America documenting in serial photographs no longer functional nineteenth-century industrial structures. Their highly objective photographs are grouped in sets according to the purpose of the structure, and the images are evenly lit without emphasis, and exhibited, as it were, without comment. In the 1950s their work appeared in startling opposition to the expressionist tradition that was generally associated with the German national output, but by the 1970s their work had made a lasting impact on contemporary art by helping to establish the importance of photography for German Conceptual Art.

The Bechers have documented blast furnaces, water towers, grain silos, oil refineries, and *Cooling Towers* (1983) reproduced here, as well as other industrial structures. Each image is enlarged or reduced to create comparable uniformity of size, and framed in grid structures that draw attention to the sculptural rather than the architectural monumentality of the forms. The Bechers, in fact, call their work "anonymous sculptures" and, in many ways, it is similar to that of the American Minimalist sculptors, such as Donald Judd, Sol LeWitt, and Carl Andre, who tried to reduce the art object to its simplest and most striking form.

Although their photographs can be read in opposition to classic art photography's concerns with self-expression, the origins of the Bechers' use of serial documentation can be traced back to the systematic, "objective" records of botanical and human life by late nineteenth- and early twentieth-century photographers August Sander, Karl Blossfeldt, and Albert Renger-Platzsch. The apparently obsolete nature of the Bechers' subject matter, however, glances backward in time, as if to take a second, politically savvy, look at the industrial buildings of the Victorian age that originally gave us the obsessive desire to categorize and document: botany, biology, and especially ethnology. Only the Bechers' is a "cool" science, one without recognizable human life.

The very absence of the human beings that created and owned, or even populated, the structures recorded by the Bechers contrasts sharply with the portraitlike intensity of the photographs. This intensity creates characters or personae out of the buildings; they seem to have faces or bodies, albeit "dysfunctional" ones. In contrast to this architectural "humanity," however, is the seriality of the work: the very repetition of *Cooling Towers* undercuts the value of each individual image and ultimately acts as a sort of refutation of the notion that photography can represent a recognizable reality.

JM

Cooling Towers

 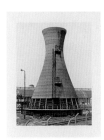

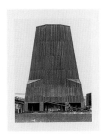 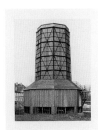 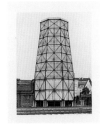 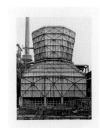 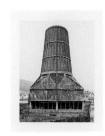 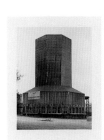

1983
Gelatin silver prints
Twelve parts, each 20 x 16 in.
(50.8 x 40.6 cm)
Gerald S. Elliott Collection
(95.31.a-l)

ALEXANDER CALDER

•

American, 1898–1976

Born in Philadelphia, the son and grandson of sculptors, Alexander Calder first studied mechanical engineering before training at the Art Students League in New York. In 1926, at the age of twenty-eight, he established a studio in Paris. In Paris, Calder made figurative works in wood and wire (one of his first subjects was Josephine Baker, the popular American singer and dancer then based in Paris) and then playful objects, which he thought insignificant, that became his legendary *Circus.*

By 1930, after he had come into contact with such European avant-garde artists as Jean Arp, Constantin Brancusi, Marcel Duchamp, and particularly Joan Miró and Piet Mondrian, Calder's work became abstract. Calder later claimed that this entrance into abstraction resulted from visiting Mondrian's studio, where he told his host that he would like to make

Mondrian's colorful rectangles oscillate in space (Mondrian objected). In 1932 Calder constructed his first mobile (a term coined by Duchamp). Over the next forty-four years, Calder created hundreds of abstract "objects" (he preferred this term to "sculpture"), from enormous outdoor constructions to diminutive whimsies of shaped, cut, and colored metal. They are both moving and stationary, some planted firmly on the ground, some suspended delicately from the ceiling. His ideal source of form, in his words, was the system of the universe. In 1932 he wrote: "How does art come into being? Out of volumes, motion, spaces, carved out within the surrounding space. Out of different masses…out of directional lines….My purpose is to make something like a dog, or flames; something that has a life of its own."

Calder's approach to mechanics was simple, bordering on the primitive. He applied his engineering skills only to the degree that his art required. This suited his love of tinkering. He often constructed objects from the scraps of metal and wire that filled his studio. The mobiles evolved from early wire forms which Calder first moved by simple mechanical devices, like hand cranks. Unsatisfied, Calder quickly discovered that through a system of cantilevered and counterbalanced armatures and suspensions, his forms could move freely and independently, activated solely by air currents.

Snow Flurries II (1951) is a large hanging mobile, an open construction of flat white disks, suspended high above the floor. Linked branches of variously sized disks descend from a central wire, the forms quietly swaying and turning as air currents move through and around the surrounding space. The

movement is not repetitive; forms dance like leaves on the branches of a tree. The first version of this series, *Snow Flurries I*, is in the collection of The Museum of Modern Art in New York.

Calder returned to the United States in 1933, already widely recognized for his mobiles. He settled in Roxbury, Connecticut, where he continued to live and work until his death in 1976. His first American exhibitions took place in 1935 in Chicago, at the Renaissance Art Society and The Arts Club of Chicago. To this day Chicago maintains a special relationship with Calder's work, particularly visible in major public sculptures such as his *Flamingo* (1974) at the Federal Plaza on South Dearborn Street and *Universe* (1974) in the lobby of the Sears Tower.

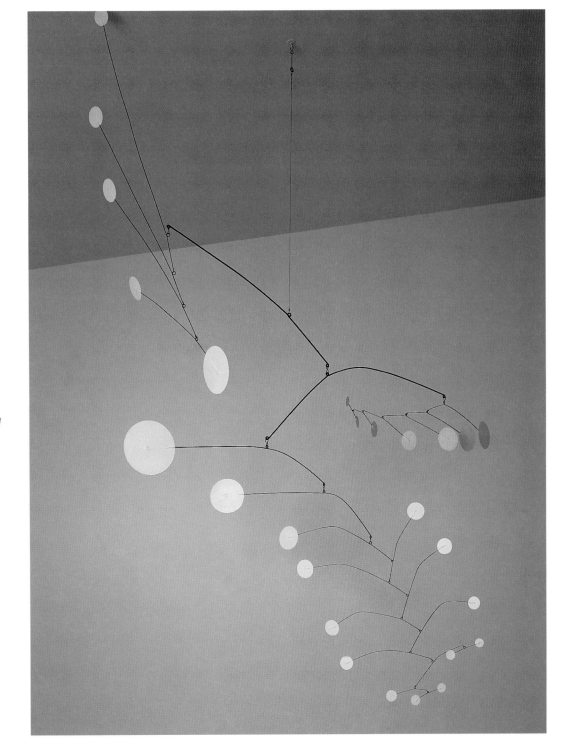

Snow Flurries II

1951
Painted sheet metal and steel wire
96 x 96 x 96 in. (240 x 240 x 240 cm)
Gift of Ruth and Leonard J. Horwich
(83.80)

TONY CRAGG

•

British, born 1949

Not only do British sculptor Tony Cragg's sculptures cover myriad materials, but the artist brings a similarly diverse set of approaches and techniques to the making of sculpture. Cragg reveals a remarkable capacity to work in different media: from his wall or floor "drawings" configured out of pottery fragments or plastic rubbish, to carved wooden forms that resemble oversized children's toys, to the more conservative (in material only) bronze sculptures in the form of monumental laboratory flasks and containers.

Cragg lives in Wuppertal, Germany, but was raised and educated in England, receiving his MFA from London's Royal College of Art in 1977. He had absorbed both traditional sculptural modeling and the more recent lessons of Minimalism, Conceptual Art, Earth Art, and Arte Povera when his work started to receive critical attention in the late 1970s. Cragg's earliest sculptures consisted of found refuse—wood, plastic scraps, and bricks—that he arranged into wall or floor mosaics, which he called "drawings." Abandoned plastic products that he collected on the beach in Sussex were separated into chromatic groups and arranged in the shape of one of the objects contained in the color-coded works—an American Indian figure, for example, or a Coca-Cola bottle. These "drawings" have elicited comparisons to Giuseppe Arcimboldo's seventeenth-century trompe l'oeil vegetable paintings; to the sculptures of Richard Long—which use a similar kind of assemblage (although manifesting a romanticism that is completely absent in Cragg's work); and finally to the relief paintings of 1980s artists Julian Schnabel and Anselm Kiefer, which similarly contain broken pottery and debris. Yet Cragg's works also engage with social and material issues that distinguish his art from that of his contemporaries. Although it was clearly a relevant concern, the artist was not primarily interested in condemning the waste and overproduction of a late capitalist, industrialized society. He was determined to give the objects in his "drawings" an after-life by leading the audience toward a reconsideration of the shapes beyond their use-value and to suggest the potential beauty of industrial materials in a weathered, discarded state, and not only as they appear in the pristine Minimalist works of Donald Judd or Carl Andre.

Spill (1987) is part of a series of later works that were cast in steel or, as in this case, bronze, that has been left to rust or to gather a green patina. A comparison of these monumental works to those of the British sculptor Henry Moore, who has dominated the art scene in his native country since the 1940s, is not entirely fanciful. Cragg has vocally taken Moore to task for his grand generalizations on humanistic issues in his thematic sculptural works such as the "mother and child" series. In contrast to Moore's "universal" themes, and consistent with Cragg's scientific interests (he studied science during his university years and is well informed about recent scientific advances), the artist's cast works take the form of gigantic laboratory equipment—retorts, flasks, and test tubes—that have been stretched, bent, and distorted. In *Spill* and other similar works, Cragg has given these instruments an almost humanoid presence. The bodily associations of *Spill*—the magnificently curvaceous bulb and the molten pool that it emits—suggest that the human body, like the flask, is a container and indeed the root of all experimentation.

JM

1987
Bronze
39 x 79 x 39 in. (99.1 x 200.6 x 99.1 cm)
Gerald S. Elliott Collection
(95.36)

DAN FLAVIN

•

American, born 1933

Dan Flavin was one of the first Minimalist artists to match the use of commercially available, industrial material to a reductivist spirit in art-making. Introducing in the early 1960s his spare works composed solely of flourescent light bulbs, he contributed in truly original and landmark fashion to an investigation of the art-work's occupation of space. While Marcel Duchamp and Robert Rauschenberg, among others, had already introduced the everyday object into the realm of art, Flavin was one of the first to make use of it as a purely formal element. Flavin's more immediate focus on the nature of materials and transformation of space, however, is enhanced by subtle expressions on a more spiritual and personal level.

Flavin was born in 1933 in Jamaica, New York, to a Roman Catholic family of Irish and German descent. He attended the Cathedral College of the Immaculate Conception in Douglastown, New York. In 1953 he entered the US Air Force in Rantoul, Illinois, and then served as an air weather service observer in South Korea. Back in New York, he enrolled at the New School for Social Research (1956) and took art history classes at Columbia University (1957–59). Self-taught as an artist, he developed in the late 1950s primarily under the influence of Abstract Expressionism and Jasper Johns. His exhibition debut, at the Judson Gallery in New York in 1961, included watercolors and constructions. Later that year Flavin introduced light as a material in his "icons," painted wooden boxes with light bulbs attached. His first piece composed solely of light, *the diagonal of May 25, 1963 (to Constantin Brancusi)*, is an eight-foot-long, yellow fluorescent light tube hung at an angle of forty-five degrees to the horizontal.

An early supporter of Flavin's work (and fellow Minimalist), Donald Judd singled out *the diagonal of May 25, 1963* in a review of the first museum exhibition of Minimal Art, *Black, White, and Gray*, held at the Wadsworth Athenaeum in Hartford, Connecticut, in January 1964. Two months later Flavin exhibited more lightbulb works at the Kaymar Gallery in New York, including *the alternate diagonals of March 2, 1964 (to Don Judd)* (1964). *the alternate diagonals* references its predecessor in its angle and in its use of a long yellow bulb. Paying homage to Judd is in keeping with Flavin's dedicating works to artists to whom he owes an aesthetic debt, such as Constantin Brancusi or Russian Constructivist Vladimir Tatlin. The color scheme reflects the palette Judd was using in his sculpture at the time (the MCA's 1962 *Untitled* by Judd is exemplary of this trait).

Beyond the introduction of industrial materials as formal art elements, Flavin's light pieces possess an austere spiritual quality. Referring to the more "otherworldly" connotations of light and illumination, the haunting solitary presentation of the work in the gallery space gives it an ethereal quality rarely found in Minimal Art. Yet, *the alternate diagonals* remains true to Minimalism in its use of light to occupy—and determine one's experience of—the surrounding space. The interplay between the bright gold glow of the long yellow bulb and the darker "field" created by the shorter red bulbs reflects the Minimalists' consideration of color as a necessary vessel of meaning in their spartan visual vocabulary.
DM

64

the alternate diagonals of March 2, 1964 (to Don Judd)

1964
Red and yellow fluorescent light
145 x 12 x 4 in. (368.3 x 30.5 x 10.2 cm)
Gerald S. Elliott Collection
(95.40)

LEON GOLUB

•

American, born 1922

Leon Golub has probed the depth and complexity of the human condition throughout his fifty-year career. Although his concern with such issues as power, tragedy, and violence has remained constant, his imagery has shifted from generalized, emblematic figuration to overtly critical and political subject matter. Only in the 1980s, when figurative painting and social content began to command greater interest, did Golub's work receive widespread critical acclaim: the time was right for his explicit scenarios depicting brutal views of white colonialism, American interventionism, and other moments of modern warfare.

While by no means autobiographical, Golub's art has been clearly informed by personal experience. Born and raised in Chicago, Golub studied art history at the University of Chicago before serving in the military during World War II. When the war ended, Golub, along with many returning veterans, enrolled at The School of the Art Institute of Chicago on the GI Bill. His early depictions of wailing and often limbless figures reveal the profound effect of his war experiences. His work was also influenced by African and Oceanic artifacts at the Field Museum of Natural History, Existentialism (American Existentialist Paul Tillich was teaching at the University of Chicago), and Freudian analysis (Chicago was the home of the pioneering Institute of Psychoanalysis).

Golub's early artistic endeavors centered around the exploration of the human psyche: angst-ridden, mythical hybrid forms seem frozen in perpetual agitation, their eyes pleading for peace. Golub shared this type of dark—often grotesque— figurative imagery with other young Chicago artists, whom critic Franz Schulze dubbed the "Monster Roster." Despite this uniquely Chicago-style figuration, however, Golub's attention to the physical act of painting, along with the monumental size of many of his canvases, corresponds with the gestural heroics of Abstract Expressionism, the New York School of painting that dominated postwar American art. His vigorous brushwork and scraping produced dynamic surfaces that contrast with the still and timeless nature of his figures. The figure in the colossal *Reclining Youth* (1959), for example, is rendered with a mottled surface that evokes flayed or burnt skin. Yet the nude form itself, based on the Hellenistic *Dying Gaul* of Pergamon (third century BC; Musei Capitolini, Rome), recalls the monumental stoicism and permanence of classical sculpture. Whereas the model is solid and impenetrable, however, Golub's flattened form with its eroded veneer approaches disintegration.

Golub's interest in Greek and Roman sculpture is evident in his work as early as 1952; European travel heightened this interest. Golub and his wife, the artist Nancy Spero, spent a year in Italy (1956–57) and lived in Paris (1959–64), a stay initially made possible through the sale of *Reclining Youth* to the Chicago collector Lewis Manilow. Based on Roman busts, a series of raw, scraped, generalized *Head* paintings (three of which are in the MCA collection) are equally penetrating studies in the pathos of human nature. Golub continued this series from 1956 until the late 1960s, later embarking on a series of individualized political portraits, which paved the way for his more recent works based on current events and news photographs.

SB

1959
Lacquer on canvas
78 ³/₄ x 163 ¹/₂ in. (200 x 415.3 cm)
Gift of Susan and Lewis Manilow
(79.52)

FELIX GONZALEZ-TORRES

•

American, born Cuba, 1957–1996

Felix Gonzalez-Torres emerged in the late 1980s as one of several young artists who were engaged in invigorating a Minimalist geometric vocabulary by infusing it with content. Using photography, painting, and sculpture, Gonzalez-Torres created quietly evocative works that address social issues and explore the intersection between private and public experience.

Gonzalez-Torres, who died in 1996, was born in Guaimaro, Cuba, and was raised in Puerto Rico. He moved to New York in 1979. His art can be divided into several overlapping series, including works made of stacks of paper, wrapped candies, and strings of lights. His earliest works, dating from 1983, are photographs printed onto jigsaw puzzles. In 1986 he began a series of word portraits commemorating individuals, institutions, or historical events with texts describing significant moments in the subject's history. He enlarged one of these works in 1989 to billboard size for a public project in New York, and subsequently produced billboards with texts or images in several cities. In the candy works, begun in 1990, Gonzalez-Torres created piles of wrapped candies that lie directly on the floor to be consumed by viewers. The following year he introduced a series of works composed of strings of ordinary light bulbs that can be installed in any manner—hung from the ceiling like festival lights or dimmed and lying on the floor, evoking a more somber mood.

Gonzalez-Torres began the "stacks" in 1988. Each stack, comprised of identical sheets of paper printed with a text or image, stands directly on the floor at an ideal height and resembling a Minimalist cube. Paradoxically, what appears to be a sculpture is actually an edition of prints. Viewers may take a sheet. As long as a stack is on view, the supply of sheets is replenished so that the stack never disappears. In this way viewers become participants in the work and collectors of Gonzalez-Torres's art. The stacks confront the conventions of how an artwork functions by undermining the traditionally passive relationship that exists between the artwork and its audience. They also question public and private ownership and the originality and status of works of art. The candy works function in a similar manner—each comprised of a particular amount of candy, determined by weight, which, as viewers consume the candy, is constantly replenished.

Untitled (The End) (1990) is one of Gonzalez-Torres's earliest stacks. Each sheet is white with a black border. The blank central portion acts as a projection space, encouraging viewers mentally to add their imaginings, which are framed in black. Gonzalez-Torres considered his early stacks to be monuments, describing their ideal height as that of a tombstone. His work often focused on a theme of mortality, as the parenthetical title "The End" suggests. *Untitled (The End)* is complete only when the stack is eliminated. Until that point, it exists in a constant, vulnerable state of exhaustion and renewal, functioning as a metaphor for the body.

AC

1990
Offset print on paper
Sheet: 22 x 28 in. (56 x 71 cm), height variable
Restricted gift of Carlos and Rosa de la Cruz;
and Bernice and Kenneth Newberger Fund
(95.111)

ANN HAMILTON

•

American, born 1956

Ann Hamilton, who in 1993 was awarded the prestigious MacArthur Fellowship, established her artistic career with labor-intensive, multidimensional installations that explore communication and perception as processes embodied in a kind of physical, body poetry. She pursues in her art a means to externalize what is felt and sensed, focusing on "the importance of the information that comes through our skin." Hamilton transforms humble materials and imagery into metaphoric portrayals of experience, of attitudes toward existence. Her works ritualize mundane gestures, imagining simple objects and actions on an enormous scale, with an abundance of individual and communal labor.

Using the mechanism of one sense to trigger the perception of another, Hamilton shifts our registry of sense to unexpected parts of the body. Hamilton, who comes from a background in textiles and received her MFA in sculpture from Yale University in 1985, focuses largely on speech, and the acts of speaking and hearing, transformed through often silent rituals into mute, poetic gestures. In her 1991 installation *malediction*, each day over a two-week period the artist sat at a refectory table filling her mouth with mounds of raw bread dough to make molds of the hollow cavity of her mouth, as if giving form to her muted speech. In *tropos* (1993), a year-long installation at the DIA Foundation in New York, the act of walking through the large exhibition space offered a surprising and poetic excursion through the realm of the senses.

Recently, Hamilton has increasingly interwoven moving images into her happenings, performance pieces, and process-oriented works. These four small untitled videos, her first works relying exclusively on video, can be installed as a group or separately as individual works of art. Each monitor is set seamlessly into the wall (the compact mechanics are hidden within the wall). Each video displays a close-up, tightly cropped image loop of the artist rolling pebbles around in her mouth, allowing water to spill into (or out of) her mouth, onto her throat, and into her ear. Her simple, isolated gestures are repeated into abstraction. The four images focus on the points in the body where language is based, where speech is uttered and received. In *Untitled* (mouth/water) (1993) the mouth endlessly rolls around its capacity of small round stones, denying the

possibility of speech. Yet, as in *malediction*, speech is re-formed, imagined anew having texture, weight, and capable of movement. Rather than annihilating speech, Hamilton awakens our sensation of communication by means, paradoxically, of the sensuous, that is, tactile (often with erotic associations). Water, in the place of language, fills and spills from the cavities of sound, forming a presence sensed and experienced "through the skin."

LB

Untitled
(ear/water)

Untitled
(mouth/water)

Untitled
(neck/water)

Untitled
(mouth/stones)

1993
Four videos, each 30-minute
video disk, LCD monitor
with color toned image, and
laser disk player
9 $\frac{1}{2}$ x 17 x $\frac{3}{16}$ in. (24.1 x 43.2
x 2.1 cm)

Edition: 6/9
Bernice and Kenneth Newberger
Fund; restricted gift of
Susan and Lewis Manilow and
Howard and Donna Stone
(95.12-15)

ALFREDO JAAR

•

Chilean, born 1956

Two remarkably different maps of the world confront the viewer at the beginning of Alfredo Jaar's installation *Geography=War* (1991). The familiar Mercator map, which gives central position to Europe and concentrates the majority of the land mass in the Northern hemisphere, hangs next to the Peters's map, named after its creator, Arno Peters, which reflects areas of the world according to relative size. The results of the Peters's map are startling: the Southern hemisphere, which contains most of the underdeveloped countries of the world, is almost two times as large as the Northern hemisphere; Europe is relegated to a small Northern outpost.

The differences between the two maps reflect many of the concerns that characterize the Chilean artist's work. Since the early 1980s, Jaar's photographic installations have been involved in questioning Western assumptions and viewpoints. The Mercator map, with its enlargement and central placement of Europe, is just one example of this privileged viewpoint, which reflects its makers' predilections but passes as objective science. Jaar's work is particularly concerned with questions of "place" and the ideological implications behind the terms "center" and "periphery." Typically his work concentrates on marginalized places that are under stress—often due to the collision of wealthy and weakened economies.

Geography=War is the most theatrical and architectural installation that Jaar has produced to date. The three carefully orchestrated sections contain enlarged photographs that Jaar took in 1989 in Koko, a port town in southwestern Nigeria, placed dramatically in light boxes. Between August 1987 and May 1988, five Italian tankers carrying toxic waste arrived in Koko, where a farmer had agreed to store the barrels for $100 a month.

Some of them, pointlessly marked with the international toxic hazard signal of a skull and crossbones, were emptied by locals and used for construction; others exploded in the heat, their contents seeping into the water system. The extent of the toxic contamination has not yet been evaluated.

In Jaar's installation, cinematic light boxes display images of feisty local children playing in the foreground with barrels of toxic waste looming behind them. As the installation progresses, other images are placed on the (hidden) reverse side of the light boxes, and are readable only from their awkward reflection in the mirrors opposite. Frustrating an easy reading, Jaar forces viewers to bend and contort in an effort to "construct" the story. This uncomfortable process makes viewers aware of their own implication in the construction of the narrative and denies the audience "control" over the people of Koko.

By provoking the self-conscious involvement of the viewers and questioning their relationship to the images, Jaar has attempted to avoid the pitfalls of "concerned" photo-journalism. The images become visible only through reflection (in both senses) and the mirrors serve both as distancing devices and, for Jaar, ubiquitous symbols of our narcissistic society.

In the final part of the installation, fifty-five-gallon barrels filled with water are neatly placed in rows. Color transparencies hang from the ceiling, their images—the faces of the children of Koko—perfectly reflected on the surface of the barrels. Once again, Jaar has metaphorically alluded to the impossibility of knowing "them": as one tries to get a closer look, the image disappears to reveal one's own curious reflection.
JM

1991
Color transparencies,
light boxes, fifty-five-gallon
metal barrels, and water
Dimensions variable
Gift of Mr. and Mrs. M.A.
Lipschultz and
Maremont Corporation
by exchange
(92.89 a-ddd)

JESS (JESS COLLINS)

•

American, born 1923

The San Francisco–based artist Jess has developed an inclusive and fantastical visual vocabulary in his paintings and collages—including illustrations of fairy tales, Egyptian cosmology, the occult, Victorian imagery, popular culture, and forgotten landscape paintings. Born in suburban Southern California, Jess had remarkably conventional beginnings. After military service, he graduated from the California Institute of Technology and developed a career as a radiochemist in Tennessee and then Washington. It was during the late 1940s that he became an amateur painter.

In 1949 Jess went to the University of California, Berkeley, to start a graduate chemistry program he had applied for under the GI Bill, but, on arrival, he changed to his real subject of interest, art. Hearing of Jess' switch from the chemistry to the art department, the US Government forced the emerging artist to undergo psychological testing. After a short period at Berkeley, Jess transferred to the California School of Fine Arts (now San Francisco Art Institute), where he came under the influence of the school's most renowned teacher, Clyfford Still. Jess' works from the early 1950s were largely transformations of Still's blocks of color in which Jess interpreted abstraction as romantic vision by drawing out references to forms and landscape.

Like the artists of Still's generation, such as William Baziotes, Jackson Pollock, and Adolph Gottlieb, Jess became interested in Jungian archetypes, myths, and symbolism, and by the late 1950s his work contained figurative and Surrealist forms. During the 1950s the artist became immersed in the Beat poetry groups that flourished in the Bay Area; it was here that he met the poet Robert Duncan, who was to become his long-term companion and collaborator in the development of his fecund iconography. It was also around this time that he dropped his last name.

Literary references abound in Jess' work, both in the form of excerpts of text taken from a wide range of authors and used as accompaniments to his paintings, and in the form of pictorial allusion to or illustration of fairy tales and stories. His first "paste-ups" (his term for his collages) that combine engravings, magazine pages, jigsaw-puzzle pieces, text, and cloth were inspired by Max Ernst's Surrealist collages.

For *Midday Forfit: Feignting Spell II* (1971), which represents spring in a series of the four seasons, Jess assembled a phantasmagoria of images, culled from magazines, engravings, tapestry, and found objects. The juxtaposition of images of fruition and rebirth, although seemingly random, in fact suggests numerous visual and verbal puns (such as the phonetic joke implied by the positioning of a Koala cub next to a Coca-Cola bottle cap), although many of these references are private, opaque to all but the artist. The images, which include Egyptian columns, the peasants from Jean François Millet's *The Gleaners* (1857), the Hindu god Shiva, and a Victorian child in imminent danger of being run over by a 1960s sedan, all collide in a composition that stays remarkably coherent. One of the quotations chosen by Jess to accompany the Four Seasons perhaps reveals the method behind the artist's "madness." Quoting Heraclitus, he claims that, "an unapparent connection is stronger than an apparent one."

JM

1971
"Paste-up": magazine pages,
jigsaw-puzzle pieces, tapestry,
lithographic mural, wood,
and straight pin
50 x 70 x 1 $^3/_4$ in. (127 x 177.8
x 4.4 cm)

Restricted gift of MCA's
Collectors Group, Men's Council,
and Women's Board;
Kunstadter Bequest Fund in honor
of Sigmund Kunstadter; and
National Endowment for the Arts
Purchase Grant
(82.30)

JASPER JOHNS

•

American, born 1930

The title of Jasper Johns's 1961 painting *In Memory of My Feelings—Frank O'Hara* refers to a 1958 poem written by Frank O'Hara, the writer and curator at The Museum of Modern Art in New York. Johns had become a friend of O'Hara's; they would later collaborate on a print which used an extensive impression of the artist's skin made by rubbing oil on his body and printing it on paper. There is also a sculpture, completed in 1970, in which the poet's foot, cast in rubber, creates an impression on a sandbox. O'Hara, a renowned and fashionable member of the art world, died in 1966 in an automobile accident on the beach, five years after this painting was finished. It is often assumed, wrongly, that the painting is a memento mori. Rather, it is a meditation on the vulnerability of friendship and the shortness of life. O'Hara's poem concerns his love affair with the painter Grace Hartigan which had recently ended;

Johns's relationship with Robert Rauschenberg had similarly foundered and this may be reflected in the work's somber melancholy.

The painting is made on two panels on which are shown hinges as if they could be closed (to hide the subject, conceal the feelings). The left is brushed thinly in veils while the right uses thicker, more expressive paint. Using the devices of Abstract Expressionist picture-making, Johns returned to an emotional subject directly related to him—his own feelings—although the principal component is veiled under the top layer of paint. In this work and in a painting considered a companion, *No* (1961; National Gallery of Art, Washington, DC); and in works such as *Periscope (Hart Crane)* (1963), based on poems by Hart Crane, Johns came closest to showing his own sensibility and the vulnerability of his sexuality. As in several works of this period and

later, the subject of the work or the emotional trigger is buried within the picture. Here, the subject is painted and then concealed below a second layer of paint. X-rays show a crude skull drawn in thick impasto at the top right of the picture and the words "dead man" stenciled at bottom right. (Both are visible as *pentimenti* once one is aware of them.) They give the painting an uncanny foreboding as if they prophesy death itself rather than the end of friendship. The skull was the subject of a concurrent notebook meditation where Johns wrote of inking and printing from it, much in the same way he would make the skin drawings. It can be related to numerous images in the Western tradition of the philosopher in his study, contemplating his own mortality and the brevity of life.

Johns has suspended, on a wire in front of the painting, a fork and spoon bound together. These implements,

used to consume and nourish, also become, in Johns's iconography, potent symbols of mortality. The ideas of consumption, using up, and of the comfortable spooning of the implements, become, by extension, an expression of loss, of love and, ultimately, of life.
RF

1961
Oil on canvas with objects
40 x 60 x 1 $\frac{1}{2}$ in. (101.6 x 152.4 x 3.8 cm)
Partial gift of Apollo Plastics Corporation
(95.114)

DONALD JUDD

•

American, 1928–1994

From the early 1960s, Donald Judd's criticism and artistic output were produced in reaction to the domination of the American art scene by Abstract Expressionist painting. Judd's ambition was to purge contemporary art of the figural and metaphorical associations he perceived in Abstract Expressionism, and to reduce the art object to its simple and literal essentials. The artist's earliest works were on canvas, and although he rapidly moved on to designing three-dimensional pieces for fabrication, he continued to think of his art, which generally hung on the wall, as comparable to painting rather than sculpture (a term he never applied to his own work).

Judd is famous for his central and strategic role in what was variously to be called Literalist Art, Primary Structures, ABC Art, Object Art, Specific Objects (Judd's own term), and, more durably, Minimalism. The MCA's

Untitled (1978)—a very early concept fabricated in a work of a later date—is an example of the remarkable simplicity of the first Minimalist works. The concept fulfilled Judd's desire to create a single, unitary shape that does not contain the illusory depth of painting or traditional compositional devices. To enhance the immediacy and the extreme simplicity of the form of *Untitled*, Judd painted the box cadmium red.

Singular forms, like *Untitled*, gradually ceased to satisfy Judd's ambitions, however, and he began to produce serial works in which the separate, and often identical, elements were placed in horizontal or vertical arrangements to create carefully balanced and echoing installations. One such example is *Untitled (August 28, 1970)* (1970), in which the order of the units is, in Judd's own description, "not rationalistic and underlying but...simple order, like that

of conformity, one thing after another." An additional interest in light and reflection—bringing his work closer to the fluorescent light pieces of Dan Flavin rather than to that of the other Minimalists such as Sol LeWitt and Carl Andre, whose work was more involved in the structure of solid forms—is apparent in the expansion of industrial materials Judd used beginning in the late 1960s. *Untitled (August 28, 1970)*, for example, combines a translucent green Plexiglas with stainless steel, thereby giving the work a lightness that dematerializes the otherwise obdurate forms. These serial pieces ("stacks" such as *Untitled [August 28, 1970]*, and horizontal "progressions") were produced in numerous permutations of luminous colors and materials—blue, red, green, and purple with bronze, stainless steel, and aluminum—throughout the 1970s.

JM

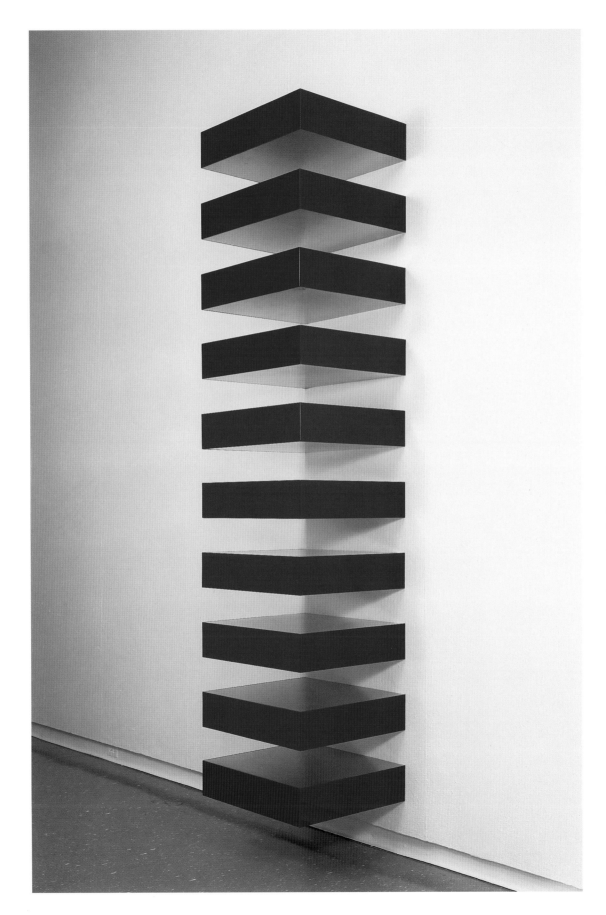

Untitled
(August 28, 1970)

1970
Stainless steel
and Plexiglas
Ten parts, each
6 x 27 x 24 in.
(15.2 x 68.6 x 60.9 cm)
Gerald S.
Elliott Collection
(95.50)

FRANZ KLINE

•

American, 1910–1962

In 1950, when Franz Kline started to work on the stark, black-and-white abstract paintings for which he is now renowned, other artists of his generation had already experimented with a similarly reduced chromatic scheme. Willem de Kooning's black-and-white enamel paintings (1946–48), Barnett Newman's black-on-black *Abraham* (1949), and Robert Motherwell's black-striped *At Five in the Afternoon* (1949), for example, were all produced before Kline's mythical "breakthrough" (as the artist's departure from a figurative to an abstract style has frequently been called). Kline's development up until 1950, however, has little in common with that of the artists associated with Abstract Expressionism (who, almost without exception, shared an initial interest in Surrealism and symbolic form).

Kline trained as a graphic artist in his youth and received academic artistic training at Boston University and the Boston Student's Art League (1931–35) and subsequently at Heatherly's Art School in London (1936–38), during which time he mastered a conservative, descriptive draftsmanship. During the 1940s Kline's work became more expressionist, but his subject matter remained representational and generally consisted of landscapes and portraits. Whether Kline's art underwent an overnight transformation, however, has been disputed. It is generally agreed that the origins for his post-1950 works are contained both in his training as a draftsman (and his consequent familiarity with the possibilities of working in black and white) and in his association with not only the Abstract Expressionists but also the young New York photographers. Robert Frank and, in particular, Aaron Siskind, were

producing black-and-white images with an energized simplicity that was similar to Kline's abstractions.

Despite the apparent conflict between Kline's early and late work (the former would appear to be the result of a studied process and the latter conveys an immediacy and spontaneity), Philip Guston once recalled that Kline would in fact spend days or weeks reworking the edge of a stroke to give the impression that it had been painted with intensity and verve. Kline's painting style had more in common with Clyfford Still's careful application of craggy swathes of paint than the rhythmic dripping of Jackson Pollock.

In *Vawdavitch* (1955) and other works from this period, Kline was careful not to suggest a figure/ground relationship between black image and white field. He remarked on this issue, "I paint the white as well as the black, and the white is

just as important." Kline similarly denied the calligraphic quality of his expressive strokes, which he differentiated from both signs and symbols.

Art historian David Amfam has suggested that Kline's abstractions, like the work of the photographers Frank and Siskind, capture the spirit of 1950s New York. Jack Kerouac and the Beat poets, jazz, popular culture, and experimental film, all superimposed on the dramatic architecture of the city, stimulated a departure from the angst-ridden Abstract Expressionists and a move toward the vernacular. Kline's work offered an alternative to the symbolic sublime and one that was welcomed by a younger generation of artists such as Cy Twombly, Robert Rauschenberg, Brice Marden, and, in particular, Mark di Suvero, whose sculpture at times resembles a Kline in three dimensions.
JM

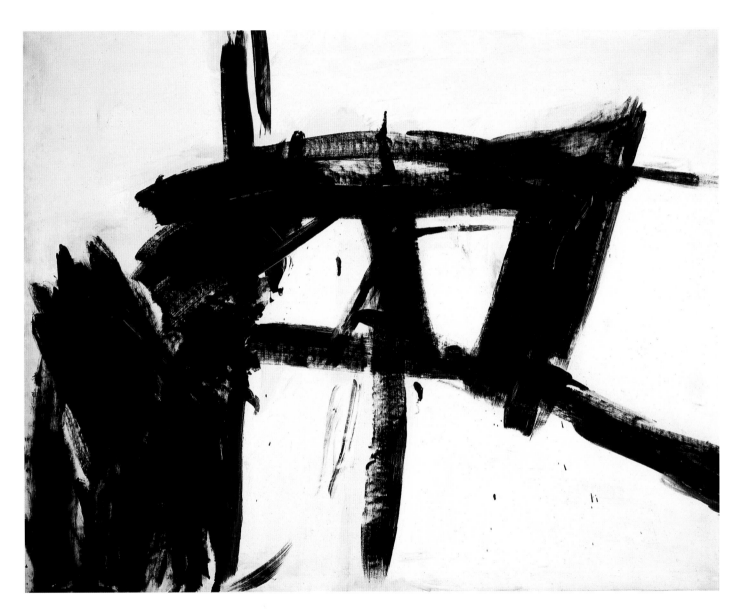

1955
Oil on canvas
62 $^1/_4$ x 80 $^{11}/_{16}$ in. (158 x 204.7 cm)
Gift of Claire B. Zeisler
(76.39)

JEFF KOONS

•

American, born 1955

Marketing is the central theme for Jeff Koons. He rose to prominence in the 1980s, when America's preoccupation with consumption was the subject of intense media interest. Koons continues to view marketing as an all-encompassing communication system in American culture, through which our most vital myths, fetishes, taboos, social differences, and even existential conditions are conveyed.

Like the Pop artists, Koons uses familiar brand-name products or common objects, as in the case of *Three Ball Total Equilibrium Tank* (1985). Following Minimalism, the objects are usually manufactured in series. For example, there are several versions of the basketball tanks, some with one or two balls, some only half-filled with water. Seriality enables Koons to evoke industry. Moreover, the process he went through to construct the tanks allowed him to emulate business practice by playing the role of entrepreneurial inventor. Koons is reported to have consulted over fifty physicists to determine how to make the basketballs float midway in the tanks.

Serial production has also impacted Koons's notorious marketing strategies. This includes exhibiting the same show simultaneously in several locations, thereby creating media events that mimic business practices, similar to the way a designer unleashes a line of products to many stores at the start of a season. When the basketball tanks were first exhibited in 1985, the show *Equilibrium* appeared simultaneously at International With Monument Gallery in New York and Feature in Chicago. Since 1985 Koons has increased his involvement with the publicity of his work. When he himself became a celebrity, in 1986, he began cultivating his persona as part of his art. Acting as a combination of all-American super-salesman and evangelistic con man, he grew to rival the master of publicity art, Andy Warhol.

Although Koons the salesman has heartily endorsed everything about the media and consumer culture, his work is more complicated. Koons the artist often exposes contradictions at the heart of mainstream culture. In this work, for example, Koons examined myths of upward mobility. The Spaulding basketballs symbolize people whose interests are tied to the game. When the tank was first exhibited, Koons hung framed Nike advertisements showing famous African-American basketball players, thus making unmistakable his reference to those legendary exceptions to the rule of unachievable dreams. Even the status of these celebrities is fragile. Like fish in a fish tank, players thrive in a specialized environment, such as the sports industry, where they are protected but dependent. Koons has asserted that the tanks connote "security" and "support"; they are "womblike" and the water is "amniotic fluid." Yet security and survival are precisely what is unstable here. Although the basketballs' defiance of gravity suggests defiance of normal limitations, the constricting, coffinlike enclosure of the tank speaks of limits.

Koons's play on dualisms extended throughout the *Equilibrium* exhibition: the tanks were accompanied by bronzed flotation equipment—a lifeboat (also in the MCA collection), a life vest with an oxygen tank, diving goggles, and a snorkel—items that, if taken into a real body of water, would sink, taking their users down with them.

AP

1985
Glass, iron, sodium-chloride reagent, and basketballs
60 $\frac{1}{2}$ x 48 $\frac{3}{4}$ x 13 $\frac{1}{4}$ in. (153.7 x 123.8 x 33.7 cm)
Gerald S. Elliott Collection
(95.55)

SOL LEWITT

•

American, born 1928

Sol LeWitt is a systematic artist; he creates a set of rules for a work and follows them to their conclusion. Many of these rules appear to deny expression and emotional content in the work, particularly if the material that LeWitt uses has a classical geometric component—cubes, squares, triangles, and circles. He is able, however, to create an almost mystical expressivity with minimal means, resulting in art of great sensuous beauty.

Although born in 1928, in the generation of Jasper Johns and Robert Rauschenberg, Sol LeWitt achieved prominence only in the early 1970s with a group of artists such as Carl Andre and Robert Mangold. They retained the material quality of their works (when Conceptual artists, for example, were making them with almost no physical presence). LeWitt's *Sentences on Conceptual Art*, published in 1969, stressed the importance of reduced means, reduced emotional content, and a careful response to the gallery space—the white box—for which much of the work was made. The art demanded a return to the Constructivist principles of an earlier part of the century and an unprecedented complicity between artist and curator in its presentation. LeWitt was able in subtle and simple ways to convert the market to accept new forms and rules for the purchase of avant-garde art.

LeWitt's own work developed as sculptures (often in series), drawings and prints, and perhaps most significantly, wall drawings. For a wall drawing LeWitt offers a written description, which becomes a certificate of ownership, and instructions on the production of the work. It may be exhibited in more than one place and does not need the artist to draw it. It usually must be scaled to fit the wall where it is drawn.

One-, Two-, Three-, and Four-part combinations of Vertical, Horizontal, and Diagonal Left and Right Bands of Color, 1993–94, a suite of gouaches purchased from the artist on its completion, is no less dramatic in scale, although its means are more conventional. LeWitt used stripes of equal thickness of gouache in diluted primary colors to fill the area of each of the sixty-four sheets. He established the components—vertical, horizontal, diagonal (left to right), diagonal (right to left)— in the first group of four. In the second group (illustrated here), he divided the sheet in half and presented all the combinations of the pairs (vertical/horizontal, vertical/diagonal l/r, vertical/diagonal r/l, horizontal/diagonal l/r, and horizontal/diagonal r/l). In the third he showed all the three-part combinations and completed the work with all four-part combinations. The result is sixty-four sheets, whose complex generation is obvious when they are shown together. LeWitt's art demands not only an appreciation of the beauty of the completed work, but an understanding of the intellectual demands the work makes. Holding a mental image of the proposal and working it out conceptually is an important part of the process of looking at it. LeWitt has changed the way in which we are expected to understand a work of art. It is a change of profound importance.

RF

One-, Two-,Three-, and Four-part combinations of Vertical, Horizontal, and Diagonal Left and Right Bands of Color

1993–94
Gouache on paper
Set of sixty-four sheets, each
30 x 22 in. (76.2 x 55.9 cm)

Restricted gift of Alsdorf
Foundation, Lindy Bergman,
Ann and Bruce Bachmann,
Carol and Douglas Cohen,
Frances and Thomas Dittmer,
Gael Neeson and Stefan

Edlis, Jack and Sandra
Guthman, Anne and William J.
Hokin, Judith Neisser, Susan
and Lewis Manilow, Dr. Paul
and Dorie Sternberg, Howard
and Donna Stone, Lynn and

Allen Turner, Martin E.
Zimmerman, Mr. and Mrs.
Burton W. Kanter, Ralph and
Helyn Goldenberg, and Marcia
and Irving Stenn
(94.13.a-lll)

RENE MAGRITTE

•

Belgian, 1898–1967

René Magritte belongs to a select group of artists who can claim a successful merger of the everyday and the fantastic in their art. His visionary work has influenced artists such as Marcel Broodthaers, Robert Gober, and Allan McCollum, as well as many advertisements and popular movies. A painting such as *Les Merveilles de la nature (The Wonders of Nature)* (1953) illustrates fully Magritte's poetic sensibility. Here he has depicted two fish-headed lovers apparently joined in song. The painting betrays an affinity to fellow Surrealist Salvador Dali, yet conveys a greater sense of whimsy and humor than the more bizarre and sexually provocative works of Magritte's Catalonian contemporary.

Magritte, born in 1898, was the oldest of three sons of a minor industrialist in Lessines, Belgium. He studied at the Académie des Beaux-Arts in Brussels, served in the military, and in 1927 moved with his wife, Georgette, to Paris, where they became part of the Surrealist milieu. The Magrittes left Paris for Brussels in 1930 as a result of personal differences with André Breton. In Brussels, Magritte took a leading role among the Belgian Surrealists. He died in 1967.

The token mermaid form of the fish-tailed, human-torsoed being is reversed in *Les Merveilles de la nature*, making a creature of fantasy even more unreal. Despite their petrification in stone, the figures appear to be very much alive, with an uncannily human quality. *Les Merveilles de la nature* is exemplary of Magritte's use of the theme and appearance of petrification throughout the 1950s. The painting also contains visual elements found in earlier paintings, such as the ghost ship that blends with the waves on the horizon, which made its first appearance in *The Seducer* (1950), or the figures themselves, found in an earlier incarnation, *Collective Invention* (1935).

Magritte, like many of the Surrealists, was well acquainted with the prose poem *Les Chants de Maldoror* by the nineteenth-century French poet Isidore Ducasse, who worked under the pseudonym Comte de Lautréamont. Among the illustrations that Magritte created for a 1948 edition of Lautréamont's work was a depiction of a fish with human legs sitting on a rock by the sea with a small ship coursing the waves in the distance. This association may account for the confusion over the painting's title, once given as *The Lovers* in a 1964 exhibition in Little Rock, Arkansas, and for a long time known at the MCA as *Song of Love*. Magritte had informed Joseph and Jory Shapiro, the original owners of the work, that the title was *Le Chant d'amour*. Yet, when asked by his friend Harry Torczyner at the time of his retrospective at The Museum of Modern Art in 1965, Magritte said that he could not remember the title. Research for the recent catalogue raisonné of Magritte's work revealed the painting's actual title and the date of creation, proving that the painting had been in a mermaid theme exhibition and a solo exhibition at La Sirène in Brussels in 1953, thereby identifying the sole work unaccounted for from this period, *Les Merveilles de la nature*.

DM

1953
Oil on canvas
30 $^1/_2$ x 38 $^5/_8$ in. (77.5 x 98.1 cm)
Gift of Joseph and Jory Shapiro
(82.48)

BRICE MARDEN

•

American, born 1938

Providing Minimalism with perhaps its most poetic expressions, Brice Marden's abstract paintings of the 1970s are characterized by subtle juxtapositions of color built up to create an extraordinary surface. A maverick of sorts within the movement, Marden eschewed the use of industrial materials and the occupation of physical space that characterized the work of other Minimalists, opting for a much more human scale and medium. His work immediately recalls late-Modern Masters such as Ad Reinhardt and Barnett Newman, yet his concerns differ greatly from those of his predecessors; he rejects their worldly spirituality for a more subjective approach to the materials and process involved in conceiving and creating the art object.

In 1965 Marden began to mix wax with oil for a more physical, dense quality to the monochromatic fields that he had been painting since graduate school. He received his first one-person show at the Bykert Gallery in New York in 1966. His monochromatic paintings of this time located him squarely between Minimalists such as Donald Judd, whose work was similarly involved with distilling aesthetic expression to its most basic and essential forms, and Richard Serra and Bruce Nauman, who were investigating the "act" of making art in their post-Minimalist creations. Marden's works, however, using odd colors whose saturation in wax serves simultaneously to absorb and project light from their surface, induce a sense of meditative contemplation in the viewer.

Grove Group V (1976) developed out of a series of vertically joined diptychs and triptychs, each panel a single color, which Marden had begun making by 1968. Enamored of the Mediterranean climate, Marden made his first visit to Hydra in Greece in 1971; *The Grove Group*, begun in 1973, was inspired by a Greek olive grove. In *Grove Group V*, a light gray-blue rectangular field is flanked by gray-green fields of equal size and shape, yet of a slightly variant gradation in color. The absence of representational matter in the painting leaves the viewer to observe the interaction of the colors on the plane created by Marden's joining together the separate canvases. One might see a highly abstracted landscape in the presence of the blue field at the center of the painting.

Yet the dull materiality of the wax-laden color complicates any attempt at allegory. This delicate interplay of hues on a flat surface gives *Grove Group V* an insular and abstract quality that heightens its emblematic harmony.
DM

1976
Oil and wax on canvas
72 x 108 in. (182.9 x 274.3 cm)
Gerald S. Elliott Collection
(95.67)

MATTA (ROBERTO MATTA ECHAURREN)

•

French, born Chile, 1911

Matta, a member of the original Surrealist group founded in Paris in 1924 by André Breton, brought to this movement a magical sensibility often associated with South America. Originally trained as an architect in his native Chile, Matta relocated to Europe in the early 1930s; he worked in Le Corbusier's office in Paris and associated with many leading architects, artists, writers, and intellectuals of the day, including Walter Gropius, László Moholy-Nagy, Pablo Picasso, Marcel Duchamp, Gertrude Stein, André Breton, and Pablo Neruda. He arrived in New York in 1939, where he became part of the émigré community of Europeans fleeing World War II and played a major role in the genesis of the Abstract Expressionist movement through his brilliant intellect, charismatic personality, and mentoring of such younger figures as Arshile Gorky, William Baziotes, and Jackson Pollock.

Matta's paintings were at this time vaporous washes that formed amorphous shapes within tenuous lines; these "inscapes," as he referred to them, show his continuing association with fellow Surrealists Pavel Tchelitchew and Yves Tanguy. After travels in Mexico in the mid-1940s, his imagery became more concrete and colorful, with paint thickly applied in an expressionist manner. Many of Matta's most highly regarded works were created during this period before he returned to Paris in 1948. After being expelled from the Surrealist group, he moved to Rome, where his interest in magic and mysticism—brought forth in Mexico—was balanced by an interest in science that was newly cultivated by contacts with a younger generation. The works of this period, such as *Let's Phosphoresce by Intellection #1* (c. 1950), feature enigmatic linear forms, both organic and mechanistic, inhabiting a strange and uncertain space. In this work several entities—all with faces that seem part mask, part machine, part human—hover over a prone female figure. In Surrealist writings, Matta described environments that would cybernetically adapt themselves to an occupant, and provide "surfaces which he [the viewer] could fasten to himself exactly…carrying our organs in well-being or sorrow to their supreme degree of consciousness." This painting, as a "psychological morphology"—another term Matta used to describe his art—seems an illustration for this convergent world the artist described years earlier.

LW

c. 1950
Oil on canvas
58 x 69 ⅝ in. (148.6 x 179.1 cm)
Gift of Mr. and Mrs. E.A. Bergman
(76.45)

BRUCE NAUMAN

•

American, born 1941

Since the mid-1960s Bruce Nauman has pursued ideas of language, body, and self-definition, through a witty, albeit relentless, assault on traditional notions of art-making. Throughout his thirty-year career, he has played with the identification of self. Relying on irony and a remorseless dramatization of human weakness, Nauman's art provokes an often prickly contemplation of self. Nauman has said that his work comes out of being frustrated by the human condition. The act of making art, in Nauman's hands, becomes a physical act of thinking, an act that insists upon the mental, and often physical, activity of the viewer.

Just out of graduate school, where he focused on making sculpture, Nauman began to experiment with photography, film, video, performance, sound, and neon. He also began to think of his own body as a plausible artistic medium and his simple activities in the studio as art.

Self-Portrait as a Fountain (1966–67) belongs to a series of photographs in which Nauman literally acted out verbal expressions. He used the analogy of the "artist as fountain" in several works, including an enormous pink mylar window screen inscribed with the words, "The True Artist Is an Amazing Luminous Fountain" (1966). No doubt Nauman's human fountains also punned Marcel Duchamp's infamous and hugely influential transformation of a urinal into *Fountain* (1917).

Nauman has frequently incorporated text—printed, spoken, or implied—to produce works that ultimately materialize from the disjunctive intersection of language and object-making, from language embodied by gesture and activity. He has used language, often in the form of neon signs, like he has used the body—as plastic material. His 1983 neon *Life, Death, Love, Hate,* *Pleasure, Pain* wryly spells out the parameters of human nature in big, plain English. Life and death, love and hate, pleasure and pain flash alternately, in roman and italic type, in an endless circular dialogue. Nauman offers no answers, but instead leaves the viewer with infinite questions. Nauman has made numerous variations on this theme, including a closely related neon, *Human Nature/Life Death* (1983), which won the 1983 Chicago International Sculpture Purchase Prize.

Elliott's Stones (1989) was originally commissioned by the late collector Gerald S. Elliott whose 1994 bequest of more than one hundred works, including thirty-one Naumans, is the largest single gift in the MCA's history to date. *Elliott's Stones* consists of six carved granite stones, each inscribed with a slightly varied, two-word phrase: "above yourself," "after yourself," "before yourself," "behind yourself," "beneath yourself," "beside yourself." Nauman intended the installation of the stones to be variable. No matter what the arrangement of the stones, the viewer becomes the center of the piece. Each stone is read in relation to the reader's body. Text and space trade places; their boundaries blur. Language takes on spatial and temporal, sculptural dimensions. *Elliott's Stones* proposes a definition of space and thought in relation to the body and suggests measuring one's being through a kind of physical thought process. *Elliott's Stones* encourages us to think about the body in relation to where we are and to imagine the self connected to philosophical and spiritual ideas. He questions why we are, how we exist and create; he makes us think.

LB

Self-Portrait as a Fountain
(from the portfolio *Eleven Color*
Photographs)

1966–67/1970
Chromogenic color print
19 $^{11}/_{16}$ x 23 $^{5}/_{8}$ in. (50 x 60 cm)
Edition: 8/8
Gerald S. Elliott Collection
(94.11.11)

BRUCE NAUMAN

•

Elliott's Stones

1989
Granite
Six stones, each approximately
3 $\frac{3}{4}$ x 39 $\frac{7}{8}$ x 25 $\frac{5}{8}$ in.
(9.5 x 101.3 x 65.1 cm)
Gerald S. Elliott Collection
(95.2.a-f)

1983
Neon
Dia. 70 ⁷/₈ in. (180 cm)
Gerald S. Elliott Collection
(95.74)

CLAES OLDENBURG

•

American, born Sweden 1929

Claes Oldenburg's fascination with the humorous and disruptive effects of gigantism—specifically, the relation between minor things and major formats—was not only shared by the other major figures in Pop Art (for example, Andy Warhol and Roy Lichtenstein), but had an esteemed history in the writings of two famous satirists. Jonathan Swift's *Gulliver's Travels*, written in the eighteenth century, and the early twentieth-century novel *Alice's Adventures in Wonderland*, written by Lewis Carroll, aimed to disrupt and defamiliarize our accustomed relationship to the world—and with that our accepted social hierarchies—by reversing the "natural" order of things.

Although Oldenburg's work may not reflect quite the same ambitions for cultural change as Swift and Carroll, it contains a savvy, but humorous, look at the advertising techniques and commodification of 1960s America.

Moreover, Oldenburg's sculpture infused contemporary art with kitsch and corporeal associations that provided a jolt of the "real" after the high seriousness of Abstract Expressionism's ethereal and universalist aspirations.

The history of Oldenburg's oversize sculptures can be traced back to the collection of debris and junk he collected from the streets of Manhattan's Lower East Side. These commonplace, pop-culture objects would appear in the "Happenings" and installations he orchestrated in the early 1960s and were later simulated in lumpy, sagging, painted plaster versions that were sold at Oldenburg's *Store* (1961–62) in Manhattan. The concept of the *Store*, like Warhol's "Factory," aptly captured the iconoclastic attitude of the Pop artists. It simultaneously pointed to the involvement of art in a market, and the status of the art object as a commodity, as well as deflating the uniqueness of

the art object by a process of mass production.

After the plaster objects came floppy canvas food and clothing sculptures that sat deflated but potentially alive, on the floor, without pedestals. A move to vinyl around 1962 allowed for more direct corporeal associations. The potential for color and the smoothness of the surface, as well as the sagging fall of the material, conjured up both the thrill of sexuality and the failings of the flesh. *Green Beans* (1964), for example, consists of eighteen "beans" sliding on top of each other in a variable heap.

Oldenburg grew up in Chicago. The child of the Swedish consul, he attended Yale University in New Haven, Connecticut, from 1946, and then returned to Chicago and enrolled at the School of the Art Institute in 1952. During the mid-1950s, while in Chicago, Oldenburg developed the habit of collecting street

junk and keeping an extensive journal of ideas and illustrations, pasting in unintentionally humorous advertisements from magazines.

During the mid-1960s, in an escalation of absurdity, Oldenburg introduced into his repertoire the "Proposed Colossal Monuments"—drawings of enormous versions of his object sculptures placed in prominent locations in metropolitan centers. One of the few actually completed proposals is the *Batcolumn*, (1977), in front of what is today the Harold Washington Social Security Center on Madison Street in Chicago.

JM

1964
Vinyl and painted Formica
Eighteen parts, each
2 x 11 3/4 x 5 in. (5.1 x 29.8 x 12.7 cm)
Gift of Anne
and William J. Hokin
(96.5)

ED PASCHKE

•

American, born 1939

The definitive Chicago artist for more than two decades now, Ed Paschke has captured the feel of the garish, urban landscape at the century's end. Displaying an early fascination with bizarre human subjects—tattooed ladies, beefy wrestlers, and circus freaks—Paschke has developed his own style of manipulation, fragmentation, and mutilation of the human body in his canvases. *Adria* (1976) is an excellent example, taking a distinguished member of the local art community, art critic and historian Dennis Adrian, and transforming him into a figure of fantasy. Situated between Paschke's more lurid pictures of the 1960s and the cool, neon-like abstractions of the 1980s and 1990s, *Adria* possesses the wild, Surrealist tendencies of the former and foretells the elegant, day-glo color schemes and the restrained formality of the latter period.

Paschke was born in 1939 on the Northwest side of Chicago. He attended The School of The Art Institute of Chicago, receiving his BFA degree in 1961. After graduation he held a string of unusual jobs, including working as a psychiatric aide and selling spot illustrations to *Playboy* magazine (where twenty-eight of his illustrations have been published from 1962 through 1989). Drafted into the Army in 1962, Paschke spent two years illustrating weapons-training aids and pursuing AWOL soldiers in Louisiana. Following a brief trip to Europe, Paschke returned to Chicago and in 1965 took a job at the Wilding Studio with a team of draftsmen rendering a map to be used in training astronauts for the Apollo moon mission. Paschke then began work for Silvestri, a display company, painting a Piranesi-style scene on the temporary façade around the first-floor window of the Carson, Pirie, Scott

and Company Department Store. By 1967 Paschke quit working to give himself time to paint, and on the GI Bill, he enrolled at the School of the Art Institute, receiving his MFA degree in 1970.

Paschke is regarded as one of the foremost "Imagists"—a name created by critic and historian Franz Schulze to define the punchy, Surrealistic, pop culture–informed, figurative art that emerged in Chicago from the middle of the 1960s to the early 1970s. Dennis Adrian, like Schulze, was an ardent supporter of Chicago painters, and Paschke's homage brings his likeness to the viewer on a heroic scale. The flamboyance of the oversized hat, the swinging padded appendages replacing his arms and hands, and the lush, oval-patterned backdrop offsets the rigid classical frontality of Adrian's "pose."

Adrian did not actually sit for the painting; Paschke painted the piece from a photographic model, and so the uncommissioned piece was quite a surprise for its subject. The painting was acquired by Susan and Lewis Manilow and was given to the MCA in 1988 in honor of Dennis Adrian.
DM

Adria

1976
Oil on canvas
96 ⅛ x 74 in. (243.8 x 188 cm)
Gift of Susan and Lewis Manilow in
honor of Dennis Adrian
(88.6)

ADRIAN PIPER

•

American, born 1948

Born and educated in New York, Adrian Piper studied fine art at the School of Visual Arts in New York, then received her PhD degree from Harvard University in 1981. While living in New York in the late 1960s, she began to devote her attention to politically motivated Conceptual Art, and came into contact with other artists, such as Vito Acconci and Hans Haacke, who were similarly concerned with producing multimedia, confrontational work. Conceptual Art values, or emphasizes, the idea or concept over execution, and Piper's performances, texts, and installations established her as one of the pioneers of this movement. The artist believes emphatically in the power of art to change people's attitudes, whether by confrontation, rational argument, or shock tactics—all of which she employs, with searing intensity, in her own work.

Motivated particularly by the US government's actions in Vietnam and the Kent State Massacre in 1970, Piper focused on some of America's most complicated, and ongoing, destructive legacies: racism and xenophobia. Although her work cannot be dismissed as simply autobiographical, her life experience as a light-skinned African-American woman (her own designation), and the racism she experienced from both black and white communities, has informed her art.

Piper's earliest Conceptual performances were a series of public guerrilla actions. These pieces, which she called *Catalysis*, involved drawing attention to herself by antisocial behavior or assuming a guise of exaggerated otherness. In one of the *Catalysis* performances, Piper traveled the New York transit system with a red towel partially stuffed into her mouth; on another she entered what is now the

Trump Hotel with Mickey Mouse helium balloons attached to her teeth, hair, and clothing. Her graphic work consists of her own text, or combinations of media imagery and text, through which she suggests the fears, fantasies, and xenophobic feelings that the white viewer might be having, but not voicing, when confronted with images of black people in the news.

The installation *Cornered* (1988) stages some of what Piper considers to be the white-liberal viewer's lingering, unspoken, racist assumptions. On encountering the installation, the viewer is confronted by a video monitor playing a tape of Piper, dressed in pearls and sensible clothing, giving the news reporter-style with just her upper body showing, facing the audience head-on. The monitor is placed on a box and draped with funereal black cloth. Leaning against the box is an upturned table and in front of the table are

chairs. Above the video screen, on the wall, hang two birth certificates issued for Piper's father, also a light-skinned African-American, one of which categorizes him as white, the other, black. Piper begins her on-screen monologue with the statement, "I am black," and continues to reason out the various hostile reactions the audience may have to this assertion coming from a woman who appears to be white. The artist thus corners the viewer in a dialogue to which he or she might respond with an ideological reassessment concerning race, to be followed, perhaps, by political action.

JM

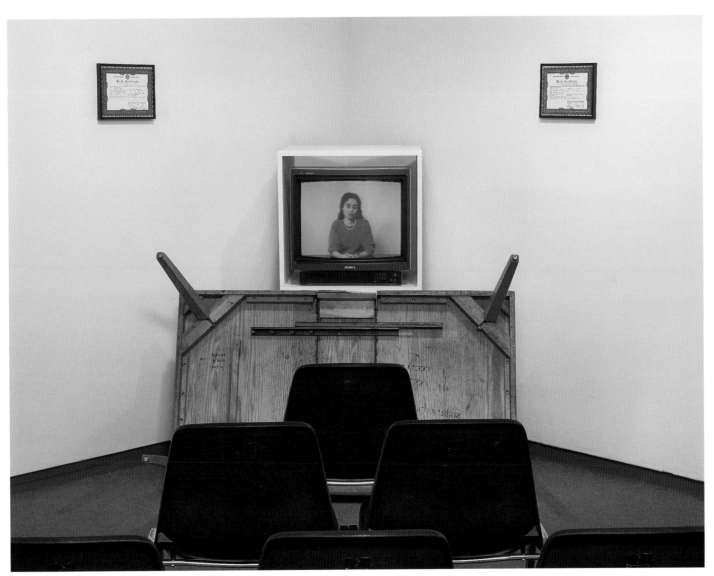

1988
Video installation with birth
certificates, videotape, monitor,
table, and ten chairs
Dimensions variable

Bernice and Kenneth
Newberger Fund
(90.4)

AD REINHARDT

•

American, 1913–1967

Although Ad Reinhardt had been producing nonobjective paintings since the 1940s, interest in his work was overshadowed first by the critically acclaimed Abstract Expressionists and subsequently by the Color Field painters. Reinhardt's commitment to a nonobjective geometric abstraction only received its due acclaim with the development of the similarly reduced pictorial elements and geometric forms of Donald Judd, Carl Andre, and Sol LeWitt's Minimalist sculpture in the 1960s. Reinhardt's work and writings provided a context and an inspiration for this younger generation's utterly unromantic and nonreferential abstraction, and created a historical link to the nonrepresentational art that had emerged from Europe in the second decade of the twentieth century.

Having struggled with the formal precepts of late Cubism, Reinhardt produced collages in the late 1930s that bore some resemblance to the work of Jean Hélion and Ferdinand Léger. Although he later railed against the romanticism that he detected in both Abstract Expressionist painting and Dada and Surrealism, during the early 1940s his work flirted with a more gestural, quasi-surreal quality. By the end of the decade, however, he had clearly committed himself to the unemotional geometric abstraction of Josef Albers and others.

During the 1950s Reinhardt worked to reduce his paintings to the least referential configuration. The works were untitled, to avoid the misinterpretation of a name, and unlike the utopian aims of such early geometric abstractionists as Kasimir Malevich and Piet Mondrian, Reinhardt did not intend his paintings to be reflective of a universal purity or harmony.

Rather, his end-of-the-road apocalyptic gesturing is reflected in his statement, "I'm just making the last paintings which anyone can make." These "ultimate paintings" were produced from 1960 on when Reinhardt established the format of the five-foot-square canvas symmetrically trisected by one horizontal and one vertical to create a cross shape. In fact the canvases are not black, but consist of extremely dark red, blue, and green, one color each for the ground and the two directional divisions.

These startling canvases, like *Abstract Painting* (1962), initially confound the impatient viewer who sees only a black canvas. Careful concentration, however, brings to view subtle color differences— in this case a black background with a blue vertical and a red horizontal. Reinhardt claims to have intended no formal, metaphorical, or religious significance by the cross element; he simply wanted to create the most symmetrical configuration (one which had already been put to use by Malevich as early as 1913). Surprisingly similar in retrospect to Mark Rothko's work, Reinhardt's paintings concentrate on light. But whereas Rothko's canvases seem to be lit by a glow from within, Reinhardt's suggest a tangible gloom that emanates from the surface of the paint itself.
JM

1962
Oil on canvas
62 $\frac{1}{4}$ x 62 $\frac{1}{4}$ x 3 $\frac{3}{4}$ in. (157.5 x 157.5 x 9 cm)
Gift of William J. Hokin
(81.44)

MARK ROTHKO

•

American, born Russia, 1903–1970

Mark Rothko adamantly denied that his luminous, abstract, color-field paintings should be interpreted formally. The artist's statements, such as that made to his friend Seldon Rodman, in which he declared, "I'm not an abstractionist…I'm not interested in relationships of color or form or anything else…I'm interested only in expressing basic human emotions—tragedy, ecstasy, doom and so on," suggest that the only critical interpretation acceptable to the artist was a communion between viewer and painting that relied upon a nigh-universal transcendental experience. The Abstract Expressionists and their contemporary critics were driven by the desire to convey the transcendental and to create an art that expressed basic human emotions for an increasingly secular world.

Born in Dvinsk, Russia, in 1903, Rothko immigrated with his family to Portland, Oregon, in 1913. Rothko later moved to the East

Coast. He studied at Yale University (1921–23) but never completed his degree, and then moved to New York, where he became involved in a series of socialist arts groups in the 1930s, such as the Artists Union and the American Artists Congress, during which time he worked on representational paintings. Like the work of many Abstract Expressionists, Rothko's early paintings from the 1940s reflect the influence of Surrealism and in particular the work of the Spanish artist Joan Miró. The Surrealistic biomorphic fantasies developed, in other artists' work, into the expressive gestural style of what the critic Harold Rosenberg, in 1952, called the "Action Painters." Rothko, however, eliminated forms from his work and concentrated on creating a luminosity within the scumbled surface of the paint, gradually developing the rectangle-based compositions for which he is now renowned.

The affinity of Rothko's work to spiritual and religious painting has been used to explain the impact of his canvases. Their size and the manner in which they are frequently displayed—apart from other artists' work, often in a room of their own—elicit a comparison to European altarpieces and devotional objects. The art historian Anna Chave has suggested that the format that Rothko settled on from around 1949—stacked rectangular fields of luminous color floating nebulously on a saturated canvas—could reflect Rothko's early interest in religious iconography. The rectangles could reflect specifically the horizontal composition of an entombment or adoration scene or perhaps a pietà (in which the seated Virgin supports the horizontal body of the dead Christ). However, it is the series of paintings that Rothko produced for the de Menil chapel in Houston in 1967 that firmly established the artist as a creator of iconic images.

Upon recovering from the serious illness he contracted after the completion of the chapel, Rothko began to paint smaller acrylic works on paper, only gradually working up to painting on canvas on a medium scale. The year before he took his life, 1969, was one of Rothko's most productive years. Among the works he produced was a group that explore the possibilities of black or very dark green or blue on a bright blue surface. These acrylic works on paper include *Untitled* (1969), which combines two black rectangles on a blue surface. The blue is so bright that it confuses the figure/ground relationship between the forms in a magical balancing act typical of Rothko's late work. A related piece, another *Untitled* (1969), is in the collection of the National Gallery of Art, Washington, DC.

JM

1969
Acrylic on paper mounted on canvas
78 $\frac{1}{2}$ x 58 $\frac{9}{16}$ in. (199.4 x 148.8 cm)
Gift of The American Art Foundation
(95.21)

RICHARD SERRA

•

American, born 1939

In the early 1960s Richard Serra was a leading proponent of "antiform," a movement developed by, among others, Robert Morris and Barry Le Va, in which the artists utilized untraditional, soft, and malleable materials such as latex, rubber, and felt. From this beginning, Serra's work developed toward greater and greater rigidity and tension through his use of lead and, later, steel. Although Serra's progression from light industrial material (rubber) to the heavy-industry associations of steel may appear to suggest a radical change in artistic direction, in fact the artist has stated that his work has consistently focused on certain essential issues in sculpture: balance, gravity, and the sculpture's spatial relationship to the human body.

Serra's titles, "Prop," "Strike," and "Casting," for example, immediately alert the viewer to the physical impact of his sculpture and the action by which it was created. Unlike his contemporaries Bruce Nauman and Eva Hesse (who were also associated with antiform), Serra never figuratively evokes the human body, yet the scale and capacity for movement that dominate his work are firmly oriented to the human figure.

In an attempt to move away from the reductive and static qualities that Serra perceived in some Minimalist sculpture, he produced a list of transitive verbs, which he later used to describe the untraditional and process-oriented sculpture he produced. The list that included "to roll," "to crease," "to fold," and "to drop" stimulated deceptively simple sculptures like *Splashing* (1968), a thrown lead piece, which literally consists of what resulted from the action of

throwing or splashing molten lead on the floor and wall. *Prop* (1968) consists of two separate pieces, a cylindrical pole and a lead plate, which demonstrate the title of the piece in a breathtaking configuration. The pole actually holds the plate in place against the wall by nothing more than pressure and tension. The piece at once draws the viewer's attention to the material quality of the work and metaphorically suggests the necessity of such interdependency in life. *Prop* is one of close to one hundred "prop" pieces comprised of flat and rolled sheets of lead made around this time. All of them consist of unpolished, mass-produced, raw materials that have surprisingly tactile and reflective surfaces.

The weighty, silent balancing act of *Five Plate Pentagon* (1988) alerts the viewer to consider the consequences of a fatal shift in balance, a shift we simultaneously dread and

desire. *Five Plate Pentagon* and *Another Look at a Corner* (1985) are later works in which Serra began to use cut steel. (Having worked in steel mills to put himself through college and graduate school, he studied at the University of California, Berkeley, and then at Yale University, Serra was familiar with the properties and potential of this material, which he continues to use to the present day.) Less malleable and more rigid, steel allowed Serra to construct different configurations and to dramatically increase the scale of his work. These later works are often startlingly simple, but the increase in size and weight radically heightens the drama and sense of potential danger.

JM

Prop

1968
Lead antimony
Overall installed: 86 $\frac{1}{4}$ x 60 x 57 in.
(218.7 x 152.4 x 148.8 cm)
Gift of Mrs. Robert B. Mayer
(78.44.a-b)

CINDY SHERMAN

•

American, born 1954

Since the early 1980s Cindy Sherman has been recognized as one of the leading contemporary artists to show new possibilities in photography. Her work demonstrates that photography, formerly ghettoized as a subcategory of art, is worthy of the art historical significance traditionally accorded to painting. To accomplish this, Sherman rejected two dominant tendencies in the use of photography: First, she opposed Conceptual Art's use of photographs as documentary adjuncts to ideas or events and instead made the photograph the principal object of importance. Indeed the vivid physicality of her images—exaggerated by Sherman's tendency after 1980 to work in large scale—is key to their dramatic power. Second, Sherman rejected the tradition of camera-centered technical virtuosity that is based on manipulations of camera settings and the development of film. Sherman does not strive for formal stunts.

Instead, she focuses her manipulations on the process of staging a scenario. As in *Untitled #137* (1984), her disguises of costume and make-up, and use of props, lighting, and acting leave no descriptive detail unaccounted for. Sherman's artistic process is most like that of a film director creating a set. Not surprisingly, the artist has often cited film as a chief source of inspiration. In her work, however, Sherman plays every role: actress, photographer, make-up artist, prop person, director, etc.

In part because Sherman has used herself as a model in most of her photographs, and therefore has been constantly involved in masquerade, she has become for many art critics exemplary of the contemporary concerns of feminism and Post-modernism. Her work has dovetailed with feminists' study of images of women in popular media. Sherman's role-playing has also inspired discussion

about how female subjectivity is constituted. For some, Sherman's character changes illustrate the schizophrenia of our Postmodern era. Her work, however, is not didactic, and neither is the artist. She prefers to leave interpretation open, refraining in interviews and statements from using specialized jargon or specifying the meaning of her work.

Certainly the identification of social types and scenarios is one of Sherman's dominant concerns. From the earliest series for which she became known, the "film-stills" of 1977–80, to her most recent, Surrealist-inspired experiments with the grotesque, uncanny, and other-worldly, Sherman has compelled her viewers to ask of each photograph, "Who or what is this?" Her work has ranged from portrayals of recognizable social stereotypes, as in her early film-stills, to presentations of disturbingly alien beings and circumstances. *Untitled #137* represents

the point in her career when Sherman began to explore the dark realm of grotesquerie and madness. This particular image is made compelling by Sherman's crafty combination of contradictory clues: The civilized is juxtaposed with the taboo. The lovely, clean red sweater looks inconsistent with the woman's dirty appearance. The horror of the—blood-soiled?—hands contradicts the demureness of her downcast eyes. The signs of lowliness are in tension with the figure's classically dignified stature, which evokes images of a Renaissance Madonna.

AP

Untitled #137

1984
Chromogenic color
print
70 $^1/_2$ x 47 $^3/_4$ in
(179.1 x 121.3 cm)
Edition: 2/5
Gerald S. Elliott
Collection
(95.98)

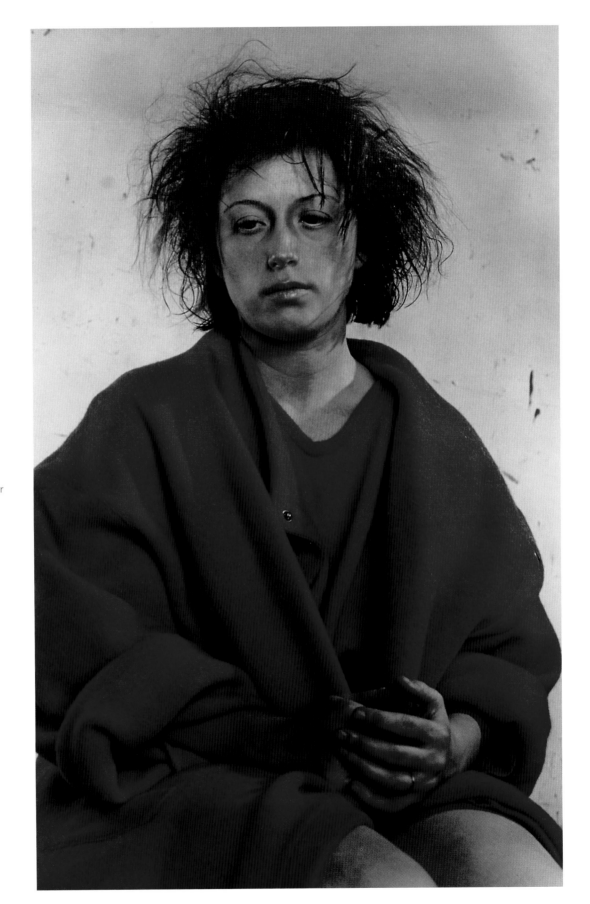

LORNA SIMPSON

•

American, born 1960

Lorna Simpson's textual/ photographic work eloquently questions stereotypical images of women, specifically of black women, by simultaneously revealing and resisting the dominant representations of gender and race. Like her slightly senior colleagues Barbara Kruger and Cindy Sherman, Simpson presents the female "object" as a complex subject by revealing how language and image insidiously can work together to create degrading stereotypes. Simpson uses a poetical and yet critical language in combination with images of black women and men to perform a series of interrogations, accusations, and pleas that both complicate and inform the issues of gender and race relations. Simpson's work is characterized by a somber, minimal aesthetic which requires concentrated attention in order to unravel the connections and contradictions between the verbal and pictorial elements. Like that of other politically motivated African-

American and feminist artists, such as Adrian Piper, Simpson's work has been informed by recent cultural criticism and the politically active role this discipline aspires to.

Simpson, who was born in Brooklyn and now lives and works in New York, received her BFA from the School of Visual Arts in 1982 and her MFA from the University of California, San Diego, in 1985. Typically, her text and photographic installations represent a generic "black woman," her face and its distinguishing characteristics hidden—variously cut off, turned away or masked—in order to suggest general rather than individual identity. Attention is not drawn to the figure's gender—posture and frequently clothing are subtly androgynous—and the text or words that accompany the images refer to racial or gender assumptions in a stylistic manner that could be called political poetry.

Simpson is clearly aware of nineteenth-century documentary photography in which black people, often slaves, members of other minority groups, and criminals were recorded for putatively scientific and anthropological reasons. Like the similarly objective and serial documentary work of the contemporary German photographers Bernd and Hilla Becher and their former student Thomas Struth, Simpson's ambiguous generic types deny the possibility of making accurate generalizations, let alone scientific observations, based on appearance, clothing, body language, skin color, or hair type.

Bio (1992) consists of eighteen Polaroid prints (nine plastic plaques) which are positioned in three horizontal rows. The central row is occupied by images of a woman dressed in a man's suit and shown in various "masculine" poses. The bottom row is a series of men's shoes, and along

the top are images of shoe boxes accompanied by text. The text refers (obliquely) to biological or physical suffering (panel three, for example, reads, "bled to death outside hospital 60 years ago"), and to the signs of difference contained within the black body which come under the punitive gaze of racism (panel four reads, "tendency to keloid"). The entire grid structure is united by the last three engraved plaques, which read "biopsy," "biology," and "biography." These three words bring to mind a powerful and disturbing concoction of pain (which is also suggested by the blood red that suffuses all the images), the physical attributes of difference, and the lack of a documented history from which a dispossessed people suffers.
JM

Bio

1992
Color Polaroids and plastic plaques
Overall: 98 x 162 in.
(248.9 x 411.5 cm)

Gift of Maremont Corporation by exchange; purchased through funds provided by AT&T NEW ART/NEW VISIONS (92.90.a-u)

Biopsy Biography Biology

ROBERT SMITHSON

•

American, 1938–1973

Perhaps the premier Earth artist, Robert Smithson was extraordinarily productive during his short eight-year career. He created his major work, *Spiral Jetty*, in 1970, bringing together in one monumental form every aspect of his practice—earthwork, theory, and film. (Smithson's film *Spiral Jetty* is in the MCA collection.) At the time of his accidental death while working in 1973, Smithson had become internationally renowned for innovative projects that took art-making outdoors and brought the principles and material of nature indoors into the spaces of galleries and museums. Smithson's art challenged the very nature of the material, site, and temporality of art. His accomplishment has grown even larger due to the continuing influence of his numerous writings.

Smithson began to make sculpture in 1964, demonstrating a strong affinity for the principles of Minimalism. While formally linked to the sculptures of Donald Judd, Tony Smith, and Sol LeWitt, early works such as the MCA's *Mirror Stratum* (1966) distort and complicate the viewing experience. Squares of mirrors stacked in order of decreasing size suggest a constant shift between structure and illusion, between the solid geometry of the sculptural form and the ceaseless variation of the mirrors' changing reflections.

In late 1966 Smithson began to make regular excursions to various quarries and industrial sites in New Jersey, with such artist friends as Dan Graham, Carl Andre, Michael Heizer, Claes Oldenburg, Richard Long, and Sol LeWitt. He photographed the sites, collected materials, wrote about the excursions and sites, and began to make works that incorporated the artifacts from his trips. His 1968 series of *Nonsites* consist of materials gathered from several sites, usually rocks or minerals, that he then regrouped in geometric containers and displayed, often with corresponding aerial photographs or maps of the original site. The process involved transferring materials from a site of origin to a site of exhibition.

A Nonsite (Franklin, New Jersey) (1968), one of the earliest *Nonsites* and the first Smithson to enter the MCA collection, is composed of five shallow wooden trapezoidal bins of decreasing size arranged on the floor. Each bin is filled with limestone rock collected from a quarry in Franklin, near Smithson's birthplace. On the wall hangs an aerial photograph of the site, which is segmented to correspond in shape and number to the bins. The formats of the bins and photographs mirror one another. Like his strata of mirrors, Smithson's *Nonsite* creates an endless dialogue between structure and illusion, between origin and point of destination. Smithson was able to link origin with execution in a fashion of Conceptual collage, a compression of distinct worlds, information, and time, linking object-making with concept and the process of thought. The *Nonsites* allowed Smithson to extend his ideas and work to the outside world, and to make that world a participant in the spaces of the studio and the gallery.

LB

A Nonsite (Franklin, New Jersey)

1968
Painted wooden bins,
limestone, photographs, and
typescript on paper with
graphite and transfer letters,
mounted on mat board

Bins installed 16 $^1/_2$ x 82 $^1/_4$
x 103 in. (41.9 x 208.9 x 261.1 cm)
Board 40 $^1/_{16}$ x 30 $^1/_{16}$ in.
(101.8 x 76.4 cm)
Gift of Susan and Lewis Manilow
(79.2.a-g)

THOMAS STRUTH

•

German, born 1954

The German photographer Thomas Struth focuses in his work on the complexity of the act of looking. All three subjects in his Conceptual photography—urban landscapes, portraits, and museum interiors—are consistently used in an investigation of what it means to see, to observe, to gaze.

The urban landscapes, taken in Europe, the United States, and Asia, which Struth has called *Unbewußte Orte* (Unconscious Places) are relatively small, black-and-white architectural views that recall both the objective documentary photography of the artist's teachers, Bernd and Hilla Becher, and the unpopulated street scenes of the turn-of-the-century French photographer Eugène Atget. Struth characteristically chooses areas of a city that tourists are likely to visit only by mistake. The MCA's *Via Medina, Naples* (1988), for example, displays none of the architectural perfection

typical of a postcard image, but concentrates instead on the disparate and often conflicting signs of an urban periphery. The aim is neither to romanticize the derelict nor to "educate" the socially unaware, but rather to elicit a more complicated reading through a patient examination of the image.

Struth's portraits are always of individuals and families he has come to know well, taken in surroundings that the participants themselves choose. Inhabitants of the desolate city areas he photographs, his subjects are uniformly middle-class, and the viewer's attention is focused on the small but noticeable cultural differences between the almost-same. In the MCA's *The Shimada Family, Yamaguchi 1986* (1988), in which the domestic group chose to be photographed in a Japanese garden, the family faces the camera, extremely self-conscious of their status as objects of the photographer's gaze. Their

relationships, clothing, and the choice of setting all demand analysis by the viewer. Ultimately, however, the photograph frustrates by its refusal to disclose the (fictitious) "real" personalities, and calls into question the potential voyeurism of the art public.

Struth's examination of the act of looking reaches an apex with his photographs of visitors in museum galleries. He contrives a ricocheting sequence: the photographer watches the public looking at paintings in a museum; we the viewers see the photographer's view of the spectators looking at art, and thereby are made aware of our own action of looking at art in a gallery. *Kunsthistorisches Museum I, Vienna* (1989–90) is a striking example of Struth's remarkably subtle, complex, and often extraordinarily beautiful photographs. Concerned here again with the construction or "building" of images, in this series Struth drew

attention to the history of compositional structures in art. Arranged in pairs, groups, and individually, the figures reflect the compositional structures of the surrounding Rubens paintings.

Kunsthistorisches Museum I, Vienna demonstrates both the reality and the artificiality of looking at art. Although clearly conscious of the comparisons that can be made between the leisure activities of visiting shopping malls and sports arenas, as well as museums, Struth is not out to condemn this—predominantly bourgeois—experience. Rather, avoiding the obvious, accusatory stance, Struth focuses attention on the long tradition of looking at art, with all its inherent sociological implications, on the museum experience, and even encourages us to feel the physical discomfort, or excitement, of sharing such an experience with strangers.

JM

1989–90
Chromogenic color print
72 x 94 in. (182.9 x 238.8 cm)
Edition: 3/10
Gift of William J. Hokin, The Dave Hokin Foundation
(93.24)

ANDY WARHOL

•

American, 1928–1987

In his paintings, sculptures, drawings, films, and, most memorably, his silkscreens, Andy Warhol documented the products and by-products of 1960s America, especially its movie stars, commercial packaging, and the subjects of the new mass media. Although Warhol himself might have teasingly suggested that he was an uncritical receptacle of the images and signs of contemporary mass culture, his work hovers ambiguously between a celebration and a critique of American values.

Warhol's photo-silkscreen prints can be divided into thematic groups, including the packaging images (Campbell's soup and the Brillo boxes); film and media stars; and the "disaster series," which documents particularly American forms of death such as car crashes and the electric chair. The silkscreening process provided a technique of mass production that appealed to Warhol because

of its ability to undermine the uniqueness and originality of the artwork, but nevertheless produced slightly varied prints. Photo-silkscreen printing allowed for the least involvement of the artist after the initial image had been devised and, accordingly, in 1963, Warhol infamously stated, "I think that somebody should be able to do all my paintings for me." Although he delegated some of the printing to studio assistants in the "Factory" (his New York studio), and despite his spectacular comments to the media, he largely retained control over most if not all of his artistic production.

Warhol's silkscreens typically contain repeated serial images on one or abutting canvases. In reference to this use of film-reel–like repetition, Warhol stated, "the more you look at the exact same thing, the more the meaning goes away and the better and emptier you feel." As with all Warhol's

statements, however, the opposite is also true. The overreproduction alerts the viewer to the original source of this visual overkill— namely, the mass media— and its corruption of tragedy for the sake of sensation.

Like the "disaster series," Warhol's images of movie stars fall into the long tradition of the "vanitas" theme (in which the viewer is reminded of his or her own mortality). Warhol produced numerous versions of his prints of both Jackie Onassis (in her various roles as widow, mother, First Lady, and socialite) and Elizabeth Taylor (a brutal record of her turbulent career and physical decline). In fact, the stars chosen by Warhol were generally dead, either literally, at the box office, or, as in the case of Troy Donahue, B-movie actors who never achieved lasting fame. In *Troy Diptych* (1962), Warhol repeated the same saccharine image over two abutting screens,

one in filmic color and the other in newspaper print black and white. Presumably the oval-shaped photograph that is signed in the corner was taken from a fan-club handout. Through repetition, Warhol revealed Donahue's slick smile and perfect helmet of blond hair to be the vacant, simultaneously tragic and laughable product of a fickle Hollywood culture.

Details are surprisingly revealing in Warhol's work. The images in *Troy Diptych* are not identically reproduced: some are "carelessly" overinked to the point of obliterating Donahue's face; there is an uncomfortable blank area at the bottom of the canvas; and an inexplicable omission of three images disrupts the seamlessness of the mechanistic reproduction and directs the viewer to a more somber and unsettling reading of the painting.
JM

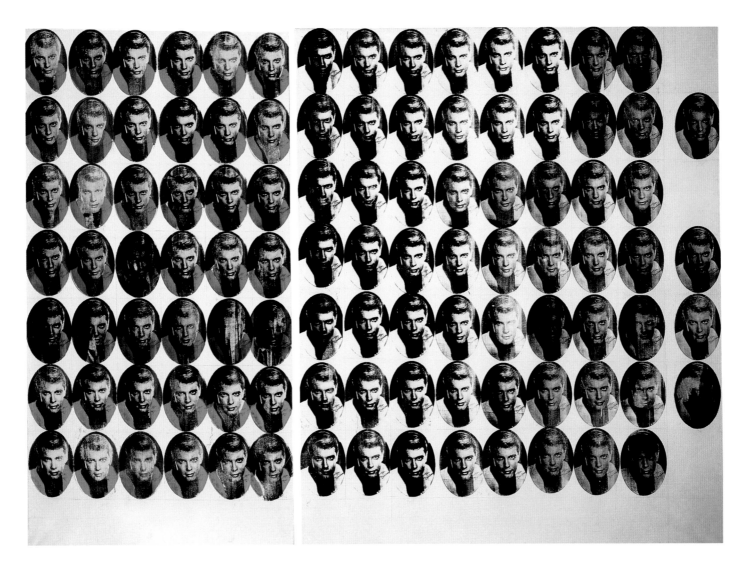

1962
Silkscreen ink on synthetic polymer paint on canvas
Overall: 81 x 110 $^3/_4$ in. (205.7 x 271.1 cm)
Gift of Mrs. Robert B. Mayer
(84.1.a–b)

H.C. WESTERMANN

•

American, 1922–1981

H. C. Westermann has been associated with a number of twentieth-century art movements, from Surrealism to Chicago's first generation of postwar artists, the so-called "Monster Roster." Yet this artist's highly individual approach, together with his aversion to art theory, disavows his inclusion in any one category. Although much of his work draws upon and refers to personal experience, Westermann ultimately was concerned with universal themes of the unpredictability and danger of human existence and the absurdities of modern life—including the art world. The harshness of this often pessimistic view is mitigated by the subtle humor Westermann often infused into his work.

After serving as a Marine gunner in the Pacific during World War II, Westermann enrolled in The School of The Art Institute of Chicago, only to interrupt his education to reenlist in the Marines to serve in Korea. Older than many of his fellow students and profoundly affected by the horrors he had witnessed during his military service (including the devastation in 1944 of the USS *Franklin*), Westermann went his own way. After making his first sale to the great architect Mies van der Rohe, however, he began to exhibit regularly in Chicago and became associated with the Chicago School of figurative art.

Mad House (1958), donated to the MCA by the widely known collector of Surrealism Joseph Randall Shapiro, another early supporter of the artist, is a major work in Westermann's oeuvre and one of a number of pieces utilizing the theme of the house. Conceived and constructed while Westermann was residing in Chicago during the painful period between his first and second marriages, *Mad House* is an allegory on sexual frustration. It speaks hauntingly of the rejection, fear, insecurity, and even hatred that can come with the dissolution of a relationship. A particularly elaborate example of Westermann's consumate woodworking skills, the work is carefully fitted together from strips of fir and fastened with dozens of screws; punctured with various trapdoors, oddly placed windows, and assorted openings framed with stylized body parts; and incised with various inscriptions. Its overall form is reminiscent of a one-room schoolhouse, and it is surely no accident that Westermann transformed this symbol of childish innocence and nostalgia into a house of adult emotional horrors.

Mad House was the first sculpture by Westermann to enter the MCA collection, which now has extensive holdings of both the artist's sculpture and works on paper, including numerous illustrated letters to friends. While Westermann left Chicago in 1961 and received a great deal of national and international attention during his lifetime, he is often held up as a prototypical Chicago artist for his refusal to follow artistic fashion, for the affinity of his work to intuitive art, and for the deeply felt humanism that inspired his work.

LW

1958
Douglas fir, metal, glass,
and enamel
69 $^5/_8$ x 23 $^3/_4$ x 25 $^3/_{16}$ in.
(176.8 x 60.3 x 64 cm)
Gift of Joseph and Jory
Shapiro
(78.5)

Board of Trustees

Architecture and Building

Architect
Josef Paul Kleihues
Berlin

Design Engineer
Ove Arup & Partners
London, Los Angeles,
New York

**Associate Architect and
Engineer**
A. Epstein & Sons
International
Chicago

Project Manager
Schal Bovis, Inc.
Chicago

General Contractor
W.E. O'Neil Construction
Company
Chicago

**Building and Design
Review Committee**
J. Paul Beitler
Chair
Edward F. Anixter
Richard H. Cooper
Gerald S. Elliott
Helyn D. Goldenberg
Marshall M. Holleb
John C. Kern
Lewis Manilow
Mrs. Robert B. Mayer
Albert A. Robin
Dr. Paul Sternberg
Jerome H. Stone
James R. Thompson
Allen M. Turner
John Vinci
Staff
Kevin E. Consey
Amy Corle
Nancy Dedakis
Mary E. Ittelson
Richard Tellinghuisen
Janet Wolski
Architect Selection Committee
Allen M. Turner
Chair
Mrs. Edwin A. Bergman
Kevin E. Consey
Mrs. Thomas H. Dittmer
Joan W. Harris
Ada Louise Huxtable
Bill Lacy
Robert N. Mayer
Paul W. Oliver-Hoffmann
Jerome H. Stone
Gene Summers
Richard Tellinghuisen

Chicago Contemporary Campaign Committee

Campaign Leadership
Mayor and Mrs. Richard M. Daley
Honorary Chairs
Jerome H. Stone
Campaign Chair
Mrs. Thomas H. Dittmer
Chair, Major Gifts
King Harris
Chair, Corporate Gifts
Donna A. Stone
Co-Chair, Special Gifts
Governor James R. Thompson
Co-Chair, Special Gifts
Mrs. Paul Sternberg
Chair, General Gifts

Edward F. Anixter
Meta S. Berger
Mrs. Edwin A. Bergman
John D. Cartland
Robert G. Donnelley
Stefan Edlis
Gerald S. Elliott
Jeffrey S. Fisher
Helyn D. Goldenberg
Jack Guthman
Allan and Norma Harris
Thomas C. Heagy
William J. Hokin
Marshall M. Holleb
Mrs. Ruth Horwich
John C. Kern
Richard A. Lenon
Lewis Manilow
Robert N. Mayer
David Meitus
Paul W. Oliver-Hoffmann
Donald A. Petkus
Penny Pritzker
Albert A. Robin
Joseph Randall Shapiro
Mrs. Leo S. Singer
Marjorie S. Susman
Allen M. Turner
Martin E. Zimmerman
Staff
Kevin E. Consey
Carolyn Stolper Friedman
Christopher Jabin
David R. Luckes

Women's Board

July 1989–June 1996

Neil Barrett*+
Julie Baskes
Meta S. Berger*
Robin Loewenberg Berger
Lindy Bergman+
Marie Krane Bergman
Lois Berry
Lillian Braude*+
Tere Romero Britton
RoJene Budwig
Edie Cloonan*
Leslie Douglass*+
Diane Drabkin
Darby Epstein
Helen Fadim*
Ann Wood Farmer
Suzette Flood
Lynn Foster
Laura De Ferrari Front
Diane Gershowitz
Helyn Goldenberg*+
Hope Perry Goldstein
Lillian N. Goldstine
Virginia Gordon
Myra Gotoff
Judy Greenwald
Nancy S. Gutfreund
Velma Hancock
Lynn Heizer
Rhona Hoffman+
Linda R. Hortick
Frances G. Horwich
Ruth Horwich+
Vicki Hovanessian
Jacqueline Jackson
Peggy Jacobs
Dona B. Jensen
Jacquelyn Jones-Lipton

Sally Meyers Kovleru◆
Margo Krupp
Pat Kubicek+
Marilyn Kushen
Lori LaRose
Bonnie Glazier Lipe
Jacqueline Lippitz
Margaret Lockett
Audrey Lubin
Judy Malkin
Kay McCarthy
Madeleine M. McMullan
Beverly M. Meyer
Lee Meyer
Maia Mullin
Ruth Nath+
Judy Neisser+
Barbara A. Noonan
Lisa Pritzker
Laurie N. Reinstein
Marian Reinwald
Eliza Hoogland Reynolds
Donatella Riback
Desiree Glapion Rogers
Ellen Rosenfels
Betsy Rosenfield+
Shelley Rosenstein
Ginger Russ
Pat Rymer
Alice Young Sabl
Hope Samuels*
Marlene Samuels
Betty Seid
Carol Selle*+
Janet Blutter Shiff
Joyce E. Skoog
Marjorie K. Staples
Laurel Stradford
Marcia Stenn

Ann Stepan*+
Bea Gray Steponate
Dorie Sternberg+
Patricia F. Sternberg
Donna A. Stone*+
Adrienne Smith Traisman
Dana Shepard Treister**
Susan Tynan
Margot Adler Wallace
Marlene S. Waller
Barbara Marquard Wanke

*Past President
**Current President
◆President Elect
+Honorary Members

123

Collectors Forum

Contemporary Art Circle

New Group

Collectors Forum

Contemporary Art Circle

New Group

Affiliates

North Shore Affiliate Board

July 1989–June 1996

Evelyn Aronson
Pam Beckman
Carole Bernstein
Harriet Bernstein
Abby Block
Jean Albano Broday
Doris Charak
Sheri Citterman
Dottie Currie
Holly Erlich**
Sandi Errant
Karyn Esterman
Jeanne Flaherty
Mary Franke
Margie Friedman
Maureen Glassberg*
Barbara Glazier
Muriel Goldberg
Karyn Graff
Kathy Harrison
Rachel Horwitch
Margot Langerman
Meryl Levenstein
Jacqueline Lippitz
Miriam Lyon
Judy Malkin
Joanie Marks
Dottie Melamed*
Audrey Miller
Sunnie Mitchell
Bernice Nordenberg
Jeanne Oelerich
Lorraine Paddor
Beverly Rapper
Ann Rosen
Joanne Scheff

Carol Schreiber
Darlene Schuff
Marilyn Spungin
Sandy Topel
Beverly Valfer
Joan Zavis
Gloria Zieve
*Past President
**Current President

North Side Affiliate Board

July 1989–June 1996

Kathy Aronstam
Dorothy Berns
Amy Burdick*
Regina Ceisler
Felicia Cohen
Karen Cohler
Dale Davison
Gale Gordon Davison
Susan Dee
Andrea Fisher
Judy Freeman**
Terry Friedman
Gwen Golan
Janice Gordon
Susan Grant
Phyllis Hemphill
Cathy L. Hertzberg
Janice Hightower
David Hirschman
Marilyn Hollenbeak
Justine Jentes
Melissa J. Kahn
Linda Lehman
Maria Leone
Jimmy Dale Love
Debbie Match

Susan Menely
Gayle Mindes
Tom Morris
Harriet New Delman
Barbara Noonan
Linda Nordenberg
Lauren Peck
Susan Pollack
Jill Portman
Nancy Rawson
Marlene Rimland
Bennye Seide
Clare Seliger
Linda Jackson Sharp
Sherri Schenkler
Barbara Singer
Paulette Solow
Michelle Taufmann
Lisa Thaler
Susan Walker
Susan Welter
David Wilner
*Past President
**Current President

South Side Affiliate Board

July 1989–June 1996

Frances Barge
Patricia Bohannon
Christine Browne
Alberta Bryant
Eleanor Caldwell*
Lillian Cole
Barbara Cordell
Naomi Driskell
Cheryl Figgers
Dorothy Fletcher
Velma Hancock

Imogene Holland
Marie Howard
Martine Hutsell
Julia Elaine Johnson**
Connie Jones
Charlette Lackner*
Ruby Love
Marian Nicholas*
Ethlyn Rice
Betty Sandifer
Hortense Shaeffer
Lois Simms
Shirley Sullivan
Dorothy Wadley
Jeanne Webster
Mary Garden Williams
*Past President
**Current President

West and Far West Suburban Affiliate Board

July 1989–June 1996

Lynn Abbie
Bobbie Adrian
Ann Bloomstrand
Eileen Broido
Sheila Bruns
Barbara Carlson
Sylvia Christmas
Betty Cleland*
Camille Cook
Myrel Cooke-Titra
Lorene Dodrill
Joan Gabric*
Kathy Gabriel
Suzanne Garnier*
Kay Garvey
Sandy Ging

Sylvia Giura
Sharon Hardy
Jeri Hejduk**
Barbara Hilpp
Sharon Hoogendoorn
Barbara Marek
Anna Mathy**
Gayle McNulty
Nancy Moreton
Betty Nagy
Carol Napper
Elaine Nerenberg
Augustine Neuert
JoAnne Nisbett
Rose Ann Owen
Mimi Rose
Ileen Rubinstein
Muriel Schnierow
Terry Seward
Joan Talano*
Dee Tovarian
Toni Troyer
Betty Wiebking*
Martha Wiltsie
Lee Zara
Susan Zwick
*Past President
**Current President/
Co-chair

Volunteer Guides

Steering Committee
July 1989–June 1996
Susan Barton
Joyce Black
Arlene Brandeis
Christine Browne
Rachel Burgess
Merle Carson
Betsy Cole
Renee Collins
Dottie Currie
Sue Ettlinger
Leah Ferrara
Geoff Fleet
Lillian Goldstine
Gayle Jacobs
Sheila James
Barbara Kite
Anne Koch*
Joel Loughman
Ruth Lekan*
Elaine Liff
Lorraine Lornzini
Susan Ludwig
Miriam Lyon*
Debbie Match
Magdalen Matthews
Molly Milligan
Faye Morganstern
Carol Nasaw-Hurvitz
Elaine Perlman
Judith Podmore
Janice Ryan
Jo Rosenfels

Andrea Sandler
Edith Shore
Phil Shorr
Penelope Steiner**
Adrienne Smith Traisman
Marsha Weis
Betty Wiebking
Barbara Van Dorf*
Beverly Yusim
*Past President
**Current President

Museum Staff

1989–1996
as of April 1996

Full Time

Jacqueline Adams
Janet Alberti
Robin Altmann
Linda Ashcraft
Denise Babicz
Salvador Barbosa
Lucinda Barnes
Amy Bennett
Donald Bergh
Philip Berkman
Toni Bertolini
Anastacia Best
Jennifer Boeder
Staci Boris
Rhonda Brown
Nicole Bryant
Frances Burke
Almetrius Burton
Thomas Burton
Anthony Cady
Patrice Callen
John Calvelli
Gregory Cameron
Shelly Cleary
Maria Coker
Shirley Colvin
Kevin E. Consey
Nancy Cook
Amy Cordova-Martinez
Amy Corle
Eileen Cosgrove
Leslie Cox
Amber Creger
Gina Crowley
Amada Cruz

Nancy Cullerton
Lynn Davis
Mary Davis
Nancy DeDakis
Tania DeGolyer
Roger Dell
Christine DerDerian
Karen DeTemple
Malvin Dixon
James Dorling
Stephanie Dryan
Helen Dunbeck
Susan Dykes
Katherine Ebershoff
Ian Edwards
Ross Elfline
Sonja Ellis
Margaret Farr
Anne Marie Fell
Marilyn Fites
Linsey Foster
Richard Francis
Thomas Fredrickson
Carolyn Stolper Friedman
Peter Fry
Thomas Gossett
Barbara Griffin
Geoffrey Grove
Anna Guarro
Bruce Guenther
Ellen Haddigan
Richard Hauge
Sharon Hawkins
Kathleen Hechinger
Christopher Heenan
Pablo Helguera
Lela Hersh
Jesse Hickman
Paula Hoffman

Sarai Hoffman
Aileen Hollis
Patricia Hollimon
Ginger Huang
Mary E. Ittelson
Christopher P. Jabin
Amanda Kaiser
Marguerite Kane
Marcie Karetnick
Rebecca Keller
Janice Kennedy
Chandra King
Maureen King
Lori Kleinerman
Deborah Kline
Jason Koziara
Michelle Kramer
Lisa Kucharski
Karen Laing
Victoria A. Latimer
Tracy Lawrence
Tuyet-Ahn Mong Le
Laura Lechlak
Karin Lesica
Krystal Lewis
Elaine Lipson
Joel Liveris
Anita Loomis-Wilkinson
Joel Loughman
David Luckes
Holly Ludewig
Esther MacKenzie
Kristin Magnuson
Amy Marver
Kathleen McCarthy
Susan Mchabcheb
Mary Claire McMahon
Donald Meckley
Monique Meloche

Meredith Miller
Maureen Mizwicki
Julie Moller
Dominic Molon
Jessica Morgan
Leanne Morgan
Donald Mrkacek
Deborah Nelson
Ava Newburger
Jenny Huff Nichol
Dennis O'Shea
Linda Peek
Brian Pentecost
Deborah Peterson
Alice Piron
Nancy Pletos
Wayne Polak
Kristin Poole
Danielle Probst
Caroline Ramming
Gregory Redfern
Brent Riley
Earl Ross
Mykl Ruffino
Julie Ruskin
Eddie Sallie
Wendy Salomon
Grant Samuelsen
Rachel Schreiber
Laura Schwartz
Gayle Shampine-Barr
Sophia Shaw
Ann Shillinglaw
Marie Shurkus
Marla Showfer
K'Talia Simon
Patrick Skvoretz
Janet Smith
Lisa Smith

Hope Spruance
Sarah Stauderman
Sonja Staum-Kuniej
Mary Stewart
Erin Stoever
Dung Ta
Maritoni Tabora
Richard Tellinghuisen
Amy Teschner
Michael Thomas
Therese Tripoli
Laura Ulasevich
Erika Varricchio
Carrie Vesely
Karen Wallace
Elizabeth Warren
Lynne Warren
Lee Warzecka
Nadine Wasserman
Margaret Welsh
David Whang
David Williams
Janet Wolski
Wendy Woon
Beryl Wright

Part Time

Susan Abelson
Marke Adkins
Brian Agne
Karen Albrektsen
Amy Allison
Lionel Alonzo
Bethany Anderson
Laura Anderson
John Arndt
Rashda Arjmand
Cheryl Bachand
John Baitlon
Joyce Banks
Karen Barcellona
Laura Bauknecht
Anne Becka
Maurice Bennett
Jeanine Bernhart
Shelly Blaemire
Elizabeth Bodner
Erin Bolema
Suzanne Bojdak
Thomas Boyle
Kenneth Bradburd
Kathleen Brendal
Keith Bringe
Eve Brooks
Lisa Brosic
Zachary Brown
Theresa Buffo
Alexis Burson
Steven Carrelli
Clifford Carson
Erik Carson
Marcia Carter
Kenitra Childress
Mia Celano
Doreen Chevrie

Elke Claus
Paul Coffey
Antoinette Collier
Denise Cox
James Davis
Jan Dean
Gary Deckard
Catherine Doll
Trang Donovan
Renee Dryg
Thomas Edgcomb
Alexander Eiserloh
Nicholas Eliopolus
Anthony Elms
Kevin Epperson
Andrew Ericson
Jayme Fantl
Robin Faulkner
Jon Fjortoft
Cathleen Flynn
Brenda Fudell
Emily Gage
Uganda Gaines
Joseph Garcia
Linda Gelfman
Kate Glazer
Anjali Grant
William Green
Eric Gude
Roberto Gutierrez
Stephen Halvorsen
Jessica Hann
Chris Hanson
Kathleen Hartman
Christopher Harvey
Elizabeth Haude
Deborah Haugh
Barbara Heilig
Sara Hohn

Esther Honson
Michael Hopkins
Douglas Hoppe
Stephanie Howard
Erin Hurban
Heather Ireland
Wendy Jacobs
Antoinette Johnson
Susan Jones
Amy Justen
Danielle Kelly
James Kendrick
Ronald Kirkwood
Brigitte Kouo
Frances Lacson
Brandon Lane
Jinaa Lane
Cara Langella
Michael Lash
Kim Larson
Mark Leonhart
Joanne Leopold
Yolanda Lewis
Travis Lomax
Brian Lynch
Samuel Mangen
Lorraine Mann
Brad Martin
Susan Matlon
Ronald Mayfield
Brigitte Maronde
Lori McAllister
Kevin McCarthy
Lindsey McCosh
Brennan McGaffey
Michael McGowan
Herbert Metzler
Lisa Michniuk
Paul Milholland

Dion Miller
Rebecca Morris
Naomi Muirhead
James Murray
Juliet Nations-Powell
Martin Ohlin
Jared Oberle
Randolph Olive
Samuel Pappas
Anthony Parker
Susan Petzold
Yolanda Philpot
James Prinz
Ted Purves
Jose Ramos
Toledo Ramos
Karen Reimer
Elizabeth Riggle
Bruce Riley
Brian Ritchard
Katie Rudigier
R.D. Sallie
Nevenka Samardzija
Martha Schlitt
Donna Schudel
Mindy Schwartz
Phil Seigert
Francesca Segal
John Seubert
Quentin Shaw
Vincent Shine
Scott Short
Carol Shuford
Thomas Sigmon
Jim Sikora
Hasie Sirisena
Cynthia Skanes
Maureen Sloan
Deborah Snead

Gilaine Spoto
James Stauber
Christopher Stewart
Quanetta Stewart
Laszlo Sulyok
Daniel Sutherland
Molly Swan
Cynthia Sy
Annette Tacconelli
Mark Takiguchi
Dina Tate
Christopher Taw
Latanya Taylor
Ronda Thorne
Elisabeth Treger
Alec Ulasevich
Darian Van
Anne Walker
Kate Walker
Keisha Watkins
Carol Wellinghoff
Katie Welty
Michael Whitney
Anthony Williams
Altis Williamson
Jeff Wonderland
Stephen Woods
Alphonso Young
Anna Yu
Joe Ziolkowski

Acknowledgments

Collective Vision: Creating a Contemporary Art Museum reflects the contributions of numerous individuals. The essayists, Franz Schulze and Eva M. Olson, have brought insightful perspectives to the new building and the history of the Museum of Contemporary Art, respectively. New and provocative discussions of works in the MCA Collection have been written by Lucinda Barnes, Curator of Collections; Staci Boris, Curatorial Assistant; Richard Francis, Chief Curator and James W. Alsdorf Curator of Contemporary Art; Domonic Molon, Research Assistant; Jessica Morgan, Curatorial Assistant; Alison Pearlman, Curatorial Intern; and Lynne Warren, Curator of Special Projects. Thanks to Sara Hahn, Curatorial Intern, who assisted with research.

Special thanks go to publication coordinator and editor Terry Ann R. Neff, whose tireless efforts are reflected throughout the book. Mary E. Ittelson, former Associate Director of the MCA, contributed significantly to the early stages of the project, and Lela Hersh, Manager, Collections and Exhibitions, contributed her extensive knowledge of both the Collection and museum history.

Special thanks also are due to the staff of the Design and Publications Department, who skillfully created this handsome volume, particularly the elegant design work of Donald Bergh, Director of Design and Publications, and the editorial skills of Amy Teschner, Associate Director of Publications. Their ideas and effort made this book possible. Thanks also to Anna Weaver, who titled the book and assisted with its production.

Joe Ziolkowski, James Prinz, Steve Hall of Hedrich Blessing, and Hélène Binet all contributed stunning photographs to these pages. Michael Thomas, Assistant Director of Public Relations, expertly gathered the historical photographs, and Juliet Nations-Powell, Photo Archivist, and Stacey Gengo, Photo Archives Intern, were invaluable in the overall management of reproductions.

Finally, for providing the inspiration for this project, I would like to thank the architect of the MCA's spectacular new building, Josef Paul Kleihues, and the numerous staff in his office, in particular Johannes Rath and Greg Sherlock in the Chicago office, who helped facilitate this book.

Kevin E. Consey

ROME

Text by
FILIPPO COARELLI

Foreword by
PIER LUIGI NERVI

MONUMENTS OF CIVILIZATION

ROME

MADISON SQUARE PRESS®
GROSSET & DUNLAP

A National General Company

Publishers New York

We gratefully acknowledge the courtesy of the Harvard University Press for allowing us to quote excerpts from the following texts, all of which they hold in copyright and which they publish in their *Loeb Classical Library*:

The Attic Nights of Aulus Gellius, translated by
John C. Rolfe. Copyright 1927.
Ammianus Marcellinus, translated by John C. Rolfe.
Copyright 1935.
Scriptores Historiae Augustae, translated by David
Magie. Copyright 1921.
Remains of Old Latin, translated by E. H. Warmington.
Copyright 1967.

We also gratefully acknowledge permission to quote from:

Urbs Roma: A Source Book of Classical Texts on the City and Its Monuments, by Donald R. Dudley. Copyright 1967 by Phaidon Press, London.

A MADISON SQUARE PRESS BOOK®

First published in the United States in 1972
by Grosset & Dunlap, 51 Madison Avenue, New York 10010

English translation copyright © 1972 by Mondadori, Milano-Kodansha, Tokyo; originally published in Italian under the title "Grandi Monumenti: Roma," copyright © 1971 by Mondadori, Milano-Kodansha, Tokyo; copyright © 1971 by Kodansha Ltd., Tokyo, for the illustrations; copyright © 1971 by Mondadori, Milano-Kodansha, Tokyo, for the text.

All rights reserved.
Published simultaneously in Canada.
Library of Congress Catalog Card No.: 78-179261

ISBN: 0-448-02019-X
Printed and bound in Italy by Mondadori, Verona.

Editorial Director
GIULIANA NANNICINI
American Editorial Supervisor
JOHN BOWMAN

Frontispiece:
Pozzuoli: Amphitheater. Flavian Era

CONTENTS

FOREWORD

Most people have been forced to approach the ancient Romans by one of two routes: by dispassionately written scientific-historical accounts, or by almost mythic traditional versions. Both approaches, however good, provide only glimpses. Finally, though, we have an approach that, by using the many exciting archaeological discoveries in the decorative arts as well as in the more monumental architecture, brings into view the full-bodied realities of the Roman past. Not many works on ancient Rome can offer such a rich, eloquent, and convincing vision as this. The intellectual characteristics of the Romans, the evolution of their esthetic taste, their daily lives — all come alive. And because of the book's totally conceived design, the reader finds parallel comment and clarification in both the photographs and the text. We should indeed be grateful to the author and everyone else involved for providing this most "full-dimensional" approach to the ancient Roman world.

I think it might be said that a characteristic common to all Roman production is the exceptional care and skill applied to every detail, even the smallest. This is to be seen not only in the Romans' architecture but in all their decorative arts as well — mosaics, frescoes, sculpture, or bas-reliefs. There is no mosaic that has not been perfectly realized, no brickwork with rows that are not masterfully uniform, no capital or bas-relief that is not excellently designed and perfectly executed. I think, too, that this characteristic has a special value, a significance that goes beyond the single object. It serves to demonstrate the mentality that must have been common not only to the artists, engineers, and designers of Rome but also to the Roman workmen. To work together with such patient care, as their structures attest they did, they must all not only have loved their work but fully understood its aim and meaning.

To look at the productions of Roman civilization in this fashion is to obtain the vision of a society that loved the beauty resulting from balance and the harmony of forms, a beauty that may be appreciated by everyone. The long, painstaking work involved in perfect execution must have had this very appreciation and evaluation as its just, and ample, reward. The great masonry monuments of Rome reveal not only a splendid daring in their architectural conception, but accurate execution of every element, even those that are secondary. It is unlikely that this would have been possible without the complete understanding of everyone involved — from the original designer down to the least-skilled workman on the job — of the nobility and importance of their endeavors.

How else can we explain masterpieces such as the Colosseum and the Pantheon, the grandiose boundary walls, the bridges and baths, as well as innumerable public and private edifices for which we have indisputable documentation, unless by taking into account the voluntary and intelligent collaboration of masters and workers? For more

than physical labor was needed to raise these buildings. It is hard to realize how much organizational and technical know-how must have been needed to construct — without scientific instruments, levels, or mechanical energy — works like the great temples, the cupola of the Pantheon, the Colosseum, and — perhaps most miraculous of all — the miles and miles of aqueducts, whose constant and exact incline furnished Rome with an unceasing flow of water from the distant hills. And it is difficult to imagine how, within the limited technical means of the period, it was possible to supply squarely cut travertine blocks, precious marbles, and limestone or to provide all the bricks and quantities of cement, many of these materials transported from distant quarries or sites, in order to construct such gigantic works, and often in a relatively short time. (Scholars have calculated that only four years were required for the erection of the Colosseum.)

The section of the cupola and the perimetrical brickwork in the Pantheon reveal a knowledge of statics, the fruit of sharp intuition that has nothing to learn from the results of the most modern science of construction. And how difficult it must have been, with neither drafting paper nor blueprints, to design and transmit to the construction yards the general plans, not to mention the innumerable detailed plans, of great monuments so functionally and technically perfect as these. In such a situation, intelligent and almost total collaboration between skilled workers and other specialists must have existed. In what other way could the scanty formal data and dimensional requirements of the "architect" or engineer be sufficient to set in motion a process by which a detailed definition of the work could be developed and realized? Such passionate collaborative activity, unimaginable physical efforts, and the obedience of the individual to a sort of collective esthetic feeling — these alone made possible such extraordinary building achievements.

Through the centuries, the executive skills, the economic and administrative plans, and the social and organizational bases from which these great monuments sprang, have remained of somewhat less interest than Rome's poetry and literature, which have always been admired, or its wars, conquests, and internal political revolutions. With just this gap in mind, the author here offers us a history of Rome seen through the history of its monuments. Despite the depredations of time, their testimony is an unchanging one that reveals, far better than mythic traditions or "scientific" texts, the true moral, political, and social substance of Roman civilization.

PIER LUIGI NERVI

Italy in the Roman Age

INTRODUCTION

The factors that transformed a poor shepherds' village in Latium into the greatest military power of ancient times and led to the growth, in a relatively short time, of the most grandiose empire the Western world has ever known, are many, and they are complex as well. No full explanation of these events will be attempted by this book; that is not its intention. Yet for a book dealing with the monuments of Roman civilization, a brief discussion of one factor seems worthwhile: the situation of Italy in the Mediterranean, the historical and geographical framework that was the setting for the birth and expansion of Roman power.

Throughout the Bronze Age, the Italian peninsula was a bridge between East and West, between the advanced and technologically sophisticated civilizations of the eastern Mediterranean and the less advanced lands of the western Mediterranean. Explorers and traders — first Minoan and Mycenaean, then Phoenecian, and finally Greek — all touched on or passed through Italy in their voyages to obtain minerals from the lands of the western Mediterranean and beyond. From the Bronze Age forward, they required the tin even of distant Britain, necessary for fusion with copper to make bronze. The tin was first brought either overland through what is now France or by ship around Spain. Spain itself had deposits of silver; there was iron on the island of Elba, alum in Tuscany. These distant western lands were the ancient equivalent of "El Dorado," and the exploits of the navigators who were attracted there furnished material for one of the greatest works of Western literature, Homer's *Odyssey*.

The Italian peninsula was a bridge to many of the traders' destinations. Stretching northwest to southeast, in communication over the Alps with the mass of Europe, a southeastern coast only a few dozen miles from Greece's northern regions, with large islands lying a reasonable distance from Tunisia and Spain, Italy was a land crossed early in history and in every direction by the migratory movements and currents of ancient civilization. From the beginning, it witnessed a complex interpenetration of races, languages, and cultures.

At least by the eighth century B.C., Italy was being colonized from the east. Southern Italy and Sicily received the agricultural colonies of an over-populated Greece; those in the former region were to grow to be a larger and greater nation than Greece itself — Magna Graecia. Carthage, the Phoenician colony founded by Tyre in North Africa, (possibly as early as the ninth century B.C.) had by the fifth century her own colonies in western Sicily and controlled Sardinia, rivaling Greece for hegemony over the entire area. All this colonization did not take place without response from the native Italian population. Ethnic groups in Sicily and southern Italy especially, whose social and military organization and cultural level were almost equal to those of their conquerors, resisted the domination of Greece and Carthage alike. But it was only to be with the coming of Roman power that both "foreign" groups were brought under control.

Central Italy had not been so directly affected by eastern colonization. The Appenine mountains divide the area into two unequal zones, and there was considerable separation among the early native cultures. But the area facing the Tyrrhenian Sea, much the larger of the central Italian regions, witnessed the flowering in the seventh and sixth centuries B.C. of the greatest civilization in pre-Roman Italy, one that neither Greece nor Carthage ever could completely dominate. This was the civilization of the Etruscans, who were settled in present-day Tuscany, Latium of the Tiber, and Umbria. The Etruscans were superior to their neighboring populations not only in cultural but in military matters, and the territory of their power expanded until they occupied an area bounded by the Po Valley Basin on the north and Campania in the south. During the greatest period of Etruscan influence in Italy, the sixth century, Rome itself was an Etruscan city; in fact, it long retained something of its Etruscan character.

If it was Etruscan, though, Rome was also provincial in terms of cultural and economic development. But the very provinciality of Rome in its early days may have led to the structures of solid primitive "democracy," based on small land-holdings, which later constituted the foundation of Roman military power. It should be stressed, though, that Rome was only one of such Italian groups. The Sabellian races of the Appenine mountains, particularly the Samnites, were in a similar situation. Italy also harbored, in the period shortly before Rome's growth, small Gallic populations, which had infiltrated the Po Basin. They also had a part to play in Rome's destiny, for they conquered the Etruscans before the Greeks were able to do so, and gravely menaced Rome itself, early in her history.

In summary, then, this was the historical and geographical situation in which Roman power was born and grew. It has seemed necessary to mention at least these few facts in a book dealing with the great Roman monuments because the Roman cultural superstructure was so closely and functionally connected to the development of society. The Romans themselves knew this; as their power expanded, they were besieged on all sides by foreign influences, by the accomplishments of sophisticated cultures such as the Egyptians' and the Greeks'. Yet the Romans usually refused to accept unquestioningly the exotic aspects of the cultures with which they came in contact. They sooner or later reaffirmed with vigor, and sometimes with brutality, their own conception of the function of art.

In Rome, art was always utilized to support the social and political structure of the state; this is especially true of Roman monumental art. The cultural traditions of conquered peoples all had some influence in Rome; there is no denying this. But Roman art can never be understood through tracing the roots of its formal aspects alone. Attempts to treat it in this fashion have been the principal obstacle to a real understanding of Roman work, up to the present. This volume attempts to rectify the situation by setting each monument — with both its architectural and decorative elements, inseparable and structurally connected as they are in Roman art — in the economic, social, and political framework that sustained it. As far as possible, the monument itself has been taken as the starting point, while an attempt has been made not to insert it into any rigid or *a priori* schemes.

A few other points require comment. The attention given to the period of the origins of Roman society, conspicuously lacking in monumental remains, might at first seem excessive. But it makes sense in the light of the book's intentions: a discussion of origins is needed primarily to clarify the structural components that were to lead to the more conspicuous historic Roman culture. It should also be admitted that the first part of the book may seem both somewhat erudite and elliptical, dealing as it does with facts known mainly to specialists in the period. We hope, however, that enough has been said to outline clearly, if briefly, the basic structures of Roman society. Throughout the book, too, further clarification is offered to the reader through the photographs, captions, maps, plans, the chronological chart, and the passages from the ancient authors. By the end, all elements have combined to complete the text, just as the many elements once combined to create Roman culture.

PLAN OF ROME IN THE FOURTH CENTURY A.D.

THE ORIGINS

Having acquired which glory, Romulus is said first to have auspiciously thought of building a city, and of establishing a government. In regard to the situation of the city, a circumstance which is most carefully to be considered by him, who endeavours to establish a permanent government; he chose it with incredible skill. For neither did he remove to the sea, although it was a very easy thing for him with his forces, to march through the territory of the Rutulians and Aborigines; neither would he build a city at the mouth of the Tiber, to which place the king Ancus led a colony many years after. For he perceived, with an admirable foresight, that maritime situations were not proper for those cities which were founded in the hope of continuance, or with a view to empire. First, because maritime towns were not only exposed to many dangers, but to unseen ones. For the ground over which an expected enemy moves, as well as an unexpected one, announces his approach beforehand by many indications: by sound itself of a peculiarly tumultuous kind. No enemy can make a march, however forced, without our not only knowing him to be there, but even who he is, and whence he comes. But a maritime enemy and a naval force may be before you, ere any one can suspect him to be come. Nor even when he does come, does he carry before him any indication of who he is, or from whence he comes, or even what he wants. Finally by no kind of sign can it be discerned or determined whether he is a friend or an enemy.

In maritime cities, too, a sort of debasing and changeable manners prevail. New languages and new customs are mingled together, and not only productions but manners are imported from abroad; so that nothing remains entire of the pristine institutions. Even they who inhabit those cities are not faithful to their homes, but with capricious inclinations and longings are carried far from them; and although their persons remain, their minds are rambling and wandering abroad. . . .

Who then more inspiredly than Romulus could secure all the maritime conveniences, and avoid all the defects? placing the city on the banks of a perennial river, broadly flowing with an equal course to the sea. By which the city might receive what it wanted from the ocean, and return whatever was superfluous. Receiving by the same channel all things essential to the wants and the refinements of life, not only from the sea, but likewise from the interior. So that it appears to me, he had foreseen this city, at some period, would be the seat and capital of a mighty empire: for a city placed in any other part of Italy would not easily have been able to acquire such a powerful influence.

CICERO: *The Republic* (II: 3-6)

Rome: The Roman Forum seen from the west.

Culture of Latium and Origins of Rome

Legends surrounding the settlement of Rome date back even beyond the traditional date of the city's founding. The arrival of Aeneas in Latium, for instance, was well known as early as the sixth century B.C., as Etruscan statuettes of Aeneas from this period demonstrate, and Virgil also relates in his *Aeneid* the myths of Evander, king of the Arcadians, who settled on the Palatine Hill, and of Hercules, who landed at the Forum Boarium, where the supreme altar, the *Ara Maxima*, of this god lay. It was traditionally the most ancient sanctuary in the city and preceded the Romulean founding.

The date of the historical founding of the city, as given (in the first century B.C.) by the historian Varro, is 753 B.C., which places Rome's settlement within the framework of the Iron Age culture of Latium. This civilization, typical of a marginal environment, and far more provincial than that of the neighboring Etruscans, is now known rather well, from necropolises discovered in Rome itself (in the Roman Forum, and on the Esquiline and Quirinal hills) and in the nearby Alban Hills. Latium's exact chronology is still uncertain, but since the first archaeological studies there has been a differentiation of its culture into two phases, based on the different burial customs employed. The first, perhaps of the ninth and eighth centuries, was characterized by cremation, with the ashes buried in urns shaped like a hut. In the second phase, burial took place in sarcophagi made of tree trunks, and the cultural homogeneity of the preceding period was ruptured by the importation of artisans' products from countries of the eastern Mediterranean, such as Greece and Cyprus.

The latter phase is often called the "easternizing" or "Orientalizing" phase of Latium's culture. The taste for exotic products, Egyptian or Mesopotamian in origin but imported through Phoenecian-Cypriot or Greek-oriental sources, is thought to correspond to a profound change in social structure. In the eighth century urban civilization asserted itself in Italy, through the foundation of Greek colonial settlements in Sicily and southern Italy, and in Rome it appears that the simple egalitarianism of the first Iron Age was transformed into a more complex social structure, characterized primarily by the rise of noble clans.

The economic factors that lie at the basis of this transformation are not easy to identify, but the most probable explanation is an increase in agricultural productivity, linked with an improvement in techniques and implements. On the one hand, this gave rise to a considerable increase in population; on the other, it caused a more marked division of labor. The appearance of groups specializing in different functions

created a need for a centralized power, not only political, but military and religious as well, to unify the different groups.

Once the specialized function of government was recognized, the city-state was born, and the conditions of a homogeneous culture, which was most likely monarchical, were tempered by the rise of a noble oligarchy. Certainly legends of Rome's early history give it kings at this period. The traditional stories of the first four kings — from Romulus, who reputedly founded the city in 753, to Ancus Martius, whose rule reputedly ended in 616 — make it hardly accidental that this period coincides with what archaeologists have called the second phase of Latium culture.

Geographic and Economic Setting

The importance of Rome's location for the later development of the city did not escape the notice of her writers such as Livy and Cicero. The recital of the facts has become a cliché, yet they are extremely important. The city grew up on a group of seven hills facing a ford of the Tiber, the last before its mouth, where a deep bend in the stream produced an excellent natural port, the meeting place of ships coming from the sea and products for export coming from the interior. Here the two most important strategic and commercial routes in central Italy crossed: the water road of the Tiber, and the land road coming from Etruria toward the river ford, beyond which the two major roads to Campania and southern Italy began — one following the Liris river, the future Via Latina, and the other the Pontine valleys, the future Appian Way.

From the beginning, the advantage of this position was clear. The first bridge thrown over the Tiber, according to tradition, was the

THE MEANING OF POMERIUM

The augurs of the Roman people who wrote books *On the Auspices* have defined the meaning of pomerium in the following terms: "The pomerium is the space within the rural district designated by the augurs along the whole circuit of the city without the walls, marked off by fixed bounds and forming the limit of the city auspices." Now, the most ancient pomerium, which was established by Romulus, was bounded by the foot of the Palatine hill. But that pomerium, as the republic grew, was extended several times and included many lofty hills. Moreover, whoever had increased the domain of the Roman people by land taken from an enemy had the right to enlarge the pomerium.

Therefore it has been, and even now continues to be, inquired why it is that when the other six of the seven hills of the city are within the pomerium, the Aventine alone, which is neither a remote nor an unfrequented district, should be outside the pomerium; and why neither king Servius Tullius nor Sulla, who demanded the honour of extending the pomerium, nor later the deified Julius, when he enlarged the pomerium, included this within the designated limits of the city.

Messala wrote that there seemed to be several reasons for this, but above them all he himself approved one, namely, because on that hill Remus took the auspices with regard to founding the city, but found the birds unpropitious and was less successful in his augury than Romulus. "Therefore," says he, "all those who extended the pomerium excluded that hill, on the ground that it was made ill-omened by inauspicious birds."

AULUS GELLIUS: *Attic Nights* (XIII:14)

THE SACRED BOUNDARY OF ROMULEAN ROME

But I think it not impertinent to show where the first foundations began, and what was the circuit fixed by Romulus. Now, from the Ox Market, where still is seen the brazen statue of a bull, because by that animal the plow is drawn, a furrow was cut to describe the boundaries of the town, so as to include the great altar of Hercules: thence, stones were placed, at certain intervals, along the foot of mount Palatine, to the altar of Consus; soon after, to the Old Courts; then, to the small temple of the Lares; and, lastly, to the great Roman forum, which, as well as the Capitol, it is believed, was added to the city, not by Romulus, but by Tatius. With the increase of her empire, the city afterward continued to increase: and what were the boundaries now established by Claudius is easily learned, as they are detailed in the public records.

TACITUS: *The Annals* (XII:24)

Rome: The Tiber near the Isle of the Tiber and the Forum Boarium. (The Isle is visible on the right.) On the left is the Emilian Bridge, now called the Ponte Rotto — the first built in brick, in two phases, 179 and 142 B.C. — of which only one arch remains. The ford of the Tiber was situated here, and the oldest traces of habitation in Rome were discovered in this area, where the most ancient sanctuary in Rome, the Ara Maxima of Hercules, was located, as well as the primitive river port.

REASONS FOR ROME'S GREATNESS

Not without good reason did gods and men select this place for founding a city: these most healthful hills; a commodious river, by means of which the produce of the soil may be conveyed from the inland countries, by which maritime supplies may be obtained; close enough to the sea for all purposes of convenience, and not exposed by too much proximity to the dangers of foreign fleets; a situation in the center of the regions of Italy, singularly adapted by nature for the increase of a city. The very size of so new a city is a proof.

LIVY: *The History of Rome* (V:54)

wooden Sublicius bridge, built during the reign of Ancus Martius, in the second half of the seventh century B.C. The occupation of the Aventine and Janiculum hills is attributed to the same king. Flanking the river, the Aventine on the east and the Janiculum on the west dominated the road that, coming from the northwest, crossed the bridge and then the Murtian valley.

The founding of the colony at Ostia, at the mouth of the Tiber, is also attributed by tradition to Ancus Martius. The seventh century was undoubtedly a period of great and rapid change for Rome, both economic and social, and the greatly increased trade relations with the Near East and Greece obviously contributed to the formation of a new ruling class and a new culture. Poor earthen tombs began to be replaced by grandiose chamber tombs, which indicate the domination of noble clans, and the formation of oligarchical power. The great Etruscan and Latin tombs of Cerveteri (ancient Caere) and Palestrina (whose extraordinary golden tomb furnishings are now the pride of the Villa Giulia Museum in Rome) belong to this Orientalizing phase of central Italian civilization. Although nothing of the same sort has been discovered in Rome itself, due perhaps simply to the destruction caused by the continuity of life there, the fact remains that the city held the key position both for the domination of Latium and for communications between north and south. And a little later, the Etruscans, the most civilized people in early Italy, settled in Rome.

Etruscan Heritage and Formation of Urban Rome

The last three kings of Rome have Etruscan names. Tarquinius Priscus, the first of them (616-578), was said to have come from the

Etruscan city of Tarquinia during the last part of the seventh century B.C., in the reign of Ancus Martius. Under Ancus, Tarquinius so excelled as commander of cavalry, among other things, that upon Ancus Martius' death the Romans chose him as their king.

Although the kings of Rome *are* legendary, legend often tells truths that have real historical value and that other evidence of history and archaeology supports. During the sixth century B.C., in the years corresponding to the traditional reigns of the last three kings, a transformation occurred in Rome that can be related only to a more or less profound "Etruscanization" of the city. Some modern historians have imagined that Etruscan domination of Rome came about through violent conquest, but this is most improbable. There is no mention of it in traditional history, which speaks merely of the peaceful arrival of a family, the Tarquins, who integrate with other citizens and end by taking over power. Etruscans in Rome must always have been a small, if politically dominant, minority, for it is otherwise difficult to explain the persistence of the language, religion, and other fundamental elements of Latin culture, which come through the period of Etruscan domination practically intact. As in the case of the Normans in southern Italy during the medieval period, it seems probable that Etruscan domination was realized through the slow process of infiltration of small groups that, by virtue of their greater technical abilities — not only in the military field, but in political and administrative organization, architecture and the figurative arts, handicrafts, and certain aspects of the divination rites of the haruspices (the Etruscan soothsayers) — end by taking over the principal levers of power.

The qualitative leap taken by Roman civilization after the insertion of the Etruscan element was considerable. The unhealthy valley floor was reclaimed by great works such as the Cloaca Maxima drainage system. Between the Capitoline and the Palatine hills the drained plain was paved, and became the economic and political center of the city, the Forum. The building of sepulchers in this area stopped, and dwellings of wood and brickwork replaced the straw huts. In place of the open-air sanctuaries, the first temples of Etruscan type were built, with rich decorations of polychrome terra-cotta, and anthropomorphic images of the gods, a Greek custom handed down through the Etruscans.

Reforms of Servius Tullius and the Servian Wall

The reign of Tarquinius Priscus' successor, Servius Tullius (578-534) is particularly important in tradition. A remarkable series of reforms is attributed to him, from the centurial disposition of the army and the distribution of the population into territorial "tribes," to the introduction of coins and the creation of numerous cults and sanctuaries. Modern historiography has rejected most of these feats as anachronistic, but a more accurate study of the sources, and important archaeological discoveries, have fairly well established the essential historical truth of the figure and works of Servius Tullius.

Tradition has it that Servius Tullius was the son of a woman slave of king Tarquinius and a divine genius that rose from the flames of her hearth. His supposed divine origin has been used as an argument against his historical authenticity, but the legend of divine birth is obviously propaganda. It was probably used by Servius to justify his assumption of tyrannical power. Cyrus, Alexander, and Julius Caesar were publicized by their own "propaganda bureaus" in similar fashion, yet this is no reason to doubt their historical existence.

The political activity of Servius was perfectly consistent with his obscure origins. According to Etruscan tradition, preserved in a speech given by the Emperor Claudius and by paintings in the Francois Tomb

THE ARRIVAL OF TARQUIN PRISCUS IN ROME

In the reign of Ancus, Lucumo, a rich and enterprising man, came to settle at Rome, prompted chiefly by the desire and hope of obtaining great preferment there, which he had no means of attaining at Tarquinii (for there also he was descended from an alien stock). He was the son of Demaratus, a Corinthian, who, flying his country for sedition, had happened to settle at Tarquinii, and having married a wife there, had two sons by her. Their names were Lucumo and Aruns. Lucumo survived his father, and became heir to all his property.... As the Etrurians despised Lucumo, because sprung from a foreign exile, Tanaquil could not bear the affront, and regardless of the innate love of her native country, provided she might see her husband advanced to honours, she formed the determination to leave Tarquinii. Rome seemed particularly suited for her purpose. In this state, lately founded, where all nobility is recent and the result of merit, there would be room for her husband, a man of courage and activity. Tatius had been king of Rome: Numa had been sent for from Cures to reign there: Ancus was sprung from a Sabine mother, and rested his nobility on the single statue of Numa. She easily persuades him, as being ambitious of honours, and one to whom Tarquinii was his country only on the mother's side. Accordingly, removing their effects they set out together for Rome. They happened to have reached the Janiculum; there, as he sat in the chariot with his wife, an eagle, suspended on her wings, gently stooping, takes off his cap, and flying round the chariot with loud screams, as if she had been sent from heaven for the very purpose, orderly replaced it on his head, and then flew aloft. Tanaquil is said to have received this omen with great joy, being a woman well skilled, as the Etrurians generally are, in celestial prodigies, and embracing her husband, bids him hope for high and elevated fortune: that such bird had come from such a quarter of the heavens and the messenger of such a god: that it had exhibited the omen around the highest part of man: that it had lifted the ornament placed on the head of man, to restore it to the same, by direction of the gods. Carrying with them these hopes and thoughts, they entered the city, and having purchased a house there, they gave out the name of Lucius Tarquinius Priscus. His being a stranger and very rich, caused him to be taken notice of by the Romans. He also promoted his own good fortune by his affable address, by the courteousness of his invitations, and by conciliating those whom he could by acts of kindness; until a report of him reached even to the palace; and by paying court to the king with politeness and address, he in a short time so improved the acquaintance to the footing of intimate friendship, that he was present at all public and private deliberations, foreign and domestic; and being now tried in every trust, he was at length, by the king's will, appointed guardian to his children.

LIVY: *The History of Rome* (I:34)

Rome: Head of a helmeted divinity (perhaps Minerva) from the "sacred area" of St. Omobono (circa 540 B.C.). The sanctuaries of Fortuna and of the Mater Matuta, identifiable with those found in this area, are supposed to have been founded by Servius Tullius; in fact the dates of these temple terra-cotta pieces coincide with the traditional dates of his rule. (Antiquario Communale, Rome.)

Rome: A terra-cotta antefix in the shape of a Silenus' head, from the Esquiline. Sixth century B.C. (Antiquario Communale, Rome.)

(an Etruscan tomb found at Vulci) he was an adventurer called Mastarna, the leader of an armed band, and took power in Rome by force. His power, like that of the tyrants in Greece at the same time, was evidently based on the support of the lower classes in the population, which might account for the legend of his slave origin. Above all, however, he had the support of the merchants, artisans, and small and ordinary farm owners. Those against his power, as well as that of all the other Etruscan rulers, were the old patrician groups, the great landowners, who had until that time been the ruling class. In order to break up the force of these factions and their clientele, a transformation of both the social and military structures was necessary.

The pre-Etruscan city of Rome consisted of three noble tribes, a division which was the basis of both the military and the political structure; in archaic societies, the two seem always to be closely connected. Servius divided the city into four tribes on the basis of territory, dissolving the link that bound the state organization to that of the nobles. He then made military service dependent on wealth, with the richest classes those most liable to call-up, a system which had previously been used in Greece. Instead of an army in which each "people" furnished its own contingents, constituting almost a private army, the new system produced a citizen's army, directly dependent on the king — that is, on the state power. Even if this change had not been politically necessary, it would eventually have had to be made for purely military reasons. The development of the hoplite infantry tactics made obsolete the "heroic" army of leaders adept at single combat, followed by an amorphous mass of soldiery. It required instead a large number of warriors armed uniformly and trained to fight in ordered ranks. This military "revolution," which the Etruscans borrowed from the Greeks; went hand in hand with the socio-economic transformations of the period, as the newly rich middle classes claimed their share of power from the older nobility.

Great economic development must have characterized Rome in the sixth century B.C. From economic and strategic points of view, the city lay in a key area, and, as it developed, its links with the other great centers of Etruria must have grown stronger. Some of this growth is reflected in several monuments from this period that have been uncovered. A group of terra-cotta architectural ornaments discovered in the Roman Forum, in the Forum Boarium, on the Capitoline and the Esquiline hills, attest to the existence of numerous temples and chapels as early as the sixth century, confirming what Roman authors say about the founding of sanctuaries by the last three kings.

Building activity seems to have been particularly intense during the reign of Servius Tullius. The erection of the boundary wall of the city is attributed to him, as well as a series of temples, dedicated for the most part to Fortuna, goddess not only of fortune and fate, but embracing functions later assumed by Venus and Juno.

Most authorities have attributed the boundary wall, although called "Servian," to the later, Republican phase of Roman history. The parts now visible, made of tufa stone, can probably be attributed to a period shortly after the conquest of the city by the Gauls under Brennus, in 390 B.C., when the walls were restored (as Livy notes). There may have been a more ancient phase of construction, however. Parts of the wall are made of friable tufa, used for the most part only in the most ancient monuments known. Furthermore, at a certain point on the Aventine Hill, the stone tufa wall of the fourth century is set upon the friable tufa one, older without a doubt. To these archaeological considerations others of a more general historical character can be added. It is hard to believe that Rome in the sixth century did not have some bulwark such as the other Etruscan cities had. The use of the hills as citadels may have been sufficient in earlier periods, when Rome was a collection of small, separate villages, but they were surely not adequate for a united city that included large flat areas absolutely

devoid of natural defense. Servius Tullius is credited with adding to the city the Esquiline, Quirinal and Viminal hills. Unlike the Palatine and the Capitoline hills, these were not isolated heights; they were sprawling features of the landscape, spread out over a large plateau-like area. To secure them for the city, a particularly stout defense on the eastern side of the city was needed, and tradition has it that Servius Tullius built an *agger*, or mound, an elaborate fortification consisting of a wall with a large rampart at the back and a ditch, which brought within the city the plateau between the Quirinal and the Esquiline.

Temples and Artistic Culture of Etruscan Rome

There is also some archaeological proof, though indirect, of Servius Tullius' authenticity. There is proof at any rate of the plausibility of his chronology as handed down by ancient writers. It is related to the sanctuaries, whose history was generally translated with absolute precision. It is known that the holiday of the god was celebrated each year on the day the temple was originally dedicated. There was also a custom of setting a nail in the wall of the temple each year. This was done with the Temple of Jupiter Capitolinus, and it certainly may have been done in other more ancient sanctuaries. Excavations near the church of Saint Omobono, in the area of the ancient Forum Boarium, have brought to light twin temples in which it is possible to identify, on the basis of literary sources that indicated their position, the sanctuaries of Fortuna and the Mater Matuta. According to tradition, these were founded by Servius Tullius. The buildings reveal numerous layers of construction, which go up to the late Imperial Age, but the most ancient remains, only partially explored, have yielded terracotta work that can be dated at the middle of the sixth century B.C. or a little later. The imported Greek ceramics found in this layer also date from the sixth century. The correspondence between the traditional

THE ACTIVITIES OF TARQUIN SUPERBUS ("THE PROUD")

Tarquinius, having thus acquired possession of Gabii, concluded a peace with the nation of the Aequans, renewed the treaty with the Etrurians, and then turned his thoughts to the internal business of the city: among which, the object of his principal concern was to leave the temple of Jupiter, on the Tarpeian mount, a monument of his reign and of his name, to testify, that of two Tarquinii, both of whom reigned, the father had vowed, and the son completed it.... Intent on finishing the temple, he sent for workmen from all parts of Etruria, and converted to that use, not only the public money, but the public labour; and although this, which was in itself no small hardship, was added to the toils of military service, yet the people murmured the less, when they considered that they were employing their hands in erecting temples to the gods. They were afterwards obliged to toil at other works, which, though they made less show, were attended with greater difficulty; the erecting seats in the circus, and conducting under ground the principal sewer, the receptacle of all the filth of the city; two works to which the magnificence of modern times can scarcely produce anything equal. After the people had been fatigued by these labours, the king, considered so great a multitude as a burden to the city, where there was not employment for them, and wishing at the same time to extend the frontiers of his dominions, by means of colonies, sent a number of colonists to Signia and Circeii, to serve as barriers to the city, against an enemy, both by land and sea.

LIVY: *The History of Rome* (I:55)

Rome: Peristyle of the House of the Vestal-Virgins in the Forum. From the most ancient times, their quarters lay near the ciruclar Temple of Vesta. Statues of the Chief Vestals were placed along the wall of the portico; some of these are visible in the photograph.

chronology of Servius Tullius, 578-534 B.C., and what can be gathered from archaeological evidence is obvious.

The most notable monument built in Etruscan Rome, however, was the Temple of Jupiter Capitolinus. This temple alone would be sufficient testimony to the level of power and wealth the city attained during the Etruscan period. Conceived and begun under Tarquinius Priscus, the temple was finished during the reign of Tarquinius Superbus. Its inauguration date is known from the ancient calendars and from the list of Roman consuls, and is the first certain chronological reference in Roman history: 509 or 508 B.C. The date coincides with the one

Detail from the statue of Apollo from Veii. End of the sixth century B.C. This image of the god, together with those of others discovered at Veii, was placed on the roof of the temple along its central beam, in the manner of acroteria. The discovery of these magnificent sculptures at the beginning of this century was proof of the existence of an important school of artists in the Etruscan city, probably associated with Vulca of Veii, creator of the terra-cotta ornament for the Temple of Jupiter Capitolinus (509 B.C.). (Villa Giulia Museum, Rome.)

THE SEWERS OF ROME

The public sewers, too, a work more stupendous than any; as mountains had to be pierced for their construction, and, like the hanging city which we recently mentioned, navigation had to be carried on beneath Rome; an event which happened in the aedileship of M. Agrippa, after he had filled the office of consul.

For this purpose, there are seven rivers, made, by artificial channels, to flow beneath the city. Rushing onward, like so many impetuous torrents, they are compelled to carry off and sweep away all the sewerage; and swollen as they are by the vast accession of the pluvial waters, they reverberate against the sides and bottom of their channels. Occasionally, too, the Tiber, overflowing, is thrown backward in its course, and discharges itself by these outlets. . . . and yet, built as they were in the days of Tarquinius Priscus, seven hundred years ago, these constructions have survived, all but unharmed. We must not omit, too, to mention one remarkable circumstance, and all the more remarkable from the fact, that the most celebrated historians have omitted to mention it. Tarquinius Priscus having commenced the sewers, and set the lower classes to work upon them, the laboriousness and prolonged duration of the employment became equally an object of dread to them; and the consequence was, that suicide was a thing of common occurrence, the citizens adopting this method of escaping their troubles. For this evil, however, the king devised a singular remedy, and one that has never been resorted to either before that time or since: for he ordered the bodies of all who had been thus guilty of self-destruction, to be fastened to a cross, and left there as a spectacle to their fellow-citizens and a prey to birds and wild beasts. The result was, that that sense of propriety which so peculiarly attaches itself to the Roman name. . . . It is said that Tarquinius made these sewers of dimensions sufficiently large to admit of a wagon laden with hay passing along them.

PLINY THE ELDER:
Natural History (XXXVI)

traditionally set as the end of the monarchical period and the beginning of the Republic. Ironically, the sanctuary was probably not inaugurated by Tarquinius Superbus, the last king, but by one of the first consuls of the Roman Republic, Horatius Pulvillus. The monument built to glorify the power of the kings through the centuries ended as the symbol of Republican liberty.

The ideological reasons for construction of the temple are clear. Rome must have enjoyed hegemony in Latium in the regal period, competing on an equal basis with the most important Etruscan cities, with success enough to justify the expense of such an edifice. It seems likely as well that the Temple to Diana that Servius built on the Aventine was used as the center of the Latin League, the transfer of whose headquarters to Rome surely indicated the subordination of the League to the Roman state. The Temple of Jupiter — who was worshiped together with Juno and Minerva, the Capitoline trinity and gods of the Roman state cult — was a glorification of the royal power, which was identified with the god on certain occasions, such as a military triumph. This custom remained alive not only for the entire Republican period but on into the Imperial Age.

The dimensions of the temple, whose base is still visible (in the Capitoline Museum) were exceptionally large. Measuring approximately 213 feet by 193 feet, it was the largest Etruscan temple known, with six columns in front and six on the sides, and three chambers for the statues of the three divinities. Like all archaic Etruscan temples, it was built almost entirely of wood — although the podium was made of tufa blocks — and covered with terra-cotta ornaments. The terra-cotta statues for worship, and the rich polychrome terra-cotta decoration, were entrusted to Etruscan artists. The name of one is known, probably the master who directed the work: Vulca of Veii. He made not only the statue of Jupiter but also one of Hercules, which may have been placed in the sanctuary of the *Ara Maxima*. The sculptures were made at Veii, or so Pliny asserts in talking of the great chariot that was placed on the roof of the edifice as an acroterium.

In the course of time, all these sculptures have been destroyed; the temple passed through many fires and renovations. It is still possible to gather a precise idea of what they looked like, however. Excavations at Veii have revealed the remains of a temple built at the same time as the Temple of Jupiter Capitolinus. This too was decorated with grandiose terra-cotta sculptures (which are now among the treasures of Rome's Villa Giulia Museum). They reveal the hand of a master who, within the stylistic framework of archaic Etruscan art, influenced by the work of Ionian Greece, achieves a remarkably personal expression, less mannered and more solid than his Ionian models. Vulca's name was mentioned when the discovery was made, and even if the work cannot be assigned to him with absolute certainty, the coincidence of chronology and artistic style make it probable that he was the artist. This is the only case where an Etruscan work can be attributed with any probability to an artist whose name is known.

The celebrated Capitoline She-Wolf, an Etruscan work from the end of the sixth or perhaps the beginning of the fifth century, also shows many of the stylistic qualities of Vulca's work. As is the case with the Apollo of Veii, abstract, archaic Greek elements — for instance, the stylized curls that make up horses' manes and tails — are used, but they are integrated into a simple, organic work of great plastic power. These two masterpieces alone clearly indicate the high artistic level reached in Rome under the Etruscan kings.

In the light of what is presently known of the sixth century in Rome, it is possible to call the period completely historical. The idea of an archaic Rome that, while rubbing elbows with Greeks and Etruscans (to whom Romans owed their alphabet), lingered on in prehistoric mists in the center of that fully evolved and vigorous environment, must be definitively rejected. Far from being isolated and provincial, the "great Rome of the Tarquins" was a full participant in the eco-

nomic, cultural and artistic development of the Greek-influenced Mediterranean world. Rome was even able to make an independent move toward new forms of social and constitutional organization. The rapid formation and growth of a complex, fully articulated urban structure took place in this period, with an economy based not only on forms of pastoral and agricultural exploitation, but on expanding commerce and trade and their related activities. The cultural development of the same time, although probably limited to the elite of the Etruscan or Etruscanized ruling classes, was nonetheless impressive. The ever-growing urbanization, the appearance of buildings used to fulfill new and complex functions, indicates clearly that although Rome may have been founded in 753, in the midst of the Iron Age in Latium, it was through the events of the sixth century that Rome as a city was truly born anew.

Rome: Head of the Capitoline She-Wolf. Beginning of the fifth century B.C. This imposing bronze, the most outstanding in archaic Etruscan art, is of great importance as a document of the activity of Etruscan artists in Rome. Figures of the suckling twins, Romulus and Remus, were added in the sixteenth century A.D. but it is not certain that similar figures were part of the original. (Palazzo dei Conservatori, Rome.)

FORMATION OF ROMAN CULTURE
Republican Period (509-31 B.C.)

Beginnings of the Roman Republic

Exactly what political consequences the fall of the monarchy in Rome had are not clear. Some scholars have interpreted the ouster of the kings as the end of Etruscan domination in the city, but a broad affirmation of this kind contains some ambiguities that must be clarified, for Etruscan domination in Rome was really more cultural than political, anyway. Although an Etruscan League existed, each city within it was absolutely independent. Individual cities could, and often did, make their own alliances and set their own policies, Rome no more or less than the others. So the fall of the Tarquins seems to indicate a constitutional crisis rather than a break in the relationship with Etruria. In other Etruscan cities in the same period a similar phenomenon occurred; they passed from monarchical to republican governments, for the most part through "tyrannical" regimes on the Greek model. It is even likely that some Etruscan families collaborated in the overthrow of the Tarquins in Rome. Collatinus Tarquinius, together with Brutus, was one of the leaders of the revolution, and the consular lists, the *Fasti*, contain Etruscan names as late as 448 B.C. According to some scholars, this proves that the monarchy disappeared only in the second quarter of the fifth century, between 475 and 450. There is no need, however, to equate the existence of the monarchy with the presence of the Etruscans in Rome. The decline of Etruscan power in Campania took place only after their defeat at the hands of the Greeks at Cumae in 474 B.C.; this date corresponds fairly well with the disappearance of Etruscan elements from the Roman consular lists.

Artistic culture in Rome at the beginning of the fifth century certainly shows no major signs of a break with that which prevailed at the end of the sixth century. Relations with Magna Graecia were intensified, however, perhaps as an anti-patrician move. The struggles between patricians and plebeians began at this period, and were to continue to play a major role in the first centuries of the Republic. It is therefore probably no accident that decoration of the Temple of Ceres (Bacchus), Liber and Libera (Proserpine), (gods corresponding to the Greek Demeter, Dionysus and Kore) were entrusted to two Greek artists, Damophilos and Gorgasos. These gods were patrons of agriculture and hence of the wheat trade. Their temple, erected in 496 B.C. at the foot of the Aventine, soon became a stronghold of the plebeians. Varro indicates it was the first edifice in the Greek style erected in Rome. All the previous temples had been built in Etruscan style. The temple of Diana founded by Servius Tullius, placed as it was near the river port, also was favored by the plebeians.

In the course of the fifth century, the temple of Ceres became the distribution center for the grain imported from Etruria and even from Sicily, at the insistence of the plebeian tribunes. The supply of grain to the plebeians, first at half-price and later free, was a revolutionary

THE DECORATION OF
THE TEMPLE OF CERES

The most celebrated sculptors were Damophilus and Gorgasus, who were painters as well. These artists adorned with their works, in both kinds, the Temple of Ceres, in the Circus Maximus at Rome; with an inscription in Greek, which stated that the decorations on the right-hand were the workmanship of Damophilus, and those on the left, of Gorgasus. Varro says that, before the construction of this temple, everything was Tuscan in the temples; and that, when the temple was afterwards repaired, the painted coatings of the walls were cut away in tablets and enclosed in frames, but that the figures on the pediments were dispersed.
PLINY THE ELDER:
Natural History (XXXV)

Rome: Temple of Castor and Pollux in the Forum. The three columns still standing belong to a restoration of the Augustan Age. The primitive Temple was dedicated in 484 B.C., in the place where the Dioscuri were supposed to have appeared to announce Rome's victory at Lake Regillus over the Latin League.

political step, and constituted a heated issue between the patricians and the plebeians up to the end of the Republican Age. The agrarian reforms periodically proposed by the revolutionary tribunes, such as the Gracchi, were another.

If there is little political or institutional continuity between the sixth and the first decades of the fifth century, there is economic and cultural continuity, and it can be followed fairly well through the importation of Greek vases, by this time almost exclusively Attic in style. This importation continued uninterrupted up to the middle of the fifth century, although it diminished somewhat in scale. There seems to have been a crisis at mid-century, however. Importation of vases stopped and there was no further introduction of Greek forms of worship. After the temple of Ceres, no more Greek divinities were imported until 433 B.C., when a Temple of Apollo was built in the Campus Martius.

Contrary to what occurred in Greece in the fifth century, Italy in the same period passed through a period of economic and cultural decadence and confusion, which began with the destruction of Sybaris in 510 B.C. The great Greek city of Lucania, one of the key trading points between Italy and the eastern Mediterranean, was destroyed by its rival, Croton. Then, after their defeat at Cumae, the Etruscans went through a political and economic recession. Although the Greeks were the victors for the moment, in the last years of the century they experienced a crisis as well, for the Carthaginians occupied and destroyed almost all the towns of Greek Sicily at that time, except for Syracuse and a few others, and the Italic populations in the interior moved toward the coasts of southern Italy and Sicily to occupy, one by one, the Greek cities there. Only Tarentum and Naples were able to offer resistance and remain Greek.

The Italic Community

The intensity of trade and economic relations in the sixth century was matched by an exceptional cultural flowering, in which Etruria and Rome participated on the same level as the cities of Magna Graecia; but the fifth century was a period of decline and closure, of fragmentation and provincialization of culture. Roman culture of this period is little known, partly because of this. It seems to have been a period of heroic endurance, of universal and daily struggles against the Sabines, the Etruscans, and the Volscians. Hints of this are found in the writing of Livy.

The fourth century, however, was an age of vigorous renewal on all levels. The fusion of the indigenous population and the Greeks in southern Italy and Sicily gave rise to an extremely florid and mixed civilization, less brilliant but all in all more robust than that of the sixth century which had been based on the power of an elite and was not deeply rooted. In 396 B.C., Rome ended its mortal duel with the Etruscan city of Veii by destroying it, and recovered from the violent shock of the sack of Rome by the Gauls in 390. The Romans craved wider influence, in the north toward Etruria and in the south toward Campania and the cities of Magna Graecia, but it was necessary first for them to overcome the Samnites, the powerful confederation of peoples who dominated the territory (corresponding to present-day Molise) east and south of Rome. The natural area expansion for the Samnites, too, was Campania.

The general economic revival quickly led to more intense relations of every kind, and little by little a unified Greek-speaking cultural community was formed. It extended from Etruria to Sicily, with its extreme points at Capua, Tarentum, Syracuse, and the outlying Etruscan cities. Pottery was no longer imported from Athens, but made locally. Its style, though derived from Greece, displays a new

A TREATY BETWEEN ROME AND CARTHAGE (509 B.C.)

"Between the Romans and their allies and the Carthaginians and their allies there shall be peace and alliance upon these conditions. Neither the Romans nor their allies shall sail beyond the Fair Promontory, unless compelled by bad weather or an enemy. And in case that they are forced beyond it, they shall not be allowed to take or purchase any thing, except what is barely necessary for refitting their vessels, or for sacrifice; and they shall depart within five days. The merchants, that shall offer any goods to sale in Sardinia, or any part of Afric, shall pay no customs, but only the usual fees to the scribe and crier; and the public faith shall be a security to the merchant, for whatever he shall sell in the presence of these officers. If any of the Romans land in that part of Sicily which belongs to the Carthaginians, they shall suffer no wrong or violence in any thing. The Carthaginians shall not offer any injury to the Ardeates, Antiates, Laurentines, Circaeans, Tarracinians, or any other people of the Latins, that have submitted to the Roman jurisdiction. Nor shall they possess themselves of any city of the Latins that is not subject to the Romans. If any one of these be taken, it shall be delivered to the Romans in its entire state. The Carthaginians shall not build any fortress in the Latin territory: and if they land there in a hostile manner they shall depart before night."

POLYBIUS: *History* (III:3)

RECONSTRUCTION OF ROME AFTER THE GALLIC FIRE (390 B.C.)

The law [under discussion] being rejected, the building of the city commenced in several parts at once. Tiles were supplied at the public expense. The privilege of hewing stone and felling timber wherever each person wished was granted, security being taken that they would finish the buildings on that year. Their haste took away all attention to the regulating course of the streets, whilst, setting aside all distinction of property, they build on any part that was vacant. That is the reason why the ancient sewers, at first conducted through the public streets, now in many places pass under private houses, and why the form of the city appears more like one taken up by individuals, than regularly portioned out [by commissioners].

LIVY: *The History of Rome* (V:55)

vivacity and expressiveness, as well as a certain provincialism. As for pottery and terra-cotta production, documentation of the period is considerable. Recent excavations of necropolises at Tarquinia and Paestum have enormously increased present-day knowledge of the painting of the period as well.

What is known of art in Rome at this time presents a similar picture. It must be called "art in Rome," rather than Roman art, for it is merely the local manifestation of the common Italic culture, which might better be called "Etruscan-Apulian-Campanian." Many artists probably came to Rome from nearby areas, just as in the preceding period; but unlike what occurred later on, art in this period was not outside the interests of the leaders of the Roman state, as the authors of the first century B.C. asserted. Toward the end of the fourth century and at the beginning of the third century, a patrician of the Fabius family devoted himself to painting and left to his descendants, among them the earliest Roman historian, the name *Pictor*, ("painter") which moralists of the late Republican period and the Imperial Age would have thought a scandal. In fact, in the second century B.C. the schism between the small Roman ruling class and the rest of the population resulted, among other things, in the feeling that it was unworthy for a member of the senatorial class to indulge in intellectual or manual activities, including the arts. Their activities were restricted to political

Rome: Sacred area of the Largo Argentina. One of the most important complexes remaining from Republican Rome. Within one portico, probably set up by Marcus Minucius Rufus in 106 B.C., there are four temples, dating from the middle of the fourth century to the end of the second century B.C.

MUNICIPES and *municipia* are words which are readily spoken and in common use, and you would never find a man who uses them who does not think that he understands perfectly what he is saying. But in fact it is something different, and the meaning is different. For how rarely is one of us found who, coming from a colony of the Roman people, does not say what is far removed from reason and from truth, namely, that he is *municeps* and that his fellow citizens are *municipes?* So general is the ignorance of what *municipia* are and what rights they have, and how far they differ from a "colony," as well as the belief that *coloniae* are better off than *municipia*.

Municipes, then, are Roman citizens from free towns, using their own laws and enjoying their own rights, merely sharing with the Roman people an honorary *munus*, or "privilege" (from the enjoyment of which privilege they appear to derive their name), and bound by no other compulsion and no other law of the Roman people, except such as their own citizens have officially ratified. We learn besides that the people of Caere were the first *municipes* without the right of suffrage, and that it was allowed them to assume the honour of Roman citizenship, but yet to be free from service and burdens, in return for receiving and guarding sacred objects during the war with the Gauls. Hence by contraries those tablets were called *Caerites* on which the censors ordered those to be enrolled whom they deprived of their votes by way of disgrace.

But the relationship of the "colonies" is a different one; for they do not come into citizenship from without, nor grow from roots of their own, but they are as it were transplanted from the State and have all the laws and institutions of the Roman people, not those of their own choice. This condition, although it is more exposed to control and less free, is nevertheless thought preferable and superior because of the greatness and majesty of the Roman people, of which those colonies seem to be miniatures, as it were, and in a way copies; and at the same time because the rights of the municipal towns become obscure and invalid, and from ignorance of their existence the townsmen are no longer able to make use of them.

AULUS GELLIUS: *Attic Nights* (XVI:13)

Among the Romans, too, this art very soon rose into esteem, for it was from it that the Fabii, a most illustrious family, derived their surname of "Pictor;" indeed the first of the family who bore it, himself painted the Temple of Salus, in the year of the City, 450; a work which lasted to our own times, but was destroyed when the temple was burnt, in the reign of Claudius. Next in celebrity were the paintings of the poet Pacuvius, in the Temple of Hercules, situate in the Cattle Market: he was a son of the sister of Ennius, and the fame of the art was enhanced at Rome by the success of the artist on the stage.

PLINY THE ELDER:
Natural History (XXXV)

and military matters. Evidently this was not the manner of the fourth and third centuries, when Roman society was more homogenous, with class divisions that were less marked by vocational absolutism.

Only a few buildings have remained from the fourth and third centuries. An idea of the architecture of the time must be formed mostly from the remains of temples. The first construction of Temple C in the Largo Argentina can be attributed to the fourth century. The building was made all of tufa; wooden parts were reduced to a minimum, but terra-cotta decoration continued in the upper parts. The podium of the temple, which is completely preserved, is very high. The Etruscan temple form, with a colonnade on three sides and the back side closed, dominates in Rome by this time. The form of the Roman temple was to remain somewhat like this, with the frontal point of view predominating, in contrast to the form of the Greek temple, where colonnades go all around and there is no orientation to one side or the other. Worship took place at an altar outside the temple, however, in both Greek and Roman temples. The temple remained the "house" (*aedes* in Latin) of the god to whom it was dedicated.

Italic Colonies and the Birth of Historical Painting

Almost nothing is known about Rome as a city in this period, but the numerous Roman colonies founded in the fourth and third centuries, some of which have been almost completely excavated, furnish some interesting facts. A number of boundary walls have been discovered. The Servian Wall was completely reconstructed in Rome in the first decades of the fourth century, as noted above, Many parts of this wall are still visible today. The rebuilding of the Servian Wall was done in tufa, but the walls of the colonies utilized local stone for the most part, usually limestone. Tufa could be cut into regular blocks, but the harder stone was cut in irregular shapes, often of a trapezoidal section, which were set with great skill to form the grandiose polygonal walls that characterize so many of the cities of ancient Latium. Once thought to be of older age, these walls are now known to belong to the period of colonization in the fourth and third centuries. The far from crude technique with which they were built — extremely refined in the best examples, as at Cosa and Alatri — is of Greek derivation. Excellent examples are to be found in Greece and the Greek colonies from the archaic period on.

As were the Hellenic colonies, the Roman colonial cities were conceived and realized after a common model, with regular urban planning. They consisted of a network of axes that marked out rectangular blocks of not too large a size. The public buildings were concentrated around a forum of rectangular shape that usually lay close to the center of the network of streets. At the edge of the living area and on the highest point of the city was the citadel, or *Arx*, the center not only of defense but also of worship. This was also the plan in Greece, as with the Acropolis at Athens. Significant Roman examples can be found at Cosa and Alba Fucens.

An interesting example of colonial temple architecture is the Italic temple at Paestum, whose first phase of building took place in the years immediately after the foundation of the colony in 273 B.C. Among other things, the series of sculpted metopes (now certainly attributed to the third century, rather than the later Sullan Age, as had once been thought) reveal an obvious relationship with the soft stone sculpture of Tarentum, further proof of the artistic unity of the Italic world in this period.

In painting, Fabius Pictor is the name best known. He painted the temple of Salus on the Quirinal, dedicated by the consul Junius

The Appian Way: Created by the censor Appius Claudius in 312 B.C., this road linked Rome with Capua through the Pontine plain. It was later extended to Tarentum and Brindisi.

A ROMAN FUNERAL

When any illustrious person dies, he is carried in procession with the rest of the funeral pomp, to the rostra in the forum: sometimes placed conspicuous in an upright posture; and sometimes, though less frequently, reclined. And while the people are all standing round, his son, if he has left one of sufficient age, and who is then at Rome, or, if otherwise, some person of his kindred, ascends the rostra, and extols the virtues of the deceased, and the great deeds that were performed by him in his life. By this discourse, which recalls his past actions to remembrance, and places them in open view before all the multitude, not those alone who were sharers in his victories, but even the rest who bore no part in his exploits, are moved to such sympathy of sorrow, that the accident seems rather to be a public misfortune, than a private loss. He is then buried with the usual rites; and afterwards an image, which both in features and complexion expresses an exact resemblance of his face, is set up in the most conspicuous part of the house, inclosed in a shrine of wood. Upon solemn festivals, these images are uncovered, and adorned with the greatest care. And when any other person of the same family dies, they are carried also in the funeral procession, with a body added to the bust, that the representation may be just, even with regard to size. They are dressed likewise in the habits that belong to the ranks which they severally filled when they were alive. If they were consuls or praetors, in a gown bordered with purple: if censors, in a purple robe: and if they triumphed, or obtained any similar honour, in a vest embroidered with gold. Thus apparelled, they are drawn along in chariots preceded by the rods and axes, and other ensigns of their former dignity. And when they arrive at the forum, they are all seated upon chairs of ivory; and there exhibit the noblest object that can be offered to a youthful mind, warmed with the love of virtue and of glory. For who can behold without emotion the forms of so many illustrious men, thus living, as it were, and breathing together in his presence? Or what spectacle can be conceived more great and striking?

POLYBIUS: *History* (VI:3)

Bubulcus in 303 B.C. It is probable that these frescoes represented episodes from the second Samnite war and that the consul was depicted in them. A painted fragment from a tomb on the Esquiline, dating perhaps from the beginning of the third century and thus contemporaneous with Fabius, gives an idea of the character of these paintings. Here, too, episodes from a Samnite war are depicted in a simple but organic style, with a certain plastic consistency. What is interesting is the repetition on different levels of the painting, one placed above the other, of the same personages, with the names M. Fannius and Q. Fabius. Both appear in two distinctly different scenes. (Some commentators have thought that Q. Fabius might be Q. Fabius Maximus Rullianus, consul in 322 B.C. and conqueror of the Samnites.) This is probably a copy of a triumphal painting — that is, a painting carried in the triumph procession, which usually depicted the main events of the military campaign. This is the oldest painting to be discovered in Rome, and it is interesting to note that it has a historical character, but the fact should not be overrated. Other paintings of the same kind and from the same period exist, but in a different setting. The most famous are the frescoes from the Francois Tomb at Vulci (now preserved in the Villa Albani in Rome). They date back to the fourth century and depict mythological scenes (Achilles sacrificing the Trojan prisoners over the tomb of Patroclus) as well as scenes referring to the archaic history of Rome (the struggle of the hero Mastarna and his allies from Vulci with a coalition of Etruscan princes, among them a certain "Aeneas Tarquinius of Rome"). The owner of the tomb, Vel Satie, is also depicted, in the painted toga characteristic of the victor. An interesting tomb was discovered at Paestum in 1970. Called the Captain's Tomb, it also dates back to the second half of the fourth century, and has frescoes depicting a battle scene in a landscape with hills in the background. The setting can be recognized as the plain of Paestum. It is not completely out of the question that this scene, certainly historical, refers to the famous battle that took place near the city in 322 between the Lucanians and the troops of Alexander of Molossus, the king of Epirus.

So "historical" scenes existed in the Etruscan and Campanian world as well. They were not exclusive to the Roman art of the period. The structure of Roman society, whose central "motor" was the political and military element, was, however, extremely favorable to the development of "public" artistic forms such as relief, historical painting, and the honorary portrait, which was to become one of Roman civilization's major contributions to the world.

Sepulcher of the Scipios

In this period, generally so badly documented, the most precious monument known is the sepulcher of the Scipio family. Discovered by chance in 1780, it was built near the beginning of the Appian Way, between it and the Via Latina. Appius Claudius, the censor who built the Appian Way in 312 B.C., is the first great protagonist in Roman public life with a definite inclination for Greek culture. This was certainly not a disinterested matter of taste; it was, rather, the consequence of Appius' politics. With great consistency, he was an advocate of Roman expansionism, especially expansion into Magna Graecia. Old and blind, he had himself taken to the Senate in order to oppose, with an eloquence nurtured on Greek culture, making peace with Pyrrhus, the champion of Magna Graecia against Rome, and to urge the continuation of the war with the Tarentines. It is unlikely then, that the position of the Scipios' tomb was chosen at random. A precise political choice may perhaps be seen in its position and in that of the tombs of other great Roman families, the Atilii, the Servilii, the Metelli, outside the Porta Capena, next to the great consular way. The Metelli and the

ARCHITECTURAL ARRANGEMENTS OF PUBLIC BUILDINGS

The Forum and the Basilica

The Greeks build their forum with spacious porticoes, two tiers in height, arranged in a square form: the columns of the porticoes are placed at small intervals from each other, supporting stone or marble entablatures: and galleries are made over the lacunaria of the lower porticoes as places of excerise. But in Italy the mode of constructing the forum is different; because by a custom, sanctioned by its antiquity, the shew of gladiators is exhibited there; and therefore the intervals between the columns surrounding the area are made greater. The lower porticoes are occupied by the offices of the bankers, which situation is calculated to facilitate the management of the public revenue; and the upper contain seats for the spectators of the diversions in the forum.

The size of the forum must be regulated by the population of the place; so as not to be too confined, nor yet so large that much of it may appear unoccupied upon public occasions. The proportion of the length to the width ought to be as three to two; because an oblong form is best adapted for viewing those exhibitions which take place in the forum.

The columns of the upper porticoes should be a fourth part less than those of the lower; because these, supporting a greater weight, require to be more massy than those above: moreover, such a diminution is consistent with the laws observed by nature in the formation of trees; such as the fir, the cypress, and the pine; which are universally larger at the base than at any other part of the bole, from whence they gradually diminish to the top. Instructed therefore by the example which nature affords us in the shape she has given to trees, we are taught, when columns are placed tier upon tier, to make the upper less in height and bulk than those below them.

The basilica ought to be contiguous to the forum, and on that side of it which is the least exposed; so that the merchants who meet there to transact business, may not be inconvenienced by the cold in winter. The width of the basilica ought not to be less than the third, nor more than the half of its length; unless we are compelled by the nature of the situation to adopt a different proportion for the building. If the site will permit, the storerooms should be situated at the ends in a manner similar to what has been observed in the basilica of Julia Aquiliana. The height of the columns should be equal to the width of the porticoes, which ought to be a third of the distance between the columns, measured across the basilica. The upper columns, in conformity with what has already been observed, must be less than those below. The pluteum, between the upper and lower ranges of columns, should be a fourth part less than the height of the columns of the upper range; for by giving it such a depth, those who are walking in the galleries above, will not be seen by the merchants from below. The

Rome: Fragment of a fresco from a hypogeum on the Esquiline, circa 300 B.C. Scenes from a war between the Romans and the Samnites are depicted on many levels, one placed above the other. The Roman leader was Marcus Fabius; the Samnite leader was Marcus Fannius. Particularly important because it is the only example of Roman painting from the period, which was dominated by the personality of Fabius Pictor, this fresco preserves an idea of the genre of triumphal painting, the representations of battles and sieges carried in triumphal processions. (Antiquario Communale, Rome.)

epistylia, zophori and coronae must be proportioned to the columns according to the principles already explained. . . .

The Theater

After the site of the forum has been determined, the next care is to select the most healthy spot within the limits of the city for a theater; in which sports may be exhibited on days devoted to the celebration of sacred rites. For those who frequent them in company with their families, engaged by the interest they take in the representations, remain in fixed attention; whence it happens that the pores of the body are exposed to the effects of the atmosphere; which in the neighbourhood of marshes, or spots otherwise unhealthy, is charged with vapours prejudicial to the human frame. This inconvenience may be avoided if the situation be chosen with care and circumspection. It is no less necessary that the theater be not placed with its concave part facing the south; because, from its peculiar form, the sun would heat every part alike and prevent the circulation of air; which becoming rarefied and heated, causes the evaporation and exhaustion of the corporeal juices. On these accounts unwholesome situations must be avoided, and healthy spots carefully selected.

If the situation chosen for the theater be in the side of a hill, the substructure will be formed with little labour; but if we are compelled by circumstances to build a theater in a plain, or on marshy ground, the foundations and substructure must be made in the manner already described for those of sacred edifices. Upon the substructure, the rising steps may be constructed either of stone or marble. The number of praecinctions must be proportioned to the capacity of the building: their height should be equal to the width of the passages which they form around the theater; for were they made higher, the sounds would not be heard with distinctness by those in the seats above them; but be interrupted in their ascent, and reflected back from the upper part of the theater. The method of arranging the seats is determined by extending a line from the uppermost to the lowest, and making the angles of all the intermediate steps to touch it. In theaters thus constructed the propagation of sound will not be interrupted.

The approaches should be numerous and spacious; nor should those from the upper and lower parts of the theater have any communication, but the passages to every part be direct, and without deviations; that when the representations are ended, the audience may retire with facility from all parts of the theater, and not be subjected to the pressure of the multitude.

We must also be careful in observing that the situation chosen be not calculated, through local circumstances, to check the dilation of sound; but, on the contrary, be such as to permit the free expansion of the human voice. This is the property of those places in which there is nothing to interrupt the vibrations of the air. . . .

VITRUVIUS: *Civil Architecture* (III:1,3,10)

Scipios, above all after the second Punic war, were the chief supporters of Roman imperialism.

The sepulcher of the Scipios has a hypogeum, or underground vault, cut out of the tufa of a hill, in a manner similar to the great noble tombs of Etruria at the same period. It is relatively more simple than they are, however. The walls were plastered and had no paintings. The tufa sarcophogi, in general plain and smooth, were lined up against the walls. The only sarcophagus of any artistic worth is that of Cornelius Scipio Barbatus, consul in 298 B.C., with a Doric frieze decoration and rich cornices. The model for this came not from Etruria, as might be expected at this period, but from Magna Graecia; similar monuments have been discovered at Syracuse. The particularly high artistic polish of this solitary sarcophagus may be explained by the fact that the tomb was constructed at the beginning of the third century by the person whose sarcophagus it is. He was probably the first person to be buried here, and his sarcophagus is placed in the most central and visible position, facing the main entrance.

The simplicity and relative poverty of materials and decoration in the tomb relative to Etruscan examples of the same period is such as to accentuate the most important element: the inscription. The inscription on the oldest sarcophagus was originally rather short and most certainly contained only a mention of the name, duties, and offices of Scipio Barbatus. This primitive inscription was later rubbed out, however, and replaced by an ode in six verses in the ancient meter of Roman poetry, the Saturnian meter, which not only recorded the facts about Barbatus but celebrated his achievements as well. Other sarcophagi in the tomb, too, beginning with that of Barbatus' son, consul in 259 B.C., bear the same sort of metrical inscription. These are the most important examples known of funerary "eulogies." They are of the same sort as those known to have been pronounced during the funerals of the Romans. In them the essential note of all Roman art is sounded. Whether the productions were of a modest quality, as is the case, in general, with productions of the earliest Republican period, or were bedecked with the glamorous forms of Hellenistic art, like the sarcophagus of Barbatus, in every case the ultimate end of the artistic work seems to be predominantly political and propagandistic. Roman art is ideological art.

Although this is most clear in public monuments, it is also true in apparently private spheres, such as funerary art. At a certain point, most likely at the middle of the second century B.C. and perhaps thanks to Scipio Emilianus, the destroyer of Carthage, the tomb of the Scipios became something of a family museum. A monumental facade was constructed, decorated with half-columns and perhaps with the statues of Scipio Africanus, Scipio Asiaticus and the Roman poet Ennius. The statue of Ennius, and probably the others as well, was of marble, according to Cicero, and was the work of Greek artists. The epitaph of Barbatus' sarcophagus may have been redone at this point. The whole operation seems to have had a precise propagandistic intent. Ennius, immortalized in marble, was the Roman Homer, the extoller of Roman glories who devoted the last cantos of his *Annals* to the achievements of the greatest Romans, among them members of the Scipio family. The family did not fail to use this opportunity to connect their name permanently with that of the poet by dedicating a statue to him.

High art in Rome might almost better be called public art, for whether it is poetic or figurative, it almost always has a function that is political or ideological. At the very least, it exalts those aspects that for the Roman citizen were the only ones which counted: the career of the "Honores," — that is, the assumption of civic and military posts, strictly obligatory for every member of the ruling class. Noble groups, or clans, became more important in proportion to the number of such posts they were able to secure. The most desirable, of course, was the consulship, and the competition for it was fierce and led to the

ideology of power that lies at the root of most of the productions of Roman art. In literature, the triumphal and convivial cantos and the funeral eulogies are all instruments for extolling the virtues, glories, and achievements of members of the senatorial class. The figurative arts — relief, painting, the portrait, and even architecture to a large degree — served the same function. As a matter of fact, it was a custom in Rome, from a rather early period, to dedicate edifices *ex voto* in gratitude for victory in a battle or in war. Originally such dedications were sacred and consisted in the gift to the god of an important and costly monument. In unusually important cases, the commander might offer his life through the ceremony of the *devotio*, dedicating himself and the enemy army to the infernal gods. As the custom became secularized, however, the dedicated building became a simple pretext for displaying the personality of the donor. In the last period of the Republic, the dedication of buildings took on an even more amazing character, becoming, as the state disintegrated, an affirmation of the almost monarchical importance of the donor, such as Scipio Africanus or, in the end, Julius Caesar.

Conquests in the East and Disruption of Italic Society

"Conquered Greece conquered in turn the uncultivated victor and introduced the arts in rustic Latium." According to Horace, the Hellenization of Roman culture took place after the second Punic War, with Hannibal and Carthage, which ended in 201 B.C. It was during the following fifty year period, however, that the battles that led to the conquest of Greece and Macedonia and to the victory over the Hellenistic power in Syria took place, ending with the destruction of Corinth by the Roman army commanded by Lucius Mummius, in 146 B.C. The important dates in this period are the triumph of Scipio Asiaticus over Antiochus III, the king of Syria, at the battle of Magnesia in 190 B.C. and the triumph of Manlius Vulso over the Galatians in Asia Minor in 187 B.C. Most Roman writers attribute the beginning of the decadence of Roman customs to these years, and ascribe it to the introduction of Hellenistic culture.

Greek culture was hardly unknown in Rome before this date, of course. As has been noted, Rome from the time of its founding had been in contact with the civilizations of the eastern Mediterranean, so much so that some Greek historians did not hesitate to classify it as a "Hellenic city." How is it possible to say, then, that Rome "opened its doors" to Greece only in the second century?

It is not really possible to understand the process without examining, albeit briefly, the historic events of the period, from the fourth and third centuries, when Rome and the figurative arts there were part of a culture which involved practically the whole Italian peninsula, to the end of the third and the beginning of the second century, when this culture swiftly disintegrated and disappeared and the forms of Italic art were replaced by others.

The common culture of Italy in the fourth and third centuries had diverse aspects, dialects of a uniform tongue, so to speak. At the basis of this culture, by and large, and particularly at the basis of Roman culture, was a society composed of small landholders, who made up the strength of the legions and were the principal reason for the victories of the Roman-Italic state over the great western and eastern Mediterranean powers. At just the moment of their greatest triumph, however, with the defeat of Hannibal and Carthage, these elements of the society experienced a crisis. The long and bloody wars, especially the devastations of the second Punic war, which lasted for sixteen years, made it impossible for the farmer-soldiers to cultivate their land. The crops they managed to raise were destroyed by their enemies. The

Of the land which the Romans gained by conquest from their neighbours, part they sold publicly, and turned the remainder into common; this common land they assigned to such of the citizens as were poor and indigent, for which they were to pay only a small acknowledgment into the public treasury. But when the wealthy men began to offer larger rents, and drive the poorer people out, it was enacted by law that no person whatever should enjoy more than five hundred acres of ground. This act for some time checked the avarice of the richer, and was of great assistance to the poorer people, who retained under it their respective proportions of ground, as they had been formerly rented by them. Afterwards the rich men of the neighbourhood contrived to get these lands again into their possession, under other people's names, and at last would not stick to claim most of them publicly in their own. The poor, who were thus deprived of their farms, were no longer either ready, as they had formerly been, to serve in war or careful in the education of their children; insomuch that in a short time there were comparatively few freemen remaining in all Italy, which swarmed with workhouses full of foreign-born slaves. These the rich men employed in cultivating their ground of which they dispossessed the citizens. Caius Laelius, the intimate friend of Scipio, undertook to reform this abuse; but meeting with opposition from men of authority, and fearing a disturbance, he soon desisted, and received the name of the Wise or the Prudent, both which meanings belong to the Latin word *Sapiens*.

But Tiberius, being elected tribune of the people, entered upon that design without delay, at the instigation, as is most commonly stated, of Diophanes, the rhetorician, and Blossius, the philosopher.... Some have also charged Cornelia, the mother of Tiberius, with contributing towards it, because she frequently unbraided her sons, that the Romans as yet rather called her the daughter of Scipio, than the mother of the Gracchi.... But his brother Caius has left it us in writing, that when Tiberius went through Tuscany to Numantia, and found the country almost depopulated, there being hardly any free husbandmen or shepherds, but for the most part only barbarian, imported slaves, he then first conceived the course of policy which in the sequel proved so fatal to his family. Though it is also most certain that the people themselves chiefly excited his zeal and determination in the prosecution of it, by setting up writings upon the porches, walls, and monuments, calling upon him to reinstate the poor citizens in their former possessions.

PLUTARCH: *Life of Tiberius Gracchus* (8)

Rome: Sarcophagus of Cornelius Scipio Barbatus. (This is a copy, placed in the original site, in the sepulcher of the Scipio family on the Appian Way; the original is in the Vatican Museum.) A precious example of the art of the early third century B.C., it is the work of an artist from Magna Graecia or Sicily. On the sarcophagus are the celebrated verses that speak of Scipio Barbatus' achievements.

Scipio Barbatus

Lucius Cornelius Scipio Long-beard, Gnaeus' begotten son, a valiant gentleman and wise, whose fine form matched his bravery surpassing well, was aedile, consul and censor among you; he took Taurasia and Cisauna, in fact Samnium; he overcame all the Lucanian land and brought hostages therefrom.

Lucius, Son of Barbatus

This man Lucius Scipio, as most agree, was the very best of all good men at Rome. A son of Long-beard, he was aedile, consul and censor among you; he it was who captured Corsica, Aleria too, a city. To the Goddesses of Weather he gave deservedly a temple.

Publius Cornelius, Son of Africanus

You who have worn the honoured cap of Jupiter's holy priest: Death caused all your virtues, your honour, good report and valiance, your glory and your talents to be short-lived. If you had but been allowed long life in which to enjoy them, an easy thing it would have been for you to surpass by great deeds the glory of your ancestors. Wherefore, O Publius Cornelius Scipio, begotten son of Publius, joyfully does Earth take you to her bosom.

Lucius, Son of Hispallus

Great virtues and great wisdom holds this stone
With tender age. Whose life but not his honour
Fell short of honours; he that lieth here
Was ne'er outdone in virtue; twenty years
Of age to burial-places was he entrusted.
This, lest ye ask why honours none to him
 Were e'er entrusted.

Gnaes Scipio Hispanus

Gnaeus Cornelius Scipio Hispanus, son of Gnaeus, praetor, curule aedile, quaestor, tribune of soldiers (twice); member of the Board of Ten for Judging Law-suits; member of the Board of Ten for Making Sacrifices.

By my good conduct I heaped virtues on the virtues of my clan; I begat a family and sought to equal the exploits of my father. I upheld the praise of my ancestors, so that they are glad that I was created of their line. My honours have ennobled my stock.

Tombs of the Scipios

result was the total ruin of the class. The farmers went into debt to survive, but unable to meet their obligations, they forfeited their possessions to a small number of families who had become enormously rich through war booty and the administration of the provinces and newly captured areas. The large landed estates that resulted were given over to a system of operation involving slave labor, plentiful after the wars of conquest, while the class of small landowners disappeared. The powerful families who had created the estates took over political power in Rome, which was henceforth governed oligarchically. There was no further identification between the citizen-landowner and the soldier, and little by little the army became a specialized function within the state, completely cut off from civil society. At the end of the second century, the demagogue Marius was to reap the harvest of this process by transforming the army finally into a professional group, personally bound to its leader rather than to the state.

The economic crisis was particularly grave in Magna Graecia and southern Etruria, exactly in those areas that in the preceding centuries had been the cultural centers. Cities like Croton, Locri, Metapontum, Tarquinia and Cerveteri (Caere) practically disappeared. The treatment given to Tarentum after its conquest by the Romans during the second Punic war is indicative. After a long and cruel siege, the city, which had sided with Carthage against Rome, was taken in 209. It was sacked, much of the population was killed, and thirty thousand citizens were sold into slavery. From a city which had been the most important center for the spread of Hellenism in Italy, Tarentum became practically a provincial village that never again revived.

Recent archaeological investigations confirm this crisis. Around Metaponto, land has been discovered that was subdivided into regular lots, or holdings — "centurization" was the Roman term — as early as the sixth century B.C. The farms that have been excavated show signs of continuous occupation from this period up to the end of the third century B.C., when all the holdings were abandoned. The date coincides with that of the second Punic war. Such a phenomenon in

the ancient world, where the chief form of economy was always the cultivation of land, is a sure indication of economic and cultural collapse. Magna Graecia simply ceased to exist as a civilized society. The Romans attempted to repopulate these areas. Colonies were founded in Sybaris and Tarentum, but with poor results. Instead the large estates, called *latifundia*, worked by formations of slaves or used for large-scale stock-raising, covered vast areas of Magna Graecia, Sicily, and Etruria from the second century forward. The slaves, uprooted from their diverse homelands and condemned to an economy of sheer subsistence, have left hardly any "cultural" traces of their existence, if we exclude the blood memory of the desperate slave wars that shook Magna Graecia and Sicily during the last two centuries of the Republic. Ancient historiography was completely in the hands of the ruling class, and it has left only a pale record of this world, which nevertheless was the economic backbone of the Roman Empire. If written history gives only a glimpse of this world, art history gives no view at all. Negative traces can be found at Rome, however, for the slave system had a tremendous effect on the structure of Roman society, and in turn affected artistic production.

Hellenistic Influx

The essentially homogenous Roman-Italic society of the fourth and third centuries was replaced after the conquests by a profoundly divided one, in which an immense, landless, urban proletariat and a professional army, ideal material for the manipulation of every kind of professional adventurer, were ruled by a few dominant families. The cultural models of a military-agricultural society, which had served up to this time, were in no way suited to the new ruling class, controlling as it did the levers of a gigantic empire. Both on a philosophical level, as a justification of power, and on an artistic level, new cultural models existed in the monarchical states of the Hellenistic world: Macedonia, Egypt, and Syria. A mere imitation of them was impossible, however, since the Hellenistic adherence to a concept of absolute monarchy — where kings, from Alexander on, took on the aspect of religious heads as well, to the point of being deified while still alive — was impossible in the context of Roman traditionalism. Attempts of this kind were made in Rome, but they were almost always timid and circumspect. Julius Caesar paid for his daring innovations with his life. For the Romans, every revolution had to assume the aspect of a return to the customs of their ancestors.

The culture that formed in Rome in Hellenizing circles such as that of the Scipio family during the course of the second century, then, was neither a simple continuation of Greek culture in a different environment nor an imitation. The Romans were really too shrewd to accept a foreign tradition uncritically, even if they knew it to be superior in some ways to their own. The choice of elements from foreign culture had to be functional. After an initial phil-Hellenic enthusiasm, there was a period of reflection and reaction. Cato the Censor was the major adversary of indiscriminate Hellenization, and more is to be seen in his writings on the subject than reactionary envy and malice. He was no fool, and he knew Greek culture quite well, though he preferred, as did Cicero later on, to give the opposite impression. Cato and others acted as filters and set criteria of choice for the Romans. In 150 B.C., when the Greek philosopher Carneades, in a speech on justice, dared to question the right of Roman imperialism, he was immediately expelled from Rome. Yet approval, protection, and praise were given Panaetius of Rhodes, who adapted Stoicism to the needs of Roman society; it became the official philosophy of the Roman ruling class.

Rome: Seated female figure in terra cotta, part of a pediment decoration discovered in Via San Gregorio in Rome. Circa 130 B.C. (Capitoline Museums, Rome).

Rome: This circular temple of marble, near the Tiber (perhaps of Hercules Victor), is the work of a Greek architect working in Rome at the end of the second century B.C.

Following page:

Above:
Rome: Relief from a Republican Age trophy, originally on the Capitol. Second to first century B.C. From the left, a cuirass with decorations in the form of heads of Medusa and Victory; then, between two trophies, a round shield with a profile of Minerva's head. The work of a Hellenistic artist, possibly an Egyptian, as the quality of the material would seem to indicate. (Capitoline Museums, Rome.)

Below:
Rome: Fragment of a monumental sepulcher with the representation of a historic scene. 40-30 B.C. (Capitoline Museums, Rome.)

THE TRIUMPH OF AEMILIUS PAULUS OVER PERSEUS

The people erected scaffolds in the forum, in the circuses, as they call their buildings for horse-races, and in all other parts of the city where they could best behold the show. The spectators were clad in white garments; all the temples were open, and full of garlands and perfumes; the ways were cleared and kept open by numerous officers, who drove back all who crowded into or ran across the main avenue. This triumph lasted three days. On the first, which was scarcely long enough for the sight, were to be seen the statues, pictures, and colossal images which were taken from the enemy, drawn upon two hundred and fifty chariots. On the second was carried in a great many waggons the finest and richest armour of the Macedonians, both of brass and steel, all newly polished and glittering; the pieces of which were piled up and arranged purposely with the greatest art, so as to seem to be tumbled in heaps carelessly and by chance: helmets were thrown upon shields, coats of mail upon greaves; Cretan targets, and Thracian bucklers and quivers of arrows, lay huddled amongst horses' bits, and through these there appeared the points of naked swords, intermixed with long Macedonian sarissas. All these arms were fastened together with just so much looseness that they struck against one another as they were drawn along, and made a harsh and alarming noise, so that, even as spoils of a conquered enemy, they could not be beheld without dread. After these waggons loaded with armour there followed three thousand men who carried the silver that was coined, in seven hundred and fifty vessels, each of which weighed three talents, and was carried by four men. Others brought silver bowls and goblets and cups, all disposed in such order as to make the best show, and all curious as well for their size as the solidity of their embossed work.

On the third day, early in the morning, first came the trumpeters, who did not sound as they were wont in a procession or solemn entry, but such a charge as the Romans use when they encourage the soldiers to fight. Next followed young men wearing frocks with ornamented borders, who led to the sacrifice a hundred and twenty stalled oxen, with their horns gilded, and their heads adorned with ribbons and garlands; and with these were boys that carried basins for libation, of silver and gold. After this was brought the gold coin, which was divided into vessels that weighed three talents, like those that contained the silver; they were in number seventy-seven. These were followed by those that brought the consecrated bowl which Aemilius had caused to be made, that weighed ten talents, and was set with precious stones. Then were exposed to view the cups of Antigonus and Seleucus, and those of the Thericlean make, and all the gold plate that was used at Perseus's table. Next to these came Perseus's chariot, in which his armour was placed, and on that his diadem. And, after a little intermission, the king's children were led captives, and with them a train of their attendants, masters, and teachers, all shedding tears, and stretching out hands to the spectators, and making the children themselves also beg and entreat their compassion.

PLUTARCH: *The Life of Aemilius Paulus* (32-3)

An operation of the same kind took place in the arts, There was no careless and indiscriminate introduction of Hellenistic art, but once again a choice. Original works of Greek art, rather than their Italic derivations, reached Rome in the wake of the wars against the Carthaginians and the Hellenistic kingdoms. The conquest of Syracuse in 211 and Tarentum in 209 began the sack of art works that little by little brought together in Rome a large part of Greek artistic production, from the Archaic to the Hellenistic periods. At the same time, interest in works of art among the cultured in Rome was increased by the presence there of Greek artists and writers. After an initial period of enchantment, however, Roman practicality prevailed; the advantages of the new situation were esteemed, but their dangers were seen as well.

Aspects of Hellenistic tradition that were difficult to integrate were rejected. They were sometimes accepted on the private level, but in the public and ceremonial art of Rome — large-scale architecture, images for cult worship, the painting and sculpture dealing with historical subjects — a more radical choice was made. The classical canons of neo-Attic art, inspired by the great Greek works of the fourth and fifth centuries B.C., were adopted, rather than the Hellenistic. They were thought to be more suited to the culture of a centralizing and artistocratic elite such as had risen out of the new political and social situation in Rome.

The situation deserves at least a summary. It was in the look and life of Rome itself at this time that the radical political and economic split could be most clearly seen. There was naturally a struggle among the dominant families for the approbation of the large urban proletariat created by the impoverishment of Italy. Flocking to Rome in numbers, the landless farmers created an enormous urban problem, and immense, poverty-stricken neighborhoods grew up. As a means to counter these, "rival projects" were endowed and elaborate areas of public resort were built — such as that around the Circus Flaminius in the Campus Martius, where Greek sculptors, painters, and architects were employed to build sanctuaries, gardens, and porticoes. The circular temple in the Forum Boarium, most likely a Temple of Hercules, is a particularly remarkable example. It has recently been recognized as the work of a Greek architect of the second century B.C., probably Hermodorus of Salamis, a Greek who worked in Rome at this time, building two temples and the Rome naval base, all in the Campus Martius, between 146 and 102. The sculptors active in Rome during the same period were for the most part Attic (although there was no lack of Rhodians): Timarchides (active around 179), his sons Polycles and Dionysus, and last of all Skopas junior, whose activity extended through the beginning of the first century B.C.

The school or shop of Skopas should possibly be given credit for the first historical relief known in Rome, the so-called Ara of Domitius Enobarbus (today shared by the Louvre and Munich museums). It depicts a retinue of marine divinities and a *lustrum*, the solemn ceremony of purification that marked the end of the quinquennial census. This monument probably formed the base of the statues of Neptune and Amphitrite in the Temple of Neptune, which was built between the Circus Flaminius and the naval base. It is interesting that the first historical relief, a type of monument considered typically Roman, should be the work of a neo-Attic artist. As a matter of fact the sole known precedent in Greece for the work is the sculpted pillar dedicated at Delphi to the glory of L. Emilius Paulus after his victory at Pydna over Perseus, the King of Macedonia, and is thus another work of art by a Greek for a Roman buyer. These works of art, then, were conditioned not so much by the nationality and cultural formation of the artist as by the needs and desires of the buyer. Although executed by Greek artists, these works are at least potentially works of Roman art. It is true that in them Roman content and Greek form are

mechanically combined; they do not blend. A formally original Roman art arrived only after a certain amount of time had passed. In this sense the second century is still a formative period. The decisive moment coincided with the beginning of the first century B.C., the Sullan Age.

Temple of Fortuna at Praeneste

Similar conclusions can be drawn about the great sanctuaries in Latium that were built in this period, renewing the ancient cults in lovely architectural forms: the temple of Fortuna Primigenia at Praeneste, (present-day Palestrina), of Hercules Victor at Tivoli, and of Jupiter Anxur at Terracina. The most remarkable and best preserved of these is that at Palestrina and it is a key example for any understanding and evaluation of the phenomenon of Hellenistic influence. Gigantic in size, the edifice covers an entire hillside of present-day Palestrina. Its series of overlaid stairways, ramps, and terraces end at the top in a large colonnaded area open on the side towards the plain. This colonnaded area is dominated in turn by a semicircular theater area and by the temple proper. The medieval city that occupied a large part of the building was destroyed in the last war, freeing the historic complex for restoration.

Scholars have proposed two different dates for the building: the middle of the second century or the years following Sulla's destruction of Palestrina in 82 B.C. Recently the inclination among experts has been to accept a date sometime in the last quarter of the second century, between 125 and 100. The oldest known, then, of this particular class of monuments, the temple at Palestrina, can be seen as a

Palestrina (ancient Praeneste): The temple of Fortuna Primigenia. This grandiose complex, dating from the last quarter of the second century B.C., occupies, with its terraces, a large part of the hill that overlooks present-day Palestrina.

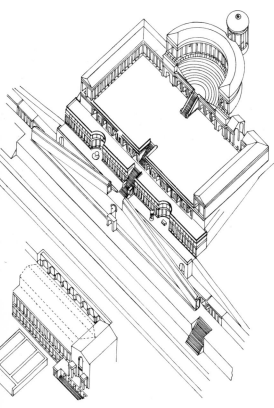

Palestrina (ancient Praeneste): Axonometric plan of the Temple of Fortuna Primigenia (130-110 B.C.).

prototype. Placing and defining the monument is a complex problem, however. Is it Roman or Hellenistic architecture? Such questions can hardly be given clear-cut answers in a historical period that witnesses the meeting of the Roman-Italic and Greek-Hellenistic cultures.

It is obvious that Praeneste would have been inconceivable without Hellenistic architecture, especially that of Asia Minor and the Aegean islands. There are no precedents for it either in an Italic setting or in Magna Graecia. These forms of architecture appear in Latium practically from nowhere, fully mature. In the light of what is known of the history of this period, to speak of originality or novelty would be rather foolish.

Precedents are to be found at Pergamon, and above all at Cos in the sanctuary of Aesculapius and in the arrangement of the acropolis of Lindos in Rhodes. The temple at Palestrina is different from these, but only because it is a logical development of them. Axiality — the vision centered on a median view, with symmetrical lateral elements — has sometimes been seen as a constant of Italic art and spirit, but it is also present in the Hellenistic examples, particularly the acropolis at Lindos. The real novelty at Praeneste is in its technique of construction. Extensive use is made of the vault cast in concrete. It must be admitted that at Praeneste it was employed for practical economic reasons. Such use could be called degenerate; the vault elements were originally hidden by applied architraves, horizontal cornices, and colonnaded porticoes, all traditional elements of Greek architecture.

It was only somewhat later that the esthetic possibilities of vaulting were recognized and appreciated. When this occurred, vaults were not only displayed, they were emphasized. The same process has occurred many times in the history of architecture (the history of the use of reinforced concrete in modern architecture being a good example).

The architecture at Palestrina was not properly Roman, then, but rather was Greek architecture executed by skilled local workers who combined their own techniques with Greek formal schemes and architectural traditions. The only architect known to have worked in Rome at this time, Hermodorus of Salamis, was from Cypurs. It may not be sheer coincidence that the buildings that may be most closely compared to the temple at Palestrina are found in Asia Minor and the Aegean islands.

Initial Achievements of a Roman Architecture

As with architecture and sculpture at Rome, the temple at Palestrina is a typical example of the importation of Greek models, still only partially adapted to local functions and techniques. Disparate elements are still only placed side by side; the birth of Roman architecture comes with their fusion.

The moment of this transformation came at the beginning of the first century B.C., in the age of Sulla. The monuments of this period continue the tradition of Palestrina, but they show that Romans had not only perfectly assimilated the Hellenistic lesson but had brought to fruition the innate potential of their own building tradition. The most significant monuments of this period are the Temple of Hercules Victor at Tivoli, the Temple of Jupiter Anxur at Terracina, and the *Tabularium* in Rome. In these works, built in the first decades of the first century, a constant of Roman architecture appeared for the first time: the arch, isolated or in a series, set between semi-columns and architraves. It was to be used for the exterior of many buildings — theaters, amphitheaters, and city gates.

Nor was the use of the vault in these buildings any longer merely a technical expedient. It had taken on its own formal dignity. The development of mortar and other materials permitted an ever safer and more differentiated use of the vault, and it spread to a variety of building types. It was employed not only in the construction of temples but of villas, bridges, theaters, and amphitheaters, as well as for the docks of Roman ports. The first great epoch of Roman architecture, between Sulla and Julius Caesar, laid the groundwork for the startling architectural accomplishments of the Imperial Age.

The municipalities of Italy and the colonies of Rome were quick to adopt the newly developed urban culture of the mother city, repeating its elements precisely. Not only were their administrative and political structures imitated, the buildings that housed their functions were imitated as well. The public buildings and public places of most cities normally included a Forum, a Capitol with the temple of the gods of the Roman state cult (Jupiter, Juno, and Minerva), a Senate-house for meeting of the local Senate and a basilica. The basilica was a covered hall that housed the courts of law and was sometimes used for public meetings. Of Greek origin — its name derives from the Greek word for "royal house," and as a building type it may be connected with the "king's portico" in Athens — the basilica appeared for the first time

Rome: The *Tabularium*. This edifice, built against the Capitoline Hill, formed a monumental backdrop at the western end of the Roman Forum. Built in the Sullan Age — the inaugural date is 78 B.C. — by Lutatius Catullus, to house the archives of the Roman state, it replaced buildings damaged by the fire of 83 B.C., which also destroyed the Temple of Jupiter Capitolinus.

THE VIRTUES OF THE ROMANS

In all things that regard the acquisition of wealth, the manners also, and the customs of the Romans, are greatly preferable to those of the Carthaginians. Among the latter, nothing is reputed infamous, that is joined with gain. But among the former, nothing is held more base than to be corrupted by gifts, or to covet an increase of wealth by means that are unjust. For as much as they esteem the possession of honest riches to be fair and honourable, so much, on the other hand, all those that are amassed by unlawful arts, are viewed by them with horror and reproach. The truth of this fact is clearly seen in the following instance. Among the Carthaginians, money is openly employed to obtain the dignities of the state: but all such proceeding is a capital crime in Rome. As the rewards, therefore, that are proposed to virtue in the two republics are so different, it cannot but happen, that the attention of the citizens to form their minds to virtuous actions must be also different.

But among all the useful institutions, that demonstrate the superior excellence of the Roman government, the most considerable perhaps is the opinion which the people are taught to hold concerning the gods: and that, which other men regard as an object of disgrace, appears in my judgment to be the very thing by which this republic chiefly is sustained. I mean, superstition: which is impressed with all its terrors; and influences both the private actions of the citizens, and the public administration also of the state, in a degree that can scarcely be exceeded. This may appear astonishing to many. To me it is evident, that this contrivance was at first adopted for the sake of the multitude. For if it were possible that a state could be composed of wise men only, there would be no need perhaps of any such invention. But as the people universally are fickle and inconstant, filled with irregular desires, precipitate in their passions, and prone to violence; there is no way left to restrain them, but by the dread of things unseen, and by the pageantry of terrifying fiction. The ancients therefore acted not absurdly, nor without good reason, when they inculcated the notions concerning the gods, and the belief of infernal punishments; but much more those of the present age are to be charged with rashness and absurdity, in endeavouring to extirpate these opinions. For, not to mention other effects that flow from such an institution; if, among the Greeks for example, a single talent only be entrusted to those who have the management of any of the public money; though they give ten written sureties, with as many seals, and twice as many witnesses, they are unable to discharge the trust reposed in them with integrity. But the Romans, on the other hand, who in the course of their magistracies, and in embassies, disburse the greatest sums, are prevailed on by the single obligation of an oath to perform their duty with inviolable honesty. And as, in other states, a man is rarely to be found whose hands are pure from public robbery; so, among the Romans, it is no less rare to discover one that is tainted with this crime.

POLYBIUS: *History* (VI:3)

at the beginning of the second century. The first example in Rome was erected by Cato the Censor in 184 B.C.

The public buildings of the provincial cities, therefore, were not testimony of a local culture different from the Roman one, but rather a reflection of Rome. By this time the old Italic culture community no longer existed. It had been replaced by a system of complete economic, political, and social centralization. Indications of this may be seen in a group of terra-cotta temple pieces (now in the Archaeological Museum in Florence) that were found at Luni, a Roman colony founded in 177 B.C. They show the same participation of Attic craftsmen as in a similar set of works found in the Via San Gregorio in Rome, which date from the same period: a group of terra-cotta pieces belonging to the front of a temple dedicated to Mars.

Greek culture no longer reached the minor cities of central Italy and Campania directly, then, but rather through Rome. In some cases, works of art taken from Greek cities were distributed among the

municipalities. This happened after the destruction of Corinth in 146 and after the sack of Athens by Sulla in 86. Greek prisoners of war, hostages, and slaves were sent to every part of Italy, where they profoundly transformed Italic life and culture.

Campanian Prosperity and the Growth of a Merchant Class

Particularly interesting examples of this cultural diffusion can be seen in the Campanian cities destroyed by Vesuvius, especially in Pompeii, the largest and most intact of those excavated. In contrast to the rest of Magna Graecia, Campania retained considerable importance after the Punic wars. A rich agricultural area, gifted with good ports and important industries, it ended as the true economic "cousin" of Rome and an important commercial center. Puteoli (present-day Pozzuoli), became Rome's commercial port (the coast of Latium offers no large natural harbor), and soon became one of the most important ports in the Mediterranean, together with Alexandria and Delos. Production of metal objects, the famous "Campanian furnishings," was concentrated in Capua. They were exported everywhere, as far away as northern Germany. The excellent clay of quarries

Tivoli: Axonometric plan of the Temple of Hercules Victor (80-50 B.C.).

Left:
Tivoli: The circular temple, perhaps dedicated to Hercules, built around 100 B.C. The Greek forms of the round temple near the Tiber are here transformed into an Italic vernacular.

Right:
Rome: The Milvian Bridge. Built in masonry in 109 B.C., this bridge was the obligatory river crossing for two of the most important Roman roads, the Via Flaminia and the Via Cassia. Around this bridge the last phase of the battle between Constantine and Maxentius took place in A.D. 312.

at Naples was made at Ischia into the black-glazed vases of Campanian pottery, which were also widely exported. One of the most important economic enterprises was the production and exportation of oil (according to Cato, the best came from Venafro) and wine, the famous "Falerno" and "Cecubo."

With all of this specialized production, the traditional products of agriculture were slighted. In a list of the principal products of a rural nature, Cato places wheat sixth. Rome's supply of wheat came from the provinces — first Sicily and later Africa — where a one-product economy was imposed, a phenomenon that seems to be common to all colonial regimes. Cicero recalls that at the end of the second century B.C. the Romans had prohibited the Gauls from planting grapes. The Roman state was certainly not indifferent to "business"; the Italic producers of wine and oil were the same land-owners who, as senators, directed Roman policy.

A class of entrepreneurs was gradually formed, which consisted of so-called "equestrians" who had become rich through trade and through contracts for tax-collection in the provinces. The Roman and Italic merchants literally swarmed in the provinces. Inscriptions at Delos have left us the best testimony of this impressive phenomenon, together with the so-called "Agora of the Italians," a grandiose colonnaded square. It is likely this was the slave market, for which Delos served as the principal clearing-center.

Great fortunes must have been made in this period, if the prosperity that characterized the Campanian cities is a good example. At Pompeii, during the course of the second century and the beginning of the first century, both public and private building went forward with vigor. In some cases the relation between these new structures and the new wealth derived from trade can be proved, as with Marcus Portius and Gaius Quinctius Valgus, whose names are connected with Pompeii's covered theater, or "Little Theater," the Amphitheater, and the Temple of Apollo.

The Little Theater of Pompeii (it was originally covered, according to the dedicatory inscription) is one of the best preserved of the Roman type. It was most likely used as an odeum for musical events and public readings of literary works, while the older "Great Theater" nearby was used for regular theatrical productions. The sculptural decoration that decorates the ends of the tiers in the Little Theater, telamones and griffins' claws, is of the same type found in two other Roman theaters, at Pietrabbondante in Sannio (present-day Molise) and another recently discovered at Foce di Sarno, near Nocera. The former can be dated around 100 B.C.; the latter is about two decades older. The Great Theater of Pompeii, the nearest in form and dimensions to these two edifices, can also be placed in the second century, although it was modified during the Augustan Age. It is probable that in its oldest phase, it had the same kind of decoration later found on the newer Little Theater. The date of the Little Theater can be placed with some precision. An inscription twice repeated states that the magistrates (mayor-like officials) of the colony, M. Portius and C. Quinctius Valgus, built it. It is nearly certain, then, that the building was erected after the Social War (91-88) and after Sulla's creation of the colony of Pompeii, but not much later.

The same personages built the Amphitheater, the oldest remaining one known. The structural system used in it is interesting; the tiers were partially cut out of the earth and partially raised on a platform. The double ramps that give access to the seats, resting on a series of arches of decreasing size, are similar to the central ramp at Palestrina. Both the Amphitheater and the Little Theater seem to belong to the same period. The name M. Portius reappears on the altar of the Temple of Apollo at Pompeii (his funerary inscription has also been preserved); it, too, was built in this period.

C. Quinctius Valgus is known from various sources. An inscription at Mirabella Eclano (ancient Aeclaneum, in Irpinia), records him as one of the magistrates who raised the boundary wall that Sulla later destroyed, during the Social War. Another inscription from an ancient center nearby records other constructions (city wall, gates, the forum, the cisterns, the senate-house) attributed to the same man. Finally, a freedman of Valgus' is noted by an inscription at Cassino. The name Quinctius Valgus is recorded by Cicero as well, who talks of him as a rich landowner who made his money by rather shady methods in Sulla's retinue during the Civil War (88-82). Cicero specifies that Valgus possessed all the Irpine territory and a part of Cassino, which confirms the inscriptions.

The case of M. Portius must be of the same sort. Besides his funerary inscription, there is one more source of information concerning him: a series of amphoras bearing the inscription "M. Porci," discovered in various cities of ancient Gaul, from Narbonne to Bordeaux. A specimen of the same sort has been found at Pompeii. The amphoras, which were used for wine, can be dated at the first half of the first century B.C., and it seems likely that the M. Portius, whose name appears on these seals, is the Pompeian of the same name who was a magistrate, builder, and certainly a great landowner in the Sullan colony of Pompeii (the production of wine being most important in the Pompeian countryside).

THE CAREER OF CAIUS RABIRIUS POSTUMUS, A BUSINESSMAN OF THE FIRST CENTURY B.C.

For, when we were children, this man's father Caius Curius was a most gallant chief of the equestrian order, and a most extensive farmer of the public revenues, a man whose greatness of spirit as displayed in carrying on his business men would not have so greatly esteemed, if an incredible kindness had not also distinguished him; so that while increasing his property, he seemed not so much to be seeking to gratify his avarice, as to procure additional means for exerting his kindness. My client, being this man's son, although he had never seen his father, still under the guidance of nature herself, — who is a very powerful guide, — instigated by the continual conversation of every one in his family, was naturally led on to adopt a similar line of conduct to that of his father. He engaged in extensive business. He entered into many contracts. He took a great share of the public revenues. He trusted different nations. His transactions spread over many provinces. He devoted himself also to the service of kings. He had already previously lent a large sum of money to this very king of Alexandria; and in the mean time he never ceased enriching his friends; sending them on commissions; giving them a share in his contracts; increasing their estates, or supporting them with his credit. Why need I say more? He gave a faithful representation of his father's career and habits of life in his own magnanimity and liberality.

CICERO: *Oration Against C. R. Postumus* (II)

THE AGRARIAN LAW OF P. SERVILIUS RULLUS (63 B.C.)

But now see the force of this agrarian law. Even those men who are in occupation of the public domains will not quit possession, unless they are tempted by favourable conditions and by a large sum of money. Matters are changed. Formerly when mention of an agrarian law was made by a tribune of the people, immediately every one who was in occupation of any public lands, or who had any possessions the tenure of which was in the least unpopular, began to be alarmed. But this law enriches those men with fortunes, and relieves them from unpopularity. For how many men, O Romans, do you suppose there are, who are unable to stand under the extent of their possessions, who are unequal to bear the unpopularity incurred by the ownership of lands granted by Sylla? who wish to sell them, but cannot find a purchaser? who, in fact, would be glad to get rid of those lands by any means whatever? They who, a little while ago, were in constant dread, day and night, of the name of a tribune; who feared your power, dreaded every mention of an agrarian law; they now will be begged and entreated to be so good as to give up to the decemvirs those lands which are partly public property, the possession of which is full of unpopularity and danger, at their own price. And this song this tribune of the people is singing now, not to you, but in his own heart to himself. He has a father-in-law, a most excellent man, who in those dark times of the republic got as much land as he wanted. He now seeing him yielding, oppressed, weighed down with the burdens which Sylla put upon him, wishes to come to his assistance with this law of his, so as to enable him to get rid of the odium attached to him, and to get a sum of money too. And will not you hesitate to sell your revenues, acquired by the profuse expenditure of labour and blood on the part of your ancestors, for the purpose of heaping more riches on the landowners who have become so through Sylla, and of releasing them from danger?

CICERO: *Oration Against P.S. Rullus* (XXVI)

Pompeii: The "Barracks of the Gladiators."
This was the rear portico of the Great
Theater of this city near Vesuvius and,
like it, was built in the second century
B.C. During the Imperial Age the building
was used as a barracks for gladiators.(The
splendid gladitorial arms now kept in the
Naples National Museum come from here.)

Because of this series of fortunate archaeological finds it is possible to identify not only the magistrates responsible for public construction in a small city in Campania but their social origin as well. Landed property, no matter how it was acquired, was obviously the basis of political power. The relationship with Sulla and the Civil War suggests something about the origins of this wealth, for the dictator's partisans had enormous advantages, which they may have pressed through massive expropriation of land, at the expense both of the Italic people and of the partisans of Marius, Sulla's unlucky antagonist. A lucrative overseas trade in oil and wine further enriched the big landowners. Such landowners, then, were connected on the one hand with the rich merchant corporations and on the other with the politicians (when they were not themselves part of the Roman political class) and both groups were able to guarantee them strong state protection.

Often the interests of the landowners encouraged Roman expansionism, as in the case of Carthage and Corinth which posed no military threat to Rome. The destruction of these commercial centers can be attributed to such an important landowner as Cato. To emphasize the commercial danger Carthage posed, Cato once exhibited in the

Pompeii: The Forum. 466 feet long by 124 feet wide, the Forum of Pompeii is one of the most complete and best preserved examples of this type. Some of the columns visible in the foreground are made of tufa and belong to the Republican Age complex, which includes the Temple of Jupiter. Visible in the background to the right, it was constructed in the middle of the second century B.C. Half-destroyed by earthquake in A.D. 63, the Forum was being restored when Vesuvius (in the background) erupted in A.D. 79.

THE THEATER IN ROME IN THE REPUBLICAN AGE

There were some who alleged, that Pompey too was censured by our ancestors, for having founded a permanent theater; till then, the spectacles used to be exhibited on temporary stages, and were seen from seats raised on the moment: or, if times more remote were consulted, the people would be found to have stood to behold them; lest, had they been indulged with seats, they should consume whole days in the theater from idleness. In truth, the primitive rule in popular shows would be preserved, as often as the praetors should exhibit them, if no Roman citizen were compelled to enter the lists; but now, the usages of our country, which had long been gradually disappearing, were utterly obliterated by imported extravagances, so that at Rome might be seen, from all quarters, whatever was corrupting or corrupt; and the Roman youth were degenerating from the virtue of their ancestors, by the introduction of foreign tastes, by habituating them to gymnastics, to idleness, and filthy amours; and that under the sanction of the prince and senate, who not only have granted a dispensation for vices, but now enforce them; and the chief men of Rome are exposed to scenic pollutions under pretense of encouraging poetry and eloquence.

TACITUS: *The Annals* (XIV:20)

THE THEATER OF SCAURUS

During his aedileship, and only for the temporary purposes of a few days, Scaurus executed the greatest work that has ever been made by the hands of man, even when intended to be of everlasting duration; his Theater, I mean. This building consisted of three storeys, supported upon three hundred and sixty columns; and this, too, in a city which had not allowed without some censure one of its greatest citizens to erect six pillars of Hymettian marble. The ground-storey was of marble, the second of glass, a species of luxury which ever since that time has been quite unheard of, and the highest of gilded wood. The lowermost columns, as previously stated, were eight-and-thirty feet in height; and, placed between these columns, as already mentioned, were brazen statues, three thousand in number. The area of this theater afforded accommodation for eighty thousand spectators; and yet the Theater of Pompeius, after the City had so greatly increased, and the inhabitants had become so vastly more numerous, was considered abundantly large, with its sittings for forty thousand only. The rest of the fittings of it, what with Attalic vestments, pictures, and the other stage-properties, were of such enormous value that, after Scaurus had had conveyed to his Tusculan villa such parts thereof as were not required for the enjoyment of his daily luxuries, the loss was no less than three hundred millions of sesterces, when the villa was burnt by his servants in a spirit of revenge.

PLINY THE ELDER:
Natural History (XXXVI)

Senate some huge figs he had brought from Africa. More than Carthage's arms, Cato feared Punic competition in agricultural products. Plutarch relates that Cato lent money to certain maritime insurance companies. His investment in foreign trade seems to have paid off. When Jugurtha, the king of Numidia attacked Cirtha (perhaps present-day El Kef, in Tunisia) at the end of the second century B.C., the Roman merchants there were so numerous that they were able to organize the defense of the city by themselves.

It is possible to conclude, then, that the class of great landowners, merchants, and tax-contractors asserted itself with the ancient Roman aristocracy. The artistic culture of the elite in Rome, with its conscious importation of Greek works and artists, belonged with equal right to this new stratum of society, the equestrians. The same sculptors who worked in Rome, executing cult images and portraits for the great families such as the Metelli and the Scipios, were employed to execute the portrait of a Roman merchant in Delos; and the circular marble temple near the Tiber (mentioned earlier), the work of a Greek architect, was probably built at the expense of an oil merchant.

Resistance to Hellenistic Influence

By the first century B.C. an empire extending to almost all the shores of the Mediterranean depended on the ruling classes of Rome. Because of their aristocratic class structure, they tended to retain a patriarchal mentality of sobriety combined with a peasant-like toughness or stubbornness. This deep-seated character was undeniably a decisive factor in the Roman political struggle. Everyone had to reckon with it sooner or later. Both the aristocratic or "optimate" party and the party of the "populares" followed the line of "old rusticity," claiming priority for their party and accusing their opponents of "corruption." Without taking Roman character into consideration, it is difficult to understand anything about the political events of the late Republic. Although perhaps negligible in the eyes of modern society, it was fundamental for the Romans.

When Rome became the capital of a world empire, riches and capital came pouring in, and with it the luxury and art of the Hellenistic kingdoms. A serious state of political and cultural imbalance was the result. From a political point of view, the disproportion was between the resources and administrative structures of a small city-state, which had remained fundamentally unchanged for centuries, and the new dimensions of the empire. From a cultural and ideological point of view, there was a similar disproportion between the myopic and moralistic vision of the old noble ranks, and the impetuous eruption of new ideas, new artistic forms: a new way or "style" of life was the problem.

Yet this was not a continuous, linear development, in which the Romans passed from a substantially primitive mentality to a Hellenistic "modern" one. The Roman-Italic civilization of the fourth and third centuries was anything but primitive. It was already permeated with elements of Greek culture, but of the oldest Greek culture, that belonging to the colonial cities of Magna Graecia. This latter was the culture of an essentially agricultural society, quite different from the cosmopolitan worldliness of the great Hellenistic kingdoms. But it is wise to beware of considering Greece and early Rome as two worlds, two diametrically opposed and monolithic structures.

The Hellenistic culture that arrived in Rome in the second century was quite different. It was almost the opposite, in a certain sense, of the culture of archaic and classical Greece; it had become a civilization of great centralized, monarchical states as opposed to small, fiercely independent city-states.

Developments in Rome during the second century can be summarized as follows: after an initial phase of intense, though superficial, Hellenization, typical of the first years following a conquest, there was a violent "conservative" reaction. Cato was the principal representative of this. His censure became proverbial. It is symptomatic of this process, however, that it was Cato himself who introduced a new type of building to Rome, the basilica; even its name betrays its Greek origin. This is an essential point to stress: Roman traditionalism is not contrary to novelty as such, but rather to elements unable to be absorbed usefully by the existing structures. The Romans were eminently practical people. In the fields that interested them, such as agriculture and the art of warfare, they assimilated new elements rapidly and smoothly. The treatise on agriculture by the Cathaginian Mago was officially translated; the Roman army adopted the arms of their enemies, if such arms seemed better than their own — the Spanish sword, the Gallic shield, etc.

On the other hand, innovations that threatened to break up the identity between private and public life (the citizen is a public man

Pompeii: Little Theater. A sheltered theater, used as an odeum to complement the activities of the more ancient Great Theater. It was built, according to two inscriptions, by the same magistrates responsible for the Amphitheater, and thus was erected, like it, shortly after the foundation of the Sullan colony. The same type of decoration, with telamones and griffins' claws, is to be found in two other theaters: at Pietrabbondante in Sannio and the recently discovered theater in Foce di Sarno, near Nocera in Campania.

first of all) were always met with fierce opposition: Epicurean philosophy, certain types of spectacle, private luxury. The public aspects of Hellenistic culture were accepted as such more easily than the private aspects. The private aspects eventually penetrated, too, but in Roman culture there always remained a kind of guilty conscience. It seemed impossible to admit in public what one did in private. This curious duplicity is seen even in Cicero. In his famous orations against Verres, when he had to refer to the Greek sculptor Polycletus, one of whose statues had been stolen by the corrupt governor of Sicily, he pretended he had forgotten the sculptor's name and asked his secretary to tell him. "Who? Oh yes, . . . a certain Polycletus." Cicero's letters to Atticus, written at about the same time as his orations were delivered, reveal him to be a most refined connoisseur of Greek art. He asks his distant friend to send him some statues to decorate his Villa Tusculanum, and trembles with expectation, so anxious is he to contemplate them. Even during the Imperial Age, when luxury had already reached a level rarely realized in other civilizations, one of the richest persons in the imperial court, the philosopher Seneca, lost no time in praising

first of all) were always met with fierce opposition: Epicurean philosophy, certain types of spectacle, private luxury. The public aspects of Hellenistic culture were accepted as such more easily than the private

the frugality and poverty of the ancient Romans and citing their habits as good examples.

Again, though, a distinction must be made. Being practical, the Romans had nothing against wealth per se. The peasant avariciousness of the Roman was quite different, however, from the open and enterprising mentality typical of commercial peoples such as the Greeks or the Carthaginians. The essential thing for the Roman, was to maintain a sober and patriarchal style of life and not to abandon himself to vulgar displays of wealth or to rash spending. So it was a problem of form more than of substance. For a Roman of the Republic it was perfectly moral to exploit the Greeks, to use slaves as beasts of burden with the least expense and the greatest profit and then get rid of them when they became old or ill (the example comes from Cato's treatise on agriculture, that mirror of every Roman virtue). It was, however, immoral and reprehensible to use silver at table, dress in the Greek fashion, or speak of useless and dangerous things such as art and philosophy.

While Greek art and techniques established themselves rapidly in the public sphere, their penetration of private life was much slower and later in developing. The higher the social level and the greater the political importance of the persons involved, the slower the penetration. While in Campania, houses and villas of high artistic worth were to be found as early as the middle of the second century, there was nothing similar in Rome until the end of the century. The villa of Scipio Africanus at Literno was described by Seneca as a kind of gloomy fort, with a small and obscure bath in which a Roman of the Imperial Age would have refused to wash. The sepulcher of the Scipio family, who dominated Roman politics in the second century and were considered kings outside their country, astonishes by its poverty and simplicity. The contemporary monumental tombs of Etruria, belonging to persons who would have been happy to be counted among the Scipios' clients, were much richer. In 155 B.C. Scipio Nasica ordered the destruction of a brick theater being built by the censors at the foot of the Palatine, and prohibited the erection of theaters less than a mile from the city. At the same time, almost every little city in Italy had its own brick theater.

By the end of the second century B.C., however, and above all during the first, private life became as completely and sumptuously Hellenistic as public life had already become. Some traces of the old mentality remained, but most were of the sort described above in connection with Seneca and Cicero.

Development of the Hellenistic-Roman House

The same simplicity noted in the Scipios' tomb was to characterize the houses of noble Romans for the greater part of the second century. But from that time on, a new type of house was introduced, the result of the fusion of the ancient Italic dwelling, with its atrium, and the Hellenistic house with its peristyle. (The atrium was an inner court, roofed at the edges but with the center open to the sky; the peristyle is a colonnade surrounding an open court.) As for the decoration of the interior, the so-called First Style, which consisted of stucco painted to imitate walls made of regular, square blocks, must have prevailed even in Rome. In Rome no well-preserved houses of the second century B.C. have yet been discovered. The best examples are to be found in the Campanian cities destroyed by Vesuvius, Pompeii and Herculaneum. It is unlikely that there existed in Rome houses as elaborate as the "House of the Faun," not because of any supposed priority Campania had over Rome (Campania in the first century was in fact economically and culturally a part of the Eternal City). Rather, ideological motives prevented the Roman ruling class from exagger-

Herculaneum: House of the Wooden Partition, the atrium. One of the most famous houses of the Republican Age, it was restored during the Imperial Age, and increased in height. The basin of the impluvium at the center shows the two phases of construction.

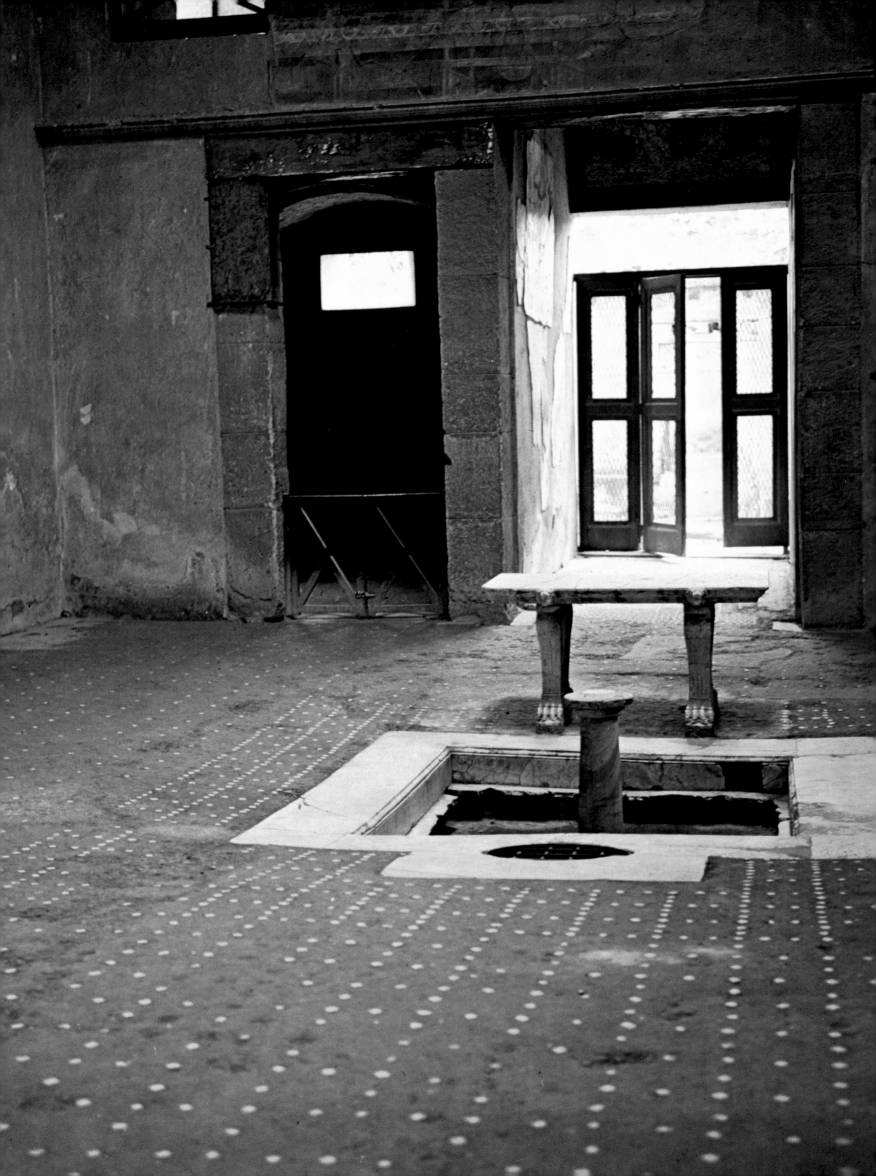

The Mosaic of Alexander, from the House of the Faun in Pompeii. Second century B.C. This is the most important and elaborate mosaic of the Hellenistic period known. Almost certainly executed by Greek artists, probably from Alexandria, it may have been imported already complete, rather

than executed on the spot. Like all mosaics
of the period, it takes its inspiration from
a great painting, perhaps the work of
Philoxenes of Eretria, depicting one of the
battles between Alexander and Darius
(either at Issus or Gaugamela). (Naples
National Museum).

ated private luxury, whereas the same motives posed no obstacles for Campanian aristocrats, landowners, and merchants.

The Hellenistic-Roman dwelling with its elegant architectural forms, ornamental paintings, sculptures, and gardens, was one of the most refined products of ancient civilization. Its sudden appearance in the second century has been regarded, as has almost everything in Roman art, in two diametrically opposed ways. Some scholars have seen it as a totally original product of the Italic world; others view it as a simple importation from the Greek world. A glance at the plan of the Hellenistic-Roman dwelling shows, however, that it is just that: the result of the juxtaposition of an Italic house with atrium and a Hellenistic house with peristyle. It is again a phenomenon of assimilation. The first examples merely mix elements from both traditions. Only later is a new type created in which the various elements are seen to merge perfectly. Roman private architecture has a history similar to that of the other arts, from monumental architecture to sculpture and painting.

That one part of the house, surrounding the peristyle, is of Greek origin is shown first of all by the Greek terms which were used to describe it: *oecus* (sitting room), *diaeta* (bedroom), *peristilium* (court or portico with columns), etc. Even the so-called Pompeian painting styles, and the decoration of the house — unlike the structural elements and the building technique — clearly are Greek in origin. The oldest of them, the First Style mentioned above, was a common style of wall decoration in Greece and the Hellenistic cities from the fourth century B.C. onward.

One principal objection made to this formulation of the development of the Roman house is that, in Greece and in the principal Hellenistic cities, there is nothing similar to what is found in Italy. The dwellings there almost never equal those of Pompeii and Herculaneum, either in size or in decorative richness. Yet very little remains of the residential areas of the large Hellenistic cities, from Antioch to Seleucia to Alexandria, and the preservation of the Campanian cities themselves is due to an extraordinary event, the eruption of Vesuvius in A.D. 79. Above all, though, the model for the aristocratic Hellenistic-Roman house is not to be found so much in the common Greek dwelling as in the palaces of the Hellenistic sovereigns. An example is still standing at Pergamon. It is fairly clear that the economic power of a rich landowner, or a banker, or a tax administrator, must have been at least as great as a senator's, and Polybius reports that a Roman senator's patrimony could be compared in Greece only to a king's. This is less surprising if it is recalled that the Roman conquest had drained almost all the wealth of the Mediterranean into Italy.

This can be confirmed by examining some Pompeian houses, particularly the "House of the Faun." Its size alone is indicative of its importance. It occupies an entire block, a lot of about 6500 square yards, slightly less than the size of the so-called "Palace of Columns" at Ptolemais (certainly the Ptolemaic governor's house), and much larger than the king's palace at Pergamon. The building has two atriums and two peristyles, one of which is particularly large — 138 by 128 feet (Ptolemais palace: 95 feet by 82 feet; Pergamon palace: 115 feet by 115 feet). Still more impressive is the high level of decoration. An *exedra*, or semicircular recess, included among the two peristyles, was paved with the celebrated "Mosaic of Alexander" (now housed in the Naples National Museum), one of the most elaborate and finely made examples from the Hellenistic world. It was executed in the second century B.C. by a Greek artist, probably from Alexandria. Smaller mosaics of similar high quality decorated other parts of the house. A small bronze statue of a satyr (rather than a faun) was set at the center of the impluvium and gave the house its name. (The impluvium was the basin in the center of the atrium to catch rainwater from the open roof.) The name of the house's owner is unknown. He

THE FIRST USE OF MARBLE IN PRIVATE HOUSES IN ROME

The first person at Rome who covered the whole of the walls of his house with marble, according to Cornelius Nepos, was Mamurra, who dwelt upon the Caelian Hill, a member of the equestrian order, and a native of Formiae, who had been praefect of the engineers under C. Caesar in Gaul. Such was the individual, that nothing may be wanting to the indignity of the example, who first adopted this practice; the same Mamurra, in fact, who has been so torn to pieces in the verses of Catullus of Verona. Indeed, his own house proclaimed more loudly than Catullus could proclaim it, that he had come into possession of all that Gallia Comata had had to possess. For Nepos adds, as well, that he was the first to have all the columns of his house made of nothing but solid marble, and that, too, marble of Carystus or of Luna.

M. Lepidus, who was consul with Q. Catulus, was the first to have the lintels of his house made of Numidian marble, a thing for which he was greatly censured; he was consul in the year of Rome, 676. This is the earliest instance that I can find of the introduction of Numidian marble; not in the form of pillars, however, or of slabs, as was the case with the marble of Carystus, abovementioned, but in blocks, and that too, for the comparatively ignoble purpose of making the thresholds of doors. Four years after this Lepidus, L. Lucullus was consul; the same person who gave its name, it is very evident, to the Lucullan marble; for, taking a great fancy to it, he introduced it at Rome. While other kinds of marble are valued for their spots or their colours, this marble is entirely black. It is found in the island of Melos, and is pretty nearly the only marble that has taken its name from the person who first introduced it. Among these personages, Scaurus, in my opinion, was the first to build a theater with walls of marble: but whether they were only coated with slabs of marble or were made of solid blocks highly polished, such as we now see in the Temple of Jupiter Tonans, in the Capitol, I cannot exactly say: for, up to this period, I cannot find any vestiges of the use of marble slabs in Italy.

THE FIRST PAVEMENTS USED IN ROME

The first pavements, in my opinion, were those now known to us as barbaric and subtegulan pavements, a kind of work that was beaten down with the rammer: at least if we may form a judgment from the name that has been given to them. The first diamonded pavement at Rome was laid in the Temple of Jupiter Capitolinus, after the commencement of the Third Punic War. That pavements had come into common use before the Cimbric War, and that a taste for them was very prevalent, is evident from the line of Lucilius —

"With chequered emblems
 like a pavement marked."

Mosaic pavements were first introduced in the time of Sylla; at all events, there is still in existence a pavement, formed of small segments, which he ordered to be laid down in the Temple of Fortune, at Praeneste. Since his time, these mosaics have left the ground for the arched roofs of houses, and they are now made of glass. This, however, is but a recent invention; for there can be no doubt that, when Agrippa ordered the earthenware walls of the hot baths, in the Thermae which he was building at Rome, to be painted in encaustic, and had the other parts coated with pargetting, he would have had the arches decorated with mosaics in glass, if the use of them had been known; or, at all events, if from the walls of the Theater of Scaurus, where it figured, as already stated, glass had by that time come to be used for the arched roofs of apartments.

PLINY THE ELDER:
Natural History (XXXVI)

Pompeii: Plan of the House of Sallust. An example of the Italic atrium-type house (third century B.C.).

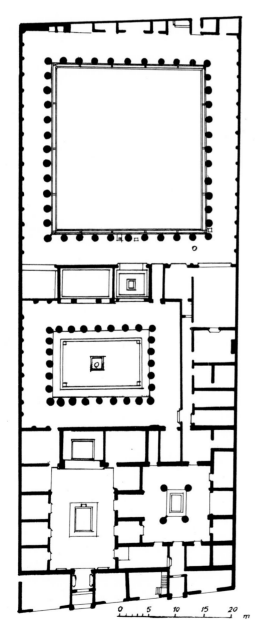

Pompeii: Plan of the House of the Faun (second century B.C.).

was probably one of the local aristocrats, or a landowner who became rich dealing in wine. At any rate the house is a magnificent example of the economic and cultural level of a rich Campanian of the second century B.C. Other houses, less elaborate but equally elegant, may be found at Pompeii and Herculaneum. In Herculaneum the so-called "House of the Samnite" has a magnificent monumental atrium with two sets of columns, an architectural style to be found in the Hellenistic Palace of Columns at Ptolemais.

The Private House in Rome

Some houses of the late second century B.C., with decorations in primitive Second Style, have been discovered in Rome on the Palatine. The best-preserved and most well-known is the so-called "House of the Griffin," built around 100 B.C. and then covered up during the time of Domitian by construction of the *Domus Flavia*. The house is of modest size, especially when compared to the larger Pompeian houses. The Palatine was, however, the most sought-after residential zone in Rome. Land was extremely expensive, as were the houses. A relatively modest house there would certainly be more costly than the houses of a small provincial center such as Pompeii, or the larger suburban villas. Cicero's correspondence gives interesting proof of this. His house on the Palatine, which he bought from Crassus in 62 B.C., cost him 3,500,-000 sesterces, whereas his Villa Tusculanum was worth only about 900,000 sesterces. In fact, even after Clodius had destroyed them, they were valued by the consul at 2,000,000 and 500,000 sesterces respectively. Cicero's Villa Formianum was worth even less; on that same occasion it was valued at 250,000 sesterces. In comparison, the lovely house of Rabirius, in Naples, was sold in 68 B.C. for 130,000 sesterces, according to Cicero.

The beautiful houses in Pompeii must have cost even less. The price of oil in Rome in Cicero's time can serve as a measure of comparison. It cost two or three sesterces a liter. In Pompeii at the beginning of the Imperial Age, a *modius* of wheat (about fifteen pounds) cost three sesterces (and one pound of bread cost about five-eighths of a sesterce); a liter of oil cost about three sesterces; a mule 520 sesterces; two slaves, 5,048 sesterces. (It would not be too far from the truth to calculate the value of the sesterce in this period at about fifty U.S. cents.)

Both the richness and the esthetic level of dwellings at Rome increased rapidly from the end of the second century. They reached their peak about the middle of the first century. What the ancient writers have to say about the use of marble, columns, mosaics, and paintings in the houses of people like Crassus, Clodius, and Scaurus smacks of the fabulous. Yet certain remains verify their accounts. For example, some fragments of a mosaic with a fish, which come from the Vio Panisperna, can be dated at around the beginning of the first century B.C. They represent one of the most refined examples of Hellenistic art, on the same level as the mosaics preserved in Pompeii's House of the Faun (where, incidentally, a square mosaic piece with the same subject has been discovered). Comparison with a similar mosaic in the lower part of the Palestrina sanctuary, probably also executed in this period, permits the attribution of all these fragments to the shop of Alexandrian artisans.

There is evidence of the presence of Alexandrian artists in Rome as early as the first half of the second century B.C. In fact, in 165 B.C., it is known that Demetrius, an Alexandrian painter who had moved to Rome, entertained King Ptolemy VI Philometor, then in exile. This painter is remembered as the "topographer," which, reasoning etymologically, probably means "landscape painter." Painters such as Demetrius are given credit for introducing landscape painting into Rome; it is amply developed in wall paintings of the Second Style.

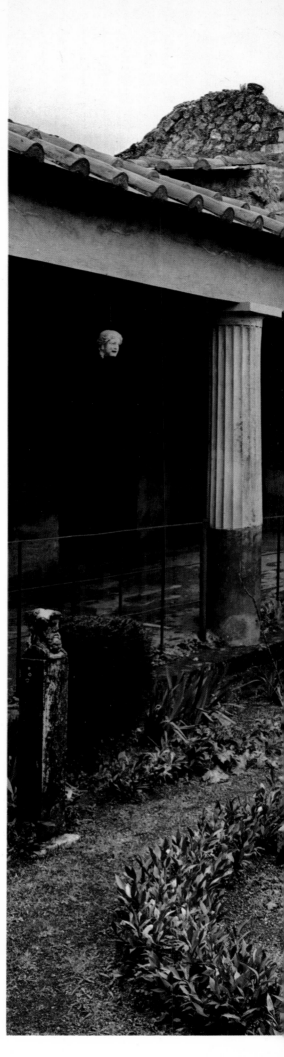

Above:
Rome: Fragment of a mosaic with fish, from Via Panisperna. Beginning of the first century B.C. As in the case of an identical example at Palestrina, this is a work executed in Rome by Greek artists. It is remarkable for the refinement and variety of its colors and tones. (Antiquario Communale, Rome.)

Right:
Pompeii: House of the Golden Cupids. The peristyle. Built during Nero's time, the house belonged to Gneus Pompeius Abitus. The colonnade, with marble decorations hanging from the architrave, surrounds the garden. The house is one of the most interesting in Pompeii from the Julian-Claudian Age.

Pompeii: Plan of the Forum
1 *Main Square*
2 *Basilica*
3 *Temple of Apollo*
4 *Temple of Jupiter Capitolinus*
5 *Food market* (macellum)
6 *Temple of the Lares*
7 *Temple of Vespasian*
8 *Eumachia Building*
9 *Comitium* (municipal elections)
10 *Hall of the Duumvirs*
11 *Curia*
12 *Hall of the Aediles*

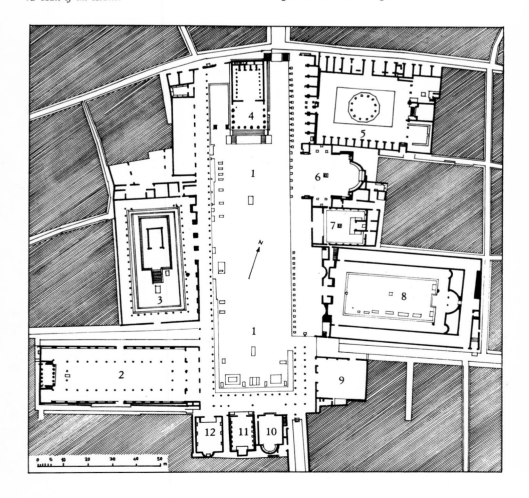

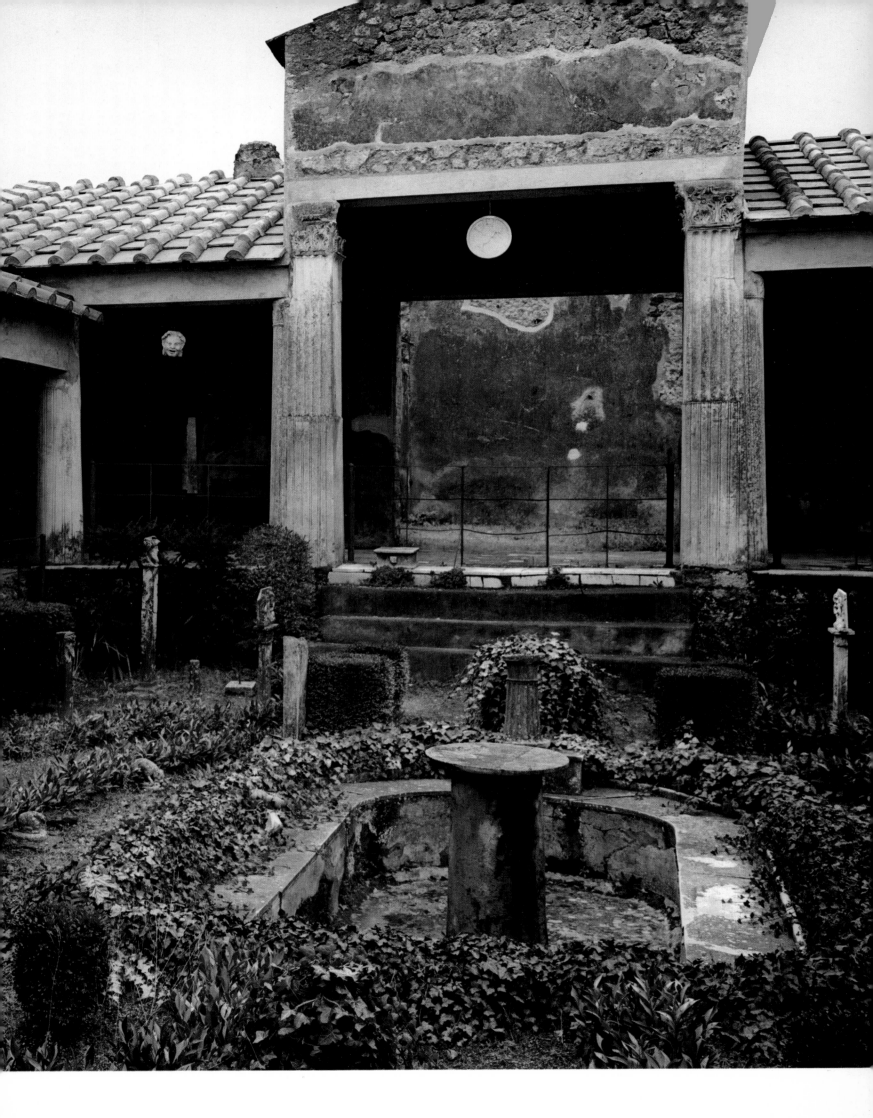

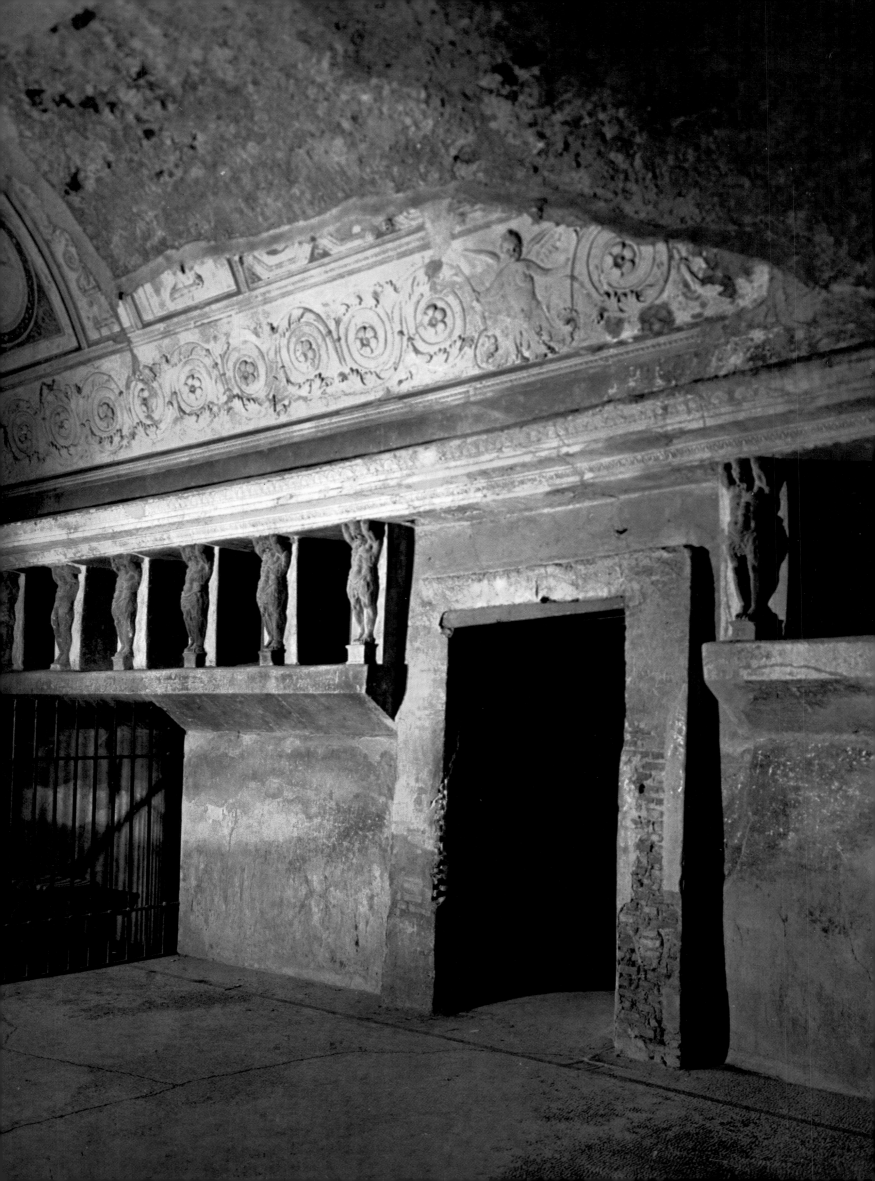

There is a temple of Hercules at Agrigentum, not far from the forum, considered very holy and greatly reverenced among the citizens. In it there is a brazen image of Hercules himself, than which I cannot easily tell where I have seen anything finer; (although I am not very much of a judge of those matters, though I have seen plenty of specimens;) so greatly venerated among them, O judges, that his mouth and his chin are a little worn away, because men in addressing their prayers and congratulations to him, are accustomed not only to worship the statue, but even to kiss it. While Verres was at Agrigentum, on a sudden, one stormy night, a great assemblage of armed slaves, and a great attack on this temple by them, takes place, under the leading of Timarchides. A cry is raised by the watchmen and guardians of the temple. And, at first, when they attempted to resist them and to defend the temple, they are driven back much injured with sticks and bludgeons. Afterwards, when the bolts were forced open, and the doors dashed in, they endeavour to pull down the statue and to overthrow it with levers; meantime, from the outcries of the keepers, a report got abroad over the whole city, that the national gods were being stormed, not by the unexpected invasion of enemies, or by the sudden irruption of pirates, but that a well armed and fully equipped band of fugitive slaves from the house and retinue of the praetor had attacked them. No one in Agrigentum was either so advanced in age, or so infirm in strength, as not to rise up on that night, awakened by that news, and to seize whatever weapon chance put into his hands. So in a very short time men are assembled at the temple from every part of the city. Already, for more than an hour, numbers of men had been labouring at pulling down that statue; and all that time it gave no sign of being shaken in any part; while some, putting levers under it, were endeavouring to throw it down, and others, having bound cords to all its limbs, were trying to pull it towards them. On a sudden all the Agrigentines collect together at the place; stones are thrown in numbers; the nocturnal soldiers of that illustrious commander run away — but they take with them two very small statues, in order not to return to that robber of all holy things entirely empty-handed.

CICERO: *Oration Against Verres*

Pompeii: The Baths of the Forum. The tepidarium. Built, like many other public buildings in the city, at the beginning of the Sullan colony, these thermae were one of the three existing bathing installations. The rich stucco decoration dates to the last phase of the Pompeian life, just before the eruption.

The most important group of these paintings left to us has been discovered at Rome: a complete cycle of paintings with episodes from the *Odyssey*, dating back to about 50 B.C., which was found in a house on the Esquiline Hill. They represent the most advanced landscape painting left by ancient artists. These are not paintings of human figures, with landscape used as background. They are, instead, painting in which nature dominates; its figures are only secondary. The concept was one reached by European painters only in the 17th century. The originals from these frescoes drew their inspiration — very similar to "Nile" mosaics such as the celebrated Palestrina mosaic — must date back to the second century B.C. and are certainly to be attributed to Alexandrian art. In this context the information about Demetrius the "topographer," active in Rome about 165 B.C., takes on documentary value.

The Roman Villa

Contemporaneous with the new Hellenistic-Roman house, a new type of private dwelling grew up that was destined to have a great future: the villa. There are Hellenistic models for it, of course, in the royal villas that must have existed in Syria and Egypt. And here again what began as a limited phenomenon spread rapidly in Rome, where affluence was the normal condition for a large part of the elite. The oldest type of villa, which Vitruvius, the Augustan architect and critic of architecture, calls "pseudo-urban," was built near to the cities as a place of rest, for that literary and philosophical "idleness" which the Roman and Italic ruling class, by now imbued with Greek culture, took pleasure in. The letters and treatises of Cicero furnish us with the most direct and complete documentation of this new way of life, which may have been inaugurated by the Scipios' circle. All the technical know-how and artistic novelties of the period were utilized in the arrangement, construction, and embellishment of the buildings. Landscape artists and other specialists in gardening from the Hellenistic Near East were employed. Statues and pictures by the great Greek artists of the past decorated the villas of the richest persons, or of those less given over to scruples (the example of Verres was certainly not an isolated one). For those less affluent, there were copies of these originals, and many Greek artisans' and artists' shops, especially in Athens, concentrated on production of these copies, predominantly for the Roman market.

By chance, the entire cargo of a ship, wrecked at the end of the second century B.C. near the Tunisian coast, has been preserved; it included columns and capitals, bronze and marble statues (one of which was signed by a noted Hellenistic sculptor, Boethus), bronze decorative pieces for furniture, and marble vases. The ship was almost certainly headed for Italy. Its cargo was probably intended as the decoration for a villa of the same type as the so-called Papyrus Villa in Herculaneum, from which a valuable group of art objects has been gathered. A little later, Cicero wrote the letter to his friend Atticus, mentioned above, asking for statues for his Villa Tusculanum.

The most beautiful example of a luxury villa extant (and one of the oldest) is the famous Villa of Mysteries at Pompeii. The original house must date back to the second century B.C., while the present building corresponds to a period a little after the foundation of Sulla's colony there, and so may have been erected sometime between 70 and 60 B.C. Immediately striking in this and similar buildings, in contrast to the urban house, is its openness to the surrounding space and the countryside. Yet the house is definitely an enclosed space, separated from the world outside, containing both its own sources of light and its own garden. Inside, large windows and doors open onto balconies covered by porticoes and raised on high structures. Views are calculated and coordinated with care, and indicate the work of landscape artists and

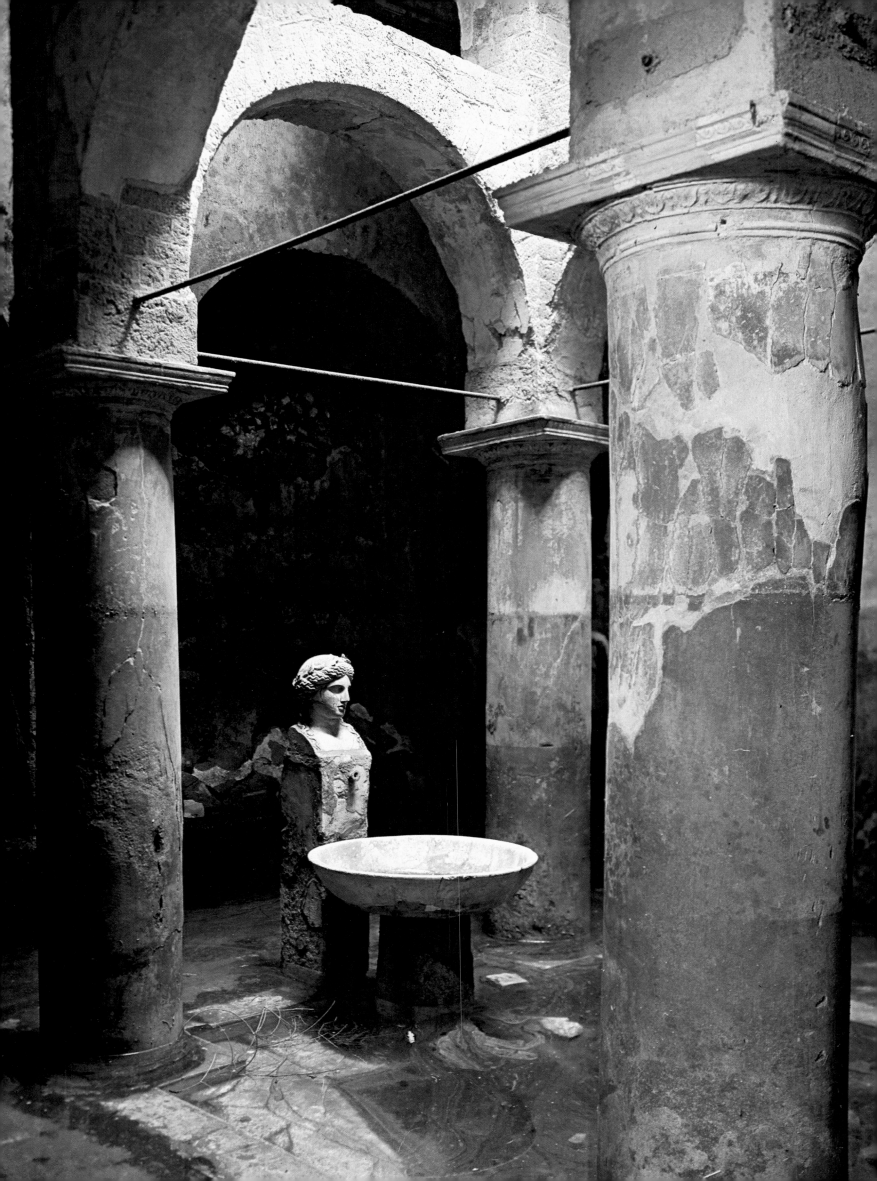

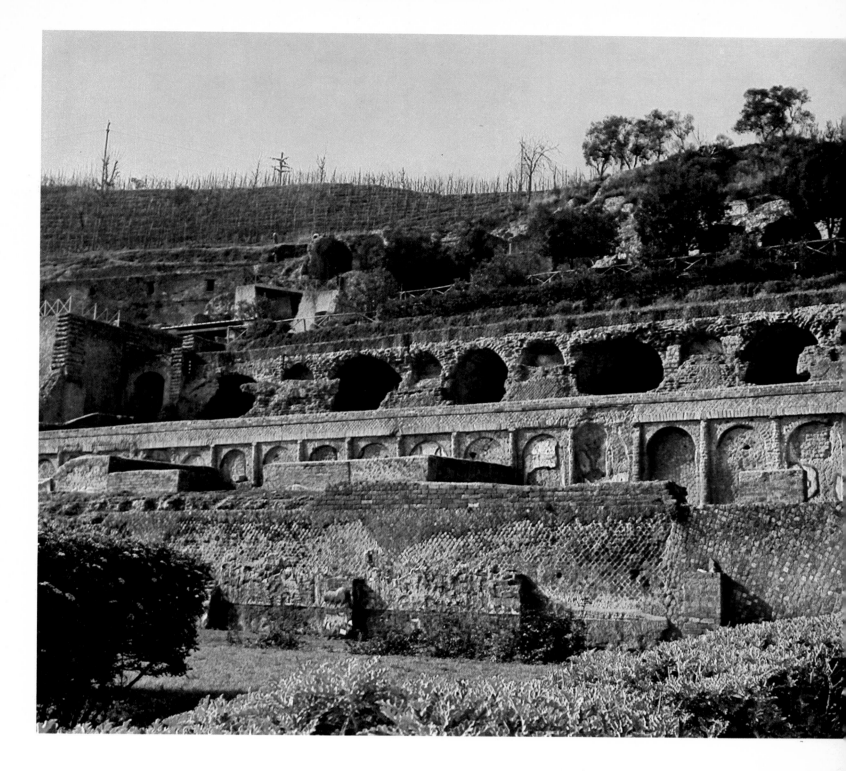

Above:
Baia: The Great Baths. This elaborate complex of terraced buildings, whose construction can be attributed to the Augustan Age, may be the imperial palace of Baia, which was the most famous resort town of antiquity.

Left:
Herculaneum: The suburban baths. Neronian-Flavian Age.

Pompeii: House of the Vettii. The peristyle. Together with the garden of the House of the Golden Cupids, this is one of the best preserved examples in Pompeii. The decorative effect of the ensemble, with statues and fountains perfectly preserved in situ, is particularly interesting.

THE THEATER OF CURIO: A TECHNICAL MARVEL OF ROME

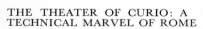

The consideration of such prodigality as this quite distracts my attention, and compels me to digress from my original purpose, in order to mention a still greater instance of extravagance, in reference to wood. C. Curio, who died during the civil wars, fighting on the side of Caesar, found, to his dismay, that he could not, when celebrating the funeral games in honour of his father, surpass the riches and magnificence of Scaurus. . . . He caused to be erected, close together, two theaters of very large dimensions, and built of wood, each of them nicely poised, and turning on a pivot. Before mid-day, a spectacle of games was exhibited in each; the theaters being turned back to back, in order that the noise of neither of them might interfere with what was going on in the other. Then, in the latter part of the day, all on a sudden, the two theaters were swung round, and, the corners uniting, brought face to face; the outer frames, too, were removed, and thus an amphitheater was formed, in which combats of gladiators were presented to the view.

PLINY THE ELDER:
Natural History (XXXVI:24)

architects, whose existence is documented by writers such as Vitruvius and Cicero. The rooms and large halls are enriched by early Second Style decoration of remarkable excellence, similar to that of the Hellenistic models. The famous group of pictures depicting the Dionysian mysteries, which give the villa its name, are derived from Greek models, probably of the fourth or third century B.C. Attribution of these paintings to the Age of Augustus is not acceptable: the Dionysian paintings are most certainly contemporaneous with the other primitive Second Style decorations to be found in other parts of the villa, and date from about 70-60 B.C.

Another Pompeian villa on the same artistic level and from the same epoch is the one at Boscoreale. (The paintings of the villa have unfortunately been separated and placed in various museums.) They depict personages of the Macedonian court, and because of their subject must be attributed to Macedonian art of the beginning of the Hellenistic period. A recently discovered tomb at Leukadion in Macedonia, decorated with pictures similar in both subject and style and dating from the end of the fourth century B.C., definitely confirms this theory. The Boscoreale villa is interesting from other points of view as well. The annual yield of the land connected to the villa has been calculated as close to 100,000 liters of good quality wine, worth 157,500 sesterces. With the oil yield figured in, the estate's annual gross production rose to a value of some 200,000 sesterces a year. This would yield a net profit of about 30,000 sesterces a year. The body of a man who died while trying to escape from the villa was found. He tried to save himself, his silverware (the famous "treasure of Boscoreale"), and a bag full of gold coins worth 100,000 sesterces (more gold coins worth 3,700 sesterces were found in the villa) — altogether more than three years' profits.

In the last years of the second century, and especially during the first, a new type of villa became popular: the seaside villa, which, unlike the pseudo-urban or country villa, had no economic function, but served simply as a place in which to spend a pleasant holiday. This may explain its relatively late appearance. These villas naturally grew up in particularly pleasant spots such as the Gulf of Naples, especially on the northern side at Baia and Miseno, and the Gulf of Gaeta. One of the oldest must have been the one belonging to Cornelia, daughter of Scipio Africanus and mother of the Gracchi. This was later bought by Marius and then by Lucullus. It eventually passed into the imperial domain; the emperor Tiberius died there. Quite fortuitously, the prices paid by Marius and Lucullus for the villa are known — the equivalent of 300,000 sesterces and 10 million sesterces respectively. This gives a fairly clear idea of the enormous increase in value of houses in this area. In Cicero's time it was the most important and fashionable resort for rich Romans, and as such it remained for the entire Imperial Age.

The middle of the first century B.C. marked the height of popularity for the seaside villa. The unsurpassed models of this type belonged to Lucullus and Hortensius, about whom the ancient writers, from Cicero to Varro, wrote over and over again, usually to deride their insolent luxury. In their villas at Baia and Naples, they took to breeding fishes and constructed the fabulously costly fishponds described by Varro.

Hortensius and Lucullus were typical representatives of the aristocracy that had fully supported Sulla and his reactionary reforms. Eventually, defeated and disillusioned by politics, they withdrew from active life and retired to their splendid villas. The situation is indicative of the political climate at the time when Pompey and Ceasar were striving for power in Rome. The dismal pessimism and the withdrawal to an idle existence, more or less literary, express the decadence of a class that had once dominated, but was on the point of yielding its power, almost without struggle. The same feeling is evident in the apparently light poetry of Catullus, or in the pessimistic conception of life so marked in Lucretius' poem *De Rerum Natura*. Disengagement

Baia: Complex of the Great Baths (probably the Imperial Palace:
1 The Temple of Mercury
2 The Baths of Sosandra
3 The Temple of Venus

0 5 10 20 40 60 80 100 M

Rome: Wall painting with subjects from the *Odyssey*, from the Esquiline. 50 B.C. The scene depicts the Laestrygones attacking Ulysses' ships. These paintings, derived from second century B.C. Hellenistic models, are the most advanced landscapes left by ancient art. (Vatican Museum, Rome.)

Pompeii: The Villa of Mysteries. The great pictorial frieze with scenes of Dionysian (or Orphic) initiation rites. 70-60 B.C. A woman being flogged and a dancer.

Pompeii: Plan of the Villa of Mysteries (second half of the second century B.C.).
1 Hanging Gardens
2 Exedra
3 Tablinum
4 Atrium
5 Hall of the fresco of the Dionysian mysteries
6 Peristyle
7 Winepress
8 Workmen's quarters
9 Vestibule
10 Kitchen
11 Thermae

Pompeii: The Villa of Mysteries. The great pictorial frieze with scenes of Dionysian initiation rites. From left to right, above: scenes of worship (libation?); Silenus and a young satyr playing the lyre and syrinx; a female satyr giving suck to a roe-buck; a frightened woman. Below: Silenus giving a young satyr a drink while another satyr displays a theatrical mask; Bacchus and Ariadne; the unveiling of the mystic phallus; a winged female demon flogging a woman, who is depicted on another wall (see illustration on pp. 74-75).

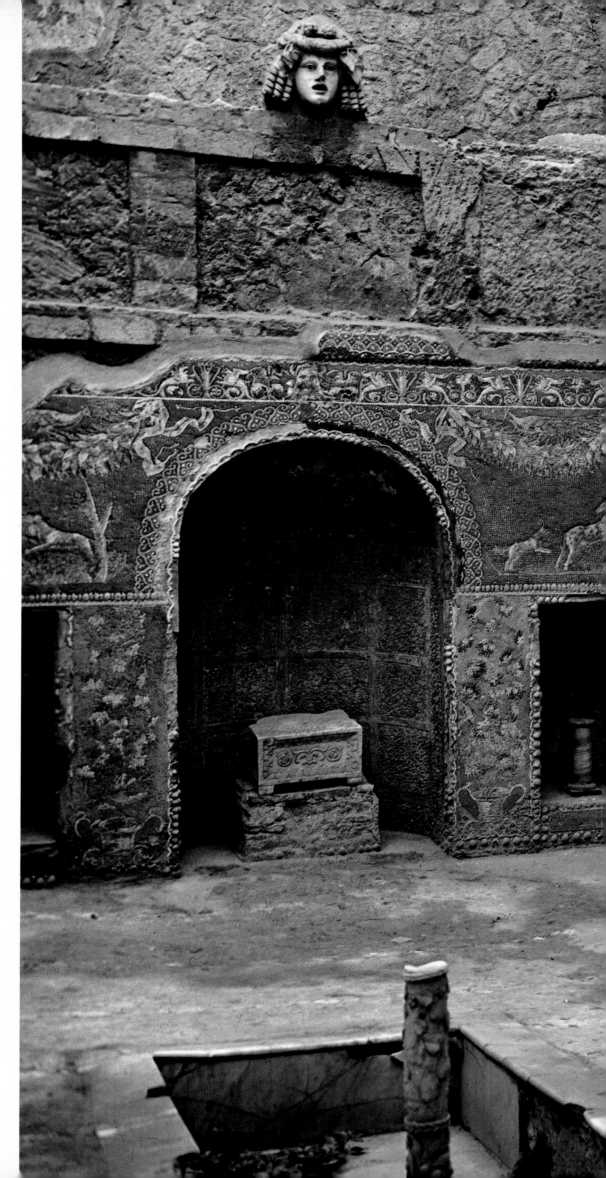

Herculaneum: House of Neptune and Amphitrite. The nympheum. Flavian Age. These wall mosaics of glass paste, alternating with paintings, include, besides ornamental motifs and hunting scenes, the group of Neptune and Amphitrite that has given the house its name.

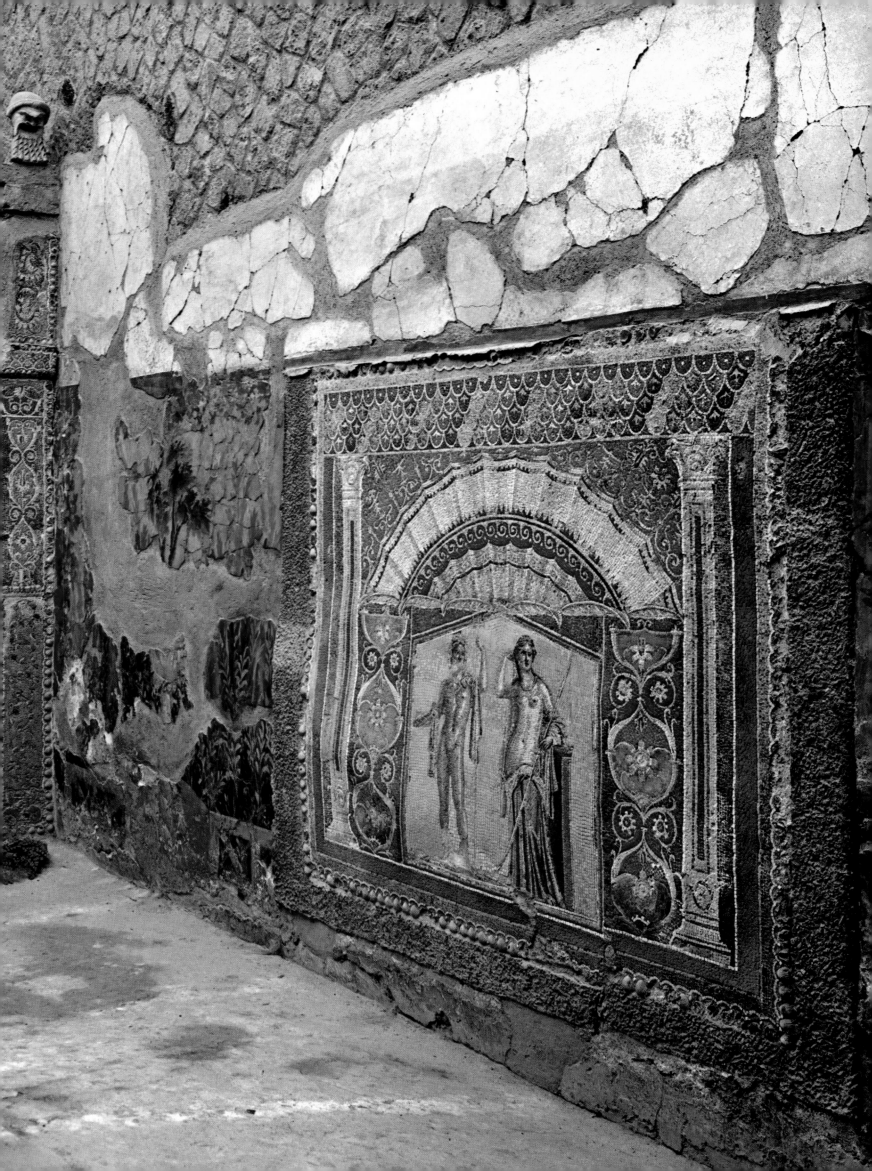

was the common tendency at this time, an escape from the brutal reality of the civil wars. Those who could created a little personal paradise for themselves, far from the cities and their problems. Those belonging to the lower classes sought promises of salvation, a better life in the next world, in the eastern religions that were becoming triumphant. These two aspects of the same problem soon found their solution: both the Empire and Christianity were very near.

Plebeian Art

As noted above, the passage from the third to the second century was marked by profound economic and political change, reflected on a cultural level in the break with the preceding Italic-Roman tradition and the creation of a fundamentally Hellenistic elitist art, at the service of the oligarchies. A change occurred among the lower classes, and a new art was created which has been described as popular plebeian. This plebeian art is difficult to define precisely because of the lack of documentation. The phenomenon is complex, elusive, and variable. At times it shows original elements and at other times it dutifully and explicitly turns to "cultured" models, adapting them to its own needs.

It is probable that the originality of plebeian art is really the residue of the earlier Italic-Roman tradition. Once its most valid sources, Magna Graecia and Etruria, had exhausted themselves, this tradition was set aside by the upper class of the population as no longer suitable for its needs, but it survived in deteriorated and inferior form for what remained of the middle class. It is no accident that this type of art is so widespread in municipal and colonial spheres — that is, in exactly those areas of central Italy and the Po River region where the regime of small property owners was best able to survive, in a social structure comparable to the one that in the preceding centuries had been much more widespread.

That this is at least a partial explanation is demonstrated by the succession of Republican coins made in the third and second centuries B.C.; from one century to the other there is a progressive decline and impoverishment in artistic form, just at a time when, with the arrival of Greek culture in Rome, the contrary might have been expected. The explanation probably lies in the fact that the minting of coins was in the hands of persons of the lower classes, whose culture had not been affected by the new Greek contributions; so the devitalized models of the preceding century were repeated and copied in worn-out forms. In short, coins in this period were plebeian artistic products, clear examples of the sharp cultural rupture that caused two fundamentally different cultures to exist side by side for over a hundred years.

Nevertheless, this explanation is not sufficient. The most notable development of plebeian art did not take place, as might be expected, in the second century but in the first, especially during the second half, and on into the Julian-Claudian age. It must therefore be supposed that the middle and lower-middle classes hardly expressed themselves at all during the course of the second century. Then, with the first century, came a relative revival, perhaps related to the colonial expansion and development of the ages of Julius Caesar and Augustus, and certainly related to the politics of the latter, which was based in large measure upon the Italic middle classes. In this period, though, rather than going back to forms of mid-Italic art, plebeian art absorbed and transformed elements of Hellenistic art, adapting them to its own needs.

The field in which this art developed most decisively was funerary art. The sepulcher was a means for people of the middle class — entrepreneurs, contractors, freedmen become rich, municipal officials, retired non-commissioned army officers — to assert their prestige. The tombs were built along the sides of streets outside the cities, in

full view of the public. A veritable mania caused the erection of thousands in a short time. Each attempted to distinguish itself through the use of ever-new architectural forms and types of decoration. The desire to represent realistically one's identity prevailed, however, An inscription, a portrait, a scene of the subject at his work — these were the elements that constantly repeated themselves on the tombs.

And as in every popular art form, the preoccupation with realism was accompanied by a need for clarity. In these tombs sculpture's conventional perspective and proportions are rejected in favor of representative vivacity and significant detail. Apparently archaic

Rome: Funerary stele from Via Statilia. A typical example of Roman funerary art at the middle of the first century B.C. (Capitoline Museums, Rome.)

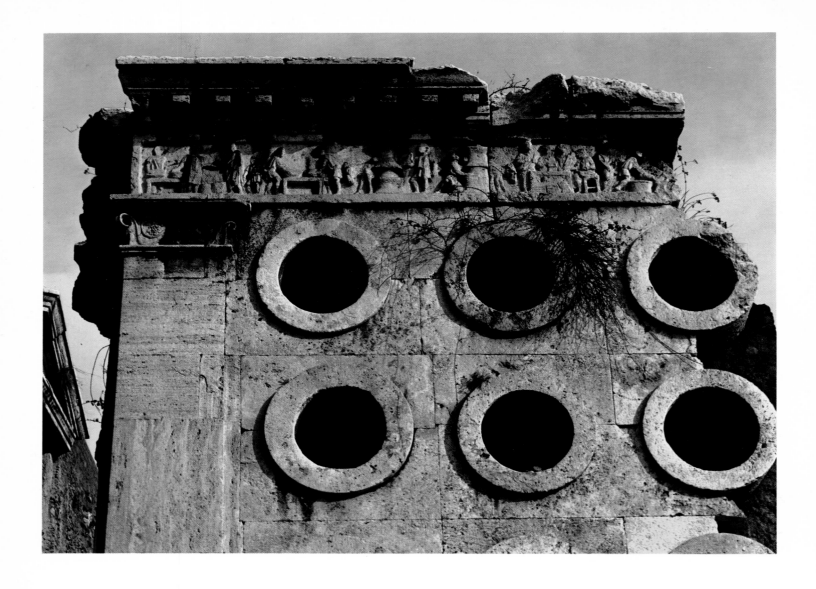

conventions became the rule, with frontal presentation and hierarchical proportions in which the dimensions of every object or person were not graduated naturalistically, but rather according to their importance in the scene. In short, it is an art of substance and content rather than of formal interest, an art whose most important aim was to be understood by the general public.

Individual and group portraits were the most widespread and conspicuous products of this art during the late Republican period. The model is the realistic aristocratic portrait, created in Rome at the beginning of the first century B.C. The cultural archetype — with all the constants of Roman ideology: the roughness, the mean peasant common sense — was accepted by the middle classes. They recognize themselves in it and conserve it for a long time, even when it has long been abandoned by the ruling class. The historical scenes that were one of the most important genres for the nobility became work scenes in which shop-owners, rich freedmen, and building contractors took part, minor historical representation of their own. The most notable example in Rome is the tomb of Eurysaces, a state bread supplier, near the Porta Maggiore; here the motif of the bread-kneading apparatus, constantly repeated, becomes an architectural element, and all the phases of bread-making are accurately reproduced in a continuous frieze. This tomb dates from the last years of the Republic. In a few years the representatives of that composite social stratum Eurysaces belonged to — nouveaux riches, municipal aristocrats, and equestrians — had handed over the power of the state to Augustus.

Rome: The tomb of the baker Eurysaces. 40-30 B.C. The architecture utilizes cylindrical elements similar to those used in kneading bread. Various phases of the bread-making process are depicted in the frieze in the style typical of "plebeian art" at the end of the Republic and the beginning of the Empire.

THE ROMAN UNIVERSE
The Imperial Age (31 B.C.-A.D. 193)

Age of Augustus

The advent of Augustan supremacy, after the period of the civil wars, constitutes one of the most complex historical phenomena of antiquity, and is one of the most difficult to evaluate. Unlike Julius Caesar, whose aim was openly to establish a monarchy of the Oriental type, Augustus worked a necessary compromise in the particular political climate of Rome at the time. In January of 27 B.C., when he solemnly declared before the Senate that he wanted to give up the extraordinary powers vested in him during the course of the civil war, and to restore the old Republican constitution, it was not easy to mistake his real intentions. The actual power was in the hands of the army, and Augustus remained its commander-in-chief. Although the re-established Republican institutions had been restored with the care of an archaeologist (which is enough to demonstrate their impoverished vitality), the principal organ of the revolution was the army. However masked, the government of Rome under Augustus was military autocracy.

Yet forces separate from the army formed the social bases of Augustus' power. In his combined spiritual testament and biography, which was inscribed on bronze tablets at the entrance to his tomb, Augustus declared that, during the war against Antony and Cleopatra, "all Italy demanded that I be commander." Using a term that is perhaps historically improper, "all Italy" might better be described as the Italic middle class — the municipal aristocracies, the small and middle-rank landowners, the merchants — all those, in short, who had been cut off from political activity, which had become the exclusive privilege of the senatorial class and the most important equestrians, and who had suffered economically and humanly from the eighty years of civil war that had bloodied Italy. This class, much larger and more extensive than the one in power, was interested above all in reestablishing peace. "Liberty," the ideological password of the strife-torn Republicans, held little interest for them. It was exactly this middle class that had given the power to Augustus during the battle of Actium, with the mandate to put a definite end to the civil wars and to create a new constitution that would deprive the senatorial class of its powers. All in all, Augustus faithfully carried out the task.

Restoration of Republican forms, which was such a large part of Augustus' cultural program, had a great deal to do with the ideology of these middle classes. He was, in the last analysis, their representative. Unlike both the cultured, skeptical ruling class — religiously agnostic, nurtured on Greek art and philosophy — and the lower classes of the population, whose social and political impotence found an outlet in eastern religions of salvation, the Italic middle classes were distinguished by a substantially reactionary cultural position. Their ideology was typical of the last Roman-Italic state that preceded the influx of Greek culture: traditionalist, nationalistic, tied to the values of the

THE PUBLIC CONSTRUCTION WORKS OF AUGUSTUS

Public works he built very many, whereof the chief and principal was his Forum or stately hall of justice, together with the temple of Mars the Revenger; the temple of Apollo in Palatium; the temple likewise of Jupiter the Thunderer in the Capitol. The reason why he built the said Forum was the multitude of men and their suits, which, because two would not suffice, seemed to have need of a third also. And therefore with great speed erected it was for that public use, even before the temple of Mars was finished. . . . Some works also he made under other folks' names, to wit, his nephews, wife, and sister; as the gallery and statley basilica of Lucius and Gaius, likewise the gallery or porches of Livia and Octavia; the theater also of Marcellus. Moreover, divers other principal persons he oftentimes exhorted to adorn and beautify the city, every man according to his ability, either by erecting new monuments, or else by repairing and furnishing the old. By which means many an edifice was by many a man built; as namely, the temple of Hercules and the Muses by Marcius Philippus; the temple of Diana by L. Cornificius; the Court of Liberty by Asinius Pollio; a temple of Saturn by Munatius Plancus; a theater by Cornelius Balbus; and an amphitheater by Statilius Taurus; but many, and those very goodly monuments, by M. Agrippa.

The whole space of the city he divided into wards and streets. He ordained that, as magistrates or aldermen yearly by lot should keep and govern the former, so there should be masters or constables elected out of the commons of every street, to look unto the other. Against skarfires he devised night-watches and watchmen. To keep down inundations and deluges, he enlarged and cleansed the channel of the river Tiber, which in times past was full of rammell and the ruins of houses, and so by that means narrow and choked.

SUETONIUS: *Augustus* (29-30)

Rome: The Forum of Julius Caesar, western side. The colonnade was erected by Diocletian after the fire of A.D. 283. On the whole, the existing Forum is the result of a reconstruction during Trajan's reign.

AUGUSTUS DESCRIBES HIS WORKS

I built: the Curia, and the Chalcidicum which adjoins it, the Temple of Apollo on the Palatine and its colonnades, the Temple of Divus Julius, the Lupercal, the Colonnade by the Circus Flaminius (which I allowed to be called the Porticus Octavia, from the name of the Octavius who built an earlier colonnade on the same site), the imperial box in the Circus Maximus, the Temple of Jupiter Feretrius, on the Capitol, and also that of Jupiter Tonans, the Temple of Quirinus, the Temples of Minerva and of Juno Regina and of Jupiter the Giver of Freedom on the Aventine, the Temple of the Lares on the summit of the Sacred Way, the Temple of the Penates on the Velia, the Temple of Juventas, the Temple of Magna Mater on the Palatine.

I repaired the Capitol and the Theater of Pompeius — both works calling for lavish expenditure — without any inscription of my own name. I repaired water conduits which had become derelict with age in very many places: I doubled the Aqua Marcia by enriching its flow from a new source. The Forum Julium, and the Basilica between the Temples of Castor and of Saturn — works which had been begun and carried forward by my Father — I brought to completion. When the Basilica Julia was destroyed by fire I began its restoration on an enlarged site . . . giving instructions that my heirs should complete it if I did not live to do so. As Consul for the sixth time and on the authority of the Senate, I restored eighty-two temples of the gods within the City, neglecting none that then stood in need of repair. In my seventh consulship I repaired the Via Flaminia from Rome to Ariminum, together with all its bridges except Pons Milvius and Pons Minucius.

From the spoils of war, I built the Temple of Mars Ultor and the Forum of Augustus on land which I owned in person. I built the Theater by the Temple of Apollo, on land which was mostly bought from private owners, which should bear the name of my son-in-law, M. Marcellus.

AUGUSTUS: *Res Gestae* (19–21)

Roman state cult, but completely lacking in any true religious content. All of Augustus' actions to restore old and forgotten cults, ancient offices deprived of any function, archaeological objects of every kind, must be seen and understood in this light. The elaborately public display of simplicity, the laws against luxury — perfectly useless, when they did not actually have the opposite effect — and those laws whose purpose was to reestablish public morality, had the same root.

On the other hand, the reestablishment of peace, the centralization of power and of the administration, brought many benefits to the structure of the Empire, especially economic ones. No longer subject to the whims of governors who were above criticism or judgment, the provinces flourished once again, and Italy itself went through a period of revival, although it was short-lived.

The most impressive phenomenon of this era was the intense colonization, especially in Western Europe. Territories such as Gaul, Spain, North Africa, the Rhine and Danube areas, passed with extraordinary speed from a protohistorical structure to a phase of urban civilization. The pre-Italic castles were abandoned and urban centers, joining several villages, grew up. There was at first something artificial in this sharp socioeconomic change. It had been planned in the highest echelons of the government with the evident aim of culturally unifying the Empire. Nonetheless, its success was immense and definitive; the birth of modern Europe is to a large extent connected with it.

The unification of power in the hands of one person had remarkable consequences for Roman culture. Augustus returned to the "moderate" tradition of Scipio Emilianus and his circle, but in a regime of absolute power. Without any serious political or ideological competition to counteract it — excluding the very first years of Augustus' rule — this cultural policy had an extraordinarily wide-ranging effect. Even today Augustus' influence on Roman culture can be seen at every turn, in every field, from literature, to architecture and sculpture, to the most anonymous of the minor arts. The truth is that Augustus succeeded in controlling the culture of the Empire through his centralized power in Rome. The feat was to serve as a model and inspiration in numerous later historical situations.

Augustus lost no time in taking up the pen himself, moreover, and using it as a political and propagandistic weapon, before employing others for the same purpose. Besides those writings that have not been preserved, he wrote the short autobiographical piece called *Res gestae*, or *Monumentum Ancyranum*, since the most complete copy was discovered in Ancyra (modern-day Ankara). It was inscribed on bronze tablets set at the entrance to his tomb, as has been mentioned. In style, the *Res Gestae* strikes the same falsely objective note as Caesar's *Commentaries*. It is an "official report" of the facts. Very few overt value judgments are included, but those few are placed strategically. An almost perfectly unreliable version of events results, yet its penetrative force is demonstrated by the fact that it has ended as the only version, and is used even in school textbooks.

Programs of Augustan Classicism

But the emperor's pen alone, however authoritative, could not establish a tradition. The Ministry of Culture was placed in the hands of Maecenas, a descendant of Etruscan aristocrats, whose vast culture expressed itself not so much in personal works as through his ability to discover talented people who could be hitched to the Augustan wagon. The operation was more successful than could have been hoped. Maecenas' "team" was none other than Virgil, Horace, and Titus Livy, the historian who, with the requisite breadth and the masterly style necessary, dedicated himself to writing the "definitive" Roman history. It would be excessive and unjust to say that Livy or Virgil or Horace acted in bad faith. In fact, the Augustan program

of pacification had earned the unconditional support of the generation that lived through the last phase of the civil wars. Nor was there any real political alternative. The partisans of the Republic had a program, but it scarcely served the purpose. It offered only an old-fashioned formula of government whose inadequacy had already been amply demonstrated.

Virgil was a small landowner of the Po region, a member of the Italic middle class, and the *Aeneid* expresses, on a high artistic level, the adherence of that class to the Augustan program of pacification and reorganization. Even though the work was realized in good faith, its propagandistic aspect is nonetheless clear. There is a consistency, even in the details, between some parts of the poem and certain accomplishments of the Augustan Age in architecture and the figurative arts. The catalogue of heroes and of Augustus' predecessors, for example, found in the sixth book of the *Aeneid*, corresponds perfectly to the gallery of portraits set in the porticoes of the Augustan Forum, from Aeneas to Caesar, each with his own "eulogy" written in the traditional style, as in the tomb of the Scipios. It is impossible to believe that the Forum of Augustus and the *Aeneid* were independent productions. It would seem, in fact, that the *Aeneid* came first.

Rome: Plan of the Imperial Forums.

In the figurative arts, as in literature, the style adopted was an imitation of the classical. This was not the first time such a thing had occurred, of course. The first adoption of classicism in Rome — that is, a style drawing on the inspiration of Greek art of the fifth and fourth centuries B.C. — took place during the second century B.C., after the conquest of Greece, as noted earlier. Augustus followed the example of Scipio Emilianus' generation, but with the great consistency and systematization made possible by a more favorable political situation. Here again he set an example. The art of the Augustan Age is the first example of that state classicism whose pomp and splendor surfaced often later in history — in the age of Louis XIV, for instance.

The architectural program was an imposing one. Augustus himself notes, in the *Res Gestae*, that in 29 B.C. alone, eighty-two temples were restored. The destinction between private and public domains was ostentatiously reestablished by the Emperor himself, who in this way linked himself with traditional Roman moralism. According to Sue-

Above:
Rome: Frieze from the cella of the Temple of Apollo Sosianus. Circa 20 B.C. It represents a triumphal scene, perhaps that of Gaius Sosius who had the Temple re-erected during the Augustan Age after having triumphed over Judea.

Right:
Rome: Forum of Augustus and Temple of Mars Ultor. Vowed by Augustus in 42 B.C. during the course of the battle of Philippi against Brutus and Cassius, Caesar's assassins, the Temple of Mars Ultor ("the Avenger") was dedicated only in 2 B.C. Like the Temple of Apollo Sosianus, it is made of marble from Carrara.

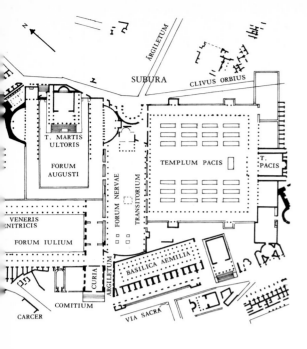

tonius, biographer of the Caesars, Augustus' house on the Palatine, which had belonged to the orator Hortensius, was modest, lacking marble floors and precious furnishings. Since the latest archaeological excavations, it is possible to say that this house is identical with the so-called House of Livia on the Palatine. For Augustus, a new quarter to the south was added, as was the grandiose Temple of Apollo, erected to the memory of the battle of Actium, a kind of private sanctuary for the Emperor. The temple ended as part of the interior of later Imperial palaces.

The public buildings of Augustus' reign were not only great in number, they were grandiose and eloquent. The Emperor boasted that he had found Rome in brick and left it in marble. From a purely architectural point of view, this may have been rather dubious progress. But the quarries of Cararra were worked heavily for the material needed in the Augustan building program, and his was the first era in Roman architecture in which marble was used on a large scale. The Augustan program was even more remarkable for its urban planning, and its reorganization of the structure of the city, than for its individual buildings.

Julius Caesar had formulated gigantic plans. They included a deviation of the Tiber, so that the Vatican area might be joined to the Campus Martius, the huge square where the most important public assemblies and voting ceremonies were held. Most of his projects were interrupted by his sudden death, but what has remained is enough to give an idea of the dictator's clear-sightedness. He had aimed at making old Rome into a capital worthy of comparison with the great eastern cities, Alexandria in particular. Caesar's building and planning had two distinct aspects. The first was innovative, almost revolutionary. The other was directed toward the restoration of all the old buildings connected with the Republican constitution (Augustus, much more prudent, gave precedence to the latter aspect).

One of the innovative plans was Caesar's Forum, begun in 54 B.C., according to one of Cicero's letters. This was a private work, rather than a public work, and was built at the expense of Caesar, who was then consul; the cost of the land alone was an astronomical 100 million sesterces. The Forum was begun in reaction to the initiative of Pompey, who as consul in 55 B.C. had inaugurated in the Campus Martius the first brick theater in Rome and the enormous portico with gardens that bore his name for posterity. Caesar's desire to crush his rival here as well is seen in his initiation of another theater in the same parade ground. (This was finished by Augustus, who dedicated it to the memory of his nephew Marcellus.) The function of Caesar's Forum is clear. It extended and enlarged the old Republican Forum, by then insufficient in size, in the direction of the Campus Martius, and at the same time linked his name with a monumental complex of an entirely new kind, probably taken from Near Eastern models; the historian Appian placed it in relation to the Parthian squares.

During the course of construction, probably after 48 B.C., the Temple of Venus Genetrix was added to the Forum, closing off the end of the square with perfect axial perspective. The apse at the end of the Temple's cella, where the sacred image of the goddess was placed, thus constituted the end and the focus of an obligatory itinerary: the colonnades guided the visitor or worshiper toward the Temple, inside which two other colonnades concentrated his attention on the apse. This was no accident; the cult of the Venus Mother served a dynastic function for Caesar. From the funeral eulogy for his aunt, he remembered the divine origin of the Julia family, which was descended from Aeneas, and hence from Venus, Aeneas' divine mother. The function of this private cult in Caesar's plans is undoubted. He wished to establish a monarchy of the eastern type in Rome, and his sojourn in Egypt had clarified for him the essence of regality. Deification of the sovereign quite clearly played a large part in it, and Caesar's Forum is the monumental reflection of these concepts.

The other aspect of Julius Caesar's construction activity was only apparently opposed to the first. In reality it was complementary. At the same time the Forum was being built, reconstruction of an ancient part of the Campus Martius in monumental form was begun. This sort of project, giving a monumental appearance to a structure whose function was no longer valid, was to become the forte of Augustus. The Augustan program was much less audacious as regards deification than Caesar's, however. Augustus always refused to accept deification during his lifetime, at least in Rome and the West. (He was adored in Egypt, though, as the god Thoth, corresponding to the Greek Hermes and the Roman Mercury, and in the East temples dedicated to Rome and Augustus sprang up everywhere).

The schemes of urban planning begun by Caesar were continued and developed by Augustus. Rome probably had 500,000 inhabitants at this time. Augustus divided the city into fourteen districts, each furnished with particular administrative and technical services; there was one fire-brigade for each two districts, for example. The bed of the Tiber was "mended," set in order and limited in size. The entrances to the ancient city walls attributed to Servius Tullius were reconstruct-

Rome: The Basilica Julia, in the Roman Forum. Begun by Julius Caesar, the building was totally remade by Augustus after a fire, and dedicated to his grandsons Gaius and Lucius Caesar. After the various sacks and destructions it endured up to the Renaissance; only the delineation of the plan remains.

ed; they had served only as topographical landmarks before this time. Agrippa, the friend and close associate of Augustus, brought a new aqueduct to Rome and created the first monumental public baths there, in the Campus Martius, next to the Pantheon, which was built at this time, also by Agrippa. Members of the most important Roman families were invited to collaborate in the program, and for the last time names other than the Emperor's were connected with public buildings. Cornificus reconstructed the Temple of Diana on the Aventine; Balbus, the theater named after him in the Campus Martius; Asinius Pollio, the ancient "Atrium of Liberty," where slaves were freed, as well as the first public library in Rome.

The activity of the Emperor Augustus was on a much larger scale. Among the most important structures he raised were the Portico of Octavia, erected in place of the older Portico of Metellus and furnished with two libraries, one for Greek and one for Latin; the Portico of Livia on the Esquiline; the Theater of Marcellus; the Temple of Apollo on the Palatine; and an enormous number of other sanctuaries, either built anew or reconstructed. The widening of the public zone of the forums was continued by the creation of the Forum of Augustus, this also built at the private expense of the Emperor. At its end, in a position analogous to that of the Temple of Venus Genetrix in Caesar's Forum, the Temple of Mars Ultor ("the avenger" — of Caesar's assassination) was built. The dynastic intention of the temple in Caesar's Forum persisted in the newer monument, although it assumed there a more traditional form, less distasteful to the Roman mentality. The statues of progenitors of the Julia family, from Aeneas on — the kings of Alba and Rome, the greatest personages of the

Rome: The *Ara Pacis* of Augustus. 13-9 B.C. Frieze from the south side. From left to right: priests (the figures with unusual headgear); Agrippa with his head veiled, followed by his wife Julia (the daughter of Augustus). Between them is one of their sons, probably Lucius Caesar. Then come Tiberius, Antonia and her husband Drusus with their son Germanicus, and the Enobarbus family.

Roman Republic — were placed in niches along the Forum's two
lateral porticoes. At the end of the series, in a grandiose hall, a gigantic
statue of Augustus was erected, probably after his death, clearly demon-
strating how all the events of Roman history providentially tended
to concentrate on one point: the person of the Emperor. It was he
who gathered up, epitomized and yet conciliated all the contrasts
and struggles of Rome in a supreme pacification, above all ranks and
parties. The ideological program was no less clear or persuasive for
having been expressed in marble and bronze rather than in writing.

Ara Pacis Augustae

For an understanding of the cultural and ideological climate in
Augustan Rome, the *Ara Pacis Augustae*, the Altar of Augustan Peace,
is equally interesting. The votive offering for it was made in 13 B.C.
and the monument itself was inaugurated in 9 B.C. It was situated
in the Campus Martius, the principal center of Augustan building
activity. Excavated in various stages and finally recomposed in 1938,
the altar is the most important example of official Roman sculpture
of the period. The structural conception is interesting; the marble
altar is placed at the center of a quadrangular enclosure, also of
marble, which has two openings. The enclosure is evidently an imita-
tion of a wooden structure; on the interior the lower part is an imitation
of a wooden floor, and the sculptured hanging garlands of the upper
part are probably copies of the real garlands that adorned the tem-
porary enclosure erected for the votive offering.

The outside of the enclosure presents a different, and much less consistent, aspect. Rich decorations of spiral form, with an acanthus motif, and populated with animals, fill the lower part of all four sides. In the upper portion of the two long sides, unbroken by entrances, a procession is depicted, most likely that in which all the imperial family participated during the sacrifice connected with the consecration of the altar. On the shorter sides, with the two entrances, there are four sculptured marble panels. Two of these depict mythical events connected with the legend of the foundation of Rome: Aeneas sacrificing to the Penates in Lavinium; and the *Lupercalia*, the scene in the sacred grotto at the foot of the Palatine, with Romulus and Remus being suckled by the wolf. On the other side there are two symbolic scenes. In one, the goddess Roma is seated on a pile of weapons, representing the final victory of the city and the imperial dominion based on military force; in the other, the Earth, represented as a woman of ample proportions, with two children in her lap, and flanked by symbolic figures of water and air, is placed in the midst of luxuriant growth and vegetation. The symbolism is transparent in this case as well: these are the material benefits and the prosperity that derive from the reestablishment of peace.

The lack of an organic principal or a sense of organization in the monument is evident even from this brief description. Realistic, mythological, and symbolic representations, as well as purely ornamental material, are placed together without any connection except their propagandistic function. As often happens in figurative art of this period, the weight of the ceremonial intentions overwhelms any possibility of coherent artistic realization. The defect is much less evident in literature, perhaps because of the greater social dignity, hence the greater liberty, that writers enjoyed. Compared to writers, sculptors and painters, since they worked with their hands, were considered little more than laborers. The split between intellectual and manual work, theory and practice, was inevitably great in a slave society such as that of the Augustan Age.

From a formal point of view the *Ara Pacis*, like all official art in the Augustan period, is an example of classically-minded academicism, correct, technically irreproachable, but without a speck of vitality. To reach this state, the various aspects of Greek art that had mixed

Rome: The Tomb of Cecilia Metella, on the Appian Way. About 20 B.C. About the time of the Mausoleum of Augustus, the use of monumental tombs, often surmounted by a tumulus, became widespread. One of the best examples is the Tomb of Cecilia Metella, daughter of a Metellus and wife of a Crassus. In the Middle Ages the tomb was transformed into a tower in the castle built along the Appian Way by the Caetani. The merlons visible in the upper part of the edifice date back to this period.

Following pages:

Rome: The House of Livia on the Palatine. The *Tablinum*. Recent excavations have demonstrated that this building is part of a complex that most likely was the residence of Augustus. The paintings decorating the walls of the Tablinum are among the finest examples of Second Style wall painting, and may be dated at the beginning of the Augustan Age.

with Roman art — "illusionism" and Hellenistic naturalism, the neo-classic that harked back to Attic models — and even Roman plebeian art, were all absorbed, manipulated, restored, and painstakingly, carefully devitalized. To unify so many disparate, contrasting elements stylistically was obviously impossible. They were instead eclectically placed one beside the other, in a fashion coldly correct, but little more.

Nevertheless, this art had the merit, recognizable also in the poetry of Horace, to which it is spiritually akin, of establishing a formal grammar; every self-respecting neo-classicism aspires to do the same. The result was an "average," "bourgeois" style, without strain or contortion if also without enthusiasm or impetus. It constituted for centuries an obligatory reference point, not only for the culture of the Roman Empire but for European culture in general.

Proof of this is the fact that, at least in urban areas, Augustan art penetrated deeply, reaching into every aspect of building. Thus, the characteristically archaic style of the Mausoleum of Augustus — built in the form of a tumulus, like the tombs of Etruscan noblemen — became the model for numerous private sepulchers, such as the famous tomb of Cecilia Metella on the Appian Way. The style of the *Ara Pacis* was an official style; it served as the model for the production of decorative sculpture on an infinite number of funerary altars, columns, and chapels that have been preserved.

Minor Arts in the Augustan Period

Finally, even in the so-called minor arts the Augustan period has left its indelible mark. Silver vases, cameos, jewels, and even the most common ceramics show their direct dependence on official art. The red ceramics of Arezzo, first produced in the last years of Julius Caesar's life, became the model for ceramics through the entire Imperial period, but it was under Augustus that their production reached almost industrial proportions. The figures on the ceramics were cast in a mold. They show great technical skill and formal correctness, as well as the academic coldness typical of the art of this period. The really extraordinary diffusion of these Arezzo ceramics (specimens have been found as far from Rome as southern India) illustrate the spread of Greco-Roman artistic culture to countries that up to then had been completely untouched by it.

As in the Republican period, the private world must be considered separately. Yet the story is about the same. The development of wall painting can be followed through the rich documentation of Herculaneum and Pompeii, and through some work in Rome itself. During the first century B.C. the type of wall decoration called Second Style became widespread. Characterized by a naturalism with the tendency to "break through" the wall, either with architectural perspective or scenes of landscape, it was really purely Hellenistic rather than Roman, and in fact represents one of the most notable contributions of Hellenism to Roman art. It continued to be used in the first years of the Augustan Age; the House of Livia on the Palatine is a perfect example of the mature Second Style.

In the Villa Farnesiana, discovered at the end of the nineteenth century near the right bank of the Tiber, the paintings (now in the Roman National Museum) are more eclectic in character. Besides parts that are still fully naturalistic, and others belonging to the more typical late Hellenistic "impressionism," there are also linear and schematic renderings, and even paintings of an archaic flavor that hark back to Greek art of the fifth century B.C. The different elements are not distinct, but they are linked to one another indifferently. This is the intellectual phenomenon typical of bourgeois art such as that of the *Ara Pacis*, although in a different environment. The decorative work of the Villa Farnesiana can be dated at least twenty or forty years after the paintings in the House of Livia, probably about 20 B.C.

The Third Style originated around 15 B.C. Characterized by extreme simplification of architectural elements, which assume a graceful, threadlike aspect, by growing use of monochrome surfaces, and by a technique that could be defined as miniaturist, this again was a classical style, and ran parallel to that in vogue in sculpture and architecture at the same time. The use of large paintings with mythological subjects continued, although there was less taste in such work for third dimension and perspective. Representations of gardens, free from any architectural frame, were popular as well; the best example found was at the Villa of Livia at Prima Porta, on the Via Flaminia (and is now in the Roman National Museum).

Art of the Tiberian Age

During the course of his long reign, Augustus was able to complete a profound reorganization of the state. So thorough was his work, so clearly was the way marked out for his successors, that they found it difficult, if not impossible, to change it. This was true not only of official culture but of politics. The two were closely connected. In politics Caligula and Nero sets out to reform the Augustan edifice by attempting to change the Roman state to something resembling an eastern monarchy, but they failed miserably. The public art of the entire Julian-Clau-

Prima Porta: The Villa of Liva. Wall painting of a garden (now on display at the Roman National Museum). Last part of the first century B.C.

dian dynasty, except for the reign of Nero, its last representative, differed hardly at all from that of the Augustan period, except in its nuances. It must be noted, however, that documentation of the Julian-Claudian Era is very scarce, especially in the urban context.

In private art, however, great differences occur from period to period in the dynasty. This can be said not primarily because the documentation is greater, as might be supposed, but rather because the personalities of the various emperors had scope for expression in areas where state policy did not intervene, at least in a direct way.

Developments of this kind began immediately with Augustus' successor Tiberius (A.D. 14–37). Although completely different in character from Augustus, Tiberius found himself compelled to continue his predecessor's policies. The result was the tortuosity, the near-maniacal displays of irritability, which characterized Tiberius as a ruler. His taste and culture led him to prefer "high" Hellenistic art over neo-Attic classicism. This fact is pointed out by ancient writers, and can be clearly seen in the monuments connected with his name. In the temple reconstructions he carried out before he became emperor — the Temple of Castor and Pollux in the Forum and the Temple of Concord at the foot of the Capitol — there is already a difference in style from the edifices built under Augustus' direction, such as the Temple of Mars Ultor. Tiberius' propensity was for "baroque" Hellenistic models from Asia Minor, a taste confirmed by the choice of sculpture for the Temple of Concord. All the works were by artists belonging to the early or middle Hellenistic periods. But the phenomenon is evident above all in the Emperor's private villas, in Capri, where he transferred his court, never again to return to Rome, and in Sperlonga (only recently discovered). The choice of sites is significant in itself. His propensity was for sea settings, for isolation in literary idleness. Tiberius seems to have despised Rome. For some years before becoming emperor, he lived in Rhodes, and his choice of retreats closely resembled that of personages in the late Republican period, such as Lucullus and Hortensius. Tiberius had an affinity for their culture, and indeed went to die in Lucullus' villa at Miseno, as noted earlier. The fact takes on an almost symbolic value.

The architecture and decoration of the Capri and Sperlonga villas are characterized by a marked taste for landscape that is a mixture of the natural and the artificial. Grottoes were transformed into nympheums, even the famous Blue Grotto, and decorated with statues. At Sperlonga these were original Greek statues, Rhodian, of the late Hellenistic Age. The choice of pieces is interesting, too. The sculptures depict scenes from the *Odyssey*, related to the nearby localities of Gaeta and Circeo, where two of Ulysses' most famous adventures took place. (The mixture of the artificial and the natural is very much akin to the taste displayed in the Renaissance art of sixteenth century gardens and villas.)

A new feature in the decoration of Tiberius' villas was the wall mosaic, which was destined for a great future. Introduced at the end of the Republican Age, this technique became remarkably widespread from the Tiberian Age on to the end of the first century A.D., particularly for decoration of the walls of nympheums and fountains. Mosaics have been found in Capri and Sperlonga, in Nero's *Domus Aurea*, in numerous houses at Pompeii and Herculaneum, especially in the last phase, between the earthquake of A.D. 63 and the eruption of A.D. 79. In one case the wall mosaic is to be found in a tomb, belonging to Pomponius Hylas, near the Via Latina, which probably dates from the Tiberian Age. A monumental specimen, with a representation of a ship in port, decorated the great nympheum of a patrician house on the Quirinal, which may have belonged to Avidius Quietus, a personage of the age of Domitian. In the prevailing use of this technique for the decoration of apses, which occurred often in nympheums, and of large surfaces, the precursors of Byzantine and medieval wall mosaics can be seen.

Above:
Rome: *Colombarium* of Pomponius Hylas. A small replica of a dovecote in a tomb of the Tiberian Age in the Aurelian Wall near Via Latina. It is noted for its frescoes and mosaics, on which is recorded the name of the owner.

Opposite page:
Rome: The *Domus Aurea* of Nero. Above, detail from the decorative painting on a ceiling. Below, a room in the eastern section with rich Fourth Style pictorial decoration.

The Works of Nero

It is worth mentioning, with regard to the residences and property of the emperors, that between the reigns of Augustus and Nero the noble Republican families were slowly eliminated. The process had important economic consequences, and went forward most prominently during the first decades of the Imperial Age, but it had been started already by the triumvirate of Octavius, Mark Antony, and Lepidus, with the proscriptions of 43 B.C., in which Cicero was one of the men killed. The political objective was to eliminate, even physically, the class that had held power. But the economic aim of the policy was no less important. In the first years of the Imperial Age, most of the great villas that had grown up on the hills east of Rome, from the Pincio to the Esquiline, passed into the Imperial domain, including those of Sallust, Pompey, and Maecenas. Outside Rome the same thing happened; the most pleasant parts of the coast and the most beautiful islands became Imperial property: Baia, Capri, the coast between Gaeta and Terracina. Along the coast, where the Sperlonga villa was built, there is an inscription that mentions an attorney whose job it was to administer the Imperial domain of Formia, Gaeta, and Fondi. This system of state ownership, which had both good and bad points, was extended in the middle and late Imperial Age to include most of the sources of production. The brick factories are one example; they will be considered later.

It was the possession of such vast areas of urban land that allowed the megalomaniacal emperor, Nero, to plan and construct two gigantic royal palaces, the *Domus Transitoria* and the *Domus Aurea*. Very little remains of the *Domus Transitoria*, which extended way beyond the confines of the Palatine, the traditional residence of the emperors. There are some frescoes with Homeric scenes, which represent one of the most ancient known examples of "Fourth Style" painting. When the *Domus Transitoria* was destroyed by the fire of A.D. 64, Nero began to build a larger palace extending from the Palatine to the Esquiline and Coelian hills, taking up most of the central area of the city. Indignant Romans immediately circulated epigrams, and pasquinades lampooned this move. One, mentioned by Suetonius, invites the Quirites to emigrate to Veii, since "Rome is already occupied by one house."

The *Domus Aurea* was not so much a palace as a grandiose villa, with pavilions set in planted areas. These had ponds, paths, forests, and cultivated fields, all laid out according to the rules of the most evolved garden art. A similar example of such a complex is Hadrian's Villa at Tivoli, which also served as the site of the Imperial court, but which had the added advantage, evidently of no importance to Nero, of being outside the urban center. The only part of this elaborate residence which remains lies on the Oppian Hill, protected by the Baths of Trajan which were built over it. The plan shows two sections quite different from each other, both in structure and architectural character. The section to the west is simpler than the section to the east, which has a great deal of movement and animation. Perhaps the separate hands of the two architects, Severus and Celer, can be recognized in the two sections. According to Pliny the Elder, they were the designers of the complex.

The name of the painter who did the major part of the decoration is also known; he was Fabullus or Famulus (Pliny's writings give both spellings), the only personality in Roman painting of this time who is known by name. The decoration of the *Domus Aurea*, which at best is poorly preserved, is one of the most interesting examples of Fourth Style painting, otherwise known so well through work at Pompeii and Herculaneum. The Fourth Style is actually a complicated and baroque version of the fantastic architectural motifs already seen in the Second Style. Ornamental exuberance is common to both. Fourth Style breaks out above all in work of the Flavian period, following

AUTOBIOGRAPHY OF TRIMALCHIO, A FIRST-CENTURY A.D. ENTREPRENEUR

"But as I was saying my frugality brought the fortune I have: I came out of Asia no taller than this candlestick, and daily measured myself by it: and that I might get a beard the sooner, rubb'd my lips with the candle-grease; yet I kept Ganymede to my master fourteen years (nor is any thing dishonourable that the master commands) and the same time contented my mistress: Ye know what I mean, I'll say no more, for I am no boaster. By this means, as the gods would have it, the governing the house was committed to me, and nothing was done but by my guidance: What need many words? He made me joint-heir with Caesar, and I had by it a Senator's estate; but no man thinks he has enough, and I had a mighty desire to turn merchant. Not to detain you longer; I built five ships, freighted them with wines, which at that time were as dear as gold, and sent them to Rome; you'll think I desir'd to have it so: All my ships founder'd at sea; 'tis a great truth, no story; Neptune swallowed me in one day three hundred thousand sesterties. Do ye think I broke upon't, (so help me Hercules) no; the loss was but a flea-bite: For, as if there had been no such thing, I built others, larger, better, and more fortunate than the former; so that every one called me a man of courage. As you know a great ship carries a great deal of force, I loaded them again with wine, bacon, beans, unguents, planes: And here Fortunata shewed her affection; for she sold what she had; nay, her very cloaths, and put a round sum in my pocket; tho' yet it was but a pig of my own sow. What the gods will is quickly done; I got an hundred thousand sesterties by the voyage, and forthwith redeemed the lands my patron had left me, built me a house, bought cattle to sell them again, and whatever I went about gathered like a snow-ball: But when I grew richer than all the country besides, I took up, and from a merchant turn'd usurer, and bought servants.

"Thus resolved to give over trading, a certain astrologer that chanc'd to light on this village, would have persuaded me to the contrary. He was a Graecian, his name Soerapa, one that held correspondence with the gods. He told me a deal that I had forgotten, and laid everything before me from top to bottom: He knew all I had within me, and told me what I had the night before to supper; you'd have thought he had liv'd with me all his life.

"I beseech you, Habinas, for I think you was there; he told me the intrigue between my mistress and me; that I had but ill luck at friends; that no one ever made me a return of my kindnesses: That I had large possessions, but nourished a viper in my bosom: Why should I not tell you all? I have by his account, thirty years, four months, and two days yet to live; and in a short time shall have another estate left me."

PETRONIUS: *The Satyricon* (75-77)

10 20 30 40 50 100M

Rome: Plan of the Domus Aurea
1 Portico projecting in front of the facade
2 Large rooms with alcoves (perhaps apartments of the emperor and empress)
3 Peristyle
4 Nympheum
5 Hall of the Golden Ceiling
6 Large serving corridor
7 Octagonal hall with fountain

Pages 104-105:
Rome: The Colosseum, seen from the slopes of the Palatine (in the foreground, the Arch of Constantine). The outer measurements of this edifice, oval in shape, are 620 feet by 513 feet. Its height is 158 feet. The collapse of a part of the external ring allows a view of the travertine supporting structure, built prior to the rest of the building, which was completed with brick.

Pages 106-107:
Rome: The Colosseum, interior view. The complex system of underground chambers, used for the most important functions and services of the amphitheater, is visible, since the original floor of the arena has disappeared.

Nero; the break with Augustan classicism could not be sharper. The revaluation of baroque Hellenism, appreciated in the private sphere from Tiberius on, is here brought even into public art, with results that — especially in official sculpture and architecture — were among the most remarkable ever realized by the Romans.

Rome in the Flavian Era; The Colosseum and Domitian's Palace

The civil war that followed Nero's death brought to power the representative of an obscure Sabine family, Flavius Vespasian. Brief though it was, the episode was important in Roman history. Augustus had had to gain the support of the Italic middle classes in his war against Antony, and Vespasian appealed to the provinces against Italy, which had declared itself in favor of his rival, Vitellus. The policy of the Flavians tended to favor the upper strata of the municipal bourgeoisie in the more "Latinized" western provinces. The ancient families of the Republican nobility not only disappeared definitively from the Senate (a process initiated under the Julian-Claudian rulers, as noted earlier), but the families of the newer nobility, that created by Augustus, were also "eliminated."

Developments in the economic situation paralleled the political developments. By this time the decadence of Italy was total. Agricultural production was decreasing; olive oil, for example, which had been one of the chief Italian exports during the late Republican period, was now imported in great quantities from Spain. In the industrial field the production of Aretine pottery stopped and was replaced by products from the ceramic factories of Gaul, which were imported by Italy on a large scale. This development became more and more acute during the course of the second century A.D. When the Roman-Italic state became the "world state," Rome, devoid of any economic "hinterland," became only the parasitical capital of an immense territory in which the provinces took on almost the aspect of separate and autonomous nations. They were the true economic centers of the Empire.

From the artistic point of view as well, the passage from the Julian-Claudian rulers to the Flavians corresponded to a sharp break. In the urban center, large-scale public construction continued; in fact it increased. In this phase some of the most remarkable monuments were built: the Colosseum, the Baths of Titus, Domitian's Stadium, the Forum of Peace, and Nerva's Forum (really built by Domitian). The municipal plebeian art characteristic of central Italy from the end of the Republican to the Julian-Claudian period practically disappeared, however. The end of the production of sculpture to decorate the sepulchers of the Italic bourgeoisie is perhaps the best demonstration of the progressive decline of the class.

On the other hand, the Flavian period, and even more, the second century, mark the rapid development of provincial artistic cultures, with the creation of autonomous "national" artistic traditions. It is possible to speak of a Gallic culture, an African culture, etc. This is particularly noteworthy in the western provinces. Through Rome, they absorbed Hellenistic artistic civilization and developed it in an autonomous, original way, mixing it with local traditions. This phennomenon was the root of the various "Romance" cultures that then formed in the Middle Ages. The course of urban artistic culture in Rome proceeded almost completely independent from this varied and complex evolution in the provinces. It was, however, no longer the reflection of the activities and choices of an articulated society, but rather a culture of the court, more and more determined by the personality of the emperor. There were obviously reciprocal influences between the artistic production in the provinces and that in the urban

center, but it would be a great mistake to consider the art in the provinces a mere reflection of urban art at the periphery of the Empire.

With the Flavians, and even more with Trajan, urban art took on a consistent and homogeneous aspect. The fluctuations in taste that had characterized the Julian-Claudian age diminished. Architecture, freed from the classical forms of Augustan tradition, took up the Republican "thread" in a new way and followed it to the point of realizing quite noteworthy achievements. The most famous urban monument of the period, the Colosseum, also serves as one of the most significant examples of the building techniques used in Rome during the Imperial Age. The work was carried out very quickly: begun in A.D. 77, the building was finished and inaugurated by Titus in 80. Scarcely four years were needed for the realization of one of the most imposing achievements in ancient architecture.

Incredible as it may seem, precise and exhaustive studies of the Colosseum do not exist, but some points have been sufficiently studied and clarified. It is known that the edifice was built in a valley once occupied by a lake belonging to the park of Nero's *Domus Aurea*. This fact has sometimes been cited as an example of the virtuosity of the Flavian architects, but it is probable that in reality it must be regarded as a simple technical expedient to save work. The digging for the amphitheater's foundations would have meant the removal of some 150,000 cubic yards of material. Using the cavity of the lake allowed the architects to eliminate a large part of this work. The Colosseum's greatest novelty lay in its structural conception. First, all the travertine pillars with their related vaults were built — that is, the skeleton support of the edifice, on which the tiers rested. This made it possible for many workers to work at the same time, even during bad weather, as they were literally "indoors." The secondary parts of the construction were quickly finished. The technique is close to that used for modern structures of metal or reinforced concrete.

The activity of the Flavians in the field of public building was not limited to the Colosseum. The Forum of Peace, which Pliny called the most beautiful monument in Rome, was built at the order of Vespasian. Titus, during the course of his brief reign, finished the work on the baths that took his name. They completed the group of buildings in the area around the Colosseum, occupying a part of the *Domus Aurea*. The most active emperor in this period, though, was Domitian, who reigned the longest of all the Flavians, from A.D. 82 to 96. Consistent with his tendency toward a highly centralized, eastern-style state, Domitian was the first emperor after Nero to sponsor a large-scale program of private Imperial building. His father, Vespasian, and his brother Titus, partially in order to make people forget some all-too-recent events, had contented themselves with the already existing edifices and had actively initiated not only the elimination of the remains of the *Domus Aurea* but its replacement by public works. Trajan was to complete the process, which had an obvious political character.

Nevertheless, Domitian built a grandiose palace on the Palatine and numerous villas. The most important, near Lake Albano, is also the most magnificent Imperial villa before Hadrian's time. The name of the emperor's favorite architect is known: he was Rabirius, the builder of the Palatine palace. The *Domus Aurea* had followed more or less the plan of a villa, with isolated pavilions in the center of a garden complex. But the palace of Domitian was a compact block, built in two sections: one, the so-called *Domus Flavia*, on the northwest, was used for receptions and other state functions; the other, the so-called *Domus Augustana*, was used as a residence.

For the construction of the *Domus Augustana* the incline of the Palatine hill was transformed into a stairway. The front of the house, facing the Circus Maximus, consisted of a large *exedra*, behind which there was a peristyle decorated with a fountain. At the end of this peristyle, a group of rooms and two staircases led to the top terrace of the hill

Rome: The *Domus Augustana* on the Palatine. Domitian Age. View of the great lower courtyard, which served as the monumental entranceway to the building, from the side facing the Circus Maximus. At the center is a large fountain with a complicated design. In the background are the upper floors, which elegantly utilize the natural slope of the hill.

THE RECONSTRUCTION OF ROME AFTER THE FIRE OF NERO

Nero appropriated to his own purposes the ruins of his country, and founded upon them a palace; in which the old-fashioned, and, in those luxurious times, common ornaments of gold and precious stones, were not so much the objects of attraction as lands and lakes; in one part, woods like vast deserts; in another part, open spaces and expansive prospects. The projectors and superintendents of this plan were Severus and Celer.... But the rest of the old site not occupied by his palace, was laid out, not as after the Gallic fire, without discrimination and regularity, but with the lines of streets measured out, broad spaces left for transit, the height of the buildings limited, open areas left, and porticoes added to protect the front of the clustered dwellings: these porticoes Nero engaged to rear at his own expense, and then to deliver to each proprietor the areas about them cleared. He moreover proposed rewards proportioned to every man's rank and private substance, and fixed a day within which, if their houses, single and clustered, were finished, they should receive them: he appointed the marshes of Ostia for a receptacle of the rubbish, and that the vessels which had conveyed grain up the Tiber should return laden with rubbish; that the buildings themselves should be raised a certain portion of their height without beams, and arched with stone from the quarries of Gabii or Alba, that stone being proof against fire: that over the water springs, which had been improperly intercepted by private individuals, overseers should be placed, to provide for their flowing in greater abundance, and in a greater number of places, for the supply of the public: that every housekeeper should have in his yard means for extinguishing fire; neither should there be party-walls, but every house should be inclosed by its own walls. These regulations, which were favorably received, in consideration of their utility, were also a source of beauty to the new city: yet some there were who believed that the ancient form was more conducive to health, as from the narrowness of the streets and the height of the buildings the rays of the sun were more excluded; whereas now, the spacious breadth of the streets, without any shade to protect it, was more intensely heated in warm weather.

TACITUS: *The Annals* (XV:42-3)

Rome: The *Domus Augustana* on the Palatine. View of the stadium, which closed the southern side of the complex.

on which another group of rooms surrounded a second peristyle. The whole was completed, on the southeast side, by a hippodrome — literally a horse track, but often to be found in villas as a circular walk.

The *Domus Flavia* consisted of a smaller number of rooms, also set around a peristyle. There were basically two groups: to the northeast the *Aula Regia*, flanked by the Basilica and the so-called Lararium; to the southwest, the grandiose triclinium, or banquet room, flanked by two nympheums. The chambers in the first group were most certainly the reception complex of the Imperial palace, which was used for a long time, not only by Domitian but by succeeding emperors. Because of its central position, as compared to the other Imperial edifices, its rational arrangement, the variety and boldness of its architectural solutions (the vault that covered the *Aula Regia* was probably one of the most grandiose ever realized by Roman architecture), the Domitian complex is the best known example of the Imperial palace. Again the planning of the building was no accident. Domitian was a "centralizer," extremely determined and consistent in his

Rome: The Palatine. View of the imperial palaces facing the Circus Maximus. In the foreground, the grandiose constructions of the palace of Septimius Severus. Toward the back, the great exedra with the portal of the *Domus Augustana*.

Rome: Plan of the palace of Domitian on the Palatine.
On the left (the Domus Flavia*):*
 1 Peristyle
 2 Aula Regia
 3 Lararium
 4 Basilica
 5 Triclinium
 6 Nympheums
On the right (the Domus Augustana*):*
 7 Facade
 8 Atrium with monumental fountain
 9 Peristyle
 10 Peristyle

affirmation of Imperial power as absolute and divine. He was given the title of *Dominus*, "lord," while still alive.

Domitian was remarkably active in the field of public building as well. His greatest achievement in that field was certainly the reconstruction of the Campus Martius and the Capitol, both ravaged by a terrible fire during the reign of Titus, in A.D. 80. Of those works of which traces remain, the most noteworthy is the stadium, whose site forms the present-day Piazza Navona.

The Emperor wanted his name linked with a Forum as well, the *Forum Transitorium*, but it was inaugurated in A.D. 97, after his death, and took on the name of the emperor Nerva. The remains of this forum display — especially in their architectural decoration — that taste for the baroque so characteristic of late Flavian art. It is to be found also in sculpture, in the admirable reliefs on the Arch of Titus, for example, which depict the triumph of the emperor after the Jewish wars. They were executed after Titus's death, certainly during Domitian's reign.

THE MARVELS OF ROME

But it is now time to pass on to the marvels in building displayed by our own City, and to make some enquiry into the resources and experience that we have gained in the lapse of eight hundred years; and so prove that here, as well, the rest of the world has been outdone by us: a thing which will appear, in fact, to have occurred almost as many times as the marvels are in number which I shall have to enumerate. If, indeed, all the buildings of our City are considered in the aggregate, and supposing them, so to say, all thrown together in one vast mass, the united grandeur of them would lead one to suppose that we were describing another world, accumulated in a single spot.

Not to mention among our great works, the Circus Maximus, that was constructed by the Dictator Caesar, one stadium in width and three in length, and occupying, with the adjacent buildings, no less than four jugera, with room for two hundred and sixty thousand spectators seated; am I not to include in the number of our magnificent constructions, the Basilica of Paulus, with its admirable Phrygian columns; the Forum of the late Emperor Augustus; the Temple of Peace, erected by the Emperor Vespasianus Augustus — some of the finest works that the world has ever beheld — the roofing, too, of the Vote-Office, that was built by Agrippa? not to forget that, before his time, Valerius of Ostia, the architect, had covered in a theatre at Rome, at the time of the public Games celebrated by Libo?

We behold with admiration pyramids that were built by kings, when the very ground alone, that was purchased by the Dictator Caesar, for the construction of his Forum, cost one hundred millions of sesterces! If, too, an enormous expenditure has its attractions for any one whose mind is influenced by monetary considerations, be it known to him that the house in which Clodius dwelt, who was slain by Milo, was purchased by him at the price of fourteen million eight hundred thousand sesterces! a thing that, for my part, I look upon as no less astounding than the monstrous follies that have been displayed by kings.

PLINY THE ELDER:
Natural History (XXXVI:24)

The Works of Trajan

The pinnacle of official Roman sculpture was reached during the reign of the last emperor who had any ambitions of conquest, Trajan, the "new Caesar," under whom the Empire reached its maximum size, after the annexation of Dacia, Arabia, and Mesopotamia. This Emperor's feats were commemorated in an impressive series of monuments, the most remarkable of which was the Forum of Trajan. This was the work of Apollodorus of Damascus who, as a military engineer, had planned the grandiose stone bridge erected over the Danube during the second Dacian war. The fact that the Forum of Trajan took up and brought to a definite solution the problem set by Caesar, of linking the Republican Forum to the Campus Martius, is not without significance. To realize the plan, the saddle of land that linked the Quirinal to the Capitol was razed to the ground, as the inscription on Trajan's Column records. Equally significant from an ideological point of view was the fact that the Emperor undertook, at the same time, the reconstruction of Caesar's Forum. The two projects were inaugurated together. Trajan's Forum was basically a glorification of the Emperor's achievements, the Dacian war in particular. A series of gigantic statues of Dacian prisoners probably decorated the attic of the side porticoes, and a complex of sculptures referring to the same campaign and to its triumph must have embellished the great barrel-vaulted arch that served as the Forum's entrance. The sculptures in the reliefs later used in the Arch of Constantine do not seem to be these, however. A bronze statue of the Emperor mounted on a horse occupied the center of the square, connecting the project even more explicitly to the person of Trajan. Augustus had realized nothing of this scope in his Forum, but the center of Caesar's Forum was also dominated by a statue of the dictator on a horse.

The most noteworthy element of the project, still preserved in its integrity, is the Column of Trajan. It is the earliest example of a monument of which only a few other examples are known — at Rome the Column of Marcus Aurelius; at Constantinople, those of Theodosius and Arcadius. The Column of Trajan was placed in a courtyard between the Basilica Ulpia and the two libraries of the Forum. Its reliefs were certainly more legible then, from the terraces of these adjacent buildings, than they are today, the more so because they were originally painted in rich polychrome. The Column was set in a narrow space; its effect was probably more didactic than monumental, a storied "scroll" that, like the texts in the nearby libraries, served to illustrate in detail the course of the two Dacian wars fought by the Emperor. The documentary wealth of the Column is such that today, given the paucity of texts connected with Trajan's reign, it is the most complete historical record of these wars that now exists. The ideological importance of the monument was also great. The Emperor's ashes were put in a golden urn placed in the base of the monument, a procedure that had probably been planned from the beginning.

With Trajan, historical reliefs reached their maturity. The fact that their documentation regarding his reign is so rich is not fortuitous. From its earliest examples, the historical relief had been connected with the Roman imperialist class. Its function was nothing more or less than the exaltation of conquest. The Emperor-soldier, who stretched the boundaries of the Roman Empire to their maximum extent, could only favor this artistic genre. This propensity for relief ended by decisively conditioning the art of the Roman urban center, which had by this time been built over almost exclusively with works of court art.

The sculpture of Trajan's Column is closely connected in style to the gigantic frieze later placed on the Arch of Constantine, which was probably originally set in the Forum of Trajan. The hand of a single artist can be seen in both works. He has conventionally been called "The Master of the Feats of Trajan," a title that has also been connected

with the architect of the Forum, Apollodorus of Damascus. Some scholars have recognized the youthful work of this artist in the reliefs on the Arch of Titus, and certain aspects of the art of Trajan's Column are in fact to be found in the earlier work.

The sculpture of Trajan's Column represents a point of fulfillment in Roman art. It had taken centuries to arrive. In the first manifestations of historical relief, such as the *Ara* of Domitius Enobarbus, Greek artistic form had been used in a context imposed by the Romans who commissioned the work, with essentially eclectic results. In the reliefs of Trajan's Column, however, the Hellenistic heritage has been completely absorbed and has fused with elements of plebeian art to form a style perfectly adapted to the realistic and historical content it was called upon to express. The result was basically new, and marked the high point of official Roman art. The scenes on the column unfold one after the other in a continuous ribbon. The sense of historical development, of time uninterrupted in its flow, which connects individual episodes in an almost cinematic way, is achieved without the individual episodes losing any of their individuality . . . This is the first time the continuous relief as an artistic form was realized so consistently.

A comparison with the frozen movement of the procession on the *Ara Pacis*, set in a fixity almost like that of a snapshot, reveals better than any discussion the difference between the classicist Augustan art and Trajanic art. The techniques used to realize the sculpture of the Column range from an exceptionally varied and modulated plastic rendering to sequences that seem to contrast with the realism of the whole, such as the bird's-eye views of cities, their proportions distorted, or the small-scale representation of large objects such as ships. Everything is sustained, however, by the continuous tension that links one scene with another. Far from decreasing this tension, the non-realistic, symbolic, almost stenographic depiction of some scenes accentuates it. It abbreviates the discourse by concentrating only on the essentials.

Yet the values of the humanistic Greek tradition are present here as well, perfectly alive. For example, the Emperor, though set in relief and given his own unmistakable physical characteristics, is not portrayed in a hieratic or hierarchic way; the tendency is rather to depict him in discourse with his officers, in natural positions, a man among men. It is difficult to judge how much propaganda is concealed behind such a conception, but in any case it is propaganda for a public still sensitive to the humanistic aspects of Greek culture. The same mentality is to be seen in the representation of the defeated enemies, killed or taken prisoner. They appear not as ferocious and vile brutes, in the style of later Roman art, but as individuals worthy of respect and understanding. Aeschylus had described the defeated Persians in a similar way.

Decadence in Italy

Unlike the Roman urban center, which is obviously a singular case, the rest of Italy in this period was a spectacle of decadence. The Flavian-Trajanic period was a transition period, but the phenomenon of economic decadence became disastrous and irreversible during the course of the second century. The total disappearance of popular or plebeian art, the principal product of the municipalities during the late Republican and Julian-Claudian period, has already been mentioned. It signaled the collapse of those entrepreneurial classes that had been the backbone of Republican and Augustan Italy.

The process of dissolution can also be seen, though only in its beginning stages, in the cities destroyed by Vesuvius. After the earthquake of A.D. 63, which destroyed a large part of Herculaneum and Pompeii, the cities began an effort of reconstruction, which was not finished when the final destruction took place, in A.D. 79. Besides a

CONSTRUCTION OF THE
PORT OF CIVITAVECCHIA
IN THE TIME OF TRAJAN

This delightful villa is surrounded by the most verdant meadows, and commands a fine view of the sea, which flows into a spacious harbor in the form of an amphitheater. The left-hand of this port is defended by exceeding strong works, and they are now actually employed in carrying out the same on the opposite side. An artificial island, which is rising in the mouth of the harbor, will break the force of the waves and afford a safe channel to ships on each side. In the construction of this wonderful instance of art, stones of a most enormous size are transported hither in a large sort of pontoons, and being piled one upon the other, are fixed by their own weight, and gradually accumulating in the manner of a natural mound. It already lifts its rocky back above the ocean, while the waves which beat upon it, being tossed to an immense height, foam with a prodigious noise and whiten all the sea around. To these stones are added large blocks which, when the whole shall be completed, will give it the appearance of an island just emerged from the ocean. This harbor is to be called by the name of its great founder, Trajan, and will prove of infinite benefit, by affording a very secure retreat to ships on that extensive and dangerous coast. Farewell.

PLINY THE YOUNGER:
Letters to Friends (31)

Rome: The markets of Trajan. The grandiose brick exedra that partially conceals the irregular multistoried complex of the shops is one of the best examples of non-official urban planning left by ancient Rome.

SOME ARCHITECTURAL PROBLEMS

To the Emperor Trajan

The citizens of Nicea, Sir, are building a theater which, though it is not yet finished, they have already expended, as I am informed (for I have not examined the account myself) above ten million sesterces; and what is worse, I fear, to no purpose. For, either from the foundation being laid on a marshy ground, or that the stones themselves were decayed, the walls are cracked from top to bottom. It deserves your consideration, therefore, whether it would be best to carry on this work or entirely discontinue it; or rather, perhaps, it would not be most prudent absolutely to destroy it, for the foundations upon which this building is raised appear to me more expensive than solid. Several private persons have promised to erect at their own expense, some the portico, others the galleries above the pit; but this design cannot be executed, as the principal fabric is at a standstill.

This city is also rebuilding upon a more enlarged plan the Gymnasium which was burnt down before my arrival in the province. They have already been at some (and, I doubt, a fruitless) expense. The structure is not only irregular and ill-disposed, but the present architect (who, it must be owned, is a rival to the person who was first employed) asserts that the walls, though they are twenty-two feet thick, are not strong enough to support the superstructure, as their interstices are not cemented with mortar, nor are these walls strengthened with a proper covering.

The inhabitants of Claudiopolis are sinking (I cannot call it erecting) a large public bath upon a low spot of ground which lies at the foot of a mountain. The source of the fund appropriated for this work are the admissions paid by those honorary members you were pleased to add to their Senate — at least, they are ready to pay whenever I call upon them. As I am afraid therefore the public money in the city of Nicea and (what is infinitely more valuable than any pecuniary consideration) your benefaction in that of Claudiopolis should be ill applied, I must desire you to send hither an architect to inspect not only the theater but the bath; in order to consider whether, after all the expense which has been laid out, it will be better to finish them upon the present plan, or reform the one and remove the other; for otherwise we may perhaps throw away our future cost, by endeavouring not to lose what we have already expended.

Emperor Trajan to Pliny

You are upon the spot so you will best be able to consider and determine what is proper to be done concerning the theater, which the inhabitants of Nicea are building; as for myself, it will be sufficient if you let me know your determination. With respect to the particular parts of this theater that are to be raised at a private charge, you will see those engagements fulfilled, when the body of the building to which they are to be annexed shall be finished. These paltry Greeks are, I know, immoderately fond of gymnastic diversions and therefore, perhaps, the citizens of Nicea have planned a more magnificent fabric for this purpose than is necessary; however, they must be contented with such as will be sufficient to answer the use for which it is intended. I entirely leave to you to advise the citizens of Claudiopolis as you shall think proper, with relation to their bath, which they have placed it seems in a very improper situation. As there is no province that is not furnished with men of skill and ingenuity, you cannot possibly want for architects; unless you think it the shortest way to procure them from Rome, when it is generally from Greece that they come to us.

PLINY THE YOUNGER:
Correspondence with Trajan (48-49)

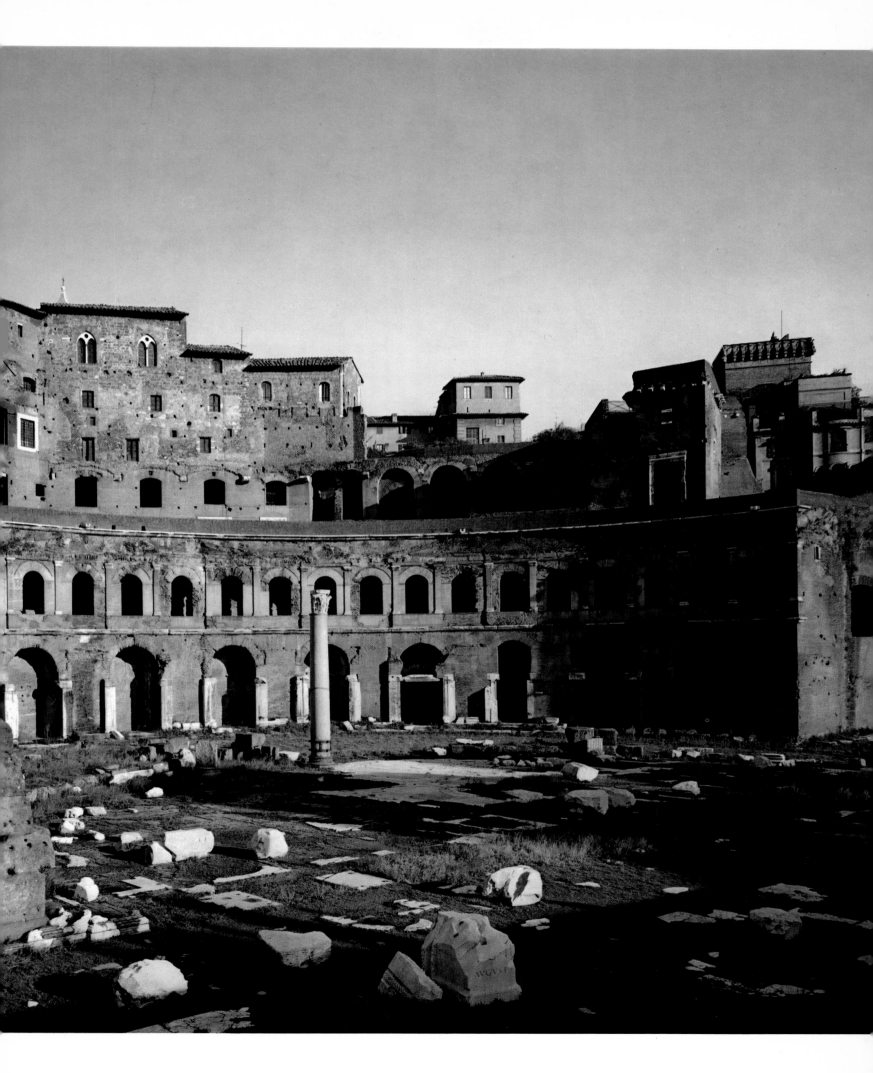

Rome: Trajan's Column. Inaugurated in A.D. 113, the column is close to 125 feet high, with its base; the column alone is 100 feet tall. In the base, decorated with friezes of arms and festoons held up by eagles, is the cella where Trajan's ashes were placed. The famous frieze representing the two Dacian wars is sculptured around the column and is almost 125 yards long. Inside the column a spiral staircase was cut out; this leads to the small terrace formed by the abacus of the capital. The statue of the emperor was placed on the top. It disappeared in the Middle Ages and in 1587 Pope Sixtus V replaced it with a statue of St. Peter.

INSCRIPTION ON THE
TRAJAN COLUMN

The Senate and the People of Rome to the Emperor, Caesar Nerva, son of the deified Nerva, Traianus Augustus, Germanicus, Dacicus, Pontifex Maximus, etc., etc., to demonstrate how lofty a hill and what area of ground was carried away for these mighty works.

general decline in quality in the new work — in wall-painting, for example — which corresponds to a considerable cultural decadence, the decline of some of the most remarkable houses and villas of the preceding period is worthy of mention. The "Cryptoporticus House" at Pompeii and the House of the Samnite in Herculaneum were occupied by new owners, who broke them up into small apartments. The case of the Villa of Mysteries is particularly impressive; from a luxury residence it became a rustic villa, its refined rooms used for rough agricultural functions. This was the case with almost all the villas in the Pompeian territory in the period between Nero and the Flavians. In the *Satyricon* of Petronius, written during Nero's reign, the guests at Trimalchio's dinner deplore the economic deterioration of the city where the scene takes place; a port town in Campania, almost certainly to be identified with Pozzuoli. At that period, the crisis was only beginning, however; conditions were to grow worse and worse.

There is no lack of phenomena that seem to contradict this general decadence, of course. The most striking can be seen at Herculaneum,

Rome: Reliefs from Trajan's Column. Opposite page (119): From the bottom up the scenes depict: 1 Construction of a camp; bound Dacian prisoners; wounded Roman soldiers being treated; the departure of the army; a prisoner is presented to the emperor. 2. Trajan, near the Danube, receives two submissive barbarian chiefs; the army passes over the Danube on a bridge of boats. 3. Trajan's speech to the soldiers; forest trees being felled; the heads of two Dacians placed on spears are displayed before the fortifications. 4. Trajan, on a hill, watches an attack of the Numidian cavalry.

Left: from the bottom up.

1. Construction of a camp; the camp is built; the cavalry passes over a wooden bridge. 2. The Dacians in flight; the Romans wade through a river; Trajan receives the Dacian ambassadors. 3. The Roman army, in a city on the Danube, prepares for a new expedition; the army passes over the river on a variety of boats with their horses and provisions.

Right:

Above: Detail from one of the two *Anaglypha Trajani* (marble relief panels) in the Forum of Trajan. The emperor giving a speech from the Julian rostra. In the background the Arch of Augustus and the Temple of Castor and Pollux are visible.

Below: Another detail from the reliefs of the two *Anaglypha Trajani*. (The Curia of the Roman Forum, Rome.)

Rome: Relief from the Temple of Hadrian, with a representation of a province. (Palazzo dei Conservatori, Rome.)

THE PLEASURES OF THE TUSCAN VILLA OF PLINY THE YOUNGER

The villa sits on the slope of a hill but has a view as from the very top. . . At the extremity of a portico stands a grand dining room, which opens upon one end of the terrace; from the windows there is an extensive prospect over the meadows up into the countryside, from whence you also have a view of the terrace and such parts of the house that project forward, together with the woods enclosing the adjacent hippodrome (or circular walk). Opposite almost to the center of the portico stands a square edifice that encompasses a small area shaded by four plane trees in the midst of which a fountain rises, from whence the water running over the edges of the marble basin gently refreshes the surrounding plane trees and the verdure underneath them. This apartment consists of a bed-chamber secured from every kind of noise and which the light itself cannot penetrate; together with the dining room that I use when I have none but intimate friends with me.

A second portico looks upon this little area and has the same prospect as the former just described. There is, besides, another room, which being situated close to the nearest plane tree, enjoys a constant shade and verdure; its sides are encrusted half-way with carved marble; and from thence to the ceiling a foliage is painted with birds intermixed among the branches, which has an effect altogether agreeable as that of the carving; at the base of a little fountain, playing through several small pipes into a vase, the water produces a most pleasing murmur. From a corner of this portico you enter into a very spacious chamber opposite to the grand dining room, which from some of its windows has a view of the terrace and from others of the meadow; those in the front look upon a cascade, which entertains both the eye and the ear, for the water dashing from a great height foams over the marble basin that receives it from below. This room is extremely warm in winter, being much exposed to the sun; and in a cloudy day the heat of an adjoining stove very well supplies its absence.

From thence you pass through a spacious and pleasant undressing room into the cold-bath room, in which is a large, gloomy bath; but if you are disposed to swim more at large or in warmer water, in the middle of the area is a wide basin for the purpose, and near it a reservoir from whence you may be supplied with cold water to brace yourself again, if you should perceive you are too much relaxed by the warm water. Contiguous to the cold bath is another of a moderate degree of heat, which enjoys the kindly warmth of the sun but not so intensely as that of the hot bath, which projects further. . . .

But not to dwell any longer upon this digression, lest I should myself be condemned by the maxim I have just laid down, I have now informed you why I prefer my Tuscan villa to those that I possess at Tusculum, Tiber, and Praeneste. Besides the advantages already mentioned, I here enjoy a more profound retirement, as I am at the farther distance from the business of the town and the interruptions of troublesome avocations. All is calm and composed, circumstances that contribute, no less than its clear air and unclouded sky, to that health of body and cheerfulness of mind that I particularly enjoy in this place, both of which I preserve by the exercise of study and hunting. Indeed, there is no place that agrees better with all my family in general, as I am sure, at least, that I have not yet lost one (and I speak it with the sentiments I ought) of all those I brought with me hither. May the gods continue their happiness to me and that honor to my villa. Farewell!

PLINY THE YOUNGER:
Correspondence (V:6)

where the neighborhoods near the sea were partly rebuilt in the period between the earthquake and the eruption. This is the continuation of a process already begun during the Julian-Claudian age, when many pieces of property were combined and the splendid houses looking over the sea were created: the "House of the Deer," the "House of the Mosaic Atrium," the "House of the Reliefs of Telephus," which recent excavations have brought to light. Construction at Herculaneum was only an apparent exception to the decadence, however. Unlike Pompeii, which was always a large commercial, industrial, and agricultural center, Herculaneum during the Imperial Age was a little resort town, frequented by rich Romans, and felt the effects of upheavals in the local economy much less. The very fact that it was possible to buy up various houses in order to create larger complexes is proof of the economic crisis within the local ruling class, which surrendered its place not so much to a class of "nouveaux riches," as had occurred many times in the past, but rather to individuals from the urban areas, whose wealth did not depend (or depended only to a small degree) on the prosperity of the local economy and was based above all on the possession of large estates: Pliny the Elder, and his nephew and adopted son, Pliny the Younger, are examples of this sort of person. Among other things, their writings furnish a rare picture of the economic and social situation of the period.

The Empire Under Hadrian

If Trajan represented the new Caesar, the soldier-prince, the propagator of an extensive Empire, Hadrian consciously attempted to be the new Augustus, organizer and arranger of the state structure from every point of view — administrative, economic, and cultural. This ideological link with the personality of the first emperor is to be seen even in facts that look insignificant at first glance. It was Hadrian, for instance, who restored many Augustan monuments, such as the Forum of Augustus and the Pantheon; Trajan had concerned himself with Caesar's urban projects.

The period that began with Hadrian and ended with Commodus was on the whole the most prosperous through which the Empire passed. The economy of the provinces greatly expanded in this period; production and trade reached levels unsurpassed until the modern age. Roman ships now normally included ports in the Persian Gulf and the Indian Ocean in their itineraries, and products from India and China flowed into the Mediterranean area. At the same time, urban civilization reached its peak. With provinces that were almost separate nations, the Empire was no longer a political-administrative fact based on the superior military of one city-state, Rome; it was an association of cities, all with considerable autonomy, gathered together predominantly for administrative convenience. Its unity was based on the economic, social, and cultural achievements of urban life, which were common to all the provinces, western and eastern.

In this framework, Italy was an element all to itself. Largely depopulated, economically parasitical, it was by this time a mere accumulation of senatorial landed estates, which to a certain extent prefigured the later feudal structure. The case was different with Rome and the minor centers functionally connected to her, however, such as Ostia and the city of Portus, which grew up around the new port of call founded by Claudius and enlarged by Trajan. The capital was now totally divorced from its old hinterland, which could no longer support her. Rome became more than ever an expression of the sheer pomp and apparatus of Empire, a backdrop for official shows, a stage for official court art and culture. Great masses of people thronged around the monumental center, feeding at the state's expense or devoted to the tertiary service industries of the capital. The urban problems that arose from the need to house this enormous mass — perhaps a million people — was resolved by the creation of multistory apartment buildings, or *insulae*, whose modernity is thoroughly amazing. Examples of these buildings are to be found at Rome, although the best surviving examples are at Ostia Antica.

The first two emperors of the second century, not so incidentally, Trajan and Hadrian, were both provincial in origin; they were Spanish. During the same period, the olive oil used in Rome and in most of Italy came almost exclusively from Spain. Before it was excavated, there existed near the Tiber Market an entire artificial hill, formed of an incalculable number of Spanish oil amphorae — their brand names and other inscriptions proving them such.

Building activity in Rome was at its peak during Hadrian's reign, and from this period forward regulation of building by the state authority became customary. Setting the consular date on the brick seals that served as brand names had been commonly done from Trajan's time, but in Hadrian's time the use of the date with the seal became obligatory. This may have taken place in A.D. 123, which would explain the great number of seals for that year that have been preserved. The decisive intervention by the state in the most important existing industry in Rome, building construction, can be followed by means of these brick seals. Little by little the furnaces, kilns, and quarries, once the property of private individuals, seem to have passed into the hands of the Emperor, who thus found himself in an ideal situation for instituting a policy of low-cost public building.

Art in the Reign of Hadrian: The Pantheon

The most representative monument of Hadrian's period is probably the Pantheon. Examination of the brick seals has demonstrated that the building is not the edifice built by Agrippa in 27 B.C., but a new construction that can be dated at the beginning of Hadrian's reign, between A.D. 118 and 128. The marvelous technical achievement of this building, one of the most remarkable in ancient architecture, is never an end in itself, but corresponds perfectly to the function the building was intended to serve. The form and technique of construction bear as well a symbolic weight whose meaning is quite clear.

The cupola of the Pantheon is the largest ever built with traditional means — that is, before the introduction of reinforced concrete. Its diameter, 142-1/2 feet, is slightly larger than that of the cupola of St. Peter's. The entire building is based on a system of remarkably simplified relationships. Its height is the same as the diameter of the cupola, and the interior consists of a cylinder surmounted by a semi-sphere whose radius corresponds to the height of the cylinder. Monumentality and solemnity are the result of this simple relationship, and though the building is articulated in a series of rather complex subdivisions, they are not detrimental to its unity. On the contrary, they emphasize the axes and focal points of a space that would otherwise seem undifferentiated and thus devoid of sense. These articulations are not merely technical in their function, either, but correspond to symbolic motifs and cult practices, as does the edifice in its entirety.

The Pantheon, as its name reveals, was dedicated to "all the gods" of the celestial pantheon. The cupola symbolizes — in the clearest possible manner — the vault of the heavens, while its great central opening, which is, with the entranceway, the only source of light, corresponds to the sun. This relationship must have been even more evident in ancient times if, as is probable, there were ornamental stars at the center of the coffers that decorate the cupola. The arrangement of the niches and the shrines, in correspondence with the axes oriented according to the cardinal points of the compass, shows that the statues of the gods were placed at the precise points dictated by ancient augural discipline, so that the terrestrial temple, with its circular plan and cupola, became a faithful projection of the celestial panoply.

From a structural point of view, the edifice is the most remarkable achievement of vaulted Roman architecture; through the methods used in it, the construction of huge internal spaces ceased to be a problem. From the end of the second century on, the premises of this architecture became more and more firmly rooted.

Yet the problem of the relationship between interior and exterior space does not seem to be solved. The facade is a huge octastyle portico surmounted by a pediment, which keeps fully to Greek tradition. This was even more evident at that time, when the edifice rose up from a stairway and behind a long axial portico. This frontal arrangement, the only one then considered appropriate, rendered the cylinder and most of the cupola practically invisible. The temple thus had a completely traditional aspect, which was perhaps necessary to make its function immediately recognizable. The exterior and interior space were completely independent and had no relation to each other. With the elevation of the ground (it has now covered the stairway) and the disappearance of the front portico and the other edifices that once surrounded the Pantheon, the original relationship of the portico to the circular portion of the building has been lost. In the more complete view now possible, the contrast between the front portico and the cylinder with its cupola can be seen quite easily. The problem of their relationship to each other has existed from the beginning, of course, and was originally solved only by the separation of the two views.

Just before his death, he compelled Servianus, then ninety years old, to kill himself, as has been said before, in order that Servianus might not outlive him, and, as he thought, become emperor. He likewise gave orders that very many others who were guilty of slight offences should be put to death; these, however, were spared by Antoninus. And he is said, as he lay dying, to have composed the following lines:

"O blithe little soul, thou, flitting away,
Guest and comrade of this my clay,
Whither now goest thou, to what place
Bare and ghastly and without grace?
Nor, as thy wont was, joke and play."

Such verses as these did he compose, and not many that were better, and also some in Greek.

He lived 62 years, 5 months, 17 days. He ruled 20 years, 11 months.

Scriptores Historiae Augustae (XXV-XXVI)

Rome: Section and plan of the Pantheon (A.D. 118-128).

From its Augustan origins, the Pantheon had borne a precise dynastic meaning. It glorified the ancestors of the Giulia family who were associated with the gods of the sky, the planets, and the stars. Venus, who was one of them, was considered the family's first progenitor. It is interesting to note that one of the first edifices restored by Hadrian was exactly that one that best corresponded to his political, religious, and dynastic program. Even more than Augustus, Hadrian emphasized the interrelationship between the cosmos (dominion of the gods), and the Roman Empire which represented the immutable order of the earth — the political system which was the dominion of the prince. For an idea of the ideological form the Imperial power definitively assumed from Hadrian on, there is no better text than the Pantheon.

Such a high-level program of centralization and universalization was naturally reflected in every aspect of Roman art, at least in urban and court art. Like Augustus, but with the greater consistency and profundity afforded him by the new political and social situation, Hadrian imposed a precise cultural program that once again found its natural expression in classicism. Hadrian's was a classicism less rigorous than Augustus', however, less connected to neo-Attic art, even though classical Athens was always the fundamental reference point. (The importance of Hadrian's building program in the glorious ancient city is well-known.) Artistic expressions of Hellenistic derivation were allowed, nor was pharaonic Egypt excluded, even though Hadrian detested turbulent Alexandria, in which he saw the very essence of everything adverse to his program of ordered, Olympian autocracy.

It is hardly fortuitous that, among the few historic sculptured reliefs of Hadrian's Age that have come down to us, static scenes of presentation, sacrifice, or apotheosis prevail. The pacific Hadrian would not have himself depicted in warlike poses, for that matter. Of particular significance are the splendid *tondi* (round panels) later inserted in the Arch of Constantine, in which the emperor is depicted hunting wild beasts and sacrificing to divinities connected with the hunt. It was an old Near Eastern idea, later taken up by the Hellenistic princes, that the only activity worthy of a sovereign in times of peace was hunting. For Rome, the example had been set by Scipio Emilianus. A sympathetic Polybius describes him as deserting the activities of the Roman Forum in order to give himself up to the pleasures of hunting in the Pontine plain. Such pleasures may seem gratuitous, and their depiction a whim of decoration, but in the light of the ideological preoccupation of Roman art, a sculpture of Hadrian hunting shows a certain amount of thoughtful "programming."

Hadrian's Villa at Tivoli

Hadrian's nature and his tendencies could no longer, given the structure of Roman polity, be purely private matters. They became, in fact, more and more a part of his public function. Their most obvious expression is to be found in the elaborate villa Hadrian had built a short distance from Tivoli. Unlike Augustus, who for political reasons liked to accentuate his bourgeois origins and tastes, Hadrian wanted to erect a "screen" between himself and the court, and between the court and the tumultuous and chaotic city. The function of Hadrian's villa, like the palace and its park at Versailles, was to place the emperor outside and beyond the sphere of common men, in an abstract space that made veneration easier. The difference from the policy of the preceding emperor was sharp. Trajan loved to have himself depicted among his soldiers and the masses, a man among men, although this may have been a pose, manufactured for political reasons. To a certain degree the portraits of Trajan hark back to the tradition of Republican realism. With Hadrian, the Imperial portrait takes on a more official, formal aspect, and is dressed in idealized and classical forms.

He built public buildings in all places and without number, but he inscribed his own name on none of them except the temple of his father Trajan. At Rome he restored the Pantheon, the Voting-enclosure, the Basilica of Neptune, very many temples, the Forum of Augustus, the Baths of Agrippa, and dedicated all of them in the names of their original builders. Also he constructed the bridge named after himself, a tomb on the bank of the Tiber, and the temple of the Bona Dea. With the aid of the architect Decrianus he raised the Colossus and, keeping it in an upright position, moved it away from the place in which the Temple of Rome is now, though its weight was so vast that he had to furnish for the work as many as twenty-four elephants.

Scriptores Historiae Augustae (XIX)

Despite its large proportions, Hadrian's Villa is not so far removed in its conception from other Roman villas. It was not a palace with an attached park (such as has prevailed in the modern age, beginning with the Renaissance) but rather a series of pavilions immersed in nature, built with a variety and complexity that fit them to the natural lines of the terrain. The buildings were not even set in one line, but rather along four principal axes made necessary by the shape of the land and of varying length, from 205 feet to 377 feet. It was not built all at once. Rather it "grew" as its various parts were conceived and realized in succeeding ages. This is again demonstrated by the brick seals: those in the villa cover practically all of Hadrian's reign, from A.D. 117 to 138.

The individual structures were as varied as the plan. Among the buildings of the villa a series of new and bold structural techniques created continual surprises. The methods of covering space that were used — vaults, semi-cupolas and cupolas — formed unpredictable spaces and prospects, and the rigid axiality typical of Roman architecture was tempered by the use of complex building plans in which bilateral symmetry gave way to richer and more dynamic solutions. It is no wonder that baroque architects, Borromini in particular, were attracted by the buildings of the villa, which they drew many times

Left and below:
Rome: The Pantheon, interior and exterior. The inscription of Agrippa, part of the original building, was reproduced by Hadrian and placed on the newly built temple.

Following pages:
Rome: *Tondi* (round panels) from the age of Hadrian, used in the Arch of Constantine. That on the left depicts a boar-hunting scene; that on the right, a sacrifice to Diana.

Tivoli: Schematic drawing of Hadrian's Villa
(A.D.118-134).
1 Courtyard of the Libraries
2 Piazza d'Oro (Golden Square)
3 Maritime Theater
4 The Poekile, a colonnaded area
5 Canopus
6 Academy

Tivoli: Hadrian's Villa. Overall view of the Canopus. The *Historia Augusta* records that Hadrian built reproductions of the monuments he most admired during his travels. This long basin seems to represent the canal of Canopus, which linked Alexandria with the Temple of Serapis at Canopus. The building on the left, at the end of the canal, a triclinium, has the same plan as the temple of Isis in Rome. Recent excavations have uncovered sculptures clearly connected with Egypt, as well as copies of Attic sculpture of the fifth century B.C.

Left:

Tivoli: Hadrian's Villa. Detail from the curved side of the Canopus, with reproductions of the Phidian Amazon and a Mars, Greek works of the fifth century B.C. (These are cement casts; the original copies are in a small museum nearby.)

Right:

Tivoli: Hadrian's Villa. The so-called Maritime Theater. In reality this is a small round islet, occupied by a series of small rooms and surrounded by a canal and a colonnaded portico. Originally only two wooden drawbridges connected the central complex with the rest of the villa; it could thus be totally isolated. Assumed to be the private refuge of the emperor, its exact function is still to be explained.

Tivoli: Hadrian's Villa. Detail of the preceding plan.
1 *Small Thermae*
2 *Great Thermae*
3 *Vestibule*
4 *Canopus*

and from which they certainly obtained considerable inspiration. The Piazza d'Oro, the Small Baths and the Maritime Theater move quite decisively outside the usual schemes of ancient architecture to anticipate modern forms.

It has often been said that the emperor himself was the architect of the villa. Hadrian loved to pose as an artist, and he did cultivate almost all the arts, from painting to architecture to poetry. It is most improbable, however, that he had the technical knowledge necessary for the realization of a work that is considered among the most remarkable in ancient architecture. It is certain, though, that the emperor, who had commissioned the work, imposed his point of view regarding the planning of the whole, and some of the elements, such as the Maritime Theater, seem too close to an intimate, personal vision, to be independent of the will and choice of Hadrian himself. This circular islet, ringed by a canal, could be completely isolated by removing two drawbridges. It displays in the clearest possible way the desire of the person who conceived it to isolate himself in the very heart of the

A VIEW OF LIFE IN ROME AT THE BEGINNING OF THE SECOND CENTURY A.D.

At Rome 'tis worse; where house-rent by the year,
And servants' bellies cost so devilish dear;
And tavern bills run high for hungry cheer.
To drink or eat in earthernware we scorn,
Which cheaply country cupboards does adorn:
And coarse blue hoods on holidays are worn.
Some distant parts of Italy are known,
Where none but only dead men wear a gown
But here, attired beyond our purse we go,
For useless ornament and flaunting show:
We take on trust, in purple robes to shine:
And poor are yet ambitious to be fine.
This is a common vice, though all things here
Are sold, and sold unconscionably dear.
Who fears in country towns a house's fall,
Or to be caught betwixt a riven wall?
But we inhabit a weak city here;
Which buttresses and props but scarcely bear:
And 'tis the village mason's daily calling,
To keep the world's metropolis from falling,
To cleanse the gutters, and the chinks to close;
And, for one night, secure his lord's repose.
At Cumae we can sleep quite round the year,
Nor falls, nor fires, nor nightly dangers fear:
While rolling flames from Roman turrets fly,
And the pale citizens for buckets cry.
Thy neighbour has removed his wretched store
(Few hands will rid the lumber of the poor);
Thy own third story smokes, while thou, supine,
Art drench'd in fumes of undigested wine.
For if the lowest floors already burn,
Cocklofts and garrets soon will take the turn;
Where thy tame pigeons next the tiles were bred,
Which, in their nests unsafe, are timely fled.
'Tis frequent here, for want of sleep, to die;
Which fumes of undigested feasts deny;
And, with imperfect heat, in languid stomachs fry.
What house secure from noise the poor can keep,
When e'en the rich can scarce afford to sleep:
So dear it costs to purchase rest in Rome;
And hence the sources of diseases come.
The drover who his fellow drover meets
In narrow passages of winding streets;
The wagoners that curse their standing teams,
Would wake e'en drowsy Drusius from his dreams.
And yet the wealthy will not brook delay,
But sweep above our heads, and make their way:
In lofty litters borne, and read and write,
Or sleep at ease: the shutters make it night.
Return we to the dangers of the night:
And first behold our houses' dreadful height;
From whence come broken potsherds tumbling down;
And leaky ware from garret windows thrown:
Well may they break our heads, that mark the flinty stone;
'Tis want of sense to sup abroad too late;
Unless thou first hast settled thy estate.
As many fates attend thy steps to meet
As there are waking windows in the street,
Bless the good gods, and think thy chance is rare
To have a pisspot only for thy share.

JUVENAL: *Third Satire*

residence, to detach himself from the cares and tasks that the administration of the Empire continuously thrust upon him. The romantic "Hadrianic" poetry that has survived speaks to the same feeling, the same need for isolation.

Besides such cases as the Maritime Theater, directly linked to what is known of his personality, the intervention of the emperor in the conception of the villa may be seen and proved not so much from the technical point of view as through the ideological meaning each building bears in its context. According to a fourth century historian, the villa consists of reproductions of the most famous monuments admired by Hadrian during his journeys to the provinces. While there is no reason to suspect this information, the value and limits of the concept of imitation should be understood. All the structures of Hadrian's villa correspond perfectly to architectural styles of the second century A.D. If imitation was attempted, then, it was more likely "free" imitation, more allusive than realistic. It is really almost impossible to imagine the concept of an "architectural copy" in this period. Within these limits, however, the historian's statement is quite interesting. It seems appropriate that Hadrian should wish to surround himself with buildings that were in a certain sense representative and symbolic of the provinces of the Empire. The villa thus became a sort of microcosm, the sum and synthesis of the "Romanized" universe, and the Emperor imposed himself in the clearest and most explicit manner as the center and keystone of the whole system. A conception of this kind corresponds rather well to everything that is known about Hadrian's personality and political outlook.

Art and Society Under the Antonines: The Column of Marcus Aurelius

Antoninus Pius was distinguished from his predecessor by his much more modest, "bourgeois" qualities, but by the time he came to rule, Hadrian's imprint on the Empire was definitive. His policy was to be followed consistently for many decades. The temple to the deified Hadrian that Antoninus erected, whose northern colonnade still stands (and is one side of the modern building housing the Stock Exchange, in Piazza di Pietra) is highly interesting from several points of view. Just as in the case of the temple erected by Hadrian for his predecessor, north of the Forum of Trajan, the temple in Piazza di Pietra completes and is connected to a series of edifices built by Hadrian: the temple dedicated to his mother-in-law Matidia and the basilicas of Matidia and Marciana. Considerable dynastic continuity is implied by all of this. The fact was that every emperor already foresaw his deification. Almost all the emperors began urban plans during their lifetime, and these were meant to be completed only after their death by the erection of a sanctuary for the new "god."

The sculpture that decorates the interior of the cella of Hadrian's Temple consists of a series of female figures that symbolize the provinces of the Empire holding trophies. At the same time, Antoninus Pius had a series of coins struck that bear personifications of the provinces on one side. After all that has been said about Hadrian's organizing activities and his interest in the administration of the Empire, (and in this regard as well, Antonius followed his predecessor), it is almost superfluous to emphasize the obvious political meaning of these figures. What can usefully be pointed out is the drier, more rigid, and more archaistic style into which Hadrian's classicism — so very vital and replete with Hellenistic moods — was transformed by the age that followed his. The tendency of the age of Antoninus Pius, who came from the upper ranks of the state bureaucracy, was to reassert the value of all the aspects of more ancient Roman and Italic tradition. The process had its sources in the policies of Augustus, of course, but the resuscitation of an already dead world, like the cold classicism that was its formal dress, survived Antoninus Pius for only

a few years, and finally gave way to completely opposite artistic and ideological forms.

Already with Marcus Aurelius (A.D. 161–180) the change had begun. Antonine classicism is very vivid, as we can see in the portraits of this emperor and even more in those of Lucius Verus, who shared with him in the rule of the Empire. But it was above all in the age of Commodus (A.D. 180–192), Marcus Aurelius' degenerate son, that the break with classical form took place. It is certainly no accident that during this time, between the end of the second century and the first years of the third, there grew up the profound economic, political, and social crises that shook the foundations of the Empire. It managed to survive only through the total reconstruction and reorganization begun by Diocletian and finished by Constantine and the other emperors of the fourth century.

It was in the reign of Marcus Aurelius that the movement of the Germanic and Sarmatian populations began. The depredations of these groups were to be among the decisive causes of the collapse of Roman power. The Quadi and the Marcomanni actually penetrated into Italy, something that had not occurred for centuries, and the emperor had to take over command of the army himself to resist them. At the same time, a terrible pestilence spread over the land; it caused Aurelius' death in the plains of Vienna. The presentiment of "decline and fall" that such events provoked is clearly present in the spiritual diary of the emperor, written in Greek. In this work the pessimistic outlook of the emperor goes so far that he doubts the validity of his own office; only his characteristic tenacious sense of duty and responsibility allows him to go on with the task entrusted to him. Some parts of his diary demonstrate how far the critical outlook pervaded even the most acute spirits. Particularly remarkable is the passage in which, taking up and accepting the pirate's famous reply to Alexander the Great, the emperor compares the Roman legionary to the brigand. Although the emperor's judgment was a purely private one, not meant to be divulged, it was nevertheless a symptom of the withering away of trust in the Empire's ideological foundations.

The monument that best renders this historic moment is the Column of Marcus Aurelius, erected after his death by his son Commodus. Clearly inspired by Trajan's Column, it differs in some minor details — the base is taller and there are a smaller number of coils, which makes the figures taller. More important, however, is the fact that the relief is much more deeply cut, and shows the taste of the age for violent and dramatic contrasts of light and dark. The harsh technique also renders the scenes more legible. The Hellenistic fluidity that was one of the main characteristics of Trajan's Column, here gives way to a broken and staccato vision. The figures, less numerous and more bulky, are rendered in much greater definition; natural backgrounds are extremely simplified or almost nonexistent; standardized pictorial schemes are insistently repeated; the recurring figures of the emperor and those near him are almost always facing totally to the front. (All these motifs anticipate the "Late Ancient" artistic style). In the Column of Marcus Aurelius, expression has become more important than form, and the equilibrium between these two fundamental aspects of every artistic work has been thoroughly upset. The result is a tense, dramatic art that tends to accentuate the inhuman and horrible aspects of war. The massacre of prisoners, decapitations, the deportation of women and children, are repeated constantly; the faces of the barbarians (and those of the Romans also) are contorted and deformed by painful and grotesque expressions. The drill has here become the sculptor's fundamental tool. Unlike the chisel, which graduates surfaces and thus accentuates the organic, fluid aspects of relief, the drill makes deep cuts and creates dark areas next to completely vivid light ones. The vision rendered is more or less plastic, but it replaces a rational element with an irrational one. This fragmented, detached form was obviously most efficacious and fit for a society in crisis, stricken by the presentiment of its decadence.

TWO THOUGHTS BY MARCUS AURELIUS

From some high place as it were to looke downe, and to behold here flocks, and there sacrifices, without number; and all kinde of navigation; some in a ruffe and stormie sea, and some in a calme: the general differences, or different estates of things, some, that are now first upon being; the severall and mutuall relations of those things that are together; and some other things that are at their last. Their lives also, who were long agoe, and theirs who shall be hereafter, and the present estate and life of those many nations of Barbarians that are now in the world, thou must likewise consider in thy minde. And how many there be, who never so much as heard of thy Name, how many that will soone forget it; how many who but even now did commend thee, within a very little while perchance will speake ill of thee. So that neither fame, nor honour, nor any thing else that this world doth afford, is worth the while.

Meditations (XXIX)

As the Spider, when it hath caught the Fly that it hunted after, is not little proud, nor meanely conceited of her selfe: as hee likewise that hath caught an Hare, or hath taken a Fish with his net: as another for the taking of a Boare, and another of a Beare: so may they be proud, and applaud themselves for their valiant acts against the Sarmatae, or Northern Nations lately defeated. For these also, these famous souldiers and warlike men, if thou dost looke into their mindes and opinions, what doe they for the most part but hunt after prey?

Meditations (X)

Left:
Rome: The Column of Marcus Aurelius. Standing in present-day Piazza Colonna, it was erected by Commodus in honor of his father, and finished in A.D. 193. Like its twin, the Column of Trajan, it is some 100 feet high without its base. The spiral frieze depicts the wars against the Quadi and the Marcomanni. A statue of Marcus Aurelius once stood at the top of the column; Pope Sixtus V replaced it with a statue of St. Paul in 1589, as a complement to the statue of St. Peter on Trajan's Column.

Right:
Rome: The Column of Marcus Aurelius. Detail. The relief is higher and deeper cut, and the figures larger, than on the Column of Trajan.

Outskirts of Rome: Sant'Urbano alla Caffarella. This medieval church occupies a small second-century A.D. temple built entirely in brick except for the columns of the facade. The building may have been a part of Herodes Atticus' villa (the *Pago Triopio*) which lay in this area, between the third and seventh mile of the Appian Way; or possibly it was the Temple of Demeter and Faustina.

Below:
Santa Maria Capua Vetere (ancient Capua): The Campanian Amphitheater. This building of the age of Hadrian is the largest amphitheater remaining, after the Colosseum. Its axes are 548 feet by 450 feet. The exterior is rather similar to its Roman counterpart, with three superimposed orders and an attic; another similar element is the construction of underground rooms beneath the arena. The decoration of the keystones with the heads of gods is remarkable.

Outskirts of Rome: The so-called Tomb of Annia Regilla. This lovely brick sepulcher, built in the second century A.D., lies near the Appian Way in the Caffarella valley. Its strange position excludes any possible relation with the *Pago Triopio*. (Annia Regilla, the wife of Herodes Atticus, was actually buried in Greece.)

Left:
Ostia: The Capitolium. At the end of the Forum of this city, Rome's ancient port, rises this temple of the age of Hadrian, dedicated to the Capitoline "trinity". The frontal colonnade and marble decoration of the building have disappeared, and only the brick structure remains.

Right:
Ostia: The Baths of Neptune. Mosaic. This elaborate floor with marine subjects, the largest remaining in Ostia, decorated a room of the thermae built by Hadrian and Antoninus Pius. Black and white mosaic of this type was in wide use during the Imperial Age.

Private Art in the Second Century

Just as in the official sphere, in the private sphere the second century was a period of profound transformations. After Hadrian's Villa there rose in the suburbs of Rome imposing villas that even today, together with the aqueducts and sepulchers, are among the greatest attractions in the Roman Campagna. One of the most grandiose villas was the *Pago Triopio* of Herodes Atticus, a wealthy banker who lived in the period between Hadrian and Marcus Aurelius, which was built between the third and seventh mile of the Appian Way. Among the few remains of this immense property, one of the most notable is the little temple dating from Marcus Aurelius' time (now the church of Sant'Urbano alla Caffarella), which some investigators think may have been a sanctuary dedicated to Demeter and to Faustina. This building is characterized by extensive use of brick; the entire structure is made of brick except for the four marble columns in the facade.

This use of brick — not as a mere economic expedient but as a valid element in the building even from the decorative point of view, so that it is left clearly visible — is typical of the architecture of this period. Buildings in Ostia and probably those in Rome were built with brick facades. Light reliefs, or polychrome effects obtained by the use of different materials, were the only decoration. From this point of view, funerary art is especially noteworthy: a change in rites, from cremation to interment, and the adoption of the marble sarcophagus (a custom from the Near East), created the need for more ample tomb spaces and led to the abandonment of the types of mausoleum used in the first century A.D. in favor of tombs in the form of a temple. Other forms analogous to these were used even in cases where the cremation rites persisted.

In the second century the tomb made entirely of brick prevails, with ample interior spaces — the type found, for example, in the necropolis at Isola Sacra (between Ostia and Portus), in the Vatican necropolis, or in the necropolis in Via Latina. A celebrated example is the tomb which has wrongly been called the mausoleum of Annia Regilla, the wife of Herodes Atticus. Here the use of brick has a high dignity, with refined effects of polychromy and carving.

Page 142:
Above:
Rome: Tomb of the Pancrati on the Via Latina. Middle of the second century A.D. Detail of the molded stucco and decorative painting.
Below:
Another detail of the Tomb of the Pancrati.

THE CRISIS
The Imperial Age (A.D. 193-330)

The Socioeconomic Crisis
of the Third Century

In A.D. 193 a new dynasty was brought into being when the legions of the Rhine and the Danube proclaimed Septimius Severus emperor, and forced the Senate to ratify their choice. The Severus family ruled until 235. With an able general at its head, the frontier problems of the Empire seemed capable of solution, at least temporarily; but the economic crisis of the Empire, though latent, merely grew worse during the course of those forty years, and exploded violently in the middle of the third century. Some projects planned by the Antonines were realized, such as the concession of Roman citizenship to all the inhabitants of the Empire. Caracalla made this move in A.D. 222, but for considerations that were basically economic: the Empire needed money.

After the death of Alexander Severus, the last of the dynasty, military anarchy reigned supreme in the Empire for more than fifty years. Emperors succeeded each other after periods of a few years, or sometimes even of a few months. Some provinces, such as Gaul and Palmyra (in Syria), gained de facto independence during this period. The collapse of the economy was most clearly seen in the devaluation of the official coin, the denarius, whose silver rate reached abysmal levels. The ranks of the state bureaucracy, which had functioned in the preceding century mainly with the consent of the provincial middle classes, now became almost purely confiscators of tribute, and the central authority was often respected only by means of brute force. Events that took place in other fields were linked to those in politics. The peculiar "national" character of the various cultures began to assert themselves within the population of the Empire, assuming an "anticlassical" character adverse to the Greco-Roman culture of the ruling class. Within that class itself, the disintegration of the economy and the society coincided with a collapse of all the ideological values on which Greco-Roman civilization had been founded, values whose heir and propagator the Empire was.

Historically considered, the profundity of the crisis seems to have been greatest in religion. During the third century, traditional beliefs were virtually eliminated in the Empire and the religions of salvation triumphed. Often of eastern origin, they penetrated in the lower classes. The upper class found comfort in evasive and vague philosophies such as Neoplatonism. The popular religious movements, among which Christianity was the most important, thus became a revolutionary force, which the state labored with every means at its disposal to repress — but in vain.

The confusion and breakup is seen in art as well. But here the Roman urban centers must be distinguished from the various provinces; even within the provinces themselves further distinctions must be made. Rome had a building boom during the Severian age, followed by an impressive collapse during the middle years of the century, with few new works realized, and many of these restorations. For example,

DECADENCE AND CRISIS IN THE THIRD CENTURY A.D. AS VIEWED BY A CONTEMPORARY

The winter does not afford the abundance of rain necessary for the nourishment of the seeds left in the earth; the summer does not offer such a torrid sunny climate as to permit the maturing of the ears of wheat; the spring does not bring enough fecundity of fruit. The exhausted and worn-out quarries yield ever smaller quantities of gold and silver; the springs seem to become more arid with every passing day.

There is less agriculture in the fields, less fishing in the sea, fewer troops in the encampments, less justice in the Forum, less loyalty in friendship, skill in the arts, discipline in customs.... The rays of the sun are paler and weaker at sunset; the moonlight has become feeble during the last nights; the tree that in its time was green and flourishing has grown deformed in the sterility of its old age, and the spring that was rich and abundant at the beginning sends forth only a few drops now that decrepitude weakens it. This is the sentence that lies heavy on the world; this is the law of God: that all that has grown, grows old, all that is strong becomes weak, and through a process of progressive infirmity and diminution, disappears.

ST. CYPRIAN: *Letter to Demetrian*

Rome: Arch of the Argentari. Dedicated to Septimius Severus by the merchants and bankers of the Forum Boarium in A.D. 204, as an inscription states, this Arch was probably the monumental entrance to the square. The decorative sculpture shows members of the Imperial family making sacrifices, and barbarian prisoners.

during the time of Gallienus (253–268), which represented a period of relative revival, the name of the emperor was celebrated simply by sculpturing an inscription on one of the gates of the ancient Servian wall rebuilt by Augustus. The most notable work of the period was dictated by necessity. This was the imposing urban boundary wall, which the emperor Aurelian had built in the years 271–275 to be the principal defense of the city against the barbarian hordes. (It was later enlarged by Honorius at the beginning of the fifth century.)

Most of the provinces also experienced some economic decline relative to their former prosperity; a negative gauge of the situation is the small number and small importance of the public works undertaken. There were some exceptions, however, in particular the African provinces, which seem to have been the richest part of the Empire in the third century. Their prosperity was due above all to agricultural and commercial factors — African oil, for example, replaced Spanish oil in the market — and it corresponded to an extraordinary cultural and artistic boom in Roman Africa, in literature, architecture, and the figurative arts. The mosaic art of these provinces, in particular, is one of the most remarkable products of ancient civilization.

Public Art of the Severian Age

The best example of official art in Rome during the time of Septimius Severus is the Arch of Septimius Severus, erected in the Roman Forum. The dedicatory inscription dates the arch at A.D. 203. It has three barrel vaults and very bold proportions. Only ten years passed between the Column of Marcus Aurelius and the Arch, and the stylistic character of the sculpture on the Arch, which celebrates the emperor's campaigns against the Parthians and the Arabs, does not differ much from that of the sculpture on the column. The four large panels that decorate the two facades are of particular interest. The scenes are arranged on many superimposed levels, which some scholars think indicates that they were planned for use in a column like Trajan's or Aurelius', but then adapted to an arch. It is more likely that the sculptures were taken from "sketches" like those in the triumphal paintings that had existed in Rome from the earliest periods of the Republic and whose most ancient specimen can be recognized in a

Rome: The Baths of Caracalla. Overall view. This building complex, the largest of its kind at the time (beginning of the third century A.D.) in Rome, lies at the end of the slopes of the little Avenine, near the Appian Way. The water for these baths was supplied by a branch of the Aqua Marcia, created especially for this purpose.

Rome: Plan of the Baths of Caracalla (first quarter of the third century A.D.).
1 Natatio (pool)
2 Great central hall
3 Tepidarium
4 Calidarium
5 Gymnasiums

Let me die, if I think silence so absolutely necessary for a studious man as it seems at first to be: variety of noise surrounds me on every side: I lodge even over a public bath. Suppose now all kinds of sounds that can be harsh and disagreeable to the ears; as when strong boxers are exercising themselves, and sling about their hands loaded with lead, or when they are in distress, or imitate those that are, and I hear their groans; or when sending forth their breath, which for some time they held in, I hear their hissing and violent sobs; or when I meet with an idle varlet, who anoints the ordinary wrestlers with their exercise, and I hear the different slaps he gives them on their shoulder, with either a flat or hollow palm; or if a ballplayer comes in, and begins to count the balls, it is almost over with me. Add to these the rank and swaggering bully, the taking a pickpocket, or the bawling of such as delight to hear their voice echo through the bath; add also those who dash into the pool with a great noise of water; and besides these, such whose voices at least are tolerable: suppose a hair-plucker every now and then squeaking with a shrill and effeminate tone, to make himself the more remarkable, and is never silent but when he is at work, and making his patient cry for him; add to these the various cries of those that sell cakes and sausages, the gingerbread baker, the huckster, and all such as vend their wares about the streets with a peculiar tone.

SENECA: *Letter to Lucilius* (56)

Following pages:
The Alexandrian aqueduct in the Roman Campagna, the work of the last Emperor of the Severian dynasty, Alexander Severus.

fresco from the Esquiline (illustrated on page 34). The ancient author Herodianus recalls that Septimius Severus sent some "commentaries" on his campaigns from the Near East, together with paintings that illustrated the details. Perhaps these were the originals for the sculpture found on the emperor's arch. If so, it is interesting that an emperor who came to power by force should' desire to link himself to the obsolete traditions of the Republic, by the use of a report written to the Senate and by triumphal paintings.

Some of the iconographic and stylistic elements of these sculptures seem to hark back to "popular" motifs. This was characteristic of triumphal painting, and such motifs always reappear in the monuments of official art, even in those most closely connected to "cultured" artistic forms, such as the *Ara Pacis*, or in those rich in novelty, such as Trajan's Column. The disintegration of the organic classical form seems to have given new vitality to these motifs. In the four large sculptured panels and the frieze representative of triumph, qualities of plebeian art reappear. The bird's-eye views of cities are common to almost all historical depictions, but there are also indifference to perspective and to the characterization of landscape, schematic and repeated figures, a prevalence of the narrative and contextural aspects over the formal aspect of the work, to the point where the total composition is neglected altogether.

Formal novelties are noticeable only by examining some details, for the art of the third century is actually the antithesis of classical or Hellenistic art where the total vision prevails and all the elements are linked in an organic composition. Here, on the contrary, the vision is analytic. Every element has its own value per se. The art is "expressionistic" and "psychological," as seems suitable to an epoch in which the state bureaucracy and every other structure in the ancient world was disintegrating. Individuals were left to face the ideological vacuum as best they might, or retire into themselves in a spiritual attempt to recognize themselves as individuals. It is certainly no coincidence that the most valid genre of Roman art in this period is portraiture, which reaches a very high level of accomplishment.

At the same time, in some monuments of nonofficial art, such as the arch in the Forum Boarium dedicated to Septimius Severus in 204 by some bankers and merchants, the dissolution of plastic form reaches an even more advanced level. Its human figures are submerged in a thick net of non-figurative ornamental elements, which sculptors seem to have grown to prefer.

Development of the Imperial Baths: The Baths of Caracalla

Urban architecture in Rome realized some of its most amazing works during the Severian age. This persistence of building activity offers further evidence, should it be needed, of the way in which great urban architecture is an element unto itself, separate, to a certain extent, from the objective economic situation in the Empire, which finds a reflection in it only secondarily and always after a certain delay. The reason for this is clear. Since all this building activity had a symbolic function as part of the imperial apparatus, and was realized through a completely isolated organization in the hands of the emperor, it was relatively independent of the general economic conditions.

Among the most important achievements in this field were the enlargement of the Imperial palaces on the Palatine (by the construction of a luxurious monumental front), the Septizodium facing the Appian Way, the Severian Baths on the Palatine, the Temple of Serapis on the Quirinal, and above all the grandiose Baths of Caracalla. The latter is the most remarkable and best preserved example of

what are customarily called the "Great Imperial Baths." Architecturally there is a sharp difference between the older type of public baths — thermae — derived from the Greek gymnasium (the best examples are to be found in Pompeii and Herculaneum) and the new type of edifice that developed in Rome during the Imperial Age. In the older thermae the rooms were arranged in series, one after the other, and communicated directly with one another. This elementary system was possible as long as the size of the buildings and the number of "customers" remained limited. It thus continued to be used in the minor centers even when the new type of thermae had already been the fashion in the capital for some time.

This new form originated when the population in Rome became so large that it was necessary not only to increase the size and number of the public baths, but also to invent a more rational plan for them, able to absorb the masses of people in the most rapid and efficient way and at the same time capable of taking on a more monumental and "symbolic" aspect. Roman architecture had already faced such combinations of urban and monumental problems. The creation of the amphitheater, for instance, met needs not felt in ancient Greece. An increase in size of building types already known — the theater, the stadium, the gymnasium — would not have been sufficient to solve the problem, so new building types were created, perfectly suited to new functions and capable of handling large numbers of people. The history of building in Rome is well enough known so that the stages through which the Great Imperial Baths developed can be outlined.

The first installation of public baths on a large scale was built by Agrippa in the Campus Martius during the last part of the first century B.C., and was closely related to the urban reorganization planned by Augustus. Renaissance drawings show plans of this building. Although it was restored many times in the Imperial Age, it remained substantially like the type of "Minor Thermae" derived from the gymnasium.

The qualitative leap probably took place with Nero. The thermae begun by this emperor, also in the Campus Martius, are known both by their remains and through plans drawn by Renaissance artists. Although there is some dispute about the matter, it is unlikely that the restorations of Emperor Alexander Severus changed the basic plan of the building. In these baths the essential elements of the "Great Thermae" type are seen for the first time. The fundamental conception is the duplication of the smaller rooms, forming two perfectly symmetrical wings on the sides of an axis along which the fundamental services — the *calidarium* (hot room), the *tepidarium* (warm room), and *natatio* (large cold water pool) — are placed. At the center of the complex a large rectangular hall, a sort of large basilica usually identified wrongly with the *tepidarium*, communicates with the other rooms by means of two crossing axes. This arrangement allowed a large mass of people to follow the obligatory course of a traditional Roman bath — heat to provoke perspiration, ablutions with tepid water, and then the cold water pool — along two separate one-way courses, without going back through all the rooms. The actual bathing rooms, rather than being duplicated, were merely enlarged and used for both courses. Not only was this plan more rational and less expensive than a duplication of the fundamental rooms would have been, it allowed for monumental treatment. The rooms of the little baths, set one after the other, were replaced by an organic, coherent system with bilateral correspondences, focal nuclei and symmetrical axes.

THE AQUEDUCTS OF ROME

So that I may not accidentally omit anything necessary for understanding the whole subject, I shall first set down the names of the waters that are brought into the city of Rome; then by what persons and under which consuls and in what year since the founding of the city each was brought in; at what places and milestones their aqueducts commence; how far they are carried in underground channels, how far on masonry substructures, how far on arches; the height of each of them; the size and numbers of outlets and what uses are made of them; how much water each aqueduct brings to each section outside the city and how much within the city; how many public delivery tanks there are and how much they deliver to places of public amusement, to ornamental fountains — as the educated call them — and to water basins; how much water is assigned to the use of the State (in Caesar's name) and how much to private uses by grant of the emperor; what is the law concerning construction and maintenance of the aqueducts; and what penalties enforce the law under various regulations, votes of the Senate, and Imperial edicts. . . . For 441 years since the foundation of the city, Romans were satisfied to use the waters they drew from the Tiber, from wells, or from springs. Down to the present day, springs have been given the name of holy things and are objects of veneration; they have the repute of healing the sick, as for example the spring of the Prophetic Nymphs of Apollo and the spring of Juturna. . . Under the consulate of M. Valerius Maximus and P. Decius Mus, in the thirtieth year (313 B.C.) after the outset of the war with the Samnians, the Appian water was brought into the city by the censor Appius Claudius Crassus. He also was responsible for constructing the Appian Way, from Porta Capena to the city of Capua. . . .

FRONTINUS:
The Water Supply of Rome (4)

This arrangement appears at a single blow in the age of Nero and may be the work of a single person. An age of architectural novelty and of important artists — such as the architects of the *Domus Aurea*, Severus and Celer — Nero's reign also saw important urban innovations. After the terrible fire of A.D. 64, a new city, the *nova urbs* mentioned by ancient authors, seems to have been conceived according to more rational and modern criteria than had been previously applied. More than an architectural phenomenon, the great baths are a town-planning phenomenon of the first order. Even if the plan of the baths of Nero is not the original plan, but one of the Severian age, the invention of the type need be moved only a few years, for it occurred again in the Thermae of Titus, in about A.D. 80. The next built were the Thermae of Trajan, which rose on the Oppian Hill near the Colosseum on the remains of the *Domus Aurea* between A.D. 104 and 109. By this time the great thermae type is definite and mature; it was not later modified significantly. Nor are the Baths of Trajan inferior in scale to the two grandiose complexes that followed it in Rome, the Baths of Caracalla (212–216) and the Baths of Diocletian (298–306). These three complexes, separated by nearly a century from each other, seem to mark emblematically the fundamental stages of Roman urban architecture. The architect of the Baths of Trajan was the great Apollodorus of Damascus, creator also of the Forum of Trajan.

Of the three great complexes the Baths of Caracalla is in the best state of preservation. Like the other two, it included a great perimetrical wall with an exedra — or perhaps the tiers of a theater — measuring approximately 1105 by 1076 feet. At the center of this enclosure — first seen in the Baths of Trajan — stood the thermal building proper, which measured some 722 by 374 feet, and was built to the plan described above. Space between the wall and the building was used for gardens, and the rooms set into the outside perimeter included two libraries. The Baths of Caracalla is remarkable not only in its size, but in its structural achievements as well. The greater circular calidarium was covered with a cupola over 111 feet in diameter, not much smaller than that of the Pantheon, but more advanced in its technique of construction; the large windows placed in the walls beneath the dome required the solution of quite complex problems in statics. The central hall is covered with three grandiose cross-vaults. Only the bare skeleton of the complex remains today, but enough of the original marble, mosaic, and sculptural decoration has remained to show that the functions of the bath were not exclusively utilitarian. Its artistic level was equal to that of the Imperial palaces, as were its costs. The best artists and architects of the time were employed; huge pieces of sculpture (now in the National Museum in Naples) exemplify the high accomplishment of the decorative work.

The baths were frequented by the Roman plebeians, the people of the lower class for whom the free distribution of food and the games of the circus and the amphitheater had alike been organized by the state. The term "villas of the poor," which was applied to the great thermal complexes of Imperial Rome, is on the whole correct. They were public works, but they were also works of propaganda, exaltations of imperial munificence. The living quarters of ancient Rome were a great contrast to these buildings of extraordinary luxury, dark and dank multistoried buildings where many families were crowded together in limited and unhealthy space fit only for the nightly rest. Normal life was led outside these slums; in the forums in good weather, in winter in the thermae that were numerous and spacious enough to take in thousands of people every day. Besides the advantage of the baths, they offered numerous other attractions: heating, which was nonexistent in private dwelling; libraries; gardens and spectacles of various kinds. A brief reflection on the function of buildings like the Baths of Caracalla reveals a great deal about the social and political structure of the Empire. The immense plebeian masses of the cities were bound to the emperor in a thoroughly paternalistic relationship.

Construction at Ostia

Ostia, the port of Rome (two-thirds of which has been brought to light by excavations), gives an indirect but rather faithful picture of the nonofficial building that took place in Rome between the second and third centuries. The period of Ostia's greatest building activity was during Hadrian's reign, when new construction covered about 160,000 square yards. In the period between Antoninus Pius and Commodus the land used for new works decreased to about 66,000 square yards. And the decrease was accentuated from the Severian emperors on. In all the third century, not more than 45,000 square yards of buildings were erected in Ostia. The decrease is even more impressive if it is borne in mind that most of the activity in the last period was not new construction, but rather restoration. There was also a sharp curve downward during the course of the third century. In the Severian period important public works were undertaken, such as the Baths of Porta Marina and the Round Temple, but they were completely lacking in the second half of the century. The picture of general stagnation which Ostia shows corresponds perfectly to the situation in the nearby capital.

The theater at Ostia, built in the Augustan Age, was restored at the end of the second century, with an increase of three or four thousand in its seating capacity. Although the dedication took place under Septimius Severus and Caracalla in A.D. 196, the work was done almost entirely during the reign of Commodus. At the end of the second century the enormous increase in population led to an attempt to enlarge the capacity of public buildings. At the same time the great Piazza of the Corporations, behind the theater, was restored; this was a large porticoed area with a series of cells that were the offices of representatives of the navigation and trading companies of the principal Mediterranean cities. The inscriptions on the mosaics set in front of these cells indicate in fact the "nationality" of the *navicularii* (shipowners) and the *negotiatores* (merchants) who had their offices here. An entire side of the portico was occupied by representatives from African cities, further proof of the economic importance of these provinces during this period. No other ancient monument gives a more lively and direct picture of the varied and complex economic structure of the Roman Empire.

The Aurelian Walls

The most important construction in Rome in the second half of the third century was military, and, moreover, defensive: the Aurelian walls. After the initial period of the Republic, the city had no boundary wall. The Roman conquests, which had expanded the confines of the ancient city-state to include the entire Mediterranean area, rendered such a work superfluous. The real defensive line was the *limes*, that gigantic fortification work that almost everywhere follows the borders of the Empire. The first symptom of danger to Rome itself during the Imperial period took place during the reign of Marcus Aurelius, when the northeastern frontiers of Italy were violated for the first time in centuries, and the Quadi and Marcomanni pushed down to Aquileia (west of present–day Trieste). The invasions of the Alamanni, which multiply from A.D. 258 on, showed how easy it was to penetrate deeply into Italy. The capital itself came to seem a frontier post that needed a solid wall for its protection.

The person who saw to its construction was Aurelian (A.D. 270–275), who had to do without the help of the military workers who were specialists in jobs of this kind; they were then engaged in the war against Palmyra. The work was thus entrusted to building corporations in the city. It proceeded at a remarkably rapid pace. The walls were finished in four years, a sure sign that danger was considered imminent.

POPE DAMASO'S INSCRIPTION IN THE CATACOMBS OF ST. SEBASTIAN

O you, whoever you be, who search for the names of Peter and Paul, you must know that at one time the bodies of these saints lay here. The Orient sent them here as disciples (of Christ), we admit this most heartily. Through the blood they shed, following Christ amidst the stars they reached the gates of heaven and the kingdom of the just. Rome deserved more than the other cities to claim them as her citizens. Damaso here sings your praises, O you new stars.

AURELIAN BUILDS THE WALLS OF ROME

When the war with the Marcomanni was ended, Aurelian, over-violent by nature, and now filled with rage, advanced to Rome eager for the revenge which the bitterness of the revolts had prompted. . . . Then, since all that happened made it seem possible that some such thing might occur again, as had happened under Gallienus, after asking advice from the senate, he extended the walls of the city of Rome. The pomerium, however, he did not extend at that time, but later.

Scriptores Historiae Augustae (XXI)

INSCRIPTION ON THE PORTA MAGGIORE

The Senate and People of Rome set this up to the Imperial Caesars, our Lords the two princes Arcadius and Honorius, victorious, triumphant, ever Augusti, to commemorate the restoration of the walls, gates, and towers of the Eternal City, after the removal of huge quantities of rubble. At the suggestion of the distinguished and noble Count Stilicho, Master of both of the Armed Forces, their statues were set up to preserve the memory of their name. Flavius Macrobius Longinianus, City Prefect, devoted to their majesty and divine power, was in charge of the work.

Corpus Inscriptionum Latinarum (VI:1189)

The haste with which the work was done is seen in, among other things. the relative unpretentiousness of the work — the wall was barely twenty feet high and eleven feet thick — and also in the fact that many preexisting constructions were included in it or swallowed up by it — the pyramid of Cestius, the facades of houses, tombs, and at times aqueducts, as at Porta Maggiore. Even with its limited dimensions, the work must have appeared sufficient to contain any attack by the barbarian hordes. For the most part they did not have the implements necessary for a siege, and although the initial ferocity of their attacks was great, they could not stage a long siege because of their poor logistical situation. In their present state, the Aurelian Walls are the result of much restoration and reconstruction work, the most important of which took place under Honorius at the beginning of the fifth century. On that occasion the height of the walls and of the square towers that rise up every hundred feet was doubled, numerous minor gates that weakened the fortification were sealed off, and the openings of other gates were narrowed.

Today these walls, for the most part preserved over their total length of almost twelve miles, are the most imposing fortification remaining from the ancient world. Thoroughly functional, they were in uninterrupted use up to the last century. Of the infinite number of medieval,

Rome: The Aurelian Walls. Porta San Sebastiano (once Porta Appia). A reconstruction built during the reign of Honorius, at the beginning of the fifth century A.D., of the city gate of the third century.

Following pages:
A stretch of the Aurelian Walls. Built by the Emperor Aurelian between A.D. 270 and 275, and enlarged and reinforced by Arcadius and Honorius in 403, this well-preserved and imposing wall is about twelve miles long. The square towers appear every 100 feet.

Renaissance and modern restorations, the most notable is the grandiose bastion built by Sangallo during the Renaissance. The short battle at the wall that ended with the capture of Rome in 1870 by the forces of United Italy and the ill-fated uprising against Nazi occupation after September 8, 1943 at Porta San Paulo are further confirmation of the part these walls have played in Roman history.

Besides the historical continuity that has made the Aurelian Walls perhaps the most significant monument in the city, they offer a documentary history of the extension of ancient Rome. The area inside the wall boundary is about 3,410 acres. Not all of this enormous space was covered by construction; the course of the walls was also chosen on the basis of strategic criteria. But it is still a most valuable indication of the size the city had reached. Then, too, some points of the wall take on an immense documentary value, when seen in the perspective of history. A typical case is Porta San Sebastiano, the ancient Porta Appia, the most imposing of all. It opens onto the ancient consular way of 312 B.C., attributed to the censor Appius, the first and most important opening for Roman expansionism and imperialism, going south and east. Here within only a few miles, some of the city's most significant monuments were built, from the sepulcher of the Scipios, among the first and most consistent supporters of Roman imperialism,

to the great imperial villas such as that of Maxentius, to the first Christian cemeteries, the catacombs.

It was in fact along the Appian Way that the most noteworthy catacombs were built. They are precious testimony of the religious movement that, with its revolutionary view of the relationships between social classes, between political power and individual conscience, was one of the forces most corrosive to the Roman state bureaucracy. It was only by means of one of the most genial and shrewd political operations in history that Constantine succeeded in absorbing Christianity and involving it in the new structures he created, rendering it an associate in the state power.

Attempts at Reorganization: The Tetrarchy

Under Diocletian (A.D. 284–305), an emperor endowed with exceptional energy and intelligence, an attempt was made to curb the dissolution that was spreading throughout the Empire. The organization of the state was revolutionized from the ground up and the Augustan constitution was abolished once and for all. The Empire could no longer be controlled from one center or by one leader alone. The power was thus divided between two emperors, Diocletian himself and Maximian. Diocletian enjoyed the greater dignity, however, and was distinguished by the epithet "Jovian," while Maximian was called "Herculean." Diocletian and Maximian selected two other emperors, both younger, Galerius and Constantius. It was planned that, having obtained the succession following the abdication of the elder two, they would in turn choose two new successors. This system had the advantage of dividing the empire into four segments (thus the term "tetrarchy"), making it far more manageable, and at the same time ensuring the succession, thus avoiding the worst obstacle standing in the way of stability in handing down the imperial power.

The provinces as well were divided into smaller units, forty-six at first, rising later to as many as eighty-nine. They were gathered together into dioceses and, on a higher level, several dioceses formed a prefecture of the praetorium. A rigid hierarchy of functions and ranks, which it had never before possessed, was thus introduced into Roman administration. Another new principle of the constitution of Diocletian was the separation of civil power from military power. Nor was economics neglected. The celebrated and detailed "prices edict" fixed the price of every commodity and service, and established exceptionally severe punishment for transgressors of the code. All things considered, the new structure was rigid and authoritarian. Although it managed to survive a long time as a method of administration — it was still in effect under Justinian — it failed miserably in those areas less capable of bearing such a burden: economics and politics.

A development of no secondary importance brought on by the division of the Empire was the "subordination" of Rome. It was supplanted by four new capitals: Trevori, (present-day Trier); Milan; Sirmium (in present-day Yugoslavia); and Nicomedia in Bithynia (in present-day Turkey). Official art was thus spread to the four corners of the empire, because these cities had to be endowed with facilities in keeping with their new function. Rome was by no means neglected, however. The most important edifice built during the period was the Baths of Diocletian, which occupied an area at the edge of the Quirinal Hill. These baths were the most imposing of their kind, larger even than those of Trajan or Caracalla, but they hardly differ from their predecessors in their architectural concept. Construction began after the year 298, and the baths were inaugurated between May 305 and August 306, as numerous inscriptions indicate.

Seals on the bricks used in the building are of only three types, a considerable difference from the complex situation of the second cen-

Spalato (Split), Yugoslavia: The Palace of Diocletian. Circa A.D. 300. A portion of the central peristyle. This enormous trapezoidal edifice (its sides measure 592 feet by 698 feet by 570 feet by 690 feet) was surrounded by walls with towers. The Emperor lived here from his abdication in 305 until his death in 316.

Rome: Base of the decennial monument of Diocletian in the Forum, the side showing the sacrifice of a pig, a sheep, and a bull (*suovetaurilia*).

tury, when a great many factories were hard at work at the same time turning out products for the great enterprises of official construction. As noted earlier, after the Severian period, building activity in Rome fell off sharply. The material used in the Aurelian walls belonged largely to older buildings demolished at the time the walls were being erected. Thus, for construction of the Baths of Diocletian a building industry had to be renewed from the bottom up. It was entirely under the control of the emperor, who owned all the brick factories. The revival was of brief duration, however. The industry entered a new decadence after the capital was transferred to Constantinople in A.D. 330.

The fire that devastated Rome in A.D. 283 should be mentioned in relation to the building activity under Diocletian. The Curia Julia in the Forum and the Pompeian Porticoes in the Campus Martius were restored following this disaster, taking the epithets "Jovian" and "Herculean" respectively, from the epithets of the two emperors.

The Arch of Galerius, the most important monument of official sculpture in the period, lies outside Rome, at Salonica in Greece. In Rome, however, one of the foundations built on the rostra of the Roman Forum on the occasion of the tenth anniversary of the government of Diocletian — *decennalia* — still exists. Here two sides, one depicting the victories of the emperor and the other his sacrifices, were executed

Rome: The Basilica of Maxentius (or of Constantine), begun by Maxentius between A.D. 306 and 310 and finished by Constantine. The main entrance was originally on the eastern side (upper right), with an apse at the western end. Constantine built another entrance to the south, toward the Via Sacra. In the apse there was a colossal statue of the Emperor (now in the courtyard of the Palazzo dei Conservatori). The northern side of this structure has remained practically intact, whereas almost nothing remains of the southern side and the gigantic central cross-vault.

Spalato (Split): Plan of the Palace of Diocletian
1 *Porta Aurea*
2 *Porta Argentea*
3 *Porta Bronzea*
4 *Porta Ferrea*
5 *Court and Temple of Jupiter*
6 *Court and Mausoleum of Diocletian*
7 *Vestibule*
8 *The so-called Tablinum*

Rome: Detail of the Basilica of Maxentius.

ELEGY OF THE TETRARCHY

O spring, so happy and blessed because of this new fruit, not so glad and venerable now because of the beauty of the flowers or the green growth of your messengers or the buds of your vines, and not even because of your breezes and serene light, but rather because of the apparition of the supreme Caesars! . . . How many centuries in fact, O invincible princes, do you secure for yourselves and for the state, dividing among yourselves the dominion of the world that belongs to you? As safe as it is now, since all the enemies have been subdued, this dominion nonetheless requires too many repeated journeys to places very distant from one another. Now, Parthia cast beyond the Tigris, Dacia regained, the borders of Germany and Rhaetia brought to the sources of the Danube, the punishment of Brittany and Batavia assured, the state — enlarged and to be enlarged — still required a broader government, and those who had extended the boundaries of Roman power with their worth were dutybound to render a son who would share in this power.

Moreover, not to speak of the interest and care of the state, even that majesty that related them to Jove and Hercules required for the Jovian and Herculean emperors something similar to what exists in the universe and in the very heavens. And in fact all the greatest things shine and rejoice in this characteristic number of your divinity: there are four elements, and as many seasons, and four parts of the world divided by two oceans and the lustra that return after a quadruple revolution of the sky, and there are four horses of the sun, and Vesperus and Lucifer who are added to the two principal lights in the heavens.

Panegyric of Constantinius Chlorus

in the style typical of the third century, with extensive use of the drill to carve the surface of the marble. The drill cuts out and isolates each detail sharply from the rest. The other two sides, depicting the sacrifice of the pig, the sheep, and the bull — *suovetaurilia* — and the procession of the senators, are executed with a pure and simple drawing technique, and are more plastic in feeling. On these, the drill was used only moderately. One of the most typical formal characteristics of the high Tetrarchic period is precisely this return to a highly compact and bounded plastic vision, with few details, lightly incised. This is to be seen especially in the portraits, in which the expressionism at times goes so far that the images border on the frankly brutal. Particularly suitable to this style are the hard Egyptian stones such as porphyry. It was used, among other things, for the celebrated "Tetrarchs" in the Basilica of St. Mark in Venice. The origin of those sculptures in Constantinople was demonstrated only recently, following the discovery there of a foot belonging to one of the personages in the group.

The closed, rigidly hierarchical, centralized and militaristic vision typical of Diocletian characterized the entire period and is clearly to be seen in the best preserved of the Imperial residences, that at Spalato (Split in present–day Yugoslavia), which the emperor built as a retreat where he could spend the rest of his life after his abdication.

It is highly instructive to compare this closed, geometrical structure, closer to a medieval castle than to an Imperial residence, and the loose, open, and varied plan of Hadrian's Villa. They not only express two totally different personalities; they reflect the differences between two eras.

The Projects of Maxentius

Building activity at Rome continued at a particularly high rate under Maxentius, who chose the city as his capital. In the course of his short reign (306–312), this unfortunate emperor managed to plan and in part complete an outstanding series of buildings, most of which have been preserved in fairly good condition. A considerable part of this activity was centered in the Forum. Among the edifices built here were the grandiose basilica, completed by Constantine, and in its immediate vicinity, the small temple that has erroneously been called the sanctuary of Romulus, the emperor's son, who died in boyhood and was at once deified. The basilica in particular, with its vast, imposing vaults, similar to those built a few years earlier by the architects of the Baths of Diocletian, presents an outstanding example of the technical capabilities of the Roman workmen. Brought to completion in this period, in addition to the basilica, was the reconstruction of the Temple of Venus and Rome, originally erected during the reign of Hadrian. In all probability it was only at this later time that the coffered vaults and the two opposite apses, destined to contain the statues of the two divinities, were built.

It is interesting that it was Maxentius who reconstructed the work of Hadrian, for, like Hadrian, Maxentius also desired to live in an elaborate suburban villa and began to build one, superimposed above part of the *Pago Triopio* of Herodes Atticus, on the Appian Way. The complex is made up of three large building groups: the villa itself, the great mausoleum of Romulus with its surrounding quadri–portico, and the circus, each oriented in a different direction but all converging on one center. The mausoleum is a good example of a type fairly widespread in the fourth century. It is circular in shape and has two levels. The lower was composed of a ring-like corridor around a central pillar with niches for sarcophagi; the upper was built for the worship of the deified deceased, and was covered with a cupola. The circus should be considered in close connection with the mausoleum, because here it again assumed its original function, a place for the celebration of funereal games.

By chance this latter monument has been preserved in good condition. Its documentary value is extremely important since virtually nothing remains of the other circuses, including the most imposing, the Circus Maximus. The eight *carceres*, the stalls from which the quadrigas (the four-horse chariots) departed are recognizable in the Circus of Maxentius. The numbers of the quadrigas correspond with those of the four *factiones* — teams — that divided the allegiance of the spectators. Each team had a right to two quadrigas. The carceres were laid out radically and on a slightly inclined surface, to equalize the course of the quadrigas during the first part of the race. The right side of the track, traversed first, is wider than the other, to allow for the passing of several chariots side by side before the first eliminations. For the same reason, the straight stretch of the circus began at a considerable distance (some 650 feet) from the point of departure. All told, the contestants had to circle the course seven times; the overall distance of the race was about two and one-half miles.

Many ancient sculptures were used in decorating the circus. They were no doubt taken from monuments that had been demolished or stripped; among other things found here was the obelisk, still later used by Bernini for the fountain in Piazza Navona. The inscription

Outskirts of Rome: The Circus of Maxentius. Side with starting point stall for the chariots and two towers. Built by Maxentius as part of his villa and the mausoleum of his son Romulus, along the Appian Way, in the location formerly occupied by the villa of Herodes Atticus, the circus was never finished. Work was interrupted by the death of the Emperor after his defeat at the Milvian bridge.

THE VISIT OF CONSTANTINE II TO ROME (A.D. 357)

So then he entered Rome, the home of empire and of every virtue, and when he had come to the Rostra, the most renowned forum of ancient dominion, he stood amazed; and on every side on which his eyes rested he was dazzled by the array of marvellous sights. He addressed the nobles in the senate-house and the populace from the tribunal, and being welcomed to the palace with manifold attentions, he enjoyed a longed-for pleasure; and on several occasions, when holding equestrian games, he took delight in the sallies of the commons, who were neither presumptuous nor regardless of their old-time freedom, while he himself also respectfully observed the due mean. For he did not (as in the case of other cities) permit the contests to be terminated at his own discretion, but left them (as the custom is) to various chances. Then, as he surveyed the sections of the city and its suburbs, lying within the summits of the seven hills, along their slopes, or on level ground, he thought that whatever first met his gaze towered above all the rest: the sanctuaries of Tarpeian Jove so far surpassing as things divine excel those of earth; the baths built up to the measure of provinces; the huge bulk of the amphitheater, strengthened by its framework of Tiburtine stone, to whose top human eyesight barely ascends; the Pantheon like a rounded city-district, vaulted over in lofty beauty; and the exalted heights which rise with platforms to which one may mount, and bear the likenesses of former emperors; the Temple of the City, the Forum of Peace, the Theater of Pompey, the Oleum, the Stadium, and amongst these the other adornments of the Eternal City.

But when he came to the Forum of Trajan, a construction unique under the heavens, as we believe, and admirable even in the unanimous opinion of the gods, he stood fast in amazement, turning his attention to the gigantic complex about him, beggaring description and never again to be imitated by mortal men. Therefore abandoning all hope of attempting anything like it, he said that he would and could copy Trajan's steed alone, which stands in the centre of the vestibule, carrying the emperor himself. To this, prince Ormisda, who was standing near him, and whose departure from Persia I have described above, replied with native wit: "First, Sire," said he, "command a like stable to be built, if you can; let the steed which you propose to create range as widely as this which we see." When Ormisda was asked directly what he thought of Rome, he said that he took comfort in this fact alone, that he had learned that even there men were mortal. So then, when the emperor had viewed many objects with awe and amazement, he complained of Fame as either incapable or spiteful, because while always exaggerating everything, in describing what there is in Rome, she becomes shabby. And after long deliberation what he should do there, he determined to add to the adornments of the city by erecting in the Circus Maximus an obelisk, the provenance and figure of which I shall describe in the proper place.

AMMIANUS MARCELLINUS:
History (13-17)

Rome: The so-called temple of Romulus on the Via Sacra. This small octagonal structure, built at the beginning of the fourth century A.D., still has its original bronze door. Today it is part of the church of SS. Cosma and Damiano.

on it, in hieroglyphics, bears the name of Domitian; it was almost certainly taken from the temple of Isis and Serapis in the Campus Martius, near the Pantheon, built during Domitian's reign. The trip made by the obelisk in different periods for different purposes is certainly a curious one. It was altogether normal, of course, for such a monument to belong to a temple devoted to Egyptian divinities: other smaller obelisks found at the Villa of Maxentius, in fact, came from the Temple of Isis in the Campus Martius. It has often been noted that this custom of reusing elements taken from buildings of various periods bears witness to a decadence in Rome's artistic workshops, and an inability to carry out extensive new undertakings.

It also suggests a pronounced eclectic taste in Rome, typical of a city of once-great artistic traditions that finds itself constantly on the sidelines. It had lost its true function as the administrative and political capital of the Empire. This withdrawal into nostalgia and conservation of the past is typical of a culture that is losing its vitality. The sense of an inevitable decadence leads to an attempt to recover the past at all costs, to save and pass on to posterity all that is best from a civilization. Encyclopedias, commentaries, and anthologies were assembled beginning at this time, and are a gold mine of information on almost every aspect of ancient culture. It is partly this nostalgia that must have inspired them. The rebirth of paganism at the end of the fourth century, when the Christian empire had long been an established fact, can be considered in the same light.

Rome: The Temple of Venus and Roma. The cella facing the Forum, seen here, is the better preserved of the two; statues of the two gods were placed in them. The rich decoration of the floor and walls, with the porphyry columns, as well as the coffered vault, can be dated in the reign of Maxentius, during which the building, originally erected in the age of Hadrian, was restored following a fire (A.D. 307).

INSCRIPTION ON THE ARCH OF CONSTANTINE

To the Emperor Caesar Flavius Constantinus Maximus, Pius, Felix, Augustus — since through the inspiration of the Deity, and in the greatness of his own mind, he with his army avenged the Commonwealth with arms rightly taken up, and at a single time defeated the Tyrant and all his Faction — the Senate and People of Rome dedicated this Arch adorned with Triumphs.

Rome: The four-faced arch of the Forum Boarium. Constantinian Age.

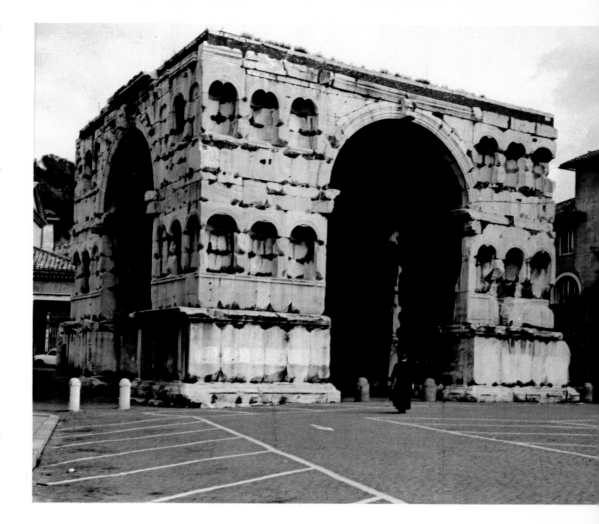

INVENTORY OF ROME IN FOURTH CENTURY (A.D.)

2	Temples of Jupiter Capitolinus
2	Circuses
2	Amphitheaters
2	Colossi
2	Spiral Columns
2	Markets
3	Theaters
4	Gladiators' Barracks
2	Naumachias (for water spectacles)
15	Nymphaeums
22	Large equestrian statues
80	Golden statues of gods
74	Ivory statues of gods
36	Marble arches
37	City-wall gates
423	Streets
423	Shrines
46,602	Ordinary homes
1,790	Luxury houses
260	Storehouses
856	Public baths
1,352	Basins
254	Ovens
46	Brothels
144	Public toilets
10	Praetorian stations (imperial guards)
4	Urban police stations
7	Fire stations
14	First aid stations
2,300	Centers for olive oil distribution

Regional Catalogues (Age of Constantine)

Rome: The Arch of Constantine. Erected after the battle against Maxentius in A.D. 312 and dedicated in 315-316, the Arch is the largest and best preserved of the three remaining in Rome. The sculpture dates to various periods. On the sides of the attic, or top section, with the inscription, there are four reliefs from the age of Commodus depicting scenes from the life of Marcus Aurelius. The four statues of Dacians belong to the age of Trajan, as do the reliefs (not visible here) on the short sides of the attic and inside the central barrel vault. The four tondi (round relief panels) with scenes of hunting and sacrifice belong to a monument from Hadrian's time, as do the four on the other side. The reliefs above the two side vaults are Constantinian, as are the figures on the spandrels of the arches and the pedestals of the columns.

The Arch of Constantine and the Decline of Pagan Culture

The most typical and best-known example of this eclectic use of materials of various origins was the Arch of Constantine. But before moving on to an examination of its formal aspect, it would be well to place this monument, one of the most significant in ancient Rome, in its historical framework. The Arch was built by the Senate after Constantine's victory over Maxentius at the Milvian Bridge in A.D. 312, in memory of this triumph; it was not officially dedicated until the year 315. As early as 313, however, Constantine and Licinius, the emperor of the west appointed by Galerius, meeting in Milan, had granted Christians freedom of worship. The Arch's inscription speaks of a victory owed to "divine inspiration" and has helped strengthen the legend of a Constantine who was a Christian even at the time of the battle of the Milvian Bridge. The insertion of sculptures of clearly pagan significance, such as the two tondi (round panels) with the sun and the moon, should be enough to demonstrate this was not the case, however. Constantine's interest in the Christians was primarily political in nature rather than religious. By granting them freedom of worship, the emperor managed to win over to the side of the state the followers of a religion that was by now by far the most important in the Empire.

The sculptures of the Constantinian age that adorn the arch, representing the various episodes of the war against Maxentius, clearly belong to the "popular" vein, the same sort was frequently in minor friezes and in other triumphal arches, such as the Arch of Titus and that of Septimius Severus. Simplification, narrative clarity, a perspective by now altogether conventional, a hierarchical arrangement of personages, and frontality are all used. These characteristics have already been noted in more ancient sculptures, but here they reach a new level of systematic and stylistic coherence. The sculptures on the Arch of Constantine mark the completion of the total formal revolution that had begun with Tetrarchic art. They have a good deal more in common with the Romanesque achievements of the twelfth century than with the culture, chronologically much closer, of the Middle Empire.

The Arch of Constantine was one of the last official works in Rome. With the founding of the new capital, Constantinople, in A.D. 330, the old capital was once again abandoned, and Imperial building activity was replaced with new religious building, which took hold with extraordinary vigor. In a few decades it transformed the city altogether. The form of the pagan basilica was adopted for the new type of Christian edifice: a great hall with three or four naves separated by columns, ending in an apse. Continuing side by side with this type was the circular building covered by a cupola, adopted especially for mausoleums; some examples are those of the Gordiani in Via Praenestina, of Sant'Elena on the Via Labicana, and of Constantina (now Santa Costanza) on the Via Nomentana, a fine example of a cupola resting on a double colonnade, surrounded by a vaulted ambulatory. There was an extraordinary expansion in these years of the art of the wall mosaic. Examples from the initial and middle Imperial periods are relatively modest, but from this period on they were fundamental to artistic culture. Santa Costanza itself furnishes one of the finest examples.

Along with the exceptional efflorescence of Christian religious architecture, a pagan culture lived on for a long while in Rome, where it was nourished by the great aristocratic families, among them the Simmaci. Altogether "intellectual," it was a reactionary manifestation, produced by a class rapidly heading toward decadence, although it remained politically important until the end of the century. The program of tenacious conservation had a certain historical validity.

THE BATTLE OF MILVIUS BRIDGE

But how did that slave who for so many years had worn the imperial purple (Maxentius) arrange the army? In such a way that no one could flee in any manner, or as usually occurs, retreat and then resume fighting: in fact, it was closed in between your army and the Tiber....

What other hope must it be thought nourished that one, who already for two days had abandoned the palace and with his wife and son had withdrawn voluntarily to a private dwelling, tormented by terrible dreams and hounded by nocturnal furies, so that you, the longed-for tenant, could succeed him in those sacred palaces after long expiatory purification ceremonies? At that point he himself had realized the reality of the situation and moved aside to let you pass him: although he set forth, armed, to do battle, from the time he had left the palace he had already abdicated. At the first sight of your majesty, and with the first surge of your many-times victorious army, the enemies were terrorized and fled; their retreat was blocked by the narrowness of the Milvius Bridge.

Thus, if we exclude those principally responsible for that government of bandits, who, despairing of any pardon, covered with their corpses the place they had chosen for the battle, all the others threw themselves headlong into the river, as if they wanted to offer a little respite to the arms of your men who were tired out from the massacre. The Tiber quickly swallowed up those impious ones; and even their leader, with his horse and splendid weapons, despite his vain attempts to save himself by going up the steep slope of the far bank, was dragged away by a whirlpool and disappeared. Thus it was impossible for that monster to leave behind even this bit of fame and glory: to wit, that he had died under the blows of a valorous soldier's sword or spear. The swirling river dragged away the bodies and weapons of the other enemies, but kept its own enemy in the same place in which it had died, so that the Roman people would have no doubts: someone might have thought that he had saved himself if the proof of his death had been lacking.

Holy Tiber, you who were once the counselor of your guest Aeneas, and later the savior of Romulus, who had been abandoned in your current, you could not bear the idea that a false Roman should live any longer and that the assassin of the city should save himself by swimming in your waters: you...rightly wanted to take part in Constantine's victory: he has thrown your enemy into your current, and you have killed him.... When the body was found and mutilated, all the Roman people abandoned themselves to the joy of revenge. His sacriligious head was taken all round the city, impaled on a pole, and no one missed the opportunity to abuse it.

...The very houses, so I have been told, seemed to move, and their height seemed to increase, wherever your divinity was transported by the chariot that went forward slowly, so great was the crowd and so dense the Senate, that pushed you forward and at the same time held you back. Those who were farthest away called those who could see you better, fortunate. Those you had already passed before seemed to mourn for the place they had had. From every direction everyone in turn hastened to follow you. The enormous crowd thronged and swept in various directions: one was struck by the fact that so many had survived after the massacres of those six years of utter madness. Some dared to ask you to stop, and complained that you had reached the palace so quickly. Once you were inside, they not only followed you with their eyes, but almost rushed inside the sacred threshold. Then, being scattered in all the streets, they began to wait, to look for, desire, hope for, your exit. It almost seemed they were besieging him who had liberated them from a veritable siege.

Panegyric of Constantine

Rome: Wall painting from the residence of the heralds at the foot of the Palatine. Third century A.D.

Scholars associated with such groups produced the collections of information noted earlier; among them were Servius, the commentator on Virgil, and Macrobius, the writer and philosopher. Members of the pagan party also carried out work in architecture and the figurative arts. As late as A.D. 393 or 394 the prefect of provisions, Numerius Proiectus, restored the Temple of Hercules at Ostia, although in 391 Theodosius had ordered the closing of all pagan temples.

It was perhaps in these years that the masterpieces of Greek sculpture then in Rome were given inscriptions bearing the names of their creators. Acutely aware of the crisis at hand, as well as of the collapse of ancient culture, these groups made an attempt to save as much as possible from the impending darkness. For that matter the cultured Christian class itself, from St. Jerome to Cassiodorus, shared this mood and took part in the salvaging operation. Their combined efforts paved the way, through the Middle Ages, for the rediscovery of ancient culture — in the last analysis, for the Renaissance.

Nevertheless, the difference between pagan and Christian was fundamental. The pagans were purely "conservative." The Christians had the tendency to save and integrate into the new situation only elements of ancient culture that were compatible with Christian doctrine. Their disagreement exploded violently in the argument concerning the statue of Victory, which had been in the Senate since the time of Augustus. Simmacus and Saint Ambrose were the protagonists in the polemical battle that raged over this statue. The letters of these two personalities to the Emperor Valentinian II, which have been preserved, are among the most important documents for any understanding of this particular historical juncture.

Ambrose won in the end and the pagan statue was removed. It could not have ended otherwise. While buildings dedicated to the Christian religion were going up everywhere, the ancient city was falling bit by bit into decay. The emperors attempted in vain to put a stop to the sacking of the remaining monuments (the texts of various edicts to this effect exist) or to intervene by ordering restoration work done. While Rome was still intact in all its splendor at the time of the visit of Constantius II, the son of Constantine, who was greatly impressed, in the fifth century one disaster followed another. The strengthening of the walls by Honorius did not prevent the Goths of Alaric from capturing the city and sacking it. The damage that resulted was probably not too great; the sack of the city by the Vandals in 455 was much more serious. But the sensation created by the sack of the Goths was tremendous; echoes of it can be found in many of the writings of the period.

With the advent of the Emperor Theodoric there was a resumption of the work of preservation. Several monuments were restored, the Colosseum among them. But the war with the Goths, with all its sieges, sackings, massacres, was the city's coup de grace; among other things the aqueducts were all but completely destroyed. After the Gothic war, there was little to be seen in the enormous, deserted area inside the Aurelian walls except a few scattered hovels and lean-tos among the ruins. The decline of population, the desolation and insecurity of the surrounding countryside, infested with malaria and brigands, became irreversible, and were to characterize the city for centuries. It is only relatively recently that the last vestiges of these conditions have disappeared from Rome so that the heritage of its civilization and the greatness of its monuments have once more become apparent to all.

Rome: The so-called Temple of Minerva Medica. Beginning of the fourth century A.D. It is perhaps a Nympheum from the villa of the Licinii, built to a ten-sided plan, with niches. The circular cupola, one of the largest in Rome, over eighty feet in diameter, is set on brick ribbing. The building technique, much more advanced than that of the Pantheon, goes a long way toward that used by the Byzantines.

Right:
Mausoleum of the villa of the Gordiani, on the Via Praenestina. A typical monumental sepulcher of the fourth century A.D., similar to the mausoleum of the Romulus. There is a lower room, which is the burial chamber proper, and an upper hall used for the celebration of funeral rites.

Page 172:
Rome: Santa Costanza. Detail from the vault of the church's ambulatory, once the mausoleum of Constantina. Fourth century A.D. The use of wall mosaics, begun at the end of the Republican Age, spread until they became the leading art form in the Byzantine Age.

Page 173:
Wall mosaic depicting a ship in port. First or second century A.D. (Antiquario Communale, Rome.)

Page 174:
Ostia: Polychrome mosaic with representations of the months. Fourth century A.D.

APPENDICES

ROMAN MONUMENTS THROUGH THE AGES

From the time the city was founded up to the present, the site of Rome has always been inhabited, without any interruption whatever. It goes without saying that this has led to a continuous transformation of the urban texture and of individual buildings, a process in which it is difficult to perceive separate stages. The phenomenon was obviously to be observed even in ancient times; indeed it was rendered more acute by the frequent collapse of buildings, by fires, and by floods.

Nevertheless, the end of the ancient world marked a significant turning point. At that stage, the transformation not only became quantitatively larger, its character changed as well. The socioeconomic organization of the city in the early Middle Ages might be termed a return to a structure no longer urban and international, but sectorial, autarchical, and based on the village system. Among other things, this explains a fearful population drop. Although Rome remained, even during the Middle Ages, one of the principal cities of Europe, this was chiefly because of the presence of the papacy. The number of its actual inhabitants declined to the point that in 1377, when the popes returned from their exile in Avignon (the exile in fact marks the period of the city's greatest decadence), the population is said to have been no more than seventeen thousand. At that time a large part of the area within the Aurelian walls — perhaps more than three-quarters of it — was cultivated land, where the only constructions of any importance were churches and monasteries.

Because of these far-reaching social transformations, most of the buildings of Imperial Rome were naturally abandoned. They had been conceived for a city infinitely larger, the capital of a worldwide Empire. Rome was not only symbolic of that Empire but parasitic upon it, a city whose gigantic population could survive only by constant transfusions from the provinces, so the city's fall from its role as capital had immediate and grave effects. The fragile native economic structures of Rome and its hinterland could by no means support a structure of its expanded Imperial dimensions. The ancient monuments, then, were inevitably left to abandonment and decay when they could not somehow be pressed into use again, adapted to new functions. Virtually without exception, the best preserved buildings in Rome are precisely those for which new uses were promptly found. A typical example is the Pantheon, which was transformed into a Christian church as early as the seventh century A.D.

From abandonment to the next stage, the use of materials from the ancient monuments for new buildings, was a short step. A great many medieval buildings show clear signs of having been constructed in this way. Yet, all things considered, it must be said that the damage caused during this period was fairly light. At the end of the Middle Ages, ancient Rome was far better preserved than it is today. The most widespread destruction, customary opinion to the contrary, was caused precisely when interest in the ancient world was reawakened — during the Renaissance. The fact is that the population of the city increased tremendously at that time. Building activity inevitably increased as well and despite all protests and attempts at preservation, a large part of what remained of the ancient city was destroyed.

The result of these centuries of history is the character that the Roman monuments have gradually assumed. Integrated into structures of various epochs, adapted to the widest imaginable range of functions, they offer exceptional testimony to historical continuity. Buildings such as the Tabularium, on the Capitoline Hill, site of the public archives of the Roman state in the Republican era, then of the medieval Town Hall, and still in use today for the offices of the Rome's city administration, are in themselves sufficient to demonstrate the close historical connection between the different periods of the city's history.

The Change in Ground Level

Immediately visible to the naked eye, and a source of astonishment to all who visit the city, is the enormous difference between the ground level of the ancient monuments and that of the present day. It varies from place to place. There is a difference in level of perhaps seven feet at the square in front of the Pantheon; at the foot of the Quirinal, at the intersection of Via Quattro Fontane and Via Nazionale, the difference is some sixty feet. The phenomenon has taken place everywhere, of course. It resulted from the progressive accumulation of mud from floods and debris from dilapidated buildings that was left where it fell, from the building of terraces and other earthworks. Even in the ancient era there had been a rise in the level of the ground; the group of archaic monuments known as the *Lapis Niger*, in the Forum, is almost seven feet below the ground level of the Augustan Age. The process is of course much slower and less visible in periods of more intense life and more advanced civilization. In such periods paved streets are built and tend to remain in use over a long time, and they receive constant maintenance. In the periods of population decline and abandonment, on the other hand, the ground level rises rapidly. Waste materials accumulate, and, remaining where they lie, they are gradually shaped by natural processes (rain, winds, erosion, etc.) until new human settlements come into being above the old.

Even in places where life has gone on without interruption — as seems to have been the case in certain sections of the Campus Martius, where the modern quarters respect quite scrupulously the orientation and foundations of the old — an increase in the ground level can be observed, although it is usually less marked. A partial explanation is that construction of new buildings over those that have been demolished or have collapsed often utilized the walls remaining from the older buildings as a foundation. The phenomenon is widespread, as may be easily observed in visits to the cellars of Rome's historic areas.

From the Sack of Alaric to the Seventh Century

It is best to discuss the changes that have taken place in Rome's monuments by an account of the specific historic developments that have led to the present situation, although some of the episodes are known only in part. But one thing may be said: the legend that the destruction of Rome was caused by the invasions of the barbarians has long been deflated. The systematic destruction of imposing buildings — such as the Circus Maximus, very little of which has been preserved — was beyond both the will and capacities of those hordes, who usually remained in the city only a few days and confined themselves at most to the sacking of precious objects or, on occasions, to the burning of a building or two. The other traditional theory, which blames the destruction of pagan Rome on the Christians, is likewise based on no serious evidence. (Episodes such as the destruction of the Serapeum (Temple of Serapis) in Alexandria by the Christians in 391 were not common in Rome.) The only people who could in fact be considered responsible for the destruction of the ancient city are the inhabitants themselves. The process went on over a long period of time and virtually all the generations that have lived in the area of Rome have taken some part in it.

The process of demolition always went forward hand in hand with the reutilization of building materials; the city devoured itself only to come back into being in new forms. The custom of using parts of ancient monuments in new edifices was beginning to take hold even in the fourth century. The Villa and Circus of Maxentius and the Arch of Constantine, all noted earlier, are typical.

Alaric's sack of Rome in A.D. 410 was the first since the days of the Gallic fire exactly 800 years before. The damage caused was primarily to private homes; two letters written by Saint Gregory provide privileged contemporary testimony of the event. According to the archaeologist Rodolfo Lanciani, excavations carried out in the areas where the homes of patrician families were concentrated in a late period of the Empire, the Aventine and Coelian hills, have shown that the homes there were destroyed by a fire at the beginning of the fifth century and were not rebuilt. The home of Valerius Severus, prefect of Rome in A.D. 386, for example, was put up for sale in the year 404, but found no buyers. People seemed to be frightened by the imposing nature, and no doubt the equally imposing price of the building. A few years later, however, in 417, the house was sold at a very low price, because in the meantime it had been sacked and half-destroyed by the barbarians.

A number of public buildings on the Aventine — including what may have been the Decian Baths — were also damaged. In fact, an inscription records restorations carried out in the area in 414, four years after the sack. Many treasures were hidden at the time of the siege. Some were apparently not recovered before their owners died, and have been recovered in various epochs since. The most outstanding of these is "Proiecta's treasure," a large number of magnificent silver pieces, discovered on the Esquiline Hill (the bulk of them are now at the British Museum in London). An inscription noted that the treasure was the property of the wife of Turcius Asterius Secundus, prefect of the city in 362.

The ever-growing insecurity of the countryside after the fifth century resulted in the progressive abandonment of catacombs and the beginning of the custom, which later became quite normal, of burying the dead within the Aurelian walls. The sack of the Vandals in 455 caused a good deal of damage. The Temple of Jupiter Capitolinus and the Imperial palaces of the Palatine were sacked, among other things. Numerous statues were taken to Carthage, to decorate the home of King Genseric; a century later they were taken to Constantinople by Belisarius. The statues carried off as Roman booty during the Judaic war, and which Vespasian then had placed in the Forum of Peace, seem to have been among these.

With Theodoric (500–520) a certain recovery occurred. The Imperial palaces on the Palatine Hill were restored, as well as a number of other buildings, including the Theater of Pompey and the Colosseum. The principal documents showing that this activity was actually carried out are the letters sent by Cassiodorus to the city magistrates with instructions for the restoration and the preservation of the works of art. The numerous brick seals bearing the name of the king, as well as the inscriptions on the buildings themselves, faithfully confirm everything we know from the literary texts.

This was, however, the last flowering of artistic activity. It was followed almost immediately by a collapse. War broke out between the Byzantines and the Goths. The city was subjected to an uninterrupted series of sieges and destructive onslaughts and passed definitively into the Middle Ages. Among other things, Procopius records that the aqueducts destroyed during the siege of Vitige (537–538) were never later repaired. Although the waters oft he aqueducts built underground

— such as the Aqua Virgo, the Appia, and the Anio Vetus — continued to flow into the city, from the sixth century on the great baths remained unused and were earmarked for certain destruction. Another result was the abandonment of the higher parts of the city, where the flow of water had stopped.

The description of the city Procopius gives in his book on the Gothic war shows that the larger part of the monuments and their decorations were still in good condition, but an episode in the war that took place around Hadrian's Tomb — even in the preceding century included as a front bulwark in the line of fortification — was an ill omen. The defenders, attacked by the Goths, who had camped in the vicinity of St. Peter's, repulsed the enemy forces by bombarding them with innumerable statues with which the building was still adorned.

The abandonment of the countryside surrounding the city, which was infested by brigands and malaria and overrun by hordes of the Longobards, characterized the end of the sixth century and the seventh century. Nevertheless, in the year 608 one last monument, the Column of Phocas, was erected in the Forum, set up by the prefect Smaragdus in honor of the Byzantine emperor who had donated the Pantheon to the Church. From that time on it became common to transform the pagan temples into churches, buildings that before this time Christians seem to have found repugnant.

In these same years the palaces on the Palatine Hill were evidently still in good condition, since Heraclius was crowned on the Palatine in 629, probably in the *Aula Regia* of the *Domus Flavia*. On this occasion the Emperor presented the Pope with the gilded bronze tiles that had covered the Temple of Venus and Roma, which were put to new use in St. Peter's. It is thus plain, according to Lanciani, that in this epoch the building must still have been well preserved.

Medieval Rome

The city in the ninth century is described in an itinerary drawn up for the use of pilgrims, known as "the Einsiedeln itinerary." Like all guidebooks worthy of the name, it is divided into itineraries that describe the monuments situated to the right and left of the roads to be followed. The roads correspond perfectly to those of the Imperial era; Carolingian Rome preserved, all in all, the city's original appearance. This itinerary may be compared with another dating from the end of the twelfth century, that of Benedict the Canon, and with the descriptions known as *Mirabilia*, or *Marvels of Rome*. The change was overwhelming. Besides the alterations that had taken place in the intervening years, a cultural upheaval had occurred as well. The ancient names of the buildings and streets have disappeared or are totally misrepresented, and the descriptions of the city, altogether fantastic, are interspersed with little moralizing fables typical of the Middle Ages. The Carolingian Age really represented the last attempt at recovering elements of classical culture that had remained accessible, though completely embalmed. Now even these scanty elements disappeared and were forgotten.

There were several key events in this period of more than three centuries. The Saracens attacked in 846, and although they did not conquer the city, they devastated the suburban quarters, sacking the treasures in St. Peter's and in St. Paul's basilica. The sack of the city by the Normans under Robert Guiscard in 1084 was even worse; of all the invasions of Rome, it was perhaps the most disastrous. The Campus Martius and the Coelian Hill were devastated. Traces of the

event are to be found in the church of San Clemente, which was half-destroyed to the extent that it was rebuilt on a level more than ten feet higher. Today this venerable building, with its three superimposed levels (the building of Roman days, with a Mithreum [Temple of Mithras], the primitive church, and the church of the twelfth century) constitutes the most striking synthesis of twenty centuries of Roman history.

In this period the major monuments were occupied and adapted to functions completely different from those for which they were built. As a rule they became fortifications for the use of the more powerful Roman families. The Frangipani family occupied the Colosseum and a large part of the Palatine Hill. The Savellis fortified themselves in the Theater of Marcellus, the Orsinis in the Theater of Pompey, the Colonnas in the Forum of Trajan and the Temple of Serapis on the Quirinal. The tomb of Cecilia Metella became a tower in the castle of the Caetanis. At this time Rome — not unlike the other principal cities of Central Italy — must have looked like a series of small fortified villages, with towers rising high above their roofs. The Tor de'Conti, mentioned by Dante and Petrach as the highest tower in existence at the time — it collapsed in 1348 — was built at Rome, in an exedra of the Forum of Peace.

Export and Destruction in the Late Middle Ages

It was in the twelfth century, at the outset of the "Romanesque Renaissance," that the sacking of the ancient monuments began on a wide scale. In this phase, the emphasis was not so much on buildings as on decorative marbles, capitals, stone or marble slabs, and inscriptions, which were used primarily for the decoration of new buildings. Anyone even superficially familiar with the churches of Rome knows how frequently their builders resorted to pilfered ancient materials, particularly columns, capitals, and inscriptions. The workshops of the marble carvers who were then intensely active (especially the Cosmati and Vassalletto families) renewed a large number of Rome's sacred buildings in those years, making abundant use of ancient marbles and stones. Lanciani estimates that in the floor of a minor church, such as that of the Quattro Santi Coronati, some two hundred inscriptions were used and not less than a thousand on St. Paul's Outside the Walls.

Nor was the custom confined to Rome. Export flourished, and was usually handled as cheaply as possible, by sea. It had begun as early as the reign of Theodoric, who had the columns of the Imperial residence on the Pincian hill taken to Ravenna. The same thing happened in the Carolingian era at Aix-la-Chapelle, where marbles from Rome were used in local buildings. Exportation reached its peak, however, in the closing centuries of the Middle Ages. Materials from Rome and Ostia were used in the Cathedral of Pisa, begun in 1063. To all appearances there were shipped to the Tuscan town by sea. There is an inscription dedicated to the "Genius" of the Colony of Ostia in the cathedral, and many of the sarcophagi in the Pisa Cemetery were no doubt brought in from the same place. The same process occurred later on in the cathedral of Orvieto, as contemporary documents mention. The materials used there had been purloined from the Tomb of Hadrian, the Portico of Octavia, the Temple of Isis in the Campus Martius and, outside Rome, from Veii and Domitian's villa near Lake Albano.

Another cause of destruction, less apparent but more lethal, was the setting up of numerous *calcare*, stone-grinding and stone-baking plants

that transformed into lime whatever was not judged suitable for further use. In this manner entire monumental buildings of travertine or marble disappeared. The kilns were scattered all over the city (one was even found inside the tomb of the Scipios), but the most important were in the Campus Martius, in the area where Via delle Botteghe Oscure and Largo Argentina are now located. Sixteenth century maps show the terrible workshops, still in operation. The place names of the area bore signs of this activity for a long time. S. Nicola de Calcarario, which occupied the space of Temple A of the Largo Argentina, has now disappeared. There were also SS. Quaranta de Calcarario and Santa Lucia de Calcarario. Excavations in the sacred area of the Largo Argentina have brought to light a remarkable number of marble fragments — sculptures, foundation stones, inscriptions — which undoubtedly came from the monuments, or even the tombs, of the surrounding area. Without question, they were gathered here to be made into lime. Monument after monument of Republican and Imperial Rome was devoured by the kilns.

The Depredations of the Renaissance

During the period that saw the transference of the papacy to Avignon (1309–1377), very little building went on in Rome, and it is unlikely that the ancient monuments suffered much harm. One of the rare works of importance carried out in this period was the great stairway of Santa Maria in Aracoeli, whose 124 steps were taken from the Temple of Serapis on the Quirinal.

The situation changed radically in the centuries that followed. For Rome the Renaissance represents a period of widespread recovery. Under the impetus of popes like Sixtus IV, Julius II, and Leo X, public works were undertaken on an impressive scale and the urban structure of the city was revolutioned. As is always the case, the intense building activity caused considerable destruction. The new city spread into areas already occupied by ancient quarters; builders continued to make use of materials from ancient buildings for their new constructions. The destruction continued undisturbed, despite the reawakened interest in the classical world that marked Renaissance culture, and even the protests of cultivated people were of no avail. In Lanciani's history of excavations there are a great many documents on the subject. Particularly impressive is the number of "digging permits" issued to entrepreneurs who then had a free hand in demolishing ancient structures to recover building materials.

A list of the monuments that disappeared in this way would be very long. It is sufficient to mention the destruction under Sixtus IV of a circular Temple of Hercules and two arches of the Augustan Age in the Forum Boarium; the demolition of a grandiose monumental sepulcher in the form of a pyramid, similar to that of Gaius Cestius (the so-called *Meta Romuli*), of part of the Baths of Diocletian, and the Forum Transitorium under Alexander VI; the almost total destruction of the Temple of Venus and Roma and the Arch of Gratian, Valentinian, and Theodosius under Nicholas V; and the destruction of the *Septizodium* under Sixtus V. In 1452 alone one entrepreneur, a certain Giovanni Paglia, a Lombard, took no less than 2,522 cart loads of travertine from the Colosseum in nine months. The depredation of the Colosseum continued unabated. Material from it was used, among other things, to build the Palazzo della Cancellaria.

In some cases the destruction was averted by a miracle. A letter written by the architect Domenico Fontana to his master, Sixtus V,

dated January 4, 1588, requests permission to destroy the Arch of the Argentari in order to use its materials for the foundation of an obelisk that had been taken from the Circus Maximus and was to be set up near St. John Lateran. Fortunately the foundation was built later with other marble and the Arch was saved. The pontificate of Sixtus V was one of the most disastrous for the ancient monuments. Besides the *Septizodium*, which Fontana demolished in the years 1588–1589 (the business-like architect even noted the expense: 905 scudi), the Baths of Diocletian suffered greatly (about 3,200,000 square yards of brickwork were, it seems, removed) as did the Claudian aqueduct. Even medieval buildings were demolished, including the *Patriarchium* of the Lateran, the ancient Papal See, by all accounts the most important building in medieval Rome. Meanwhile, the sculptor Flaminio Vacca, writing of the discoveries made in Rome during his lifetime, mentions that the capitals of the Temple of Jupiter Capitolinus, which were uncovered in the sixteenth century, were reused, among other things, for the statues carved for the Cesi Chapel in the Church of Santa Maria del Populo.

The Monuments Since the Eighteenth Century

Renaissance interest in ancient art was the direct cause of destruction to many of the monuments. To recover statues and other objets d'art for the collections of popes, princes, and cardinals, excavations were made which considerably damaged the ancient buildings. Nor did the ensuing centuries alter the rather cavalier attitude taken toward the city's heritage. A radical turning point was reached only in the eighteenth century, with the rise of a scientific archaeology. It was then that Winckelmann established guidelines for the study of the history of ancient art, and excavations were begun at Herculaneum and Pompeii. At the beginning of the nineteenth century two great abutments were erected to support the tottering walls of the Colosseum, and the systematic pillaging of the buildings was brought to an end. At the same time scientific excavations were begun in Rome — those of the Forum were of particular importance — and archaeological and topographical studies reached an exceptionally high level with scholars such as Visconti, Fea, Nibby, and Canina.

One episode, however, shows how wide a gap still existed between the attitude of the conservators and scholars and that of the contemporary society. In 1870 Piux IX ordered the demolition of the Porta Tiburtina, which had been rebuilt by Honorius. The Pope intended to reuse the materials for a column he wished to have erected in front of the Church of S. Pietro in Montorio, but the work was brusquely interrupted by the entry of Italian troops into Rome.

In the history of the ancient monuments during the last one hundred years, three distinct phases can be distinguished: the period from 1870 to the end of the First World War; the period of Fascism; and the years following the the Second World War. One characteristic is common to all: the indiscriminate expansion of the city, which never succeeded in providing itself with an effective modern town-plan. From the standpoint of safeguarding the monuments, the first period was perhaps the least disastrous. Soon after the capture of Rome by the troops of United Italy (1870), the Commissione Archeologica Communale was established. It carried out meritorious projects of conservation and study of the artifacts and remains that creation of new sections of the city kept bringing to light — primarily on the Quirinal and the Esquiline.

The twenty-year period of Fascism was ruinous. An enormous amount of lip service was paid to the importance of Roman antiquities, but they were exploited for political ends and in reality were subjected to heavy treatment. Two examples among many were the pointless demolition of the *Meta sudante*, the grandiose fountain near the Colosseum, and the building of the Via dell'Impero, which not only covered, or rather swallowed, an entire hill of ancient Rome, the Velian, as well as other ancient sections, but did not even bring the Imperial Forums to light. In fact the area of the Forums now visible is no larger than that visible before the change was made. Areas uncovered were reburied in such great haste under the gigantic avenue that at times archaeologists were not given a chance to carry out their investigations with care.

The Fascist period was characterized in actuality by a total lack of respect for the ancient monuments as historical documents. They were instead "isolated" and "evaluated" in connection with well-defined practical objectives, and then exploited as an expression of "new values." This reinterpretation of antiquities for political reasons was obvious in cases like the isolation of the Capitoline Hill, which led to the destruction of entire medieval and Renaissance sections, among the most beautiful in all Rome, and the "liberation" of the Mausoleum of Augustus, which not only caused similar damage but "endowed" the center of the city with one of its most repellent piazzas. That the "esthetic" vision behind these measures had political and practical, rather than a truly historical or scientific basis, was made most clear by the demolition of brick buildings of the Imperial Age, which occupied the presently empty spaces between the Republican temples of the Largo Argentina; their columns now remain, isolated, like a fine rhetorical gesture, in an absolute vacuum. The projects that were not carried out were perhaps even more ambitious. Among other things, it was proposed to isolate the Theater of Pompey, by lengthening the Corso Rinascimento as far as the Ponte Sisto. Then the war came, and defeat put a stop to the work. For a regime that considered the exaltation of ancient Roman virtues one of its chief goals, the performances of the Fascist period were awfully poor.

Although the postwar period brought an awareness of historical and environmental values much less barbaric than during the preceding period, it brought its own scourge: building speculation. Since the day Rome was proclaimed the Italian capital, such speculation had been on the rise, but it reached its greatest heights after the Second World War. The Umbertian and Fascist periods were responsible for the massacre of much of Rome's historical center; the present period will go down in history as that which brought about the total destruction of the suburban area. The great consular roads and the monuments that surrounded them — tombs, villas, and aqueducts, not to mention the landscape and countryside — were systematically destroyed. Only a few fragments have survived this colossal "prosperity." After the true monuments had been destroyed, an effort was made to create imitations. In this "Romanization of the periphery" operation, municipal warehouses were emptied of architraves and columns, which were placed on traffic islands in the various suburban neighborhoods. Could it be that, in such a development, we find ourselves arriving at the crossroads with a historical constant: a refined historical-critical conscience on the part of a cultured elite always goes hand in hand with a period of ever-greater destruction and desecration? But that is another subject to explore in a different book. For now, we can only conclude that we must all be wary of the many forces at work if we are to preserve the best monuments and finer elements of the civilization of ancient Rome.

CHRONOLOGICAL CHART
OF ROMAN HISTORY

DATE	MONUMENTS	HISTORICAL EVENTS
800 B.C.	Remains of huts from the Iron Age on the Palatine The Forum Necropolis.	753 B.C. Traditional date of the founding of Rome.
750 B.C.		750 B.C. (circa) Foundation of Cumae, the first Greek colony in the west.
700 B.C.	Great tombs of eastern type at Cerveteri and Praeneste.	The first legendary kings of Rome: Romulus, Numa Pompilius, Tullus Hostilius, Ancus Martius.
650 B.C.	Construction of the first bridge over the Tiber (the Sublicius), traditionally attributed to Ancus Martius.	616 B.C. Legendary arrival of Tarquinius Priscus in Rome. Beginning of Etruscan domination through Etruscan kings in Rome: 616–579 B.C. Tarquinius Priscus.
600 B.C.	First installation of the Circus Maximus.	579–534 B.C. Servius Tullius, King of Rome.
550 B.C.	Temple of Diana on the Aventine and Temples of Fortuna and of Mater Matuta in Forum Boarium, founded by Servius Tullius. First "Servian Wall" (?) Cloaca Maxima, constructed during reign of Tarquinius Superbus 509 B.C. Inauguration of Temple of Jupiter Capitolinus.	534–509 B.C. Tarquinius Superbus, King of Rome. 509 B.C. End of the monarchical period; beginning of the Republic.
500 B.C.	493 B.C. Temple of Ceres, Liber, and Libera inaugurated, the work of Greek artists.	
450 B.C.	431 B.C. Temple of Apollo inaugurated.	
400 B.C.	378 B.C. Reconstruction of "Servian" wall.	396 B.C. Roman conquest of Veii, the major Etruscan city nearest Rome. 390 B.C. Conquest and sack of Rome by the Gauls.
350 B.C.	Temple C in the Largo Argentina. 312 B.C. Appian Way, from Rome to Capua. 304–303 B.C. Fabius the Painter paints the Temple of Salus. Francois Tomb at Vulci (named for its 19th-century discoverer).	343–341 B.C. First Samnite War. 326–304 B.C. Second Samnite War, for the domination of Campania.
300 B.C.	270 B.C. (circa) Italic temple at Paestum. Sepulcher of the Scipios (on the Appian Way).	298–290 B.C. Third Samnite War. 281–272 B.C. War against Tarentum and Pyrrhus.
250 B.C.		264–241 B.C. First Punic War, with Carthage over possession of Sicily. 218–202 B.C. Second Punic War, against Hannibal and Carthage. 211 B.C. Conquest of Syracuse, ally of the Carthaginians. 209 B.C. Conquest of Tarentum, which had been occupied by Hannibal.
200 B.C.	190 B.C. (circa) Arrival of first Hellenistic artists from Asia Minor. 180–145 B.C. Activity of first Attic artists for Roman patrons. After 177 B.C. Luni pottery and ceramics.	190 B.C. Battle of Magnesia against Antiochus III of Syria.

184

150 B.C.	"House of the Faun" at Pompeii. First phase (?) of the "Villa of Mysteries," Pompeii. 146–102 B.C. Activity of Greek architect Hermodorus of Salamis in Rome. Circular temple in Forum Boarium. Temple of Fortuna at Praeneste. "House of the Griffins" in Rome.	146 B.C. Destruction of Corinth and Carthage, in the Third Punic War. 102–101 B.C. Marius defeats the Cimbri and the Teutons.
100 B.C.	*Ara* of Domitius Enobarbus. 80–78 B.C. Construction of *Tabularium*, Roman state archives on the Capitol. Temple of Hercules at Tivoli. Temple of Jupiter Anxur at Terracina. Little Theater and Amphitheater at Pompeii. 55 B.C. Inauguration of Theater of Pompey in Rome.	91–88 B.C. Social War, against Italic allies claiming citizenship. 88–82 B.C. Civil War, between Marius and Sulla, won by Sulla.
50 B.C.	54–46 B.C. Forum of Caesar Beginning of Aretine ceramic production. 40–30 B.C. Tomb of Eurysaces (Tomb of the Baker), in Rome near the Porta Maggiore. 9 B.C. Inauguration of *Ara Pacis* 2 B.C. Inauguration of Forum of Augustus Villa at Sperlonga. Villa at Capri.	48 B.C. Death of Pompey. 44 B.C. Death of Julius Caesar. 31 B.C. Battle of Actium, between Octavius and Antony, allied with Cleopatra, Queen of Egypt, for the control of power in Rome.
B.C. **0** **A.D.**		Julian-Claudian Emperors: 23 B.C.–A.D. 14 Augustus A.D. 15–37 Tiberius. A.D. 37–41 Caligula. A.D. 41–54 Claudius. A.D. 54–68 Nero.
A.D. 50	A.D. 64 Construction of *Domus Aurea;* Severus and Celer, architects. A.D. 80 Colosseum (Flavian Amphitheater). Arch of Titus. Baths of Titus. Palace of Domitian on the Palatine; Rabirius, architect. Forum of Nerva.	A.D. 64 Fire in Rome. A.D. 69 Emperors Galba, Otho, and Vitellus. Flavian Emperors: A.D. 69–79 Vespasian. A.D. 79–82 Titus A.D. 82–96 Domitian. A.D. 96–98 Nerva. A.D. 98–117 Trajan.
A.D. 100	A.D. 112–113 Inauguration of Forum of Trajan and Column of Trajan; reconstruction of Forum of Caesar. A.D. 118–128 The Pantheon. A.D. 125–135 Hadrian's Villa.	Antonine Emperors: A.D. 117–138 Hadrian. A.D. 138–161 Antoninus Pius.
A.D. 150	Temple of Divine Hadrian. Sepulchers in Via Latina. *Pago Triopio*, the villa of Herod Atticus on Appian Way. Column of Marcus Aurelius. A.D. 196 Restoration of the theater at Ostia.	A.D. 161–180 Marcus Aurelius. A.D. 180–193 Commodus.
A.D. 200	A.D. 203 Arch of Septimius Severus. A.D. 204 Arch of the Argentari. A.D. 212–216 Baths of Caracalla.	Severian Emperors: A.D. 193–211 Septimius Severus. A.D. 211–217 Caracalla. A.D. 217–218 Macrinus. A.D. 218–222 Heliogabalus A.D. 222–235 Alexander Severus.
A.D. 250	A.D. 270–274 Construction of the Aurelian Walls. A.D. 298–306 Palace of Diocletian at Spalato.	A.D. 235–284 Period of military anarchy: twenty-one emperors. A.D. 284–305 Diocletian Tetrarchy: division of the Empire into four districts, each with its own emperor.
A.D. 300	A.D. 303 Base of the Diocletian Decennial monument in the Forum. Circus and Villa of Maxentius. Temple of Romulus in the Forum. Reconstruction of Temple of Venus and Roma. Basilica of Maxentius. A.D. 312–315 Arch of Constantine. Four-faced Arch of the Forum Boarium. Mausoleum of Constantina (Santa Costanza).	A.D. 306–337 Constantine. A.D. 312 Battle of Milvian Bridge between Constantine and Maxentius for domination of Italy. A.D. 313 Edict of Milan, granting freedom of worship to Christians. A.D. 330 Inauguration of Constantinople.
A.D. 400		A.D. 410 Sack of Rome by Alaric. A.D. 476 Fall of western Roman Empire; Emperor Romulus Augustus deposed by Odoacer, King of Herulians.

RECOMMENDED READING

There is almost no end to the books about the ancient Romans; the problem is to find those suited to a reader's particular needs. This list is a representative selection of books that might well complement various aspects of this volume. They have also been chosen on the basis of their accessibility — price, recent printings, and attempts to communicate with the general public.

Ashby, Thomas: *The Roman Campagna in Classical Times* (Barnes & Noble, 1971)

Bloch, Raymond: *The Origins of Rome* (Praeger, 1960)

Brown, Frank: *Roman Architecture* (Braziller, 1961)

Carcopino, Jerome: *Daily Life in Ancient Rome* (Yale Univ. Press, 1940)

Davenport, Basil, ed.: *The Portable Roman Reader* (Viking, 1951)

Dudley, Donald: *The Civilization of Rome* (New American Library, 1960)
 Urbs Roma: A Source Book of Classical Texts on the City and Its Monuments (Phaidon 1967)

Grant, Michael: *The Roman Forum* (Macmillan, 1970)
 The World of Rome (Praeger, 1970)

Grimal, Pierre: *In Search of Ancient Italy* (Hill & Wang, 1964)

Hadas, Moses, ed.: *The History of Rome from Its Origins to AD 529 as Told by the Roman Historians* (Doubleday, 1956)

Hafner, German: *The Art of Rome, Etruria, and Magna Graecia* (Abrams, 1970)

Hanfmann, George M.: *Roman Art: A Modern Survey of the Art of Imperial Rome* (N.Y. Graphic Society, 1964)

Lissner, Ivan: *The Caesars* (Putnam, 1958)

Livy: *The Early History of Rome* (Penguin, 1960)

Paoli, Ugo: *Rome: Its People, Life and Customs* (McKay, 1963)

Petrie, Alexander: *Introduction to Roman History, Literature, and Antiquities* (Oxford Univ. Press, 1963)

Picard, Gilbert: *Living Architecture: Rome* (Grosset & Dunlap, 1970)

Plutarch: *Lives of the Noble Romans* (Various editions)

Starr, Chester: *The Civilization of the Caesars* (Norton, 1965)

Stenico, Arturo: *Roman and Etruscan Painting* (Viking, 1963)

Suetonius: *Lives of the Twelve Caesars* (Various editions)

Von Hagen, Victor: *Roman Roads* (World, 1966)

Wheeler, Mortimer: *Roman Art and Architecture* (Praeger, 1966)

RECOMMENDED VIEWING

Nothing quite compares with visiting the actual sites of the Romans or the great collections of their art and artifacts in the museums of Italy; the modern age of jet travel and tourism makes this relatively easy. Meanwhile, North Americans are fortunate in having numerous fine collections of Roman works throughout the continent. The most important are:

> The Metropolitan Museum of Art, New York City
> The Museum of Fine Arts, Boston, Massachusetts
> The University Museum, Univ. of Pennsylvania, Philadelphia
> The Cleveland Museum of Art, Ohio
> The Rhode Island School of Design Museum of Art, Providence

Listed below are the many other collections — all open, within certain restrictions, to the general public — that offer people everywhere a chance to make at least some acquaintance with Roman remains.

Alabama: Birmingham Museum of Art

California: Berkeley: Pacific School of Religion, Palestine Institute Museum
> Los Angeles County Museum of Art
> Malibu: J. Paul Getty Museum
> Santa Barbara Museum of Art

Colorado: Denver Art Museum

Connecticut: Hartford: Wadsworth Atheneum
> New Haven: Yale University Art Gallery

Hawaii: Honolulu Academy of Arts

Illinois: Urbana: University of Illinois Cultural Museum

Indiana: Bloomington: Indiana University Museum of Art

Kansas: Lawrence: University of Kansas, Wilcox Museum

Maine: Brunswick: Bowdoin College Museum of Art

Maryland: Baltimore: Johns Hopkins University, Archaeological Museum
> The Walters Art Gallery

Massachusetts: Cambridge: Harvard University, Fogg Art Museum
> Northampton: Smith College Museum of Art
> Provincetown: Chrysler Art Museum
> Worcester Art Museum

Michigan: Ann Arbor: University of Michigan, Kelsey Museum of Archaeology
> Detroit Institute of the Arts

Minnesota: Minneapolis Art Institute

Missouri: Columbus: University of Missouri, Museum of Art and Archaeology
> Kansas City: William R. Nelson Gallery & Atkins Museum of Fine Arts
> St. Louis Art Museum

New Jersey: The Newark Museum
> Princeton University Art Museum

New York: Albany Institute of History and Art
> New York City: Brooklyn Museum
> Rochester: Memorial Gallery, University of Rochester

North Carolina: Raleigh: North Carolina Museum of Art

Ohio: Cincinnati Art Museum
> Dayton Art Institute
> Toledo Museum of Art

Oregon: Portland Art Museum

Texas: Houston: Museum of Fine Arts

Washington: Seattle Art Museum

Washington, D.C : The Dumbarton Oaks Research Library and Collection

Wisconsin: Milwaukee Public Museum
> Milwaukee: Charles Allis Art Library

Canada: Montreal Museum of Fine Arts
> Toronto: Royal Ontario Museum, University of Toronto

INDEX